Final Cut Pro X
Beyond the Basics

Final Cut Pro X
Beyond the Basics

Advanced Techniques
for Editors

Tom Wolsky

Focal Press
Taylor & Francis Group

NEW YORK AND LONDON

First published 2015
by Focal Press
70 Blanchard Road, Suite 402, Burlington, MA 01803

and by Focal Press
2 Park Square, Milton Park, Abingdon, Oxon OX14 4RN

Focal Press is an imprint of the Taylor & Francis Group, an informa business

Notices
Knowledge and best practice in this field are constantly changing. As new research and experience broaden our understanding, changes in research methods, professional practices, or medical treatment may become necessary.

Practitioners and researchers must always rely on their own experience and knowledge in evaluating and using any information, methods, compounds, or experiments described herein. In using such information or methods they should be mindful of their own safety and the safety of others, including parties for whom they have a professional responsibility.

Product or corporate names may be trademarks or registered trademarks, and are used only for identification and explanation without intent to infringe.

Library of Congress Cataloging in Publication Data
Wolsky, Tom.
Final Cut Pro X beyond the basics : advanced techniques for editors/Tom Wolsky.
pages cm
ISBN 978-1-138-78711-7 (paperback)
1. Final cut (Electronic resource) 2. Digital video—Editing. I. Title.
TK6680.5.W64 2014
777′.55028553—dc23
2014015986

ISBN: [9781138787117] (pbk)
ISBN: [9781315766812] (ebk)

Typeset in Giovanni
By diacriTech

Printed and bound in the United States of America by Sheridan Books, Inc. (a Sheridan Group Company).

Bound to Create

You are a creator.

Whatever your form of expression — photography, filmmaking, animation, games, audio, media communication, web design, or theatre — you simply want to create without limitation. Bound by nothing except your own creativity and determination.

Focal Press can help.

For over 75 years Focal has published books that support your creative goals. Our founder, Andor Kraszna-Krausz, established Focal in 1938 so you could have access to leading-edge expert knowledge, techniques, and tools that allow you to create without constraint. We strive to create exceptional, engaging, and practical content that helps you master your passion.

Focal Press and you.

Bound to create.

We'd love to hear how we've helped you create. Share your experience:
www.focalpress.com/boundtocreate

Focal Press
Taylor & Francis Group

Table of Contents

INTRODUCTION .. xiii
ACKNOWLEDGMENTS .. xvii
DEDICATION .. xix

CHAPTER 1 **Back to the Basics**.......................................1
Optimizing Your Computer for FCP............................. 2
Monitors.. 5
Third Party Hardware ... 6
Coming from Other Applications................................ 7
Legacy FCP ... 7
iMovie ... 7
Updating Libraries... 10
Updating Projects and Events................................. 11
Editing Clips .. 15
Loading the Media .. 15
Editing into the Project.. 16
Summary .. 22

CHAPTER 2 **Preferences and Importing**.........................23
Preferences... 23
General and Editing Preferences............................. 23
Playback.. 24
Import ... 27
Managed Media ... 29
External Media.. 30
Consolidate .. 33
Library Backups ... 35
Preferences Files .. 36
Customizing the Keyboard..................................... 37
Importing .. 40
Creating Camera Archives 42
Converting ... 44
Importing Music .. 46
Trimming ... 49

Importing from XML	51
Red Raw	51
Reimporting and Relinking Files	52
Summary	55

CHAPTER 3 **Organization** .. **57**

Loading the Media	57
Organizing Media	57
Workflow Structures	58
Collaborating	67
Organizing Clips	70
Custom Metadata	75
Keywords	78
Search Filter	81
Smart Collections	82
Custom Metadata	85
Compound Clips and Auditions	85
Summary	87

CHAPTER 4 **Editing** .. **89**

Loading the Media	89
Look Before You Cut	89
Dynamic Editing	92
Continuity Editing	98
Overwriting the Master Shot	100
Appending Close-ups	102
Trimming	105
Summary	109

CHAPTER 5 **Working with Audio** .. **111**

Setting Up the Project	111
The Split Edit	112
Making Split Edits	114
Trimming Expanded Clips	115
Controlling Levels	119
Audio Meters	119
Audio Enhancement	120
Channel Configurations	123
Mixing Levels in the Timeline	125
Fading Levels in the Timeline	125
Changing Levels on Part of a Clip	126
Match Audio	129

Subframe Precision ... 131
Controlling Levels with Effects ... 134
Pan Levels .. 138
Editing Music ... 142
Adding Markers ... 142
Roles .. 146
Timeline Index .. 148
Synchronizing Clips ... 151
Recording Audio .. 153
Summary .. 155

CHAPTER 6 **Multicam Editing...157**
Setting Up the Project ... 157
Making the Multicam Clip .. 158
The Angle Editor .. 162
Editing the Multicam Clip .. 166
Angle Viewer ... 166
Editing.. 170
Effects ... 174
Channel Configurations... 175
Summary .. 177

CHAPTER 7 **Adding Titles and Still Images ...179**
Setting Up the Project ... 179
Text Styles ... 179
Titles .. 185
Title Groups... 185
Text and the Screen... 196
Find and Replace ... 199
Custom Animation ... 199
Compound Titles ... 202
Text.. 202
Texture .. 202
Putting It All Together.. 203
Still Images.. 204
Resolution ... 207
Summary .. 207

CHAPTER 8 **Adding Effects ...209**
Setting Up the Media ... 209
Applying an Effect .. 210
Copying and Pasting ... 211
Audition Effects... 211

Animating Effects ... 213
Adjustment Layer ... 214
Video Effects ... 218
Basics .. 218
Blur ... 218
Distortion .. 219
Keying ... 221
Mask ... 228
Luma Keyer ... 229
Light .. 229
Looks ... 232
Stylize ... 232
Tiling ... 234
Audio Effects ... 234
Retiming .. 239
Constant Speed Changes .. 239
Custom Speed Settings ... 240
Speed Blade and Transitions ... 241
Retime to Fit ... 241
Speed Tools ... 242
Stabilization .. 244
Summary ... 245

CHAPTER 9 Color Correction ...247
Color Correction .. 247
Color Balance .. 248
Video Scopes .. 249
Color Board ... 255
Using the Color Board .. 261
White Balance .. 263
Silhouette .. 264
Night .. 265
Broadcast Safe .. 267
Match Color ... 268
Looks ... 269
Secondary Correction .. 271
Shape Mask ... 271
Color Mask .. 275
Color Continuity ... 277
Setup ... 277
Master Shot ... 279
Matching Shots .. 281
Summary ... 285

CHAPTER 10 Animating Images .. **287**
 Setting Up the Project .. 287
 Transform... 288
 Scale ... 288
 Rotation .. 288
 Position... 291
 Anchor Point ... 291
 Crop .. 292
 Trim .. 293
 Crop.. 295
 Ken Burns ... 295
 Distort ... 298
 Animation .. 298
 Straight Motion ... 298
 Curved Motion .. 300
 Keyframes ... 301
 Split Screen ... 301
 Picture in Picture .. 302
 Motion Control... 304
 Brady Bunch Open .. 308
 Sliding White Bar... 309
 Fixing the Headshot.. 309
 Middle Headshots ... 310
 Extending ... 310
 Adding More Headshots.. 313
 New Headshots ... 314
 Final Headshots .. 316
 Titles... 316
 Final Polishing... 317
 Fade to Black .. 318
 Summary ... 319

CHAPTER 11 Compositing.. **321**
 Setting Up the Project .. 321
 Blend Modes.. 321
 Compositing Preview .. 323
 Screen and Multiply.. 323
 Animated Text Composite ... 324
 Adding a Bug .. 326
 Stencils And Silhouettes ... 328
 Organic Melding ... 332
 Highlight Matte ... 333

Animating the Highlight .. 335

Glints ... 335

Animating the Circle .. 336

Polishing the Glow.. 337

One More Touch... 338

Video In Text ... 339

Getting Started ... 339

Making Text .. 340

Separating the Letters .. 341

Adding Video.. 342

Edging.. 344

Animating the Text... 345

Summary .. 346

CHAPTER 12 Outputting from Final Cut Pro ...347

Sharing... 347

Destinations .. 348

Export ... 351

Master File .. 355

Roles ... 358

Working With Compressor .. 360

Sending vs. Export Using .. 361

Compressor Interface .. 361

Apple Built-In Presets .. 361

Using Compressor.. 366

Creating Custom Presets ... 370

Groups .. 376

Droplets .. 376

Preferences ... 378

Archiving .. 379

Summary .. 380

What Is Editing?

The first movies were single, static shots of everyday events. The Lumière brothers' screening in Paris of a train pulling into the La Ciotat train station caused a sensation. Shot in black and white, and silent, it nevertheless conveyed a gripping reality for the audience. People leaped from their seats to avoid the approaching steam locomotive. The brothers followed this with a staged comic scene. Georges Méliès expanded on this by staging complex tableaux that told a story. It wasn't until Edwin H. Porter and D. W. Griffith in the United States discovered the process of editing one shot next to another that movies were really born. Porter also invented the close-up, which was used to emphasize climactic moments. Wide shots were used to establish location and context. Griffith introduced such innovations as the flashback, the first real use of film to manipulate time. Parallel action was introduced, and other story devices were born, but the real discovery was that the shot was the fundamental building block of film and that the film is built one shot at a time, one after the other. It soon became apparent that the impact of storytelling lies in the order of the shots.

Films and videos are made in the moments when one shot changes into another, when one image is replaced by the next, when one point of view becomes someone else's point of view. Without the image changing, all you have are moving pictures. The idea of changing from one angle to another or from one scene to another quickly leads to the concept of juxtaposing one idea against another. The story is not in each shot but in the consecutive relationship of the shots. The story isn't told in the frames themselves so much as in the moment of the edit, the moment when one shot, one image, one idea, is replaced with another. The edit happens not on a frame but between the frames, in the interstices between the frames of the shots that are assembled.

Editing is a poor word for the film or video production process that takes place after the images are recorded or created. It is not only the art and process of selecting and trimming the material and arranging it in a specific order but is very much an extension of script writing, whether the script was written before the project was recorded or constructed after the material was gathered and screened. The arrangement and timing of the scenes, and then the selection, timing, and arrangement of the picture elements within each scene, are most analogous to what a writer does. The only difference is that the writer crafts his script from a known language and his raw imagination, whereas the editor crafts her film from the images, the catalogue of words, as it were—the dictionary of a new language—that has been assembled during the production.

The editor's assembly creates a text that, although a new, never-before-seen or heard language, is based on a grammatical traditional—one that goes back to Porter and Griffith—that audiences have come to accept as a means for conveying information or telling a story.

Unlike the written language, a novel, or an essay that can be started and stopped at the reader's whim, video or film production is based on the concept of *time*, usually linear time of a fixed length. Nowadays, of course, many forms of video delivery—the Web, computer or portable player, or DVD player—can be stopped and started according to the viewer's desires. Nonetheless, most productions are designed to be viewed in a single sitting for a specified duration.

Film and video are designed to accommodate the temporal rigidity of the theater but with the spatial fluidity and freedom of a novel. Whether it is 10 minutes, 30 minutes, one hour, two hours, or more, the film is seen as a single, continuous event of fixed duration. On the other hand, time within the film is infinitely malleable. Events can happen quickly: We fly from one side of the world to another, from one era to a different century, in the blink of an eye. Or every detail and every angle can be slowed down to add up to a far greater amount than the true expanse of time, or the images can be seen again and again.

Because film and video production are based on the notion of time, the process of editing—controlling time and space within the story—is of paramount importance. This process of editing, of manipulating time, does not begin after the film is shot but as soon as the idea is conceived. From the time you are thinking of your production as a series of shots or scenes and as soon as the writer puts down words on paper or the computer, the movie is being edited, and the material is being ordered and arranged, juxtaposing one element against another, one idea with another.

This process of writing with pictures that we call editing has three components:

1. *Selection*, choosing the words, deciding which shot to use
2. *Arrangement*, the grammar of our writing, determining where that shot should be placed in relation to other shots, the order in which the shots will appear
3. *Timing*, the rhythm and pace of our assembled material, deciding how long each shot should be on the screen

Timing is dictated by rhythm—sometimes by an internal rhythm the visuals present, sometimes by a musical track, and often by the rhythm of spoken language. All language, whether dialog or narration, has a rhythm, a cadence or pattern, that is dictated by the words and based on grammar. Grammar marks language with punctuation: Commas indicate short pauses, semicolons are slightly longer pauses, and periods mark the end of a statement. The new sentence begins a new idea, a new thought, and it is natural that as the new thought begins, a new image is introduced to illustrate that idea. The shot comes not at the end of the sentence, not in the pause, but at the beginning of the new thought. This is

the natural place to cut, and this rhythm of language often drives the rhythm of film and video. Editing creates the visual and aural juxtaposition between shots. That's what this book is about: how to put together those pieces of picture and sound.

This book is not intended as a complete reference manual for all aspects of Final Cut Pro (FCP). For that you would really need to consult the manual in the Help files that accompanies the application. This book is intended as a course to give you advanced tips and tricks for practical use of the application. If there is something specific you'd like to learn how to do I would suggest looking first in the Index to see if it's covered in the book.

There are many different ways of doing things in FCP, different ways to edit and to trim, but there are clearly more efficient ways. There are many ways to do things in Final Cut because no one way is correct in every situation. Working cleanly and efficiently will improve your editing by allowing you to edit more smoothly and in a steady rhythm, concentrating on content rather than on the mechanics of the application.

The book is organized as a series of tutorials and lessons that I hope have been written logically to guide the reader from one topic to a more advanced topic. The nature of your work with FCP, however, may require that you have the information in Lesson 10, for example, right away. You can read that lesson by itself. There may, however, be elements in Lesson 10 that presuppose that you know something about using the Viewer in conjunction with the Inspector.

Why Do I Get to Write This Book?

I have been working in film and video production for longer than I like to admit (okay, more than 40 years). I worked at ABC News for many years as an operations manager and producer, first in London and then in New York. I went on to teach video production at a small high school in rural northern California. I wrote the first step-by-step tutorial book with projects files and media for Final Cut Pro in 2001. Since then I have written many FCP and FCE books as well as made training DVDs for Final Cut Pro, Final Cut Studio, Final Cut Express, iLife, and the Mac OS. I also have written curriculum for Apple's Video Journalism program and taught training sessions for them, and during the summer, I have had the pleasure of teaching Final Cut at the Digital Media Academy on the beautiful Stanford University campus.

Who Should Read This Book?

This book is intended for all FCP users, especially those who are experienced editors, but have not had time to adapt to this new paradigm for editing.

While FCP is directed to professional video and film production market, its price point and ease of use makes it appealing to consumers, prosumers, and

professionals, really anyone making video or film from any format for any market should find this application fits their needs. Its affordability will particular benefit the prosumer market, event producers, and even small companies with video production requirements. FCP is a complex application. It requires learning your way around the interface, its tools, and its enormous capabilities.

Where's the Media?

Most of my previous books have had an accompanying DVD. In these days of cloud computing this is no longer felt to be necessary. All the project files and media are now stored on the servers. To download the media go to http://www .fcpxbook.com. On the Web site there are a number of zipped files. These contain the libraries we'll be working with. More about that in the first chapter, which actually does not need any media, but most will, so the sooner you can start downloading the better. You may want to substitute your own material—clips you want to work with or are more familiar with, but I would suggest starting with the supplied materials.

I hope you find this book useful, informative, and fun. I think it's a great way to learn this kind of application.

Acknowledgments

First, as always, my gratitude to all the people at Focal Press who make this book-writing process relatively painless, particularly Dennis McGonagle, senior acquisitions editor, for his thoughtful advice and guidance, and for bringing this project to life. My thanks also to Peter Linsley, editorial project manager, for his help and ready answers to my questions and for shepherding the project through the production process.

Thanks to project manager Charles Emmanuel Collins and to Arun Natarajan of diacriTech for helping me through the proofing process, and to production editor Denise Power. Any errors in text or substance remain mine alone. Many thanks to Mat Willis for his work on the cover.

So many people helped make this book possible and deserve thanks: Sidney Kramer for his expert contract advice; and Steve Martin of Ripple Training, the trainers' trainer, who taught us all at one time or another.

My thanks go to Steve Oakley, first, for his gracious permission to allow me to use material from his wonderful short *A Great Life*; and second, to Steve and Lexi Quinn for letting me use a professionally shot piece of green screen work. Thanks again to Rich Lipner of Finca Dos Jefes and Café de la Luna for his kind cooperation for allowing us to shoot his coffee tour, with special thanks to Lazario and Hermione for their assistance. I have to thank Travis Schlafmann, one of the outstanding instructors at Digital Media Academy, for letting me use the snowboarding and skiing video that accompanies the book. Though it's been quite a few years since we first shot at CoHo, my grateful thanks to the musicians and organizers of the Stanford Summer Jazz Workshop for allowing us to tape their performance, especially Ambrose Akinmusire, trumpet; Patrick Wolff, tenor sax; Ryan Snow, trombone; Sam Grobe-Heintz, piano; Josh Thurston-Milgrom, bass; and Adam Coopersmith, drums. Thanks as always to our friends in Damine, Japan. A great many thanks are due to my partner, B. T. Corwin, for her insights, her endless encouragement, her engineering technical support, and her patience with me. Without her, none of this would have been possible. Any errors, mistakes, or omissions are solely mine as I've looked at these words and thought about them long enough. If errors are brought to my attention I shall post corrections on my Web site as well as changes that are made to the application as it moves forward.

Dedication

For B.T.
With Endless Love and Gratitude

CHAPTER 1

Back to the Basics

Welcome to Final Cut Pro X (pronounced *ten*) version 10.1, referred to simply as FCP or FCPX. Like the operating system OS X, which began as Mac OS X 10.0 and eventually moved through to OS X 10.9, so Final Cut Pro X started out as version 10.0 and has now, after more than three years, moved on to version 10.1. This is not to say that there have not been significant upgrades since then. There were two major upgrades, version 10.0.3 that introduced multicam editing and version 10.0.6 that made important changes to importing and exporting, what FCP calls Sharing. As of this writing we are up to version 10.1.2, on which the libraries and media that accompany this book are based.

Version 10.1 is designed to take advantage of the newest technologies included in Mavericks OS 10.9, particularly it takes advantage of what Apple calls Timer Coalescing and Compressed Memory, which speeds up low-level system events. Timer Coalescing allows these system events to be grouped, to happen in bursts when there is available processor time, allowing the system to be more efficient when it's doing application tasks. Compressed Memory allows the system to compact background memory usage and allows more free memory for active applications like Final Cut Pro. This has been a huge improvement over previous versions of OS X, which had significant memory problems when many applications were open simultaneously, building up large amounts of inactive RAM, which would not be released quickly when suddenly need by an application. In previous versions of the OS, I could regularly run up this inactive memory state that brought FCP to its knees. This problem went back as far as Mac OS X Tiger in 2006. Mavericks has been an amazing improvement and for this alone it makes sense to require 10.9 for the latest version of Final Cut Pro.

Another important feature in Mavericks that is significant to FCP is the operating system's ability to use multiple monitors including Air Display to wirelessly use multiple monitors. It also has integrated notifications to tell you background tasks like sharing have been completed. The OS also allows access to multiple graphics cards for processing, and FCP has taken advantage of that, allowing it harness the full power of the new Mac Pros.

> **TIP**
>
> **Memory Clean:** Though Apple boasts of the capabilities of Timer Coalescing and Compressed Memory in reality when you have many applications open and are constantly switching between them, which we all do, and really know we shouldn't, RAM usage does get overwhelmed. A very useful and free application, available from the App Store, is Memory Clean. It will release inactive memory and make it available. It works best when you have closed a RAM-intensive application, like Motion, that you don't plan to come back to for a while. Simply open Memory Clean, click Clean, and it will free the memory in a few moments. The application can be left open, and it appears as a menu bar display to show memory usage and allow you to clean it from there (see Figure 1.1).

FIGURE 1.1
Memory clean.

Optimizing Your Computer for FCP

Like most high-end professional software, FCP requires the best possible hardware you can afford, computer, monitor, and drives. The Apple FCP requirements are really the absolute minimum needed and should not be considered anything more than barely adequate. In addition to having the best possible hardware you can afford, there are some steps you can take to. In addition to having the best possible hardware you can afford, there are some steps you can take to optimize your computer for video editing with Final Cut Pro, using a few simple procedures.

One of the most important is to check on **Prevent App Nap** in the Finder information box. This should be done for all professional applications especially FCP, Motion, and Compressor. To do this, select the application in the Applications folder and press **Command-I** or **Command**-click to select multiple applications and use **Option-Command-I**. In the Finder information window, check on **Prevent App Nap** (see Figure 1.2). You do not want your video editing application falling asleep while it's rendering or exporting in the background. As long as the application is in the foreground, this isn't a problem, but as soon as you go off to answer e-mail or surf the web, the application is likely to take a nap. That said you really shouldn't be using your computer for anything else while it's working in FCP. You will just slow down the processes and create potential for encoding errors. If you just have to check your e-mail, use your phone or get an iPad.

Next, there are a few steps you can take to improve performance and make it easier to use the application. Many users who aren't familiar with recent versions

of OSX find the use of hidden scroll bars disconcerting. This functionality is hidden by default but can be switched on in **General** System Preferences as in Figure 1.3.

FIGURE 1.2
Prevent App Nap.

FIGURE 1.3
Scroll bar preference.

In System Preferences, you can switch off a few items that might interfere with the application's operations while it's running.

For the **Desktop**, most professionals recommend switching off screen savers and working in a neutral, usually medium-gray desktop, because it is more restful for the eyes and does not affect the color rendition of your eyes. (You'll see this tonal display in the application—mostly gray shades.)

The **Displays** should be set at the resolution settings the system recommends for your monitor, which should be a minimum of 1280 × 768. The application will not run properly at lower resolutions. In **Displays**, the Color tab should be to the default color setting.

The **Energy Saver** should be set so that the system never goes to sleep. It's less critical, however, that the monitor doesn't go to sleep. I usually set it around ten minutes, but the system and the hard drive should *never* shut down. If you're using a recent MacBook Pro, mid-2010, or later, you'll see an option at the top of the **Energy Saver** panel that is on my default. This switches between graphics systems used by the computer. It tends to go to the low-powered, lower performance battery setting to lengthen battery life. If you can, it's better to switch this off while using FCP to improve graphics processing performance.

Another feature that appears in **Trackpad** or in **Mouse** is the use of natural scrolling (see Figure 1.4). Natural scrolling emulates mobile devices, push up to go to the button and pull down to go to the top. This is the opposite of older, conventional scrolling used on Windows machines. To keep the old way of scrolling, switch Natural off.

TIP

Natural Scrolling Hand: The Hand tool when used in the Timeline to move the timeline content up and down uses natural scrolling, pull down to see the top of Timeline panel and push up to see the bottom of the Timeline panel. This cannot be changed and is not controlled by System Preferences.

TIP

Right-Clicking: If you do not have a three-button mouse, either an Apple Magic Mouse or a third-party mouse, you really should get one. If you have the Apple Magic Mouse, make sure you go to the System Preferences and enable right-clicking in the Mouse controls. Any inexpensive USB three-button mouse with a scroll wheel will also do. The application uses right-clicking to bring up shortcut menus, and the properly configured scroll wheel can move sliders as well as window displays. If you are not using a three-button mouse, whenever I say "right-click," you can press down the **Control** key while clicking to bring up the shortcut menu. Also on a laptop without a mouse, press the **Control** key and mouse down to bring up the shortcut menu.

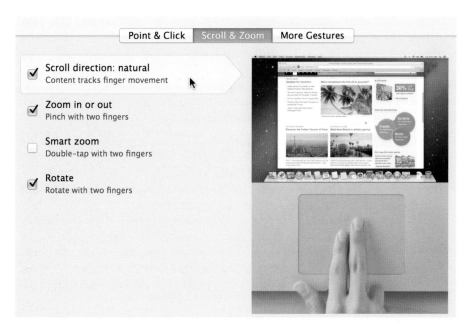

FIGURE 1.4
Natural scrolling.

I also recommend that you switch off networking. This is done easily by going to **Network Preferences** and creating a new location called **None**. Set up your **None** location without any active connections—no internal modem, no Airport, no Ethernet—everything unavailable and shut off. To reconnect to the network, simply change back to a location from the **Apple** menu that allows access to whatever connection you want to use.

Monitors

Final Cut Pro is designed primarily to work with specific, standard video resolutions. It can edit anything from 640 × 480 standard-definition footage to projects that are 2K or 4K, 2048 × 1024 pixels or 4967 × 2048 pixels, which are feature-film sizes with very wide aspect ratios. For most users, whether you shoot with an AVCHD camera or a DSLR or high-end HD camera, the aspect ratios are constant: All high definition is widescreen; if you work in DV or uncompressed standard definition, your project can be either 4:3 or 16:9. The application can also edit projects in nonstandard sizes and aspect ratios, portrait-shaped output for instance, or shapes for specific types of displays.

Apple has done a great deal to make this easier in Final Cut Pro by using the system's ColorSync technology to keep color for your media consistent as it moves between applications. This will keep your video correct on your computer screen, but it will not show you how it would appear on a television set or a video monitor. This is important because your material is being made into a video format, and many video formats are still interlaced and work in color and luminance specifications that date back many years.

In addition to your main monitor, you may want to use a second computer display to break up the large FCP window. This is really useful for video editing applications. This is especially helpful for long-form video production, or any production with a lot of media, and it's just nice to have the extra screen space. You can put either your Viewers, that's the main Viewer or the Angle Viewer on a second display, or your Libraries and Browser on the second monitor. This selections can be toggled on and off from the **View** menu.

There are a number of ways to monitor video on your computer, either in the FCP Viewer or in full screen. Full-screen view can be toggled on and off with a button or with a keyboard shortcut (**Shift-Command-F**). One of the nice features of using the button or the shortcut is that it also initiates playback. In addition, there are third-party tools for monitoring and ingest.

> **NOTE**
>
> **New Drivers:** Most third-party hardware technologies will need new drivers to work with FCP. Check on the manufacturers' websites to make sure you have the latest software add-ons that are compatible with FCP, and before you purchase any, make sure that the hardware has been tested and approved for use with the version of Final Cut Pro you're using.

Third-Party Hardware

There is an ever-changing field of third-party products, boards for use in older Mac Pros, and external boxes to connect your computer to broadcast monitors and decks to ingest media in the highest quality. If you're working with an older Mac Pro, there are cards such as the Kona cards from AJA (www.aja.com), the Kona 3G for SD, HD, and 4K ($1995), Kona LHi for SD and HD ($1495), and KONA LHe Plus ($995). These can be used to mirror your desktop or as a second display. Some cards also offer a standard HDMI connector, which carries video and embedded audio to view work on large consumer flatscreens; note, however, that color values will not be accurate broadcast gamut, which requires specialized calibrated TVs.

In addition to their Kona cards, AJA Video Systems make Io 4K and UltraHD boxes that use SDI and HDMI to Thunderbolt 2 ($1995) and Io XT for HD and uncompressed SD 4:2:2 and 4:4:4 ($1495) and Io Express ($995), all work with FCPX.

For older Mac Pros, Black Magic Design has the DeckLink series from as little as $145 as well as the Intensity Pro card ($199). They have a huge number of other products from H.264 Encoders (from $149) to UltraStudio 4K (from $995), UltraStudio Express ($495). For capture, they also have the Intensity Shuttle for USB3 ($199) and Intensity Shuttle for Thunderbolt ($239). In addition, Black Magic has branched out into acquisition with their amazing Pocket Cinema camera ($995), a Cinema Camera model ($1995), and Production Camera 4K ($3995). They also have acquired software products that they have continued to

develop DaVinci Resolve ($995) and DaVinci Resolve Lite (free), both of which can be accessed from FCPX.

There is also Matrox, while primarily the manufacturer of PC products, which has an I/O box for FCP the MXO2, as well as the Mojito Max H.264 hardware encoder.

Connections to external broadcast monitors can be toggled on and off by selecting **Window>A/V Output**.

COMING FROM OTHER APPLICATIONS

Legacy FCP

In my previous book on FCPX, I spend considerable time comparing FCPX to iMovie and earlier versions of Final Cut Pro and Final Cut Express, but in reality, this is entirely new concept for professional video editing built on an entirely new foundation. Many users are still in the process of moving from legacy software to the new Final Cut Pro. For those coming from Final Cut Pro 6.0.6 and 7.0.3 or from recent versions of Adobe Premiere, the essential tool is Intelligent Assistance's XML tool called **7toX**. This is a sophisticated XML conversion tool for changing the XML format used in legacy software to the new version of XML used in FCPX. As FCPX has evolved, Intelligent Assistance has kept this tool up to date. To use it:

1. Simply export an XML file from late versions of legacy FCP or an FCP XML file from Premiere.
2. Launch 7toX, which on opening will ask you to select an XML file.
3. Choose the exported FCP XML.
4. The utility will run and open FCP, where a dialog appears asking you which library you want to import the XML or make a new library (see Figure 1.5).

The XML content appears as an event in the library, and the bin structure from FCP or Premiere is carried over and keyworded. The XML sequence appears in FCP not as a project, but as a compound clip (see Figure 1.6). The best procedure I suggest would be to create a new project set to the default settings, then double-click the compound clip to open it, and copy and paste everything from the compound clip into the new project.

There is also a similar utility, Xto7, from Intelligent Assistance that will go in the opposite direction, take an FCPX XML file, and convert it to a legacy XML file for use in FCP7 or Premiere.

iMovie

Many users' first foray into video production is with iMovie. Serious hobbyists and professionals starting to work with the application often became quickly frustrated by that application's limitations and quality issues and had to step up to legacy Final Cut Pro's younger brother Final Cut Express.

FIGURE 1.5
7toX XML import
in FCP.

FIGURE 1.6
XML imported event.

In the first versions of FCPX, the similarities between the professional application and iMovie were apparent. Those similarities are now even stronger. About a month before the release of FCP 10.1, Apple released iMovie 10. It quickly became clear that this was a roadmap to the new FCP media management

model. After the release of FCP 10.1, it was obvious the new version iMovie was a stripped down version of the new FCP. Because of iMovie 10's close relationship with FCP 10.1, it is a very viable first step in many production situations. For instance, reporters or producers can work with iMovie to import media, view media, take notes, make rough cuts, make interview selects, and then send the whole thing to FCP for an editor to assemble. With iMovie 10, this is completely seamless. Not only are the two applications similar in behavior and terminology but also now you can effortlessly move a project started in iMovie to Final Cut Pro.

In iMovie, simply open the project you want to put into FCP and use **File>Send Movie to Final Cut Pro**. This will appear in FCP in a new event with the name of the project in an iMovie library (see Figure 1.7). The media will be copied into the library that will be in the user's Movies folder. You can of course close the library in FCP and move it to whatever location or drive you want. You can also move the media out of the library and move it into another location, which we shall see in Chapter 3.

The only thing to be careful with here is that the project sent from iMovie only sends the media used in the project. The simple work around for this is to send the material twice.

1. Inside iMovie import all your media.
2. Make a new project and make your rough cut or make your selects.

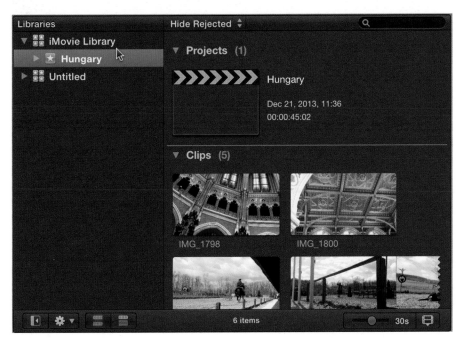

FIGURE 1.7
iMovie library in FCP.

3. Make a second project and select all your video in the event and put it into the new project. Just press **E**, just like in FCP, to append all the media into the project.
4. With the second project with all your media open, use the **File>Send Movie to Final Cut Pro** function.
5. If it isn't open, FCP will launch and the new iMovie library with the project and all the media will appear.
6. Switch back to iMovie and open the cuts project and send that to Final Cut Pro.

Because the media has already been sent and is already in the iMovie Library, only the cuts project with the selects or whatever you edited will appear in FCP. You can now simply move the cuts project into the event with the media and delete the event that's now superfluous. The ability to use iMovie 10 as an adjunct to FCP makes it a really useful tool for those who don't want or need to learn the complexity of the full editing application but want to be able to quickly and easily put together clips in a rough order for finishing in FCP.

> **NOTE**
>
> **Updates:** Applications are constantly being refined and updated to fix problems or to accommodate developments in hardware or the operating system. The App Store will notify you when there are new versions of the software. The libraries used in this book may need to be updated to work with your version of the software. The application will ask to update the projects automatically when the new application version is launched. Once they have been updated, they can no longer be used by older versions of the application.

> **TIP**
>
> **Audio Contents:** Some users have had problems downloading the additional content that comes with FCP, particularly the audio sound effects and loops. If you are having a problem accessing them using Software Update, you can also download them from the Apple website at http://support.apple.com/kb/DL1394. Some have had trouble with the Photo Browser and the Music & Sound Effects Browser not displaying. If this happens, you might try launching iPhoto and Aperture and GarageBand and then reopening FCP.

UPDATING LIBRARIES

You're probably familiar with the terms libraries, events, and projects as used by FCP. Even if the terminology such as these used by FCP seems strange and perhaps not really relevant; put the terminology aside for the moment. Rather it is important to understand something of the craft of editing to understand why the application is built as it is. Applications too often are built to duplicate existing

paradigms, some built to emulate videotape editing, some built to resemble film editing, but the fact is you're not doing either. You're editing digital files on a computer. So if you understand something of the craft of editing, you can see why FCPX has a logic that makes sense.

Though this book is to take you beyond the basics, because the application has been fundamentally changed, I would like to go back to the basics and look at the way it now works to make sure you're up to speed. Not only have the underlying functions of the application changed but also have many of the main features in the interface. It's important to understand how the application works and what are the best practices for working with the application. There are a number of different views on this, and we'll look at those in more detail in later chapters.

Updating Projects and Events

Before you launch the application and update your old events and projects to the new FCP library structure, you should do some housekeeping in FCP 10.0.9 or whatever earlier version you're using. Ideally this is done inside the older application, but if you've already updated the application and no longer have access to the older version, it can be done with care at the Finder level.

My recommendation is to update groups of projects and events together. A number of people have been working with the *Final Cut Projects* folder on one drive and the *Final Cut Events* folder on another drive. This has proven to be a disaster for updating to 10.1. You must consolidate these onto one drive as 10.1 will only look at one drive at a time.

So with projects and events on the same drive, if you can open the projects and events in your old version of FCP and make sure all the media and projects are correctly linked and there is no offline media. If there is use, the **Relink Event Files** function to get everything in shape.

Next put the first group of projects that you want to update in the *Final Cut Projects* folder. If the projects are inside another folder in that base folder, take them out. Make sure they are at the top level of the *Final Cut Projects* folder. The update process seems to have difficulty with project folders embedded inside folders in *Final Cut Projects*. Do the same for the *Final Cut Events* folder. Put the associated events, events associated and needed for those projects in the folder. Intelligent Assistance's Event Manager X is a great tool for this. It's now free as 10.1 libraries have obsoleted it. Use it to hide the projects and events you don't want to update and make the ones you do want to update available to FCP. Then launch the application and use **File>Update Projects and Events** and point the application to the drive with the projects and events you want to update. In the dialog that appears always, repeat always, save the original projects and events (see Figure 1.8). The default is to Move to Trash. Do not do that until you are certain all the media is where it's supposed to be and all the projects properly linked to the media. When you use the Save button, the application will put them in a folder with the name of the hard drive.

FIGURE 1.8
Save dialog.

FIGURE 1.9
Relink dialog.

If any of the projects are not correctly linked to their media, you will get the dialog in Figure 9 asking you to use the Relink function to reconnect the media.

Once the first set of projects and events have been updated, rename the library. FCP names the library after the drive the projects and events came from, such as *Macintosh HD's Library*. So rename it something that references the projects and events you just updated.

Next, move the another set of projects and events you want to update into a new *Final Cut Projects* and *Final Cut Events* folders. FCP will have moved the original folders in the saved projects and events folder.

Use **File>Update Projects and Events** and in the dialog that appears select **Locate** (see Figure 1.10). Point the dialog to the drive you want to update. The *Final Cut Projects* and *Final Cut Events* folders will be grayed out as in Figure 1.11. This has puzzled some users. Don't worry. You don't select the folders, simply the drive, and FCP looks for the folders it needs in the location where they are supposed to be.

Repeat this process of moving projects and events into the correct folders and updating each batch in turn until all your projects and events have been updated and put into new libraries.

FIGURE 1.10
Update dialog.

FIGURE 1.11
Updating drive.

TIP

Launching the Application: You can boot the application by double-clicking a library icon wherever it is stored. This is handy if the library was closed when the application was quit, and you want to work with it now. Second tip: Hold the **Option** key while you double-click the library and wait for the application to launch. This will (in addition to closing the Finder window) open a dialog that allows you to select a single library (see Figure 1.12) and open that library or select multiple libraries you want to open. Only the selected libraries will open, not any previously opened libraries as the application normally does.

FIGURE 1.12
Open library dialog.

TIP

Plug-ins: If you are updating to 10.1 from an older version of FCPX, it's probably best to remove or disable all third-party video and audio plug-ins until you have verified with the developers that their plug-ins work correctly with the latest version of the software.

Sidebar

WHAT'S A LIBRARY? WHAT'S AN EVENT? WHAT'S A PROJECT?

The library is the overall container for the events and projects for one production. It has many of the properties of the iPhoto and Aperture libraries; it's a self-contained, closed bundle. The file extension for the library is .fcpbundle. Unlike the stills libraries, the FCP library does not need to hold all your video. Think of the library as the container for your production. It's the master container for the events and projects used in the production, holding all the media and information about the production. (That's not strictly true, the media does not have to be in the library, but it's a good place to put it for many productions.) If you right-click on the library icon in FCP

and select **Reveal in Finder**, or use **Shift-Command-R**, in the Finder, you will see the four event star icon. If you right-click on the library in the finder and select **Show Package Contents**, you might see something like Figure 1.13, where the folders are the names of events. The word *even* might be confusing for some, but try not to focus on the word. Think of it as your media container, like a folder, where a separate event might be a folder, created for each day of shooting or for each scene. If you have come from legacy FCP, these might be analogous to

FCPX library = FCP7 project
FCPX event = FCP7 bin
FCPX project = FCP7 sequence.

The event holds your media either as actual files in a folder called *Original Media* or as symlinks that point to the media that resides in some other folder or some other drive or on a SAN (Shared Area Network). Wherever your libraries are and your actual media is, this needs to be on a big, fast, dedicated media drive. Even if the media files are not inside the library, the library will contain high data rate render files that need a fast drive. The projects are your edited programs. You can have multiple projects in different events, and they can all use media from any event in the same library. So you might have a separate event for each scene and within the event have a project in which the scene is edited. The various scene projects might then be assembled inside a master project for finishing and sharing. The master container for all your events and projects is the library.

FIGURE 1.13
Library bundle content.

NOTE

Keyboard Shortcuts: Using any complex application like Final Cut Pro or Photoshop or Motion can be done much, much more efficiently from the keyboard than with a mouse. The FCP keyboard is pretty comprehensively mapped, and it would be very beneficial to learn the most important shortcuts. A complete list of shortcuts can be found in the application's Help menu. If trying to remember all of the keyboard shortcuts is shorting out your brain, you can get color-coded special keyboards with keys that display the topmost shortcuts. A great tool is Loren Miller's KeyGuide, a laminated color-coded keyboard display of all FCP's shortcuts. No FCP editor should be without one. Miller makes them for a number of applications, including the new Final Cut Pro. You can find out more about them and order them from www.neotrondesign.com.

EDITING CLIPS

Loading the Media

In anticipation of readers who might leap to this book with perhaps not a great deal of experience with the application, I would like to take you through a quick

edit using solely the principle keyboard shortcuts. To do this, you'll need to download the first of a number of libraries that we'll be working with. The files can be downloaded from my website www.fcpxbook.com. There is a link on the home page to where the material can be found. All the libraries used in this book are in ZIP files. Once you have downloaded the first ZIP file called *BB1. zip* from the website, you should double-click it to unzip the bundle. Next, you should move the *BB1* library to your media drive before opening it. When you copy or move it to the media drive, the contents will play from that drive. Once you have the library where you want it, double-click it to launch the application and open that library together with any other libraries you last had opened.

The media files that accompany this book are heavily compressed H.264 files. Playing back this media requires a fast computer. If you have difficulty playing back the media, you should transcode it to proxy media.

FIGURE 1.14
Viewer appearance popup.

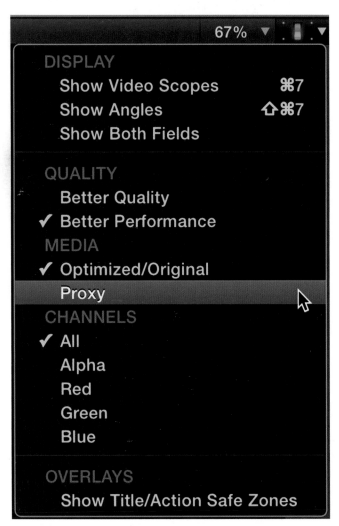

1. To convert all the media, select the event called *Edit* in the Libraries panel, right-click on it, and choose **Transcode Media**.
2. In the dialog that appears, check **Create proxy media**.
3. Next, you have to switch to proxy playback. You do this with the light switch popup in the upper right of the Viewer (see Figure 1.14) by selecting **Proxy**. Be warned: If you have not created the proxy media, all the files will appear as offline. In this case, you will have to switch back to **Optimized/Original**.

Editing into the Project

With the application open and the library mounted, your screen should look something like Figure 1.15. Let's look at our clips. Make sure the Skimmer is active.

1. Click the Skimmer button in the Timeline panel or press **S**.
2. Skim across the clips to quickly view the content.
3. If audio skimming is on, switch it off with **Shift-S**.
4. Press the **Tab** key until the event *Edit* is select with a blue band.

FIGURE 1.15
FCP screen.

5. Press the **Tab** key again or press **Return** to highlight the name and change it to *Market*.
6. Press **Shift-Command-1** to close the Libraries panel.
7. Press the **Up** or **Down arrow** keys to select the first clip or with the Skimmer over it select it with the **X** key.

To play the video, you can use a number of familiar shortcuts, press the **Spacebar** to play. To play the clip backward, press **Shift-Spacebar**. You can of course also play the clips with the **L** key, **K** to pause, and **J** to play backward. Fast forward by repeatedly tapping the **L** key. Fast backward by tapping the **J** key a few times.

1. Press **Down arrow** key to go to the next clip.
2. Tap the **Right arrow** key to step through the clip and hold the **Right arrow** to play slowly or use **K** and **L** together.
3. **Shift-Right arrow** to go forward in 10 frame increments.
4. Press **semi-colon** to go to the beginning of the clip and **apostrophe** to go to the end of the clip.
5. Use **Option-Command-2** to switch to List view. (**Option-Command-1** switches to Filmstrip view).

Table 1.1 is a list of useful navigation and playback keyboard shortcuts.

Table 1.1 Principal FCP Panel Shortcuts	
Action	**Shortcut**
Browser	Command-1
Close and Open Libraries	Shift-Command-1
Close and Open Browser	Control-Command-1

Continued

Table 1.1 Continued	
Action	**Shortcut**
Timeline	Command-2
Play	L
Pause	K
Play backward	J
Fast forward	Repeat L
Slow forward	L and K or hold Right arrow
Fast backward	Repeat J
Slow backward	J and K or hold Left arrow
Forward one frame	Right arrow
Backward one frame	Left arrow
Forward 10 frames	Shift-Right arrow
Back 10 frames	Shift-Left arrow
Go to previous clip	Up arrow
Go to next clip	Down arrow
Go to first clip	Home
Go to last clip	End
Mark Range In point	I
Mark Range Out point	O
Mark Subsequent Range In point	Shift-Command-I
Mark Subsequent Range Out point	Shift-Command-O
Go to In point	Shift-I
Go to Out point	Shift-O
Play selection	/
Select clip	X
Add marker	M

TIP

Tab Key: If you have a clip selected in List view, the **Tab** key will, like the **Return** key, select the clip name to change it. If you press **Tab** again, the cursor will move to the Notes column, where you can enter information about your clip, such as a few words about an interview. If you select sections of a clip using keywords, each keyword or favorite selection will have its own Notes box.

To edit, we need a project to edit into, so let's make a new project.

1. Click the button Timeline panel or, like every Mac application, press **Command-N** for the new document.
2. Name the project *Edit* and save it with the default settings in the event *Market*.

Let's start with the first shot we want to edit into the project. Let's begin with the shot called *man standing at counter*.

1. Play the shot with the spacebar. Wait for the camera to settle, and around 3:05, enter an In point with the **I** key to mark the beginning of the selection.
2. Play forward in the clip for around six seconds to around 9:10.
3. Enter an Out point by pressing the **O** key to mark the end of the selection.
4. Press the **F** key to mark a Favorite.

Though selections are persistent in recent versions of FCP, they can easily be dropped by accident, so marking a Favorite is good practice, making it easy to come back to a selection.

You could grab the selection and drag it to drop it anywhere in the Timeline, but here we're using the keyboard only.

1. Press the **E** key to do an Append edit.
2. If an orange bar does not appear under the portion of the clip edited into the project, use **View>Show Used Media Ranges**.

OK, we had to use the mouse for that. I honestly don't know why it's not on by default. Though you've edited the shot into the Timeline panel, the Browser is still active.

1. If you need to use **Command-1** to switch to the Browser.
2. Next let's use *man handed bag*. Use **Up arrow** to move up to the shot.
3. Play the clip until the camera pushes in and settles around 2:19; then mark the beginning of the selection with the **I** key and use the **O** key to mark the end around 16:00 after he has his grocery bag.
4. Press **F** and then press **E** to Append.
5. Let's add a third shot, *ls woman getting sample*. Find it using the **Up** and **Down** arrows.
6. Press **Control-P** to make the Dashboard active and type in *925* and press **Return**.
7. Press **O** to mark the selection end from the beginning of the clip.
8. Press **F** and press **E**.
9. In the same shot, play forward to about 14:00. Press **Shift-Command-I** to add the second section as a separate selection to the same clip.
10. Play forward to about 24:07, shortly before the end of the shot, and then press **Shift-Command-O**.
11. Press **F** and press **E**.

Your Browser should look something like Figure 1.16. You'll see the clips with the disclosure triangles open. Let's close these.

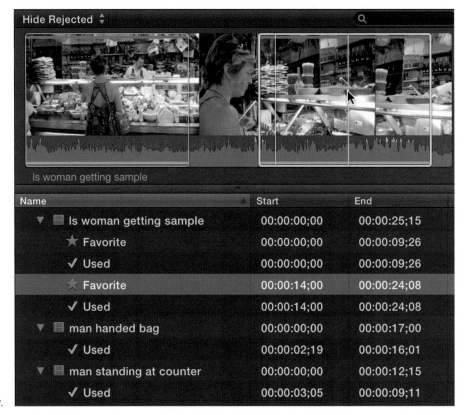

FIGURE 1.16
Browser in list view.

1. Use **Command-1** to switch to the Browser if needed.
2. Press the **Tab** key will the name of the clip ls woman getting sample is highlighted in blue. (If you Tab too much and go into Notes, use **Shift-tab** to go back to the clip name.)
3. Press **Down arrow** to step into the selections.
4. The **Left arrow** takes you back to the clip name.
5. Press the **Left arrow** again to close the disclosure.
6. Down to go to the next clip and **Left arrow** to close.
7. Repeat as needed.

So far we've done append edits to add clips to the Timeline, which are a great tool at the editing process. Next, we'll insert a few clips at the beginning of the Timeline.

1. Fast-forward through the lengthy shot called *cutting meat*.
2. Mark an In point with **I** at 31:09 and an Out at 34:15 with the **O** key.
3. Go to 26:06 and mark an In point for the start of the selection using **Shift-Command-I**.
4. Mark an Out point at 29:06 using **Shift-Command-O**.
5. Let's go to the close-up of the butcher, starting at 20:06 and mark the start with **Shift-Command-I** and the end at 22:10 with **Shift-Command-O**.

6. So we don't lose the selections accidentally and to make them easier to access mark them as favorites with the **F** key.

Now that you have the selections made we're going to put them into the Timeline starting with the last selection we made.

1. Press the **Tab** key till the *cutting meat* shot is selected blue in the list as in Figure 1.17.
2. Press the **Down arrow** key move down to the third favorite to select it.
3. Use **Command**-2 to switch to the Timeline.
4. Press the **Home** key (**fn-Left arrow** on a laptop) to move the playhead back to the beginning of the project.
5. Press **W** to insert the wide shot of the butcher at the head of the project.
6. Check the edit and use **Command**-1 to go back to the Browser.
7. **Up arrow** to select the middle favorite and **W** to insert it after the first shot.
8. **Up arrow**, **W**.

> **NOTE**
>
> **Fit Content to the Window:** One of the most useful keyboard shortcuts has been carried through since the earliest versions of FCP into the newest version: the shortcut to zoom to fit as it's now called. The shortcut is **Shift-Z**, and it works to fit all the clips in the project into the available space of the Timeline panel. It also works to fit the content of the Viewer into its available space. I find I use it a lot.

> **TIP**
>
> **Moving Between Edit Points:** The simplest way to move between edit points is to use the **Up** and **Down arrow** keys. The **Up arrow** takes you back one edit event. It moves the playhead back from where you are to the edit before. The **Down arrow** key moves the playhead to the next edit event, whether an audio or video edit point, whichever comes next in the Timeline. You can also use the **semicolon** key to move backward through the edits and the **apostrophe** key to move farther down the Timeline.

A connect edit is a type of edit that is unique to Final Cut. All clips are either on the primary storyline or connected to it. Let's start by making a connected clip, putting a cutaway in the middle of the man handed bag shot.

▼ ▤ cutting meat	00:00:00;00	00:02:29;04	00:02:29;04	Aug 19, 2011, 3:16:19
★ Favorite	00:00:20;06	00:00:22;11	00:00:02;05	
★ Favorite	00:00:26;06	00:00:29;07	00:00:03;01	
★ Favorite	00:00:31;09	00:00:34;16	00:00:03;07	

FIGURE 1.17
Selected clip.

1. Make the Timeline active if it isn't (**Command-2**) and press **Control-P** to move the playhead to around 17:15, a beat after the camera pulls back and before the image brightens.
2. **Command-1** for the Browser and then use **Tab** and the arrow keys to locate and select the *prosciutto samples* clip.

3. Press **X** to select the clip.
4. Press **Control-D** for duration and type *3.* (that's three and a period) and press **Return** to make a three-second selection.
5. Before we edit this into the Timeline, let's switch off the audio. Press **Shift-2** to do a Video Only edit.
6. Press **Q** to connect the selection into the project.

Let's add part of the dried tomatoes clip right after the first connected clip, but let's use a slightly different technique, defining the duration of the clip in the Timeline:

1. With the playhead at the end of the first connected clip, and the Timeline active (**Command-2**), mark a selection with the **I** key.
2. Play forward till the woman in the foreground clears the frame, about 24:13, and mark the end of the selection with the **O** key. My selection is about three and a half seconds.
3. Switch back to the Browser and locate the *dried tomatoes* clip.
4. Press the **X** key to select it and the **Q** key to execute the connect edit.

Table 1.2 is a list of editing shortcuts.

Table 1.2 Principal Edit Shortcuts	
Edits	**Shortcut**
Connect	Q
Insert	W
Append	E
Overwrite	D
All (Video and Audio Edit)	Shift-1
Video Only Edit	Shift-2
Audio Only Edit	Shift-3

TIP

Help: If you have problems with Final Cut Pro, help is available in a number of places, including the Apple Support Communities Final Cut Pro discussion forum, which you can link to from https://discussions.apple.com/index.jspa. You can also get help at the fcp.co website forum at www.fcp.co/forum or my website at www.fcpxbook.com.

SUMMARY

This chapter has been designed to help you to get started correctly in using Final Cut Pro on your system and make sure you're up to speed with the edit functions of the application. In the next chapter, we'll look at some of the nuances of FCP preferences, importing into the application, and organizing your production and your media.

Preferences and Importing

Importing your media into FCP is a crucial part of working with the application. The libraries used by FCP allow great flexibility, perhaps more than many people realize. Though media can be moved and operational workflow can be changed at any time, doing so requires time, care, and patience. Generally it's better to set up importing right to start with so your library structure and media are correctly organized for your productions. There is no one true and certain method for all production and all situations. There are quite a few variables, and I will try to explain some of them in this and the following chapter.

Before you import your media, you should set up your application correctly for the way you like to work so that it's set up for importing. In Final Cut Pro, as in most video editing programs, that means setting up your preferences. After setting preferences, we'll move on to importing media. I'm not going to go through the technical steps of importing, which I'm sure you know, but with various strategies for organization and workflow which can be set up during the import process. For this chapter, you can use your own media, but if you want to follow along, I will be working with a little AVCHD media that you can download from www.fcpxbook.com. On the website, there are a number of ZIP files, most of which contain an FCP library; the one we'll use for this lesson doesn't. For this chapter, we'll use the ZIP file called *NO_NAME.zip*. This is about 300 MB in size.

PREFERENCES

FCP has far fewer preferences than legacy versions of the application where there were no fewer than 17 panels of preferences. I don't think the application needs that many. There are five preference tabs in FCPX. We'll look at the last tab, **Destinations**, in the final chapter on Sharing.

General and Editing Preferences

Open the preferences with **Command-**, (comma), which seems to be pretty much the standard for most Mac applications. When you open preferences, you will see the window in Figure 2.1, which first opens on the **General** tab. This tab has, which previously held more options, now only two minor preferences,

FIGURE 2.1
General preferences.

which probably should be elsewhere. Here, you can change the Timeline display from H:M:S:F to include subframe amounts or to frames only or to seconds.

In the **Editing** preferences panel (see Figure 2.2), I'd like to point out a few things. The first is the checkbox for **Position playhead after edit operation**, which is the default behavior. That means when you edit a clip into the Timeline, the playhead moves to the end of the clip. This does not happen if you edit on the fly. For instance, if you are playing the project and press **Q** to connect a clip, the playhead does not leap to the end of the clip, but playback continues from where you are, except now you probably see the connected clip.

Inspector Units can be in pixels or percentages. I prefer pixels, but percentages can be useful when you're doing motion graphics animation.

In **Audio**, Show Reference Waveform can be useful also, but I'd leave it off for now, as it clutters the Timeline a little. When we get to audio editing, you can turn it on.

For **Still Images**, you can set the edit selection duration to whatever you prefer. Four seconds is the default. Notice you cannot set seconds and frames, but you can set seconds and a decimal value. This is not the import duration of a still image, but the default duration of a still image when it is selected in the Browser.

Like the Still Images preference, the **Transition** preference, which defaults to one second, uses seconds and decimals, not seconds and frames. For instance, 0.20 is a fifth of a second, or six frames at the NTSC frame rate, or five frames at the PAL frame rate.

Playback

The **Playback** tab lets you switch off Background Rendering, which I think is generally the recommended procedure. I usually leave it on, but set the start time for when it kicks into something like 600 seconds or 10 minutes (see Figure 2.3). So after 10 minutes of idle time, while I'm writing or surfing the web or gone off

FIGURE 2.2
Editing.

FIGURE 2.3
Playback preferences.

to lunch, the application will start rendering in the background. When you get into heavy compositing and effects work, you can force rendering by making a selection and using **Control-R** or rendering everything **Control-Shift-R**.

> **NOTE**
>
> **Background Rendering:** Apple marketing calls what FCP does background rendering, but the truth is that it's not. It's seamless rendering or automatic rendering. It renders when it has time, when you're not doing anything. It is initiated after a chosen delay and will pause when you start to do something in the application and resume when it can. It does not actually render while you're doing other things in the application.

Because multicam editing requires a great deal of processor power, there is a preference to optimize material used in multicam clips. If you have a decent computer, from the last three years or so, I generally don't recommend this. It makes huge files and requires very fast drives as there's a lot of data to pump through your system. I would have rather there was a preference to create proxy media for multicam, which is very much useful, and something I would strongly recommend if you're having trouble playing back a multicam project.

Player Background can be set to Black, White, or Checkerboard. This means the Viewer background display. The default is black, but the background is actually transparent. As a result, text over an empty background is text on transparency, so you might prefer to use checkerboard as the background to show that, although checkerboard during playback does look strange.

A/V Output lets you select third-party hardware like Black Magic or AJA or Matrox to output to a broadcast monitor. Once the device is selected, here you can turn the function off and on in the **Window** menu.

> **TIP**
>
> **Improving Playback:** If you're having difficulty playing back your media because your system is underpowered and the format, such as AVCHD, is too processor intensive for your computer, you can help playback considerably by during off the audio waveforms in the Browser or in the Timeline. Select a Timeline display that shows only video filmstrips, and the processor will not have to rebuild the waveform as it plays the project. Removing this extra load can be a big benefit in improving video playback performance.

> **TIP**
>
> **Black Magic Disk Speed Test:** A really useful, and free app from the App Store, is the Black Magic Disk Speed Test. It will look at your media drive, run tests on it, and tell you exactly what type of media it can handle and what it's capable of. This is especially important as your drives start to fill beyond two-thirds, and the performance drops off noticeably.

Import

Importing preferences sets the behavior of how clips are handled when they are brought into the application (see Figure 2.4). In every previous version of FCP going back to its first days, where media was imported was one of the most important preferences for you to set, whether scratch disks or folders or libraries, this preference was critical. For the first time, this option is not inside the FCP preferences. These preferences are now set on a library by library basis and inside the Inspector as we'll see shortly. The **Import** tab sets your default importing behavior and is used as the import setting whenever you drag and drop to import something into your Library or into a project. On the other hand, unless you're dragging and dropping, the import tab is just a default and can be changed at any time for any media that you're importing.

There are two checkboxes for transcoding that allow you to immediately make duplicates of your original media in high-resolution ProRes or in small, highly compress ProRes Proxy files. Generally I think it's best to leave these off. Transcoding can always be done at a later time as needed, and transcoding on import, especially when importing a great deal of media, can really slow down the process. There are a number of operations, such as moving files to the trash, renaming a file in the browser, or moving or duplicating an event, which cannot be done during the time when background tasks such as transcoding and analysis are being run.

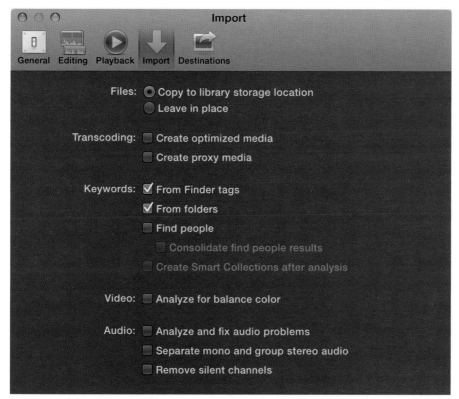

FIGURE 2.4
Importing preferences.

There has been a lot of discussion about what is the best practice for handling your media. The general recommendation is that when you're importing compressed formats such as H.264, which is used in AVCHD and DSLRs, it's best to optimize the media. This produces a QuickTime file using the ProRes codec, a visually lossless, high-resolution, high-data-rate format that produces very large files. This will improve playback performance but requires fast hard drives. In my view, this is not really necessary with recent computers and graphics card capabilities. If your computer is fast enough and has a good, fast graphics card, I suggest working with H.264 is not a problem and should be used, saving yourself a great deal of processing time and hard drive space. Some formats such as DV and HDV and XDCAM cannot be optimized in FCP, as the application handles them in their native codec. At any time in the editing process, you can transcode specific files or even all your files to standard ProRes 422 or ProRes Proxy files.

You can import items applying keywords based on their Finder tags, if you use those, or based on folder names, whose clips get added into a Keyword Collection based on the name of the tag or the folder name. This is a useful feature, and it's probably a good idea to leave this on as your import preference. You can always switch it off during the actual import process.

Another useful feature in FCP is its ability to analyze and correct media on import. There are separate sections for video and audio analysis. Color balance analysis doesn't apply any correction, but it does slow down the background task functions. Again, this is something I would leave off. The same with Find People, which we'll look at in the next chapter. These can be manually activated when required. Usually I recommend leaving the audio analysis and actions checked on. These are done very quickly in the background process and are actually switched on and executed as needed, so a useful process to happen while importing.

> **TIP:**
>
> *Drag and Drop:* When you drag and drop from the Finder to an event, the import function will be guided by the Import preferences. You can override these options while you drag. If the drag indicates a copy function with the green + circle, you can change this to leave in place by hold **Option-Command** while you drag. If the drag is indicating a symlink that leaves the file in place and you want to copy it into the library, just hold the **Option** key to copy, just like in the Finder.

> **TIP**
>
> *Importing into Keyword Collection:* You can import directly into an existing Keyword Collection by either having the clips in a folder with the same name as the Keyword Collection and having **Import folders as Keyword Collection** checked on; or if you right-click on the Keyword Collection in the event and select **Import Media**, the imported media will be added directly into the collection. You can also drag and drop to import of course, and if you drag and drop to the Keyword Collection, the files are not only imported into the event but also keyworded.

Managed Media

Media management is now on a library-by-library basis. This is controlled by the Library Properties in the Inspector. This is where you now set your importing preferences for where your media goes. If you select a library in the Libraries pane, the Inspector will show its properties (see Figure 2.5). If you click on the **Modify Settings** button opposite **Storage**, you will get a drop down sheet that lets you assign the location for the media. This will be the import preference for the library (see Figure 2.6). The default Storage Settings is **In Library**, which creates what's called *managed media*. These are files, video files, still images, and audio files, which get copied into an event in your library bundle when you import. This is the standard operational procedure for a great many users, and there is absolutely nothing wrong with it. iMovie users are probably very used to this, and like still image libraries, many users may have only a single library of managed media.

However, video files are substantially larger than still images, and when media files need to be rendered, they are rendered into high data rate, large ProRes QuickTime format files or even larger. So if you have your media and all your media files and your shared videos, which are also stored in your library, it isn't long before the library becomes very large and too large for your hard drive (see the Note called Drive Space).

Keeping your media inside the library, using managed media, is a simple way to work, and a very good way to work for many types of productions. Who should use managed media? Hobbyists and small production companies where a project is edited on a single system, and wedding and event production can easily

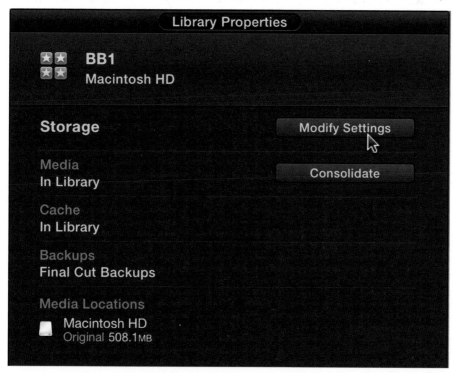

FIGURE 2.5
Library properties.

Set storage locations for the library "BB1".

Choose locations for imported and transcoded media, cache files (including render and analysis files), and library backups.

Media: In Library

Cache: In Library
 Default
Backups: ✓ Final Cut Backups

 Choose…

 Do Not Save

FIGURE 2.6
Storage settings.

use managed media for their production. Also those who collaborate by physically moving a hard drive from place to place will find managed media within the library very useful. Basically anyone who is producing video on one system using only one application, Final Cut Pro from ingest to delivery, will benefit from working with managed media. Who should not use managed media? Those working on productions in a collaborative environment. Those working in situations where multiple users need to access the same media. Those working with multiple applications, for instance, those who need to access the media in Motion or After Effects. This is not easily done with managed media.

> **NOTE**
>
> **Drive Space:** It is usually recommended that you leave at least 10% of your drive as free space, though many consider 20% the minimum free space, especially in a collaborative environment. This is considered an absolute minimum except in real emergencies when you might need space for copy files temporarily. So for a 1TB drive, this means that at least 200G of free space, more would be better. Generally when a drive is close to 70% full, performance will suffer. This is important to consider for both external drives and for system drives that need space for swap files and virtual memory.

External Media

For those who need not copy media into the library bundle when you import, you have the option to leave your media in place or move it to a selected location. The location for your media is a preference you should set for each library as you create it. I do not recommend leaving files where they are, because files

then get scattered all over your drives, though you can consolidate your media later, which we'll look at that in a moment.

My recommendation is to have a separate folder on your media drive that holds all the media for your production. This folder should be on some kind of backup routine using software like Carbon Copy Cloner or SuperDuper! Everything goes in there, all your video, all your audio, all your still images, all your Motion exports, all your multi-layer Photoshop compositions, everything gets imported into this location. When you create a new library, you set Storage settings for Media to a specific location by using the **Choose** option, and creating a new folder on one of your dedicated media drives. When you import something into your event in the library, you can then immediately send it to the dedicated media folder. The folder can be anywhere, on any directly connected drive, or SAN, or network storage. Performance of course is entirely dependent on the speed of the connection and the number of users accessing the network simultaneously. The media location selected in Storage settings now includes not only your Original Media but also your transcoded media. The folder that contains your media now has separate folders called *Final Cut Optimized Media*, *Final Cut Original Media*, and *Final Cut Proxy Media*. These are all stored in your media location and not inside the library bundle. You can also store your Cache files here, so your media location might look something like Figure 2.7.

You now have the option to select where your Cache files are saved. Again the default is to save them in the library, but for the first time, you can select a separate location, either inside the library or any external folder, either where your media is stored or some other separate location. If you change the Cache storage settings, you will get a dialog that asks if you want to migrate your current cache files (see Figure 2.8). This creates another FCP bundle, a library cache bundle,

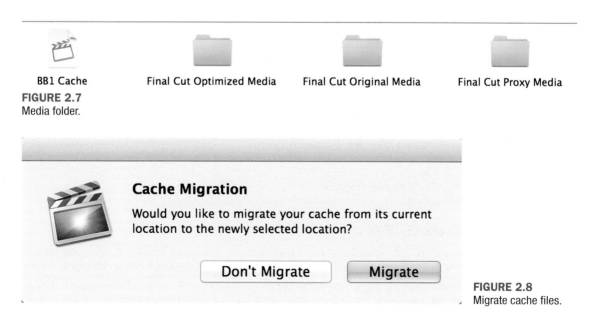

BB1 Cache | Final Cut Optimized Media | Final Cut Original Media | Final Cut Proxy Media

FIGURE 2.7
Media folder.

Cache Migration

Would you like to migrate your cache from its current location to the newly selected location?

Don't Migrate | Migrate

FIGURE 2.8
Migrate cache files.

which stores all the cache files for the library, all the thumbnail files, and peak data, as well as your render files. So this bundle can get quite large.

When you use the import function (**Command-I**), you can select the files you want, and the drop down sheet will have your production folder already loaded with your default preferences as in Figure 2.9. However, when you

(•) Add to existing event: Pine ▲▼

() Create new event in: "Sumi-e" library ▲▼

 Event name: []

Files: (•) Copy to library storage location: Sumi-e Media
 () Leave files in place

Transcoding: ☐ Create optimized media
 ☐ Create proxy media

Keywords: ☑ From Finder tags
 ☑ From folders
 ☐ Find people
 ☐ Consolidate find people results
 ☐ Create Smart Collections after analysis

Video: ☐ Remove pulldown
 ☐ Analyze for balance color

Audio: ☑ Analyze and fix audio problems
 ☑ Separate mono and group stereo audio
 ☑ Remove silent channels

[Cancel] [Import]

FIGURE 2.9
Import sheet.

drag and drop from the Media Browser, from iPhoto or Aperture, or iTunes, to an event, no dialog appears, and library preferences will be applied and your still will be copied out of the Aperture library and into your dedicated media folder or into the library itself. This is a good thing. The application will not access them from the other library. This applies to iTunes music as well, though this does often leave the media in its original, usually very heavily compressed media format. I recommend compressed audio always be converted to an uncompressed format, either AIFF or WAV. We'll look at how to do that in a moment.

Though your media is external to your library and very easy, some would say too easy, to access by anybody, you need to make sure that files are never moved from the folder or renamed or altered in such a way that changes the media fundamental properties, such as video frame rate. Media at the Finder level should not be fundamentally changed, or FCP will lose the connection to it. You can alter stills and other media, change colors, and modify and enhance the images, and FCP will update the changes in the application, but media properties should never be altered.

TIP

Leave in Place: Regardless of how to have your import preferences set, if you drag a file from the Finder into the application, into either and event or a project, while holding **Option-Command**, you will get a hooked arrow and create a symlink and the file will be left in its original location (see Figure 2.10).

Consolidate

FIGURE 2.10
Option-Command-Drag.

Though you have essentially two options for working with your media, either managed media within the library or external media outside of the library, you do have a way to switch from one condition to the other at any time. If you have a great deal of media, this can take a great deal of time, so gener-

ally it's best to get it right to start with, make the decision to work with managed media or external media before production begins. Should you need to change at any time, you can use the **Consolidate Library Files** or **Consolidate Event Files** functions from the **File** menu. As the names imply, Consolidate Library means you affect the entire library, and an Consolidate Event means you effect only that one event in the library. So what does Consolidate do? Simply put it moves files in and out of your library. It's a two-way street. It will either move all your media that's in the library out of the library or it will copy (not move) all the media that's outside of the library into the library. So how do you do this? If your media is external to the library, change your library preference to **In Library**. When you select **Consolidate Library Files**, you will get a simple dialog that asks if you want to consolidate in addition to your original media your transcoded and proxy media as well (see Figure 2.11). This will copy the

media into the library. Because FCP uses hard links, this does not double your drive space. If your media is in the library bundle and you want to move it out of the bundle, change the Storage settings in Library Preferences. Now when you select **Consolidate Library** or **Consolidate Event**, you will get the same dialog, except it will be set to the location designated in the Library Preferences. If the preference is for an external location, the files will be moved into the appropriate *Original Media*, *Optimized Media*, or *Proxy Media* folders and replaced with symlinks. This symlink connection can be broken by moving the files or renaming or changing their basic properties in the Finder. Don't do that.

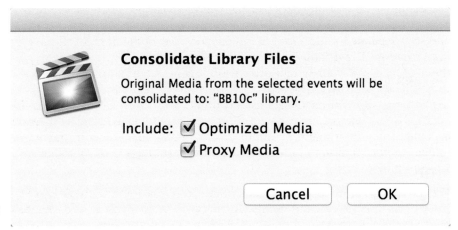

FIGURE 2.11
Consolidate library files.

Sidebar

HARD LINKS

This is a technique Apple uses when it has two directories that need to access the same files, but does not want to duplicate the files because this is unnecessary. This is used during the updating process and when consolidating. Physically your media is on a specific section of your hard drive, whether it's a spinning platter or a solid-state drive, which takes, let's say 100G of your 1TB drive. When the system uses hard links for two directories, the one for the library and the one for the folder that has the media, both are referencing the same section of the hard drive where the media is physically stored. Both locations appear to be using 100G, but they're using the same 100G. When the library is using symlinks, it is pointing from the directory where the library is to the directory

with the folder, which in turn is looking at a physical location from the media. What this means is when the library is using symlinks and you dump the media from the folder and trash the files, the symlinks are broken and the used drive space gets smaller; you get 100G back. When hard links are used, you're still only using 100G. When you trash the clips from either the library or from the folder, you're still only using 100G and you don't get the 100G back. You have to trash the media from both locations before you recover the 100G. This is why when you consolidate to the library from an external folder, the consolidation is instantaneous, because no files are actually being copied, though both the library and the external folder appear to be 100G in size.

> **NOTE**
>
> *Consolidate in Library Preferences:* There is also a button to **Consolidate** in Library Properties. This simply copies or moves the media into whatever the library preference is. This lets you change the preference and immediately consolidate into that location without using the **File** menu.

Library Backups

You definitely want library backups, and you get to choose where they're stored. This preference is part of the Library Preferences. You can select any location, and set a separate location for each library, or have all the libraries use a common location. The default is the Movies folder, which is pretty good place for them, especially if your system drive is on a Time Machine routine. You want to keep your library backups separate from your active libraries. As your working libraries with your media are usually on dedicated media drives, saving the backups in the internal drive is a good strategy. If multiple users are working on a single computer, it might be useful to save the backups folder in the *Shared* folder. Another option is to use a cloud storage solution such as saving your backups in Dropbox.

These backups are not the entire library thankfully, just the metadata needed to reconstitute the projects and events. The backups can be little as a few kilobits but more usually around 25 or 50MB. Backups are created every 15 minutes in which there is activity in the library. They are stored in folders with the library name. You can access a backup directly from the folder, which might look something like Figure 2.12. To open a backup, you can double-click it, which will launch FCP if it's not open, and the library will appear with the library name together with the time stamp as in Figure 2.13. You can also open a backup directly from inside the application. Select the library, and from the **File** menu, choose **Open Library**. Near the bottom, you'll find **From Backup**, which open a

FIGURE 2.12
Library backups.

FIGURE 2.13
Backup library.

dialog that lets you select the backup you want. If it doesn't appear, you can click **Other** in the same dialog (see Figure 2.14) to select any backup for any library that has been saved.

Because the backups are for emergency situations for the most part, it's probably a good idea to go into whatever folder you're storing them in and trash the backups for old and obsolete productions. Though the files are relatively small, they can add up and chew up a good deal of space.

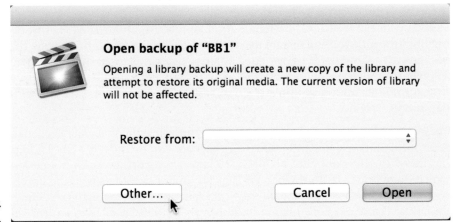

FIGURE 2.14
Backup dialog.

> **TIP**
>
> ***Rebuilding the Library Database:*** In addition to using the backup files to solve some problems, you can sometimes also fix the problem by rebuilding the library database. With the application closed, if you right-click on the library in the Finder and select **Show Package Contents**, you can access the database. Drag the *CurrentVersion.flexolibrary* file out of the bundle and relaunch the application. FCP will rebuild the library database using the event information.

Preferences Files

All the preferences you make are stored in preferences files in the user's home Library folder. These files are updated when the application is closed. That is when it's closed normally with **Quit** function. They are not saved when the application is force quit or when it crashes. When that happens, the preferences refer to the application in a different state, which may no longer be possible, so

basically the files have become corrupted. Because of this, if you have problems with FCP, one of the first remedies anyone will suggest is to trash your preferences file. If there is a problem with your system, it's often your FCP preferences that are corrupt. What trashing the preferences does is reset the application to its default state, as if you're opening it for the very first time. It will create a new *Untitled* library in your Movies folder. Rather than directly launching the application after you trash your preferences, you can also open it by double-clicking a specific library you want to open at launch. This will open that library for you.

Trashing preferences has been greatly simplified in recent versions of FCP. You can now hold **Option-Command** as you click on the application icon in the Dock or in Launchpad to open the applications, and the preferences will be reset.

You can also get Preference Manager from Digital Rebellion at www.digitalrebellion.com/prefman. This is a free component of Digital Rebellion's Pro Maintenance Tools. I urge you to get the full package, as it has many useful tools, and Jon Chappell at Digital Rebellion makes excellent products for Final Cut Pro users. One of the great advantages of Preference Manager is that it also backups sets of preferences from which you can restore at any time to return to a specific application state with customized preferences rather than the default.

TIP

Keep Untitled: Because FCP wants to create a new ***Untitled*** library in the Movies folder every time your trash preferences or return the application to its default state, you may as well just keep one there. It doesn't have anything in it, though I use mine for testing purposes. So whenever you trash preferences, the application will see that Untitled library and simply open it and not create another.

Customizing the Keyboard

Technically the keyboard isn't part of preferences, which you access with **Command-comma**. For the custom keyboard layout, you use **Option-Command-K**. Like preferences, it's in the **Final Cut Pro** menu. Once the Command Editor, as it's called, opens, the first step you want to take is to duplicate the current layout using the popup in the upper left (see Figure 2.15). Either the Default layout is open which you can't change and have to duplicate, or someone else's layout is active and you don't want to mess up theirs. So duplicate the layout and name it.

Changing the layout is pretty straightforward. If there's a function you want to add, search for it in the search box in the upper right. To see what's used by a particular modifier key, just hold it down or click the modifier or combination of modifier keys at the top. To see what's used by a particular key, just click on

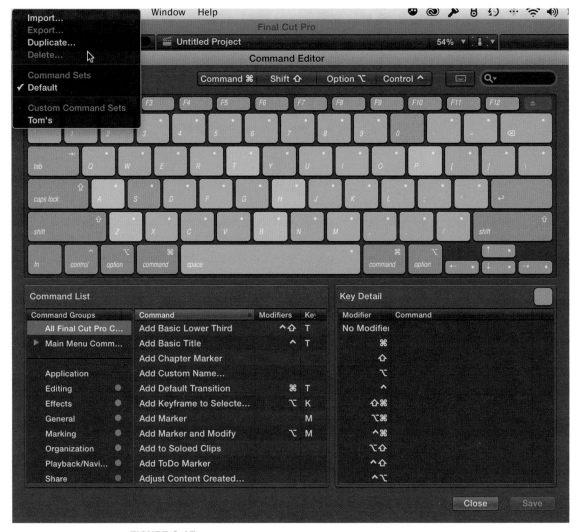

FIGURE 2.15
Command editor.

it. To see what's under **W**, click it, and the Key Detail pane in the lower right will display what's there (see Figure 2.16). To create a custom keyboard shortcut, for instance to close a library, do this:

1. Search for *library*.
2. At the top of the Command Editor, click a modifier combination like **Shift-Control**.
3. Drag the function *Close Library* and drop it on the **W** key.
4. Click the **Save** button in the lower right, and when you're done, click the **Close** button.

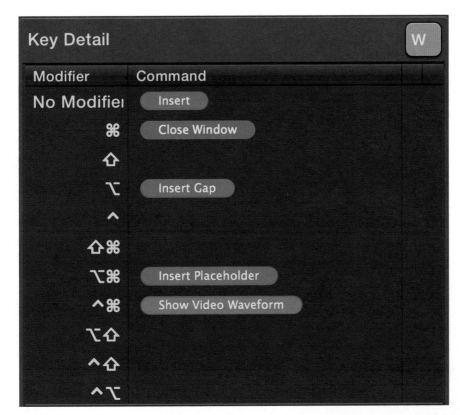

FIGURE 2.16
Key detail.

That's it. **Shift-Control-W** will now close a library. You simply need to have the library or an event in the library selected. In addition, I set up **Shift-Control-O** to bring up the Open Library function to select a library, and I also set up **Shift-Control-N** to make a new library. **W**, **O**, and **N** are of course the default keys on the Mac for Close, Open, and New.

Once you've set up the keyboard the way you want it and saved it, you probably want to back it up or save it on a flash or jump drive. With the Command Editor, open the layout you want to save, from the popup in the upper right select **Export**, and save the file onto the drive. You can now carry your preferred keyboard layout wherever you go to any FCPX system. When you get to the other system, mount your jump drive, and in the Command Editor, select **Import** from the same popup and point it to the file on the jump drive called *Tom's.commandset* or whatever you named your personal keyboard layout. When you're ready to leave, you can use the **Delete** function to remove your layout if you wish.

If you're curious where the keyboard layouts are stored, they're in your home Library/Application Support/Final Cut Pro/Command Sets. If you need to access them without opening the application, you can always copy the .commandset file from that location or copy it into that location.

> **TIP**
>
> **Updating Your Keyboard Layout:** When Apple makes a major update, or sometimes even when not a major update, they change or add keyboard shortcuts. These of course won't be in your custom keyboard layout. So whenever the application is updated be sure to check if there are new shortcuts added or changed shortcuts and to update your custom commands.

IMPORTING

Whether we're importing from a tape-based or file-based camera, camera archive, or our hard drive, it's all importing, and it all uses a single window. All these processes are essentially data transfers, whether from a hard drive, a memory card, or digital tape. Whenever you import media, it gets put into an event folder, either as digital files or as symlinks to the digital files. So begin by creating a new event. Events are bins or folders inside a library. So when importing think about what event you want to import your media into. We'll look at organization in more detail in the next chapter, but importing into the correct event in the correct library is the first step. Whether you imported managed media or external media, the library and the event in it contain the links to it and all the associated metadata generated externally by the camera or by you. So set up your library and events before you import. Once these are created, you should be ready to import.

FIGURE 2.17
Sidebar.

The import process in FCP is as simple and straightforward as it could possibly be. Here's a quick review:

From FCP's import window (**Command-I**), you can access any connected camera, or drive, or archive that's available to your computer. If the camera or camera card is detected, you simply select it in the sidebar of the import window (see Figure 2.17).

If you don't have file-based media of your own and you want to follow along, you can download and unzip the *NO_NAME*.zip from my website. Double-click the disk image from the ZIP file to mount it. It appears as a camera card.

1. In the Import window, select the memory card called *NO_NAME* under Cameras on the left, which will fill the Import window with the clips.
2. You can click the **Import All** button in the lower right if you wish.
3. You can also select clips by clicking on them and then using the Import button, which has now changed to **Import Selected**. You can also simply press the **Return** key.
4. You can play your clips with **spacebar** as well as **JKL** and mark selection with the **I** and **O** key.
5. You can also drag a selection on the clip with the pointer.
6. You can also mark additional selections on a clip by pressing **Shift-Command-I** and **Shift-Command-O**.

All these selections are persistent. If you press **Command-A** to select all, all the selections that you have made will be honored. Any clips without selections will be imported in their entirety. This effectively allows you to log your media before you import the footage.

Do not use selections in the Import window as an editing function. Import more than you need. It's better to import too much, than too little. Most people simply import everything except for shots that are completely messed up, such as when the camera's recording and is in the trunk of your car or pointed at the ground as you walk around.

Each time you click the Import button, you will get the Import dialog. After you've imported a clip, a gray bar will appear on the clip or the portion of the clip in the Import window.

There is a checkbox in the lower left under the clips that will let you hide previously imported clips.

NOTE

Filmstrip View: When importing from a camera, camera card, or camera archive, in the lower left, you have the option to switch between filmstrip view (**Option-Command-1**) and list view (**Option-Command-2**) just as in the Browser. This function does not appear when importing from hard drives, nor does selective importing of sections of media. More about that in the section called Trimming.

TIP

Videos, Photos, All Clips: New in the latest version of FCP is a little popup on the right side of the Import window that appears when importing from a camera. The popup lets you switch the window display from Videos to Photos or to All Clips to help isolate what you're looking for. This is especially useful when working with DSLR type cameras that do a lot of double duty as both stills and video cameras.

Creating Camera Archives

Most video media is now recorded as files on an SDHC or SDXC card, a CF card, a P2 card, or a hard drive. All these are camera media, designed to be reused, not stored. Before you import your media, back up the media from the card or hard drive. The first step you should always take with file-based media is to archive it. The tiny memory card is the only recording of your production or of a precious, never-to-be-repeated moment. Make another copy before you do anything else. It's really simple to do in FCP.

1. Select the card, which is usually called *NO NAME*, in the Cameras section of the sidebar.
2. At the lower left of the Import window, click the **Create Archive** button.
3. A dialog sheet drops down that lets you specify where you want to save, put it in a folder, and even add it to Favorites in the sidebar (see Figure 2.18).
4. Name the archive something useful such as the event and the date or the name of the production.

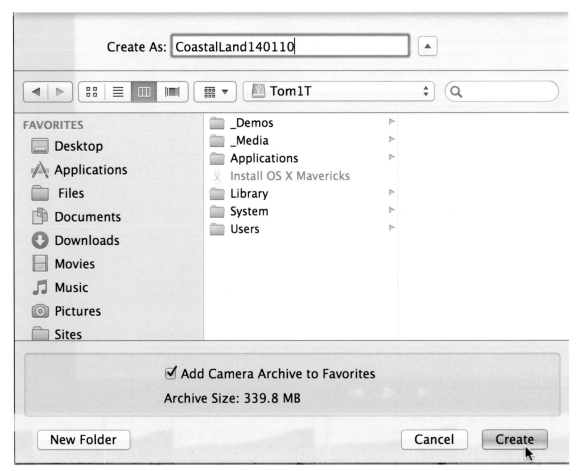

FIGURE 2.18
Archive dialog sheet.

To use the archive simply, select it in Favorites, if that's where you put it, or navigate to wherever it's located in the Import window, select the archive with it's nifty locked film can icon, twirl open the disclosure triangle, or double-click it. Though it's a bundle like a library, it acts like a folder. When it's open, the window will be populated with the archive's contents.

You can also archive your media manually by creating a disk image.

1. From your *Utilities* folder in *Applications*, open the Disk Utility.
2. On the left, select the mounted disk called *NO NAME*, or whatever it's called.
3. Go to **File>New>Disk Image from "NO NAME."**
4. Give the disk image a more useful and appropriate name and save it wherever you like on your archive drive.

To use the disk image archive, simply double-click the disk image to mount it, and it will appear under the Camera section of the sidebar.

One of these methods should always be used to archive media from your memory card or camera drive. One of the significant advantages of using an FCP camera archive is that should your media become corrupted, or the drive fails, or the file is moved, or some similar catastrophe, all you have to do is use the **Reimport from Camera/Archive** function, and the application will find the correct camera archive and reimport the media immediately. The application knows which archive the media came from, and all you have to do is make that archive available by mounting the drive it's on.

NOTE

Spanned Media: *Spanned clips* are clips that bridge across multiple memory cards. To import them, you need to make a separate camera archive of each card that contains the spanned media. Make sure all the camera archives are mounted and available, select them, and click **Import All**. If only some portions of the spanned clips are available, the camera archives can still be imported, but they will remain as separate clips and not be joined together when they are imported into the Library.

TIP

Cantemo Portal: This is extensible media asset management software, based on an Internet browser interface that imports, organizes, and keeps track of all your media inside and out of FCP's libraries (www.cantemo.com/portal.html). It is an enterprise positioned tool, i.e. expensive, but it does come in a more affordable version for smaller shops, which can be expanded upon with modules to arrive at the full-blown version with all its features for large organizations with many remote users. One of the really nice features of the system is that the interface appearance is easily customizable, with themed looks and branding options.

Converting

FCP will import from many different types of cameras and will work with many different types of video, audio, and still files into FCP. While the application can work with a huge number of formats, some simply work much better than others. The truth is camera manufacturers use formats and compression types that are great for making terrific picture quality and packing it into an astonishingly small amount of space. However, these acquisition formats using formats like .mts (MPEG Transport Stream) and codecs for H.264, although great for both acquisition and delivery, are horrible for production. Codecs and formats that use GOP (Groups of Pictures) structures often only have a full frame of video every 15 frames, all the rest are intermediate frames made up by using portions of data from other frames. Only the I-frame every 15 frames is complete. Generally editors like to work with greater precision than every 15 frames. They want frame accuracy. What's remarkable is that modern computers can build the intermediate frames on the fly in real time to give the editor single frame precision.

Most video applications work best with video that's optimized for production, which means video that's made up entirely of I-frames. To make it easier on the system to work more efficiently, FCP often rewraps files from its native structure to QuickTime and also makes available the option to optimize your media to a high-quality ProRes I-frame codec with 4:2:2 color space, while many native formats use 4:1:1 or 4:2:0 for color rendition. Basically FCP works best with QuickTime video files and uncompressed audio files with a sample rate of 48k, the most common digital audio standard used for video. Compressed audio files like MP3s and audio in the CD sample rate of 44.1k should be converted before being brought into FCP. MPEG-4 video, especially video files with compressed audio, should be optimized in FCP or converted before being imported. AVI files should also be converted or optimized in FCP when they are imported. You can use Compressor or MPEG Streamclip to convert these. MPEG-2 files from DVD cannot be imported and should be converted using MPEG Streamclip, which is a free download. Streamclip can rip DVDs, unless they are copy protected. Though Streamclip is free, you might need to purchase the MPEG-2 playback component from Apple, however.

We'll look at Compressor in a little detail at the end of the book, but let's look at ripping a disc with Streamclip, which will give you some idea about working with its interface. The first problem with Streamclip is installing it, which is slightly confusing. The download of the latest version, which at this time is MPEG_Streamclip_1.9.3b8, comes with two components, the application itself and a utility script (see Figure 2.19). The problem is when you run the QuickTimeMPEG2.pkg, you get an error dialog that says: "You can't open the application 'QuickTimeMPEG2.pkg' because PowerPC applications are no longer supported." So this is what you do:

1. Drag the MPEG Streamclip application from the MPEG Streamclip disk image to the Applications folder.
2. Mount the QuickTime MPEG2 disk image which will look like Figure 2.20. Don't do anything in there.

MPEG Streamclip 1.9.3b8

MPEG Streamclip

Utility MPEG2 Component M. Lion

FIGURE 2.19
MPEG Streamclip components.

QuickTime MPEG2

For QuickTime 6.3

For QuickTime 6.4 and later & Intel Macs

FIGURE 2.20
QuickTime components.

3. Go back to the MPEG Streamclip disk image and run the little utility script Utility MPEG2 Component M. Lion. Ignore that it says M.Lion. This utility will install the playback component.

Now you're ready to go. In MPEG Streamclip, if you need to convert a single file or combine multiple files into a single clip, use **File>Open Files**, or if you have a DVD mounted, use **File>Open DVD**.

Follow these steps to convert your MPEG-2 standard definition material:

1. Use **File>Export to QuickTime**, which brings up the window in Figure 2.21.
2. Set frame size on the left to 720×480 (DV-NTSC) or 720×576 (DV-PAL).
3. Set the frame rate to 29.97 for NTSC or 25 for PAL.
4. Set the **Field Dominance** to Lower.
5. Set the Compressor pop-up at the top to **Apple DVCPRO50-NTSC** or **Apple DVCPRO50-PAL**. These are excellent codecs, with twice the data rate of standard DV, but not as weighty as ProRes. You could also use Apple ProRes LT, which is another excellent codec.
6. If your media is widescreen, click the **Options** button next to the compressor type and change the **Aspect Ratio** to 16:9. If you wish, you can also make the media progressive rather than interlaced by selecting it here.
7. Finally, set the audio to **Uncompressed Stereo 48kHz**.

If you need to convert multiple files in MPEG Streamclip, rather than using the Open Files function, use **List>Batch List** to access multiple files in a single folder.

Importing Music

The simplest way to import music is to use the music note button on the right side of the Toolbar for the Music and Sound Browser (see Figure 2.22). This will allow you access to your audio content that comes with FCP and iLife, as well as your own iTunes library. To bring the music into your project, simply drag it from the media browser into the Timeline. This makes a copy of the file

FIGURE 2.21
MPEG Streamclip movie exporter.

FIGURE 2.22
Music and sound browser.

inside the FCP project. You can also drag directly to an event. This is all well and good in theory, but the fact is that a great deal of iTunes music is in heavily compressed formats like MP3 and, while they will work in FCP, they are not really suitable for professional production work and should be converted to high-quality AIFF or WAV files—even AAC files such as those imported directly into iTunes without conversion are not in the best possible format. Audio CDs use an audio sample rate of 44.1 kHz. This is not the sampling rate used by

digital video, which is most commonly 48 kHz. These compressed and audio CD standard files should be converted while being resampled and having their compression removed. There are a number of ways you can convert audio files. With MPEG Streamclip, Compressor, or even directly in iTunes, by changing the iTunes import preferences.

To do a batch conversion in MPEG Streamclip:

1. Go to **List>Batch List (Command-B)**.
2. Click **Add Files** at the bottom and navigate to the files you want. If you're opening audio files, make sure it is switched to Audio Files or All Files in the popup (see Figure 2.23).
3. Select the files you want and click **To Batch**.
4. A dialog appears to "Please choose a task" and from the popup select **Export Audio** (see Figure 2.24).
5. Next select the destination location and then Audio Exporter dialog appears.
6. Set the format to AIFF.
7. Set the Channels to Stereo and the Sample Rate to 48 kHz as in Figure 2.25.
8. Click **To Batch** and then the **Go** button in the lower right (see Figure 2.26).

FIGURE 2.23
MPEG Streamclip batch list.

FIGURE 2.24
MPEG Streamclip task popup.

Before you run the batch, you can add more files from different locations, both video and audio, with different settings and destination, and note that you can set it to do up to four simultaneous tasks. MPEG Streamclip is a really excellent tool that everyone should have.

Trimming

One of the features of importing from a camera is that you can trim media by making selections. This can be very handy for long interviews or for long

FIGURE 2.25
AIFF settings.

sections of GoPro media that's really garbage before the camera arrives at the right location for instance. Sometimes you have media that's already on your hard drive that you want to trim, but you can't do that when importing files. There is a workaround that makes trimming possible and that's to create a disk image for the files. You can do this using the Disk Utility, but a better way I think is to use Andreas Kiel's handy little utility called Create Disk Image, which you can download from www.spherico.de/filmtools/createDiskImage. Here's how to do this:

1. Open the utility, enter a name, and the sparseimage size, and click **Create Disk Image** (see Figure 2.27).
2. Drag all the clips you want to trim into the sparseimage.
3. The sparseimage appears under Devices in the FCP Import window. Select the sparseimage and click **Create Archive**, making sure **Add Camera Archives to Favorites** is checked on.
4. Select the newly created camera archive in Favorites and trim your clips before you import them.

Hung onto that sparseimage you made and reuse it. Sparseimages work by filling up to a maximum allocated size. So if you make an image of 30G, it doesn't take up 30G of space unless you put that much media into it. One of the useful features of Create Disk Image is that it can also be used to resize images if they're too small and to compact them if they grow too large.

FIGURE 2.26
MPEG Streamclip batch list.

Importing from XML

FCP 10.1 uses a new form of XML (Extensible Markup Language) to transfer information between users and applications. This is very powerful tool for sharing as we will see in more detail in the next chapter. The XML format allows you to export a small file that provides exact instructions about an event or a project. You can now export an event with the projects it contents, or even an entire library together with its events and projects. If you use **File>Import>XML**, you get a dialog that allows you to select on which drive the imported library or event will be saved. Importing an XML file will copy the media for that library or event into the new location.

RED RAW

FCP has the ability to import and work with RED RAW footage. To do this, you will need to install the RED plugin from the RED website. The clips are imported using the standard import function once the plugin has been installed.

One of the fantastic features of working with RED RAW media, apart from its great image quality, is the ability to control the image in metadata. Once the media is imported, in the Info inspector at the bottom is a button to **Modify RED RAW**

FIGURE 2.27
Create disk image.

Settings. In the HUD that appears, you can control the RAW file metadata, changing the color space, gamma, ISO, and much more. Because this is only metadata, this can be reset at any time and revert either to the original camera settings or to the neutral values (see Figure 2.28). These settings are part of the RED RAW media files only. If you optimize the media or create proxies, these settings are fixed in the converted files. If you do create optimized files for your RED media, these files are in full ProRes 4444 and not the standard ProRes 422. If you have optimized the media and want to make changes again, when you click the **Modify** button, you'll get a dialog asking if you want to discard the optimized media.

Reimporting and Relinking Files

Sometimes clips might get disconnected while you're editing or may not have imported properly, and it may become necessary to reconnect them. You can do this from the library. Select the project or event in the library with the missing clips, which should display a little yellow exclamation warning

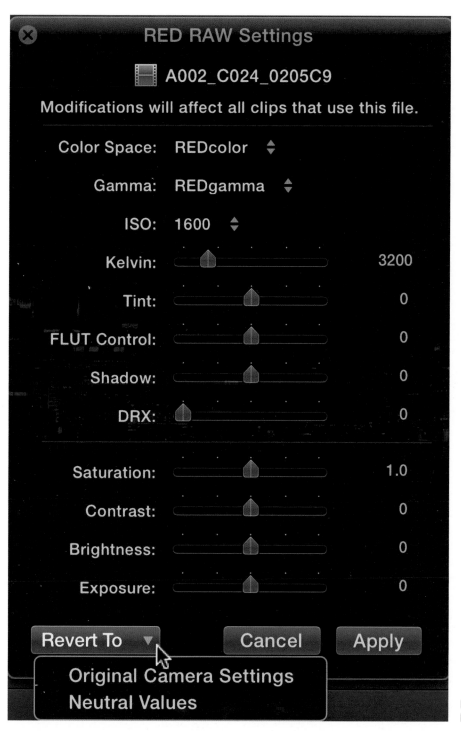

FIGURE 2.28
RED RAW controls.

FIGURE 2.29
Missing file icon.

icon next to the project or event icon (see Figure 2.29). If the files have not been imported properly or show a camera icon in the filmstrip, you should use **File>Import>Reimport from Camera/Archive**. Simply click the **Continue** button in the dialog that appears, and if the archive is mounted and available, the application will immediately re-import the clips into the appropriate event and reconnect the clips in the project. This function works only for camera media and camera archives, which makes it even more imperative that you back up and archive your camera originals and save them on a secure drive, separate from your media drive. It is the only way to re-access media that has been misplaced or moved and appears with the dreaded red offline media icon in the Viewer.

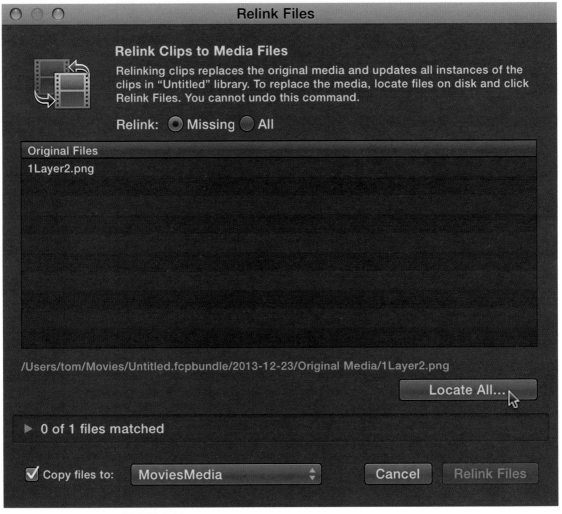

FIGURE 2.30
Relink files.

Another important feature is the ability to relink missing media, or even to relink to a different file after it has been altered or moved. This can be done either in the Browser or in the Timeline. Select the item or items that have the garish red warning, and use **File>Relink Files**. Relinking a file allows you to relink to a file with a different name.

The clip names that appear in the upper pane are not the names of the clips assigned in the browser, but the original file names. If you select a clip name, you will see the file path to where the file should be in the lower portion of the pane (see Figure 2.30).

Notice the buttons at the top that let you select **Missing clips** or **All clips**. At the bottom of the dialog is the checkbox to copy the file to the library or another location or by unchecking the Copy box to leave it in its current location. This is similar to the import dialog. Use the button to **Locate All**, which takes you to the navigation dialog. Find the file you want to relink to and press **Choose**. The file will move to the bottom half of the dialog. Files that need to be relinked that are in the same file path will automatically be relinked. Other files in other locations can be selectively added using the dialog. Once you have all the files to relink loaded in the bottom portion of the window, click the **Relink Files** button. All the files in the Browser and in projects that use the relinked files will be automatically relinked.

TIP

Corrupted Libraries: Sometimes a library will get corrupted and not open. If you're working with managed media, the first step is to get your media out of the bundle. Right-click on the library in the Finder and select **Show Package Contents**. Find all the Original Media folders and copy the media out of them into another folder. Then open the latest backup version of the library. Use the Relink function to point at the new media location, and if you want, use the Consolidate Library function to copy the media back into the library.

SUMMARY

With these last two chapters, you have completed the process of correctly setting up your system, and we have looked at some aspects of the importing process. We set up our preferences for editing, playback, and importing. We looked at importing from cameras and converting media and importing still images from iPhoto and Aperture, and audio from iTunes. We also looked at converting files from DVD. In the next chapter, we'll look at organization and workflow and different scenarios for different types of production.

Organization

In this chapter, we'll look at working in the Libraries panel and the Browser to organize footage using FCP's tools for working with metadata, the extra information attached to a piece of media that either comes from the camera itself or that you add to it.

LOADING THE MEDIA

If you skipped directly to this chapter, you should download the material that we'll be using later in the chapter from www.fcpxbook.com. We'll be working with the ZIP file called *BB2.zip*:

1. Download the file and then copy or move the entire ZIP file to the top level of your dedicated media drive.
2. Double-click the file to open the *BB2.zip*.
3. Double-click the *BB2* library to launch the application.

The library contains two events called *Farm* and *Roasting*.

The media files that accompany this book are heavily compressed H.264 files. Playing back this media requires a fast computer. If you have difficulty playing back the media, you should transcode it to proxy media:

1. To convert all the media, select the event or events in the Libraries panel, right-click on them, and choose **Transcode Media**.
2. In the dialog that appears, check **Create proxy media**.
3. Next, you have to switch to proxy playback. You do this with the light switch popup in the upper right of the Viewer. Be warned: If you have not created the proxy media, all the files will appear as offline. In this case, you will probably have to switch back to **Optimized/Original** for your other libraries.

ORGANIZING MEDIA

Your media are your digital files, however they're acquired, from a camera, generated in a graphics program, or your recorded narration. These are what you edit with, and without them you have no program, so it is imperative that you keep them safe and duplicated in case of emergency.

There are no firm rules about how you organize your media, and each production or series tends to dictate its own organizational structure. Usually, I begin with one library that holds all of the media for the production, video, audio, and stills, so they're all collected into one place and are easy to back up. I prefer to use external media rather than managed media as it allows more flexibility for working with other applications like Motion. Even though the media is external, the library remains a self-contained unit which links everything involved in the production. The external media folder is routinely backed up and contains other files that are not part of the FCP library, files like scripts, notes, communications, and sometimes even invoices.

With the library selected in the Libraries panel, you can see all the content of all the library's events in the Browser, broken down into event groups as in Figure 3.1. At the bottom of the Browser is the total number of items in all events. Once you have the library selected like this, you can close the Libraries panel with **Shift-Command-1**.

The purpose of events now is a primarily organizational tool. These are the equivalent of top-level folders or bins within your production. I only have two events here, but if you have many more, you can close and open the ones you want to work with using the disclosure triangles, while still seeing them all at once. Of course if you want to focus on any one event, you can simply select it in the Libraries panel. Remember you can use the **Tab** key and the arrows to move around the Libraries content and the Browser content. In the latest version of FCP you can use the arrow keys to open and close events when there are multiple events displayed in the Browser.

From the library, you start breaking down your material to organize it. If you ingest everything into one event, you can make new events and start moving clips around by dragging them from one to another. This is the same as moving files between folders or bins, unless you hold down the **Option** key while you drag to make a duplicate. This does not duplicate the media or move the media. The media, whether it's managed media within the library, or external media, remains where it was first imported. By copying from one event to another, you're only making another pointer to the same media. Making copies of clips for organizing in the library does not take up more space.

You can also merge events by dragging one event on top of another in the Libraries panel or use **File>Merge Events**. All the clips and Keyword Collections and Smart Collections and folders will be combined into a single event.

Workflow Structures

Libraries and events can be used in a variety of ways. Narrative projects tend to have material broken down into scene events, with separate keyword collections for different types of shots or characters, which are all grouped together in a single event, depending on how complex the scene is, which is often identified by a scene number on a head slate linked to a shooting script. Documentary projects

FIGURE 3.1
Library and browser.

tend to break the material down into subject matter: an event for all of the forest shots, another for logging scenes, another for road work, another for weather, another for all of the interviews, another for audio, another for graphics. FCP can accommodate both structured story editing forms required in feature film editing and free association often required in scriptless documentary and anything in between.

Narrative projects with separate events for each scene inside a single library container might look like Figure 3.2. This would be in the early days on the project, where only a few scenes have been shot, and much more material is still to be shot and ingested. Here, the library has all the scenes. Each scene is ingested as a separate event. Each event contains the clips for that scene, together with the projects that make up that scene edit. Each event can use keywords to break down the clips used, a collection for each actor for instance, and another collection for master shots, and so on. There might be a separate event for Assemblies, which projects that combine scenes, including a master assembly. Assemblies can basically be done in two ways. The first way is combining compound clips made from each scene that includes the entire scene. This way the assemblies are made up of separate compound clips. This has the advantage of neatness and the ability to more easily swap out scenes for other versions and to rearrange scenes. The other way to do assemblies is to simply copy and paste entire scenes and their clips in their original layouts into master assembly projects. This has the advantage of having everything in one place and anything can be easily fine-tuned and adjusted in relation to everything else.

A television series, or any ongoing series of programs from monthly corporate presentations to weekly church services, might be broken down something like Figure 3.3. This is the master library for a single season where each event contains all the media for a single episode. That can be further broken down into separate libraries for each episode (see Figure 3.4), so that it might look like Figure 3.5. The episode libraries might be distributed to different editors, where each will break down the episode library into scene events something like Figure 3.6. There is no duplication of any media throughout this process as long as all media for the whole series is contained in a single external media location. Or each episode library might be duplicated onto a separate hard drive to be worked on independently, while the master media files are still contained in a central, backed up location.

These are scripted programs. For unscripted documentaries, structures can be very different. There are probably more different ways of organizing your media in documentary work than in any other type of programming. A commonly used structure is to create one library for the production and master events for your clips, one event for each day of shooting. Usually with unscripted or loosely scripted productions, a running log is kept of what is shot, where, and when. This day log becomes the basis for the master events, which might look something like Figure 3.7. Each date named event holds the master clips, which hopefully match the production log. From the master events, the clips are distributed to other events for organization based on content. The trick here is not to drag a clip from a master event to a new event like *B-roll Town*, but to **Option**-drag

FIGURE 3.2
Movie library.

FIGURE 3.3
Series master library.

it, so that you duplicate the clip, leaving a copy in the master date event. As the media is in the same library for both events, this works for both managed media and external media. There is no file duplication. One nice feature is that if you copy a keyworded clip from one event to another, the Keyword Collection is created in the new event if it isn't there already. This does not include Smart Collections. However, keyword changes made to a clip in one event will not appear on its duplicate in another event, which is probably a good thing.

Notice there is a separate event for projects. This is fairly typical as multiple projects can be used with media from multiple events. Sometimes a project is inside a topic event, such as the *B-roll Town* project might have started out in the *B-roll Town* event. Here, all the clips were laid out and trimmed and selects made from the clips in that event, and then the project was moved into the *Projects* event, where it could be easily accessed and material could be moved between projects, either using **Copy** and **Paste** or **Paste as Connected Clip**. The other project *Interview Selects* is similar; all the interview and narration pieces might be laid out and rearranged and saved as the bed for the documentary to which the B-roll is

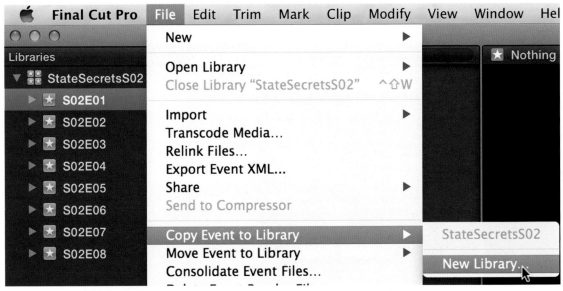

FIGURE 3.4
Series episodes transferred to new libraries.

added in the master project with snapshots taken intermittently. Snapshots of projects are a great tool for documentary makers, as the project can change substantially during the postproduction process, and go through a great many variations, quite a few of which might get tried out and abandoned along the way; but it's always a good idea to keep this various iterations and revisit them to see if perhaps a different, perhaps previously tried and discarded, approach might not be better.

Wedding and event photography and video production is of course a huge industry, especially in the United States, approximately $6.4 billion out of the $70 billion wedding industry, about 2.5 million weddings a year. The production needs of a wedding are quite similar and usually laid out not unlike a documentary. Using a single library for the production, the various wedding events are broken down into Final Cut events (see Figure 3.8). Unlike a real documentary, which can be much more fluid, wedding productions are usually very much a formula, based on the extent of the coverage requested. Though technically unscripted, they are often assembled very much like a feature film, using separate projects that can be edited in each event and then combined in a master project.

Working with clients presents different types of challenges. Here, you often do want to segregate

FIGURE 3.5
Series master library and episode libraries.

FIGURE 3.6
Episode liabrary.

FIGURE 3.7
Documentary structure.

FIGURE 3.8
Wedding structure.

one client's media from another. A typical structure here to be used is a single master library for each client. FCP 10.1 and later makes it easy to load a single client's work and close out other client's productions. If you had multiple clients' libraries open, it might look something like Figure 3.9. Here, there is a library for each client, and an event for each production, sometimes named after what it is, like *CEO Presentation,* or sometimes based on some code like the start date of principal photography for a production, such as *CLD140214,* a code which might be used for everything related to the production from first scripts to slate numbers to log sheet identification and finally to invoicing. Every production company will have it's own structure, but these are a couple that are widely used.

In addition to segregated libraries in FCP, media for client production needs to be segregated, and it might look something like Figure 3.10. Here, there is a central repository for all client media. The advantage to this is that it simplifies backing up client material, especially if there are other types of production added into the mix. The master *Clients* folder has separate folders for each client, which in turn have separate folders for each production, which might be further broken down into folders for different types of media.

FIGURE 3.9
Client structure.

FIGURE 3.10
Client media structure.

TIP

Libraries in the Dock: If you're not working with a huge number of libraries, it's sometimes handy to keep them all in a single folder and to keep an alias of the folder in the Dock for easy access as in Figure 3.11.

FIGURE 3.11
Libraries in the Dock.

> **NOTE**
>
> **Copying Between Libraries:** You can copy clips from an event in one library to an event in another library. If the media is managed media, the file will be duplicated. If however the media is external and both libraries are using the folder to contain the media, even though the little green plus icon appears indicating the media is being copied, the file is not duplicated. Moving the clip to the trash, **Command-delete**, in one library will not produce a warning because the same file is still being held for use in another library.

COLLABORATING

Collaboration essentially has two components, sharing the media and sharing the information. Sharing the media is one component, and this can be done in a number of ways. You can:

1. Share the media physically, sneakernet it, move a hard drive from one location to another whether down the corridor or across an ocean by FedEx or the carrier of your choice.
2. Use a Shared Area Network, SAN that holds the media files, that all the collaborators can access from individual systems.

Sharing information, where metadata like events and libraries are passed back and forth, can be either done physically or on shared storage. On shared storage, though media can be accessed simultaneously by multiple users, only one person can access a library at a time. Libraries can be shared and copied, but only one user per library at a time. However, multiple libraries, using symlinks, can access the same media on a SAN at the same time. How many people can access media files simultaneously is a function of the speed of the system and the number of users trying to access it and what they're all trying to do with it at the same time. For most SANs, two people, a reporter and producer, accessing a file while the editor is playing the same file should not be a problem. Ten people trying to access the file at the same time might cause problems. If many people need to access a file simultaneously, it might be useful to think in terms of duplicating the files and having it available on multiple drives.

Managed media is no bad thing even in a collaborative environment where hard drives can be passed around. There is a single drive (and backup of course) that I work on to do the edit. I then pass the drive to someone else who does the color enhancement, who in turn passes the drive to someone else who does the sound sweetening, and who may pass it on to yet another person or perhaps back to me to output and compress the final deliverables. I'd suggest passing it back to the editor again, as I've found that during sound sweetening, regardless of how much the picture is supposed to be "locked," you would really like to tweak the picture edits because of the sound edits. Personally I loathe the term *picture lock*. However, if you have to collaborate with people across town or across the country or on another continent, physically moving the drive can be a problem, though FexEx and UPS overnight makes it much less problematic than it used to be.

However, if you need to collaborate immediately in a fast moving and changing environment, the internal media on a physical drive is not going to cut it, and SAN becomes essential, and here it's useful that libraries use external media, not managed media. Everybody has libraries, either individual libraries or duplicate libraries, that all use symlinks to access the same media. A library with a single event with a couple of projects can be very small and can be easily passed around.

Another common procedure on SAN systems is to have one editor work on a library and when he or she is ready to pass it on to a co-worker, the library is simply closed on one machine and opened on the other. It's a matter of seconds.

In addition to physically moving media on a drive, another widely used procedure is to have duplicate media in identical folder structures in different locations. Now collaboration is solely through metadata, transferring libraries or events, which can be very small when stripped down to their bare essentials. A library with the project event can be easily passed around and shared using services such as WeTransfer and Dropbox, and for smaller projects, they can be even small enough to e-mail. This is a huge advantage. Once the media has been delivered to all the locations, everybody can be working on duplicate libraries simultaneously in a matter of minutes. Updated projects can be sent back and forth at will. This is essentially cloud-based collaboration, especially using Internet sharing with tools like Dropbox. Sharing an event is used to share collections that have been created, so other editors have the same information. Generally project sharing is probably more common.

Transfer libraries, which contain just the event and/or project stripped of any render files or optimized media, is uploaded to the cloud and downloaded to other users. Another option is to send an XML file. XML can be an event or a library. This is the smallest file, fastest for transfer. To create a transfer library:

1. Select the project or event to be duplicated. Choose the *Selects* project in the *Farm* event.
2. Use **File>Copy Project to Library>New Library**.
3. Name the library something like *BB2_Selects* and click **Save** and the dialog in Figure 3.12 appears.
4. Make sure the checkboxes for Optimized and Proxy are both off. These don't need to be duplicated.

You don't need to worry about render files; they are never duplicated when a project is duplicated. Render files are shared across duplicate projects. If they are needed, the other editor will have to re-render. When you duplicate a project like this, the project, together with the used clips, appears in the new library. If the library used external media, this isn't a problem, and the library is ready to go. In this case, the transfer library is less than 1MB, and more than half of that is the thumbnails and peak data.

You can delete render files at any time from within the application using **File>Delete Generated Event Files**, which brings up the dialog in Figure 3.13. You can select multiple events in a library and delete the files at once. Notice the

Copy media to the library "BB2_Selects"

Final Cut Pro will copy all selected items and original media files to the library "Final Cut Pro".

Media stored in external folders will be linked to, but not copied. You can include any available optimized or proxy media.

Include: ☐ Optimized Media
☐ Proxy Media

Cancel OK

FIGURE 3.12
Duplicate library dialog.

Delete Generated Event Files

Delete generated files to free up hard disk space. You cannot undo this command.

☐ **Delete Render Files**
◉ Unused Only
○ All

☐ **Delete Optimized Media**
☐ **Delete Proxy Media**

Cancel OK

FIGURE 3.13
Delete generated event files.

options to delete unused or all render files, and also the options to delete proxy file and optimized files that may be in a library. One thing to be aware of when you delete render files is you will also delete any shared files, such as YouTube exports, which are stored inside the library bundle.

If you are working with managed media on a SAN, when you create a transfer library on the same partition, though it would appear that FCP is copying the media from one library to the other, and using **Reveal in Finder** will point a clip to the new library, nothing is copied. If the original library and the new library are on the same drive or SAN, the application will use hard links. Though the media appears to be in the new library, and the Finder will tell you it is taking up significant space, the media is not duplicated, it is still pointing to the media in the original library. If you move the new library to another drive, then the media is duplicated. This gives working on a SAN the capability of external media while still allowing you the benefits of a self-contained, managed media library. If you delete a clip from any library, the media is never lost, not until it has actually been deleted from every duplicate event and project that uses it. Hard links allow the system to keep a single piece of media and have it seem to appear in multiple places at once.

You can share an event or a whole library using XML. To transfer a library using XML:

1. Select the *BB2* library to be transferred.
2. Use **File>Export XML**.
3. Name the XML and save it to your desktop.
4. E-mail or send the XML file however you like to your co-worker.
5. When the file is received, your co-worker uses **File>Import>XML** to add it to an existing library.

The file is immediately relinked to the external media in the corresponding media folder on the other machine. All the information for selects and collections is now available to your co-worker.

Alex Snelling of Slack Alice Films has a wonderful document on line that I would highly recommend to you. If you're interested in working in a collaborative environment, it's a "must read." It can currently be found at www.10dot1 .co.uk/content/FCPXInASharedEnvironment_FINAL.pdf.

ORGANIZING CLIPS

Clips are the representations of your media in FCP. There is of course no actual media within the application, only the clips that point to where the media is and tells the computer what to do with it. The real trick to breaking down your material and organizing it is to put it into enough events and collections so that your material is organized, but not so many that it becomes difficult to find material. It's not helpful to have dozens of events with a few clips in them or Keyword Collections with a single clip in each. As you add clips into events, for instance when you're copying a clip from a master event to a subject event, add

SMART FOLDERS

Because libraries can now be anywhere, on any drives, in any folders, the Mac OS's ability to create Smart Folders makes it easy to find your libraries.

1. In the Finder, go to **File>New Smart Folder**.
2. Click the **+** button on the right and in the popup list go to **Other**.
3. Find file extension to bring up *is* and type in *.fcpbundle*.
4. At the right end of the criteria line, hold the **Option** key to change the **+** button to a **−** button.
5. Set the popup to **None** and in the type select **Other** and find *filename*.
6. Make the criteria for *filename contains* and enter *EST* or whatever time zone tag your backup files are using. This will exclude the backups. You can use **Option** and **+** as many times as you want to enter as many file name time zones such *GMT* or *PDT* as you need to exclude the time stamped backups (see Figure 3.14).
7. Save the Smart Folder and make sure **Add to Sidebar** is checked to make it appear as a Smart Folder in the sidebar for every Finder window.

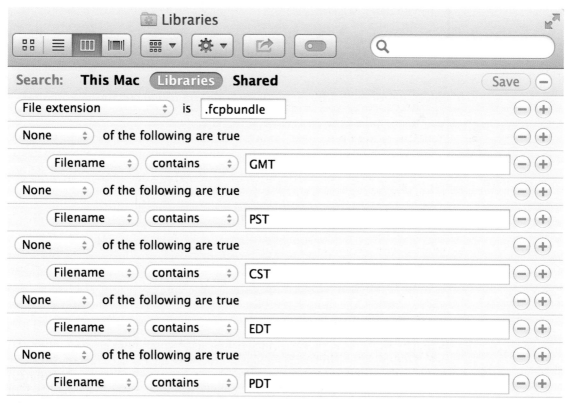

FIGURE 3.14
Smart folder criteria.

NOTE

NFS: In addition to using powerful SAN systems, a number of users have had success using NFS (Network File System) that allows you to set up any drives connected by fast Ethernet using the NFS capabilities of OS X. This gives the sharing and collaboration capabilities of a SAN at much lower cost while being quite adequate for most H.264-based media.

TIP

Final Cut Library Manager: Though you have the ability to delete render, proxy, and optimized files from within FCP, a great utility to help organize and maintain your libraries is Final Cut Library Manager (www.arcticwhiteness.com/finalcutlibrarymanager/). The Library Manager interface allows you to not only trash the appropriate files but also see how much space these files are taking and organize the interface to show which libraries can be most usefully be managed to delete the files to recover drive space. A wonderful feature is the ability to sort your libraries based on their potential space saving by removing unnecessary files. The interface shows all libraries, anywhere, on any connected drive that's been Spotlight indexed. It is a great utility and enormously useful, especially in collaborative workflows where libraries and media are being shared and moved around, or any FCP user who wants to organize his libraries for archives.

notes—lots of them. The more information you include on the clips, the easier it will be to find them.

From the master shots, which in the *BB2* library, you can access by selecting the library with the two events, you can organize the clips into collections. One of the events has the clips renamed descriptively, whereas the other has the names FCP assigned on ingest. Collections are based on metadata, either that the application uses based on specified criteria, which are Smart Collections, or that the application uses based on keywords applied by you.

It is critical that you cut up your shots and organize them into collections to work efficiently, particularly for long-form work, productions longer than 20 minutes or so, short projects with a lot of material, or productions that may go on for a longer period of time. The longer the production, the more cards you've archived, the more project timelines, the more events, the more complex everything becomes. Having your material well organized is crucial.

Because of the extensive use of metadata in FCP, clip names are less important than they used to be in legacy Final Cut Pro. Nonetheless, a cluster of date/time stamps like *2011-05-01 14_05_06* isn't very appealing or informative. Although you can rename your clips whatever you like, this does not change the name of the media file on your hard drive that it refers to.

You can rename a clip in the Event Browser either in Filmstrip view or in List view or in the Info inspector. Clips in the Timeline can also be renamed by

right-clicking on the name of the clip either in the Timeline or in the Inspector's Info tab. Changing the name of the clip in the Timeline does not change the name of the clip in the Browser. The two are quite separate, two individual instances of the same piece of media. However, within the Browser, any instance of a clip in any collection or Smart Collection has to share the same name.

FIGURE 3.15
Original name from camera.

You can restore the original camera clip, name at any time. To do this:

1. Select the *cooling* clip in the *Roasting* event and go to the Info inspector.
2. Click the **Apply Custom Name** popup in the lower right and select **Original Name from Camera** (see Figure 3.15).

In this instance, this is not the name FCP assigned, but *Clip #35* was the clip name on the AVCHD camera card, which is even less helpful than the FCP assigned name.

1. With the *Clip #35*, the *cooling* clip, selected change **Apply Custom Name** to **Clip Date/Time**, which changes the clip to the Apple assigned name, which in this instance is the name of the media file in the library.
2. With the same clip selected, from the popup choose **Custom Name with Counter**. The clip will probably be named *<Untitled> 1*, or something similar, which isn't all that useful.
3. From the **Apply Custom Name** popup select **Edit**, which takes you to the Naming Presets window (see Figure 3.16).
4. Select **Custom Name with Counter** in the sidebar.
5. Near the bottom of the window where it says **Custom Name** you can type in a custom name, or at the top, simply select **Custom Name**, delete it, and type in *Coffee* (see Figure 3.17).
6. This will not change *<Untitled> 1*, so select it and again choose **Custom Name with Counter** to name the clip *Coffee 1*.

Let's make our own custom preset. To do this:

1. If the Naming Presets window isn't open from the popup in the lower right of Info inspector, select **Apply Custom Name>Edit**.
2. At the bottom of the sidebar, click the + button and name the new naming preset *Custom Info*.
3. If you want, pick up the new name and drag it to the top of the sidebar list. This will make it top of the list in the inspector popup.
4. In the Format box at the top, type in *Coffee*.
5. From the Clip Info area, drag **Counter** into the Format box and follow it with a space. Put a space after each button, so elements don't run together.

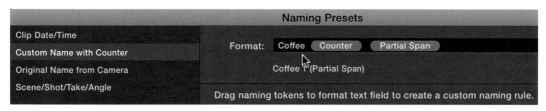

FIGURE 3.16
Naming presets.

FIGURE 3.17
Custom name.

6. From the Date/Time area, drag **Clip Date** followed by a space and also **Clip Time** into the Format box.

7. From the Camera section, drag **Source Format** and **Manufacturer** into the Format box, which should look something like Figure 3.18.

8. Before you apply the custom name, at the bottom of the Naming Presets window, you might want to change the **# of digits** popup to 2 or 3.

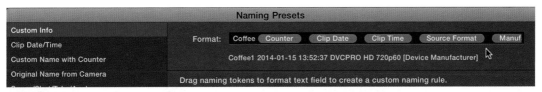

FIGURE 3.18
Custom info.

9. When it's ready, select all the clips in the Browser in the *Roasting* event, and in the Info inspector, apply the new **Custom Info** naming convention.
10. If necessary click the column header *Name* to bring the clips into alphanumeric order.

This is perhaps more information than you want in the clip name, but I think it gives you an idea on how custom naming can be used. In addition, instead of the pre-built tags, you can type in whatever information you want, such as the location or the scene name.

> **TIP**
>
> **Lumberjack:** Although organization of clips within FCP is extremely important, the ability to organize your media prior to import is very useful. More and more producers and production assistants are using digital on set or on location tools to make records of the media shot and to prepare the metadata prior to post production. One of the key tools for this type of work is Intelligent Assistance's Lumberjack (http://lumberjack-system.com). This uses a web browser on a mobile device, iPad, iPhone, Android, for its on location logging, where keywords, people, places, and other information can be entered to a server. Lumberjack uses XML from a desktop version of the software to bring the metadata associated with your media into FCP.

Custom Metadata

The Info inspector allows you to look at information about your clips in a variety of ways from the popup in the lower right that defaults to **Basic** (see Figure 3.19).

From this popup, you can, using the option at the top **Add Custom Metadata Field**, customize any existing preset. The Basic preset is pretty basic, whereas the General preset has more useful information, and Extended is quite comprehensive, though long. In addition to technical information about the selected clip, it also gives you information such as the original camera name and also the bottom file information, which is where the file is located and what media is available. Original is always green, unless the media is missing, and Optimized and Proxy will turn green as these files become available. Notice the handy button that allows you to a create proxy file. This button only appears when you have clip selected in the Browser, not when you have a clip selected in the Timeline. An optimize button would handy as well. Though no file path to your media is listed, if you put your pointer over the library location, a tooltip will appear giving the complete file path (see Figure 3.20). There is also the handy **Reveal in Finder** button next to it.

Add Custom Metadata Field...

METADATA VIEWS

✓ Basic

General

Extended

Audio

EXIF

IPTC

Settings

Save Metadata View As...

Edit Metadata View...

FIGURE 3.19
Select metadata view.

There is a separate display for Settings, which is very useful and has functions that allow you to control your media (see Figure 3.21). In addition to Roles, which appears in every metadata view as does File Information, you can change the Timecode Display, the Alpha Handling, which lets you set how transparency is handled, and Field Dominance Override. There is also a popup for Log Processing, including Arri Log C, Black Magic, Canon, and Sony log types.

If the Basic metadata display is insufficient, but Extended is too extensive, you can make your own metadata view. At the bottom of the popup is the option to **Edit Metadata View** to bring up the Metadata Views window (Figure 3.22). Either select one of the existing views or from the Action popup (the gear) in the lower right select **New Metadata View**. Notice the little checkbox that allows you to switch off and on all the available

Location
BB2

Reveal in Finder

Availabl /Users/tom/Documents/ Files/
● Origin _FCP_AdvMediaFiles/BB2.fcpbundle/Farm/
 Original Media/2011-05-01 14_21_14 (id).mov

FIGURE 3.20
Location tooltip.

settings. The other useful popup is at the top. This allows you to narrow down the enormous list below to only should the Video Properties or Audio Properties, or other available options.

To create a custom metadata view:

1. If you're not already in the Metadata View window, from the metadata view popup, select **Edit Metadata View.**
2. Select **Basic** in the sidebar and from the popup at the top select **Video Properties**.
3. In the list that appears check on **Camera Angle**. This will add the Camera Angle box in the metadata view, allowing you to assign camera angles for multicam editing.

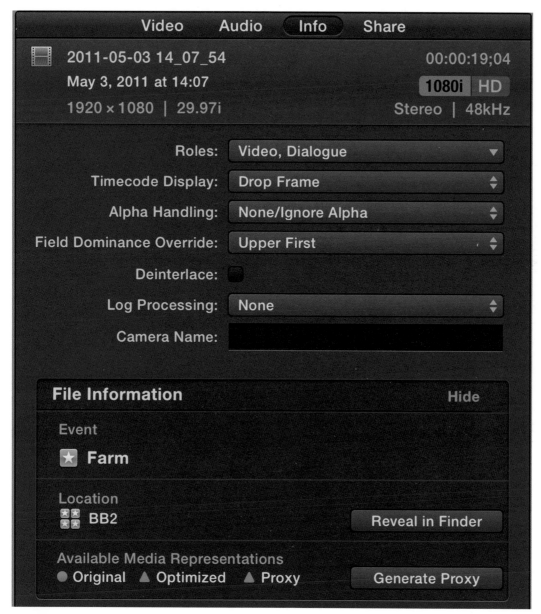

FIGURE 3.21
Settings view.

4. From the Action popup select **Save Metadata View As**.
5. A drop-down sheet appears where you can enter a name. Call it **Basic+**.

Your Basic+ metadata preset will appear in the metadata view popup at the bottom of the Info inspector.

FIGURE 3.22
Metadata view.

KEYWORDS

Collections are fundamental to organizing your clips in FCP. You can make two kinds of collections Keyword Collections or Smart Collections, based on parameters you specify. You can add a keyword to a clip or to a portion of a clip in quite a few different ways in FCP.

1. Let's begin by opening the keyword HUD by clicking the key button in the toolbar or pressing **Command-K**.
2. If necessary twirl open the HUD, and in the first keyword shortcut space, enter *cherries* (see Figure 3.23).
3. Select the *2011-05-01 14_15_30* clip from the *Farm* event.
4. Around the 54-second mark, mouse down and drag a selection of about six seconds of the clip. As you do this, a tooltip will show you the length.
5. Once you have the selection made, you can drag the handles on either end to adjust it.
6. Hold the **Command** key to drag another selection on the same clip.

FIGURE 3.23
Keyword in HUD.

These selections are persistent. That is if you make a selection, move to a different clip, and then return to the first clip, the selection is still there. Furthermore, you can make multiple selections within a single clip. The selections are pretty fragile though and can be lost, so it's best to mark them as Favorites or with a keyword.

1. With the selections made, press the keyboard shortcut **Control-1** to add the *cherries* keyword to the selections and create the Keyword Collection in the event.
2. Go to the clip *2011-05-03 14_05_52* and drag a short selection near the end of the clip.
3. Drag the selection from the Browser into the libraries panel and drop it on the *cherries* collection.

If you do want to drop the selections, press **Option-X**, or click on a specific selection and press **Option-X**. To select the entire clip, which also drops the selections, just press the **X** key.

Just as the analyses of Smart Collections such as *Close Up Shots, Medium Shot,* and *One Person* are grouped into a folder, you can group your own collections into folders by right-clicking on the event and selecting **New Folder**, or with the event selected, use **File>New Folder** or press **Shift-Command-N**.

> **TIP**
>
> *Going to an Exact Frame:* You can use the Dashboard to go to an exact frame. Click the timecode in the Dashboard once, or press **Control-P** for playhead and type in a number such as 5404 for 54:04. You don't need to type in the colon. Press **Return** and the playhead will leap to that position.

> **TIP**
>
> *Playing a Selection:* To play just a selection that you've made from beginning to end, press the forward slash (**/**) key.

> **TIP**
>
> *Opening Disclosure Triangles:* In the Event Library, Event Browser, or Project Library, you can select an item or items and use the **Right arrow** to twirl open the disclosure arrow for the item. The **Left arrow** will close the disclosure triangle for selected items.

You can have up to nine keyboard shortcuts for keywords at a time using **Control-1** through 9. The last shortcut, **Control-0** (zero), is reserved to allow you to select a clip and remove all the applied keywords. If you like clicking buttons, you can also click the shortcut button in HUD to apply a keyword to a selection.

In the *cherries* collection, each keyworded section behaves as if it were a separate clip.

You can also create a Keyword Collection and import directly into it:

1. To create a new Keyword Collection, you can use **File>New Keyword Collection** or the shortcut **Shift-Command-K**. Or you can right-click on the event in the library and select **New Keyword Collection**.
2. Choose your preferred method to make a new Keyword Collection and call it *fruit*.
3. In the Browser, you have a button that you can use to import clips directly into that Keyword Collection (see Figure 3.24).

If you wish, you can also drag and drop clips, video, audio, or stills directly from the Finder into a Keyword Collection. The items become keyworded and are added to the event the collection is in.

> **TIP**
>
> *Used Clips:* Though the **Show Used Media Range** function can be activated from the **View** menu, there is also a function to show Unused media in the Browser. Selections such as **Favorites**, **All Clips**, and **Hide Rejected** appear in the popup at the upper left of the Browser, the **Unused** option now does. You can activate it with the shortcut **Control-U**, which displays only portions of the media that are unused in the project.

FIGURE 3.24
Empty Keyword Collection.

Search Filter

In addition to keywords and ratings, it's often useful to include notes about clips or segments on the clips themselves, a few words about a soundbite, or a note about fixes such as color correction that need to be made. Here's how:

1. In List view in the *Roasting* event, select the clip named *green beans on tray*, and press the **Tab** key, which is another way to select the name for renaming.
2. Continue pressing the **Tab** key until the selection moves across the list to the Notes column.
3. Type in the word *sample*. This is now a searchable piece of information that can be found easily and used as a tag for creating a collection.
4. In the *cherries* Keyword Collection, select a clip and tab over to Notes to again type in *sample*.
5. In the Libraries panel, select the library *BB2*, and in the Browser, click in the search box in the upper right or type the shortcut **Command-F** for the Filter HUD.
6. Type in *samp*, which will filter out everything except the two clips, one in each event, with the note *sample* and the clip called *sampling* (see Figure 3.25).

> **TIP**
>
> **Notes:** Not only can you add notes to clips, but also you can add them to ranges, either keyworded segments or favorites. Notes added to a keyword in a Keyword Collection will also appear opposite the keyword in the event.

> **TIP**
>
> **Same Keyword in Multiple Events:** Using the same keyword in multiple events allows you to search a library for Keyword Collections across all the events. This will load all the clips that share the same keyword regardless of the event.

FIGURE 3.25
Search filter HUD.

SMART COLLECTIONS

Metatagging is tagging media with metadata, such as we do when we create keywords or add notes to clips. This metatagging can be used to create Smart Collections. This can be done in two ways, either by entering the metadata criteria yourself or by having the application search your media for specific types of shots. FCP has some automated tools that divide material into shot types and shots with people. Though this sounds good in theory, for large projects, it's not really of great benefit, and you might be better off imposing an organizational structure that suits your project and your needs. Though these Smart Collections can be created automatically on import, it's generally better to do this analysis after import, like overnight.

Though you can't analyze a library, you can select multiple events, right-click on one and select **Analyze and Fix**. These are grouped in the *People* folder, in which there are Smart Collections for shots with one person, two persons, or groups. These can also be created on import, with the application analyzing the content

and putting material in the appropriate Smart Collection. The same shot can appear in multiple Smart Collections: it might be in close-ups and one person.

Here's how:

1. Select the event *Farm*, right-click on it and use **Analyze and Fix**.
2. In the drop-down sheet that appears check on **Find People** and **Create Smart Collections after analysis.** Leave off **Analyze for color balance** and **Consolidate find people results** (see Figure 3.26).

Analyze and Fix:

Video: ☐ Analyze for balance color
☑ Find people
☐ Consolidate find people results
☑ Create Smart Collections after analysis

Audio: ☐ Analyze and fix audio problems
☐ Separate mono and group stereo audio
☐ Remove silent channels

[Cancel] [OK]

FIGURE 3.26
Analysis sheet.

Analyze for color balance can be done very quickly on a clip-by-clip basis, and there is little point in doing it in an event analysis. **Consolidate find people results** will combine the predominant type of shot, one-person, or two persons, close-up or medium shot, into one collection. It may take quite some time to run the analysis.

Once the analysis is complete, you will have a number of new collections with the purple gear icon of Smart Collections, three grouped in a folder for *People* (see Figure 3.27). If you go inside the library bundle, you will see a new folder called *Analysis Files* with a folder inside for *Find People files*.

FIGURE 3.27
Smart collections.

NOTE

Renaming Collections: While Keyword Collections can be renamed, thus changing the keyword itself, analysis Smart Collections cannot be renamed, as they take their name from the analysis that was performed. On the other hand, manually created Smart Collections can be named whatever you want, and renaming them will not change the criteria. Renamed Keyword Collections will change every instance of the keyword used in the Browser. Renaming will not change keywords that have already been edited into a project.

Obviously, you don't have to run a whole event through analysis; you can run selected clips and can continue working while this automatic process continues.

These automatic Smart Collections are created by FCP. You can delete a Smart Collection at any time. Simply select it and press **Command-Delete**. If you do this, the Smart Collection is gone, but the analysis files remain in the library bundle.

You can remove any one of the analysis keywords by right-clicking on them in list view and selecting **Remove Analysis Keywords**. This will remove just the selected analysis. If you want to remove them all, select them all and use the shortcut menu. Alternatively, simply select the clip itself and press **Control-Option-0** (zero), and they will all be gone.

You could make an empty Smart Collection by using **File>New Smart Collection** or the shortcut **Option-Command-N**, and then double-click the icon to initiate the Search Filter HUD. But let's do it another way:

1. Select the *Roasting* event and right-click on it to select **New Smart Collection** or use **Option-Command-N**. You can also click the magnifying glass to bring up the Filter HUD.
2. If you made a new Smart Collection, name it *Audio* and double-click the purple gear icon.
3. Click the + button in the upper right of the Search Filter HUD and select Media Type.
4. Change the pop-up in the center to **Audio Only** (see Figure 3.28).
5. From the Music and Sound Effects Browser, drag any sound effect or music into the *Roasting* event. (You can't drag it into the Smart Collection.)

The audio file will immediately appear in the Smart Collection. Audio Smart Collections are very handy I find while you're working with a lot of sound effects and music in an event.

The search filters are in the Filter HUD based on Boolean selections, so, for instance, you can search for text that Includes or Does Not Include or Is or Is Not. You can search a date based on when the clip was created or when it was imported, on a set date, before a date, after a date, or whether it was the last *x* number of days, or not the last *x* number of days. As you create the filter, the browser will update to your specified selections. Any time you create clips that

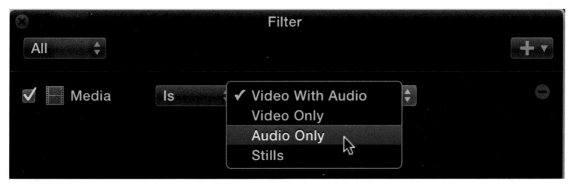

FIGURE 3.28
Audio only smart collection.

meet these criteria, the clips, or selections, will automatically be added to the Smart Collection.

You can also use the Search Filter to create Smart Collections of multiple keywords. Create a Smart Collection, and from the + pop-up menu, select **Keywords**. All the keywords you've applied will appear. With the checkbox, you can choose **Uncheck All** and then check on the ones you want.

> **NOTE**
>
> ***Spanned Searches:*** You can search multiple events at one time if you want by selecting all of them, but you can make a Smart Collection for only a single event. The Smart Collection has to be in one event and cannot bridge multiple events.

CUSTOM METADATA
Compound Clips and Auditions

Compound Clips and Auditions are some advanced tools, which we'll look at in later situations, but FCP users have found them useful as organizational tools, so I've included them here as well. In the browser, even in Filmstrip view, it's difficult to play through your media because it stops at every clip. You can use the apostrophe (') key to jump to the next clip in Filmstrip view and start playback again, or you can use the **Down arrow** key to go down through the clips in List view to start playing that clip. But wouldn't it be great to group a bunch of clips together into the Timeline and just sit back and look through them? This is what Compound Clips can do. Here's how:

1. Select all the clips the *Roasting*.
2. Right-click on one with all of them selected and choose **New Compound Clip** or press **Option-G**.
3. Name the event *RoastingClips*.
4. Double-click the Compound Clips icon to open it into the Timeline.
5. Press **Shift-Command-F** for full screen and sit back and watch your video play.

This is actually a separate sequence inside your event that you can edit into as if it were a project. You can add music and titles and effects. You can also cut and paste from it into a project. You can place the entire Compound Clip into a project if you wish.

Auditions are similar but different. They allow you to combine multiple clips into a container from which you can select the clip you want to view and use. When you edit the Audition into the Timeline, all the clips go together, and in the Timeline, you can switch between them. We'll look at working with Auditions in the Timeline in the next chapter, but let's look at creating them here:

1. In the *Roasting* event, **Command**-click to select three clips: *cooling, different roasts,* and *sampling.*
2. To make the Audition, you can either right-click on the clips to select **Create Audition** from the shortcut menu (**Command-Y**). A new item will appear in the browser with a Spotlight icon, which can also be seen as a badge in the upper-left corner of the preview.
3. Either in List view or Filmstrip view, click the badge in the upper-left corner of the preview to open the Audition container (see Figure 3.29).

You can switch between the Audition clips in the container by clicking on the clip you want, and the preview will update. You can also move between the items using the **Left** and **Right** arrows. To close the Audition, you can click **Done**

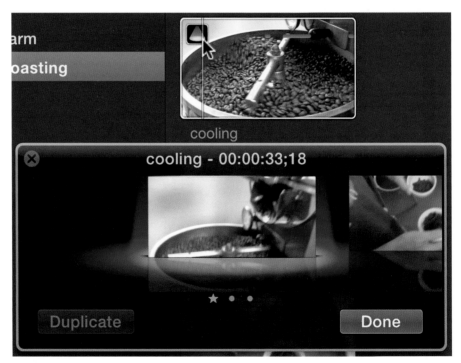

FIGURE 3.29
Audition in the browser.

or press the **Y** key. The **Y** key will also open the Audition if you have it selected in the Browser. The Audition is a complete unit, separate from all the clips, and contains the clips you want in it. This is a handy way to group clips together, which can be edited and switched as you like. It's a great tool for prevaricators or those suffering from a serious case of indecision.

You can edit the Audition into the Timeline, where you can continue to switch between items. Once the Audition is in the Timeline, more clips can be added to it, or clips can be removed from it.

SUMMARY

In this chapter, we looked at the importance of organizing our material. We looked at naming our clips and deleting clips. We created keywords, made Keyword Collections, made Favorites, and organized our event in collections and folders. We used the search filter to make Smart Collections. We also looked at Smart Collections created by analysis. We even worked with some advanced editing tools, Compound Clips and Auditions, and used them for grouping and organizing our media. In the next chapter, we will look at putting our shots together in a sequence.

CHAPTER 4
Editing

Now that you've organized your material in the Final Cut Pro Event Browser, it's time to edit your clips into the Timeline to assemble your project. FCP has several different ways to perform most of the editing functions. You can edit directly into your project Timeline with the mouse or with keyboard shortcuts, which is probably the most efficient way to edit in most instances.

LOADING THE MEDIA

If you skipped directly to this chapter, first you must download the tutorial material from www.fcpxbook.com website. For this chapter, we'll need the ZIP files called *BB3.zip* and the *BB4.zip*. Proceed like this:

1. Download the first ZIP file and then double-click it to unzip the *BB3* library to start.
2. Double-click the library to launch FCP.
3. You can close any other open libraries.

The media files that accompany this book are heavily compressed H.264 files. Playing back this media requires a fast computer. If you have difficulty playing back the media, you should transcode it to proxy media:

1. To convert all the media, select the event in the Event Library, right-click on it, and choose **Transcode Media**.
2. In the dialog that appears, check on **Create proxy media**.
3. Next, you have to switch to proxy playback. You do this with the light switch popup in the upper right of the Viewer. Be warned: If you have not created the proxy media, all the files will appear as offline. In this case, you will probably have to switch back to **Optimized/Original** for your other libraries.

LOOK BEFORE YOU CUT

Whether you work your video into selections with keywords or with favorites, you're really looking through your material. You should watch for relationships—shots that can easily be cut together. Getting familiar with the material is an

important part of the editing process, learning what you have to work with and looking for cutting points.

Look through the shots in the *BB3* Browser. While skimming through the shots is great for quickly seeing your material and while you're organizing, it's not really a good way to view your video, which should be done while viewing in real time. You really need to play your video to see it continuously and to get the natural pacing of events, how long does it take him to cross the room, and how quickly does she do that action. You can look at your shots sequentially in Filmstrip view or in List view. By default in Filmstrip view, the Action popup (the gear in the left end of the Toolbar) is set to **Sort By>Content Created** (see Figure 4.1), which is the order in which the material was shot not in name order. Similarly, in List view, **Group Clips** is set to **None**, which means the clips will normally appear in shot order. To make sure they are in order in which they were shot, scroll to the right to the Content Created column and click on the header. In documentary type work, this is often beneficial. With scripted work as we'll see later, this usually isn't of much real value and it helps to set the shots of name order by clicking on the Name column header in List view or in Filmstrip view by setting **Sort By** to **Name**.

FIGURE 4.1
Sort by>Content created.

The real problem is that most editors like to look at the media continuously rather than by looking at one shot, and then another shot, and then another shot. There are two ways to view your clips continuously, as if you're sitting back and watching a reel of rushes. One is to put the clips in a project and the other is to put the clips in a Compound Clip. I don't think one way is essentially better than another, though loading up a library with a lot of long projects can slow

down the launch process. Personally I prefer to use Compound Clips for this. I will never be putting these compounds in a project. This is purely for viewing purposes. Here's the simplest way to do this:

1. With the Browser in Filmstrip view or List view, set to show the clips in Content Created order, select them all.
2. Press **Option-G** and name the compound something like **_Clips**. I use the leading underscore so that when the clips are in Name order, the compound will be at the top of list.
3. Double-click the compound to open it into the Timeline.
4. Press **Shift-Command-F** to start playing the sequence of clips in full screen.

Don't do anything just watch and let the video effect you. How was that move? That's a nice shot. That doesn't work. That's better. Often a cameraperson will shoot a whole sequence without shutting off the camera, simply moving around the subject. These sections are often worth repeating immediately and looking at again, particularly to look for relationships within the shot, what can be cut together, what's the key action, what are the cutaways. Typical of the type of shot is the two-and-a-half-minute clip called *cutting meat*. There are close-ups of the meat being cut. There are close-ups of the butcher while he works, head down, concentrating on where he's slicing. You don't see what he's cutting, you see him—the perfect cutaway, a bridge in time and space. There are wider shots that show him behind the counter and set his space. There are even shots of people watching him work, meat being weighed, a knife being sharpened.

Once you've watched the raw footage, it's time to start marking it up and making selects. You could go back to the Browser and start marking up the shots there, but you can switch back and forth so you get the best of both, making selections in the Browser, while viewing continuously in the Timeline. Let's do that:

1. Play the first clip in the Timeline, *cheese*, and pause just after the pan to the left begins and then back up a little before it.
2. Press **Shift-F**, which takes you to the Browser with the clip, select and the playhead in the same position as it is on the clip in the Timeline.
3. Press **I** to make a selection and play till the pan left end and press **O**.
4. Press **F** to mark a favorite or use **Command-K** to create a Keyword Collection.
5. Press **Command-2** to switch back to the Timeline and continue playing.
6. On the third shot, *dried tomatoes*, shortly after the shot starts switch back to the Browser with **Shift-F**. Pressing the shortcut not only switches back to the Browser but also pauses playback.
7. Mark an In point and play the clip for a few seconds and mark an Out.
8. Continuing playing in the Browser, using **JKL** to rock and roll the shot.
9. Just after the woman says "Buon giorno," there's a quick push in. Use **Shift-Command-I** to mark a new In point.
10. Play forward and press **Shift-Command-O** after she clears the frame.

11. Press **F** to mark the selection.

12. Use **Command-2** to return to the Timeline and the down arrow to skip to the next shot.

That's the basic procedure. This is just one of many different ways of looking at your material and marking it up. The flow of continuous playback in context can be very useful.

Take a look at the last three video shots, *man standing at counter, man handed bag,* and *ls woman getting sample*. The same man is in the first two shots. A woman crosses through the second shot, and then she appears in the third shot. These shots can be obviously cut together to make a little sequence. Sometimes you might need a cutaway to bridge an edit where the shot change would occur, such as if you cut out a section in the middle of one of the shots.

Searching for these relationships between shots is critical as you look through your material. Some editors like to immediately create small sequences and group them together, not finely honed but roughly laid out, so that first important impression is preserved. We can do this right inside the *_Clips* compound. You may not use it in your project, but assembling related shots quickly into a sequence is an efficient way to make notes about your material.

> **NOTE**
>
> *The Cutaway:* Any editor will tell you that cutaways are the most useful shots. You can never have too many, and you never seem to have enough. No self-respecting editor will ever complain that you have shot too many cutaways. A cutaway shot shows a subsidiary action or reaction that you can use to bridge an edit, like the shot of the interviewer nodding in response to an answer. The cutaway allows you to bridge a portion of the interviewee's answer where the person has stumbled over the words or has digressed into something pointless. A wide shot that shows the whole scene can often be used as a cutaway. Make note of these useful shots as you're watching your material.

DYNAMIC EDITING

There are basically two types of editing, usually called Dynamic or Montage Editing and Continuity Editing.

Montage is usually seen in documentaries and music videos. Here, shots are usually not edited to appear continuous, but edited for impact, to contrast each other, to juxtapose shots. The editing is often based primarily on rhythm rather than content, on light and dark, rather than a balanced continuity of light and color. Montage is often a collection of shots used to set the atmosphere of a location and to give a quick introduction to a scene. The most cli-chéd use is in every TV show at the beginning of a scene in a nightclub. In this

chapter, we'll work with something a little more prosaic but equally important for the scene.

Once you've looked through your material, you can start to assemble it. For documentary style editing, there is a push and pull between the pictures and the words. You can, in some instances, simply write the script and then shoot the script. Though it's not really narrative, it can be much closer in terms of how to edit. Basically here the words come first and lead the picture. You edit the sound, essentially radio, and then lay the pictures to the narration. This works well for many controlled productions. However, for most documentary work, the process is a back and forth between narration, between words, and pictures.

The library *BB3* may be part of program about artists in Florence. One of scenes to depict everyday life is a scene about shopping in the central market. The original script might include a narration that talks about fresh fruit and rows of meat on display. You could record this narration and lay it down, but unfortunately there were no fresh fruit or cuts of meat on display at the market that day. So now the pictures take command over the words. You know from the context of the script, approximately how long the sequence is intended to be. This is not a central part of your story, at least not as planned, just an aside, a brief intervention of reality in a world of art theory and abstract painting. Now the editor has to lay out a rough cut of the best pictures available, so the script can be written to dried tomatoes, fresh fish, provolone and gorgonzola, prosciutto, and lean filets. Once the script is written, the shots can be re-arranged and trimmed as needed, so that they are precisely cut to the cadence and pace of the narrator. The rough cut for the sequence is laid out inside a project or inside the compound clip. There are of course an almost infinite number of variables and tempo for this. I've laid out one in the *Projects* event called *Rough*. The shots are almost all longer than would need to be, but generally it's easier to cut away than to add. If a shot seems too short, it's often because that's all the media there is available for that framing of the shot. This is a crucial step in the editing process, perhaps the most essential, because you're selecting the shots you want to use. These shots, these selections that the cameraperson originally made in the Florence market, and these frames show what we want to say about this place and time. Something in this selection will appear in the final project (unless the whole scene is deleted of course, as is often the case). The sequencing of shots might not be their final arrangement, but the choices made, and the choice of sequence, the order of the shots, will very often largely dictate the course of the narration for this scene. You make the selection, and the script and its narration get written to those choices and then you trim the choices for pace based on the narrator's cadence.

Creating the rough cut that you see in *Rough* is pretty basic and straightforward by making selects in the Browser and editing the shots into the Timeline. You can however do this type of rough cut entirely in the Timeline by cutting away unwanted material and rearranging what you want. To facilitate this, the *Projects*

event has a project called *Raw* that contains the market clips in content created order. Begin by opening the *Raw* project into the Timeline.

1. On the first shot, *cheese*, mark In and Out points from just before the pan left begins till just after the pan ends and then press **Option-** (backslash) to top and tail the shot, which should be about four seconds.
2. Pick about a three-and-a-half-second section in the middle of the next shot, *fresh tomatoes*, and top and tail it using **Option-**.
3. Play about a second into the next shot, *dried tomatoes*, pause, and use **Option-[** (left bracket) to cut away the beginning of the shot. It's a little disconcerting that the front of the Timeline moves toward you, but don't worry about that.
4. Play a few seconds into the shot and mark an In point. This marks the beginning of a section that we want to cut out.
5. Play down to the moment just after a quick push to the bottles on display. Mark the Out point while the woman's hands are still on the bottle and press the **Delete** key to edit out the middle section of the shot.
6. Play a little further and pause shortly after the woman walks out of the shot and use **Option-]** (right bracket) to tail the shot and cut off the end.
7. Top and tail the next shot by pressing **I** shortly after it starts and pressing **O** a couple or three seconds later while the shot is still wide, and press **Option-** to top and tail it.

I'm not sure if all of these shots will get used, but it's good idea to clean them up and trim them to rough length during the first pass. The opening five shots might look something like Figure 4.2.

> **NOTE**
>
> ***Top and Tail:*** Terminology varies enormously in editing from place to place and country to country. A commonly used phrase is to *top and tail* a shot, to cut off some of the beginning and some of the end of the shot. This is often done for no other reason than that it ensures available media for transitions. To *top* a shot is to cut off the beginning of a shot, and to *tail* a shot is to cut off the end.

FIGURE 4.2
First five shots.

The next shot, *cutting meat*, is two and a half minutes and is a sequence unto itself. There is no right way to cut these types of shots. You just have to select what appeals to you and what you think is interesting. As always, though you

may put a lot of effort into it, you should be aware that chances are pretty good that sequence you love or that shot you think really must be in the program, may well end up on the digital cutting room floor. Here's one cut:

1. We'll top the shot, but first let's define where the first shot ends. To make this easier, activate clipping skimming with **Option-Command-S**. The clip skimmer allows you to see the timecode of the shot itself in the Dashboard while you're skimming over the shot (see Figure 4.3).
2. Move the clip skimmer to about 20:14 in the shot and mark an In point where there butcher's lips are pursed in concentration.
3. Play through the title down to a beat before the knife flicks out to about 25:24 in the shot, mark an Out, and delete the selection.
4. Let's top the first shot. Skim to about 16:02 in the first segment while the meat is in close-up and before the camera tilts up. Use **Option-[** to trim off the beginning of the shot.

FIGURE 4.3
Clip skimmer.

5. In what's now the second part of the shot, mark an In around 28:24 while still on the close-up on the meat and an Out around 31:29 when the shot is wide. Press **Delete** to remove the middle section.

6. Skim down to clip timecode 34:21 and use **Command-B** to blade the clip, which will leave about a two-and-a-half-second segment of the wide shot.

7. Around 40:28 when you're back into the tight close-up of the carve, use **Command-B** again to blade the clip, and selecting the middle section of the through edits, delete it.

8. Either mark an In point or blade the clip around 44:24 before the camera goes wild and go all the way to around 56:04 when the camera as settled on the close-up of the customer watching. Delete the section between 44:24 and 56:04 with your preferred method.

9. Put a cut before the camera pulls away from the customer around 58:29, and be sure to say a thank you to the cameraperson for providing an excellent and useful cutaway.

10. With the cutaway isolated, skim all the way down to about 1:21:00 to where the meat is on the scale and use **Option-[** to top the shot and then blade it around 1:23:17 before the camera moves away.

11. Make the next cut around 1:43:06 while the camera is on the butcher, deleting everything between 1:23:17 and 1:43:06.

12. For the final cut, go down to 1:46:14 just after the butcher flips a piece of meat onto the scale and use **Option-]** to take off the remaining tail of the shot.

You should have a total of seven shots totaling about 22 or 23 seconds. The filmstrip in the Timeline might look something like Figure 4.4.

1. From the next shot, *cleaning fish*, cut three segments each about three seconds long, first a close-up of cutting the seafood, the second a close-up cutaway of the fishmonger, and the third a wide shot that shows the sink and man at work.

2. The next shot, *ls cleaning fish*, is a static shot from behind the display case, and though a little dark can easily be fixed. Top and tail with **Option-** to save about a five-second segment from the middle.

3. Leave the *cu ham* shot as use the Range Selection tool (**R**) to drag about a five-second segment in *ms ham* and then press **Option-** top and tail it.

4. Do the same with the Range Selection tool for the *prosciutto* shot and then cut off the end of the *prosciutto samples* shot leaving about five seconds of the close portion of the shot before the pulls back.

FIGURE 4.4
Cutting meat shots.

This brings us to the last three shots in the market scene, *man standing at counter, man handed bag,* and *ls woman getting sample.* It has the potential for a short little sequence of shots that well together. To begin we'll cut the first two shots and move them to the beginning of the Timeline.

1. Drag select or **Command**-click to select *man standing at counter* and *man handed bag* and cut them with **Command-X**.
2. Use the **Home** key on an extended keyboard or **fn-left arrow** on a short keyboard to put the playback back to the beginning of the Timeline and press **Command-V** to paste the shots back into the project. Of course FCP always does a paste insert edit when pasting with **Command-V**.
3. Press the **Z** key and drag a selection area around the two shots to fill the Timeline with the two clips.
4. Return to the Select tool (**A**), and using the clip skimmer, go to about 3:10 and mark an In point with the Out around 9:15. Then use **Option-** to lop off the beginning and end.
5. In the *man handed bag* shot, mark an In around 2:10 while the camera is on the man's hands and the Out around 16:00 as he turns from the display case. Top and tail that.

The pull back from the tight shot to reveal the woman works, but the exposure change is ugly. To help this, we'll use a couple of cutaways to bridge the middle part of the shot.

1. Play through the shot till just before the iris opens around 5:15 and press the **M** key to add a marker.
2. Press **Control-P** and type +3. (that's plus three period) and then press **Enter**. Use the **M** key to add another marker.
3. Go down near the end of the sequence, find the *prosciutto samples* shot and cut it out using **Command-X**.
4. Go back to the first marker. (You can use **Control-;** twice.) With the playhead positioned, press **Option-V** to paste as Connected Clip.
5. Trim the end of the connected clip so it snaps to the second marker.
6. Just a few shots farther in the Timeline, find the second of the *dried tomatoes* shots of the woman with the bottles and cut it from the sequence.
7. Go back to the second marker at the end of the first connected clip and use **Option-V** again to paste the shot as a connected clip.
8. You could leave the two connected shots where they are or you could select them both and use **Option-Command-down arrow** to overwrite them into the primary storyline.

The shots should look something like Figure 4.5. You can discard a few shots and fix the last shot and rearrange however you like. To finish off, let's:

1. Discard a few of the shots from the sequence, maybe the *fresh tomatoes* shot, the *cleaning fish from behind* shot, and a couple of the ham shots.
2. Trim off a couple of seconds from the beginning of the last shot, *ls woman getting sample.*

FIGURE 4.5
Opening shots.

3. Split the shot about four seconds later so you have a wide shot from behind the woman.
4. Split the shot again around 16:00 just as she's taking off her glasses and discard the middle portion.
5. Let the camera pan to the counter and trim off the end of the shot.

That's one possible cut out of millions for this sequence of shots. The pacing and selection and arrangement of shots will be determined by the context in which the shots are used, but don't forget the first purpose of the editor. Early in his career, Hitchcock was asked what he did, and he replied he was a film editor. To which the response was: "Oh, you cut out the bad bits." Your first decisions are about cutting out the bad bits.

Sidebar

SECONDARY STORYLINES

Because FCP no longer has tracks in the sense of more traditional NLEs, there are those who recommend using secondary storylines as a way to create tracks that will make the application behave and appear like legacy software. Although there's nothing wrong with this technique inherently, I personally don't recommend it as a way of working with the application.

However, I do think secondary storylines are a great way to group together sections of connected clips that are all related or are all connected to a specific section of a project. They're especially useful as a tool for adding cutaways to an interview that was shot with a single camera that appears as if shot with multiple cameras. They're also useful when overlaying B-roll related to a section of a narration or interview that's been collapsed

into a Compound Clip. The great thing about editing in secondaries is that they behave exactly like the primary, with all the same editing tools and magnetism. The only tool that's missing is the Precision Editor.

One way to work with secondaries after you've connected your first clip is to convert it to secondary. As soon as you've done that, you can add to it at any time, using it as a container to group of related clips, perhaps cutaways or B-roll, all linked at a single point in the Timeline. To add to it, you select the secondary storyline's shelf, and then when you use **W**, **E**, or **D**, the edits go into the secondary. To add to the secondary further down the Timeline, you use Overwrite (**D**). The clip will be added into the secondary, and the intervening space filled with a transparent Gap Clip.

CONTINUITY EDITING

Continuity editing is generally a scripted material and is very different from dynamic editing regardless of whether it's pure fiction or dramatization of real events. As the editor, you are constrained by the script and by the performances.

You have a great deal of latitude, but you also have a substantial duty to remain true to the intent of the script and true to the performances you were given. Yes, you could cut up and even speed up or slow down a performance, and re-edit the script, but you really need to be restrained by bounds of remaining honest and true to the actors' performances and the script.

Continuity editing is largely the way Hollywood movies and serial television are edited. This type of editing is designed to move the story forward as smoothly and unobtrusively as possible. Continuity editing is designed to be invisible, while dynamic editing is designed to be apparent, often juxtaposing shots that are apparently incongruous, but combine in the viewer's mind to make a point or have an effect. Generally continuity editing is used where scenes are shot from multiple angles, either by repeating the same action and dialog or with multiple cameras shooting simultaneously. This technique is used to create a continuity of time and space. Continuity editing is generally more demanding and makes greater requirement for everything in postproduction, from the editor to match action and eyelines through the audio editor and the colorist to match sound and color. The advantages of continuity editing for the viewer of course is that the scene and the story are clear, that the action moves along smoothly, that it's easier to suspend disbelief, and easier to keep track of characters. Generally cutting is done on action, during movements to disguise the edit and to make the flow as seamless as possible.

For this section, you'll need to download the *BB4.zip* file and open the *BB4* library.

The library contains one event called *couch scene*. The scene is from my friend Steve Oakley's short *A Great Life*, which I urge you to watch the whole movie on YouTube (www.youtube.com/watch?v=ngY7iGbVI-A). Steve created it; he wrote, directed, shot, edited, and color enhanced it. It stars Michael Denks and Kathy Beringer as the couple, and it's a beautiful crafted and touching piece of work, with wonderful performances. The material here is a short scene where the couple are sharing memories of the 80s. The project was shot on the Canon C100 at 1920×1080 and the sound recorded on the Sound Devices SD522 mixer. I used FCP's sync sound function to marry the video and audio and exported the clips from a 1280×720 project in the ProRes Proxy codec to reduce the file size. Though the media files are in the ProRes Proxy codec, do not set playback to Proxy as the file are created and imported as proxies, not proxies generated in FCP in the Transcoded Media folder of the library.

Start by looking through the clips in the *couch scene* event. There are two master shots, three close-ups of Kathy, and over the shoulder of Michael, three close-ups of Michael, and two cutaways of the photo album. The tradition for this type of scene is to start wide to establish the setting and then to move into closer shots, first medium shots, and then into close-ups as the scene develops and for the climax of the scene. Traditionally, once you move into close-ups, you don't come back out, unless the topic changes. In this short scene, there is only a single topic, old memories, and the photo album. The scene ends by leading the

audience toward the dinner, which comes up shortly afterward. Though there is an intervening scene where Michael is on the deck of the cabin, the next dialog is in the dinner.

To make it easier to work with the material, you might want to break the clips down into keyword collections, *masters*, *kathy*, *michael*, and *cutaways* or any other scheme of collections that you prefer.

Overwriting the Master Shot

In this scene, because the master shot doesn't show what the couple are looking at, though it's pretty obvious, it might be a good idea to actually start with one of the cutaways of the photo album, which is the way the scene is edited in the finished movie. There are any number of different ways to edit the scene in terms of shot selection, let's look at a couple of different techniques for assembling the scene.

1. To start let's make a new project using **Command-N**. Name the project *couch scene* leaving the default settings and save it in the event.
2. Next play *0025* and mark an In at 2:09:03 and an Out at 2:57:07. This is the first of the master shots.
3. Next go to *0026* and start a selection at 3:00:03 and end it at 3:45:11.
4. Select the two clips and press **Command-Y** to create an Audition.
5. Press the **Y** key to open the Audition and try the clips leaving *0026* as the selected clip.
6. Edit it into the *couch scene* project using the E key to do an Append edit.
7. Around three seconds into the project, mark an In point on the primary storyline and an Out at about five seconds, just after Kathy exclaims.
8. In the Browser, go to the tighter cutaway *0033* and mark an Out point at 8:09:19, just before Kathy's fingers come into the shot. You don't need an In as the clip will take it's duration from the selection in the Timeline.
9. Press **Shift-2** to do a video only edit.
10. Press **Shift-Q** to edit the shot as a Connected Clip. This will backtime the shot into the project, so that it ends just after Kathy's fingers leave the frame.

TIP

Going to a Place in the Video: To go to specific frame of video, either click the timecode display in the Dashboard or press **Control-P** for playhead and type in the number you want, such *2606* and press **Enter**. You don't need to type in the colon or semicolon.

Though there is also an Overwrite edit function in FCP, it is not as widely used in X as in legacy versions. An Overwrite edit is one in which the video will punch into the storyline overwriting what's already there, cutting it out for the duration

of the new shot. There is no button for the Overwrite edit, and you cannot Overwrite by dragging into the Timeline with the Selection tool, but you can use the menus or a keyboard shortcut.

After you've put in the first master shot and connected the cutaway, we get to add the first close-up. Because you've gone into scene with the cutaway, you can now go into the close-ups of the actors. Let's go in for Kathy's close-up in *0027*.

1. Make a selection beginning about 3:53:00 where Kathy says, "Look at that" and go through Michael's line until 3:58:18 after she says, "… we were cool."
2. Make sure that a video and audio edit is selected by pressing **Shift-1**.
3. To edit the shot into the Timeline, use the **D** key to do an Overwrite edit.
4. Next you might select *0030a*, the shot of Michael where he says, "That's OK. Cute." Start at about 6:29:06 and end at about 6:33:15.
5. Again use the **D** key to overwrite into the Timeline. The opening of the project might look something like Figure 4.6.

If you play forward from that point, you'll see that the timing isn't bad. The pacing of the close-ups and the master shot is pretty close, though you might want to trim it a little. We'll go back to the master shot for the next few lines of dialog.

1. Play the master *0026* to try it.
2. Press the **Y** key to open the Audition HUD and use the left or right arrow keys to switch to the other clip *0025*.
3. With *0026* in the Timeline until just **before** Michael says, "It was OK," and mark an Out point.
4. Press the **Delete** key to wipe out the repeated section of the scene.

FIGURE 4.6
Opening of project.

5. Let the master play until after Kathy says, "It was warm." Wait a beat and leave the playhead positioned in the Timeline.
6. Go back to *0030a* shot and mark an In about 6:43:19 just before Michael looks up and asks about food and end it at 6:47:08.
7. Overwrite that in the Timeline with **D**.
8. Next we'll go back to Kathy for a close-up of her response. In *0028b* start about 5:20:08 till just after she takes off her glasses at 5:23:16. Overwrite that.
9. Move the playhead over the previous close-up of Michael and press **Shift-F** to take you back to the Browser and same shot.
10. Play through Kathy's line and then mark In and Out around Michael's line, "How about my favorite?" Overwrite that into the Timeline after the Kathy close-up.
11. Next cut in the close-up of Kathy from *0028b* where she says, "Absolutely. I've got that." Wait for her to clear the frame as she stands before cutting the shot.
12. In the master shot in the Timeline trim of the beginning where Kathy is standing so the shot starts just as Michael says, "Ah, wouldn't you like some help?"

By continuously cutting into the master shot with the Overwrite edit function, you're keeping the pacing of the master close to the pacing used in the close-ups. This allows you to cut back to the master shot at any point if you need to. This is helped enormously by having experienced actors like Michael Denks and Kathy Beringer, who will perform the same scene with very similar timing every time they do, making the editor's job substantially easier.

Two things you might want to do: At the end, connect on the close-up of Michael from *0031* as Kathy walks by in the background, keeping the underlying sound. The second edit you should do is to add over the master shot *0025* in the middle of the project a connected cutaway, again without sound, of the photo album either *0032* or *0033* that shows the picture of the football game. The end of the Timeline might look something like Figure 4.7.

FIGURE 4.7
End of project.

Appending Close-ups

Another way to assemble the scene is to work with close-ups with perhaps one master in the middle where there are no close-ups for the dialogue.

This technique is very commonly used to make the first assembly of a scene, basically editing in the shots sequentially, one shot for each actor's line of dialog.

1. Begin by selecting the *couch scene* project in the Browser and pressing **Command-D** to make a duplicate. Name the duplicate *couch scene master*. In this instance, there is no difference between making a duplicate and a snapshot because there are no Compound Clips.
2. Select everything in the Timeline and delete.

You could have made a new project but why have more than one project open in the Timeline when you don't need to. At the time of this writing, there is no function to close an open project, or all open projects, other than by closing the application. When the application is reopened, only the last previously open application opens; no other previously open projects appear, which can be a bit of pain. So with an empty project, let's begin by editing in the clips in a sequential order. A list of the principal FCP editing shortcuts can be found in Table 4.1.

1. Start with the cutaway *0032*, the wider shot, and make a selection beginning around 7:50:11 before the page turns and ending around three seconds later. You can probably mark the In and Out on the fly.
2. Press **Shift-2** to make sure a video only edit is selected and press E to Append into the Timeline. In fact **E** is the only shortcut we'll use to edit shots into this project.
3. Go to shot *0030a* and mark an In at 6:23:14 and an Out just after Michael says his line "Look at your hair."

Table 4.1 Principal FCP Edit Shortcuts	
Edits	**Shortcut**
Connect	Q
Insert	W
Append	E
Overwrite	D
All (Video and Audio Edit)	Shift-1
Video Only Edit	Shift-2
Audio Only Edit	Shift-3
Backtime Connect	Shift-Q
Backtime Insert	Shift-W
Backtime Append	Shift-E
Backtime Overwrite	Shift-D
Replace	Shift-R
Replace from Start	Option-R

4. Press **Shift-1** to activate video and audio edits and then press E.

5. In the Kathy shot *0028b*, mark an In just before Kathy says, "Hmmm," while Michael is still looking at her. Make the out just after her line, "We were cool." Edit that into the Timeline.

6. Next we'll use *0030a* and mark an In about 6:29:03, before he says, "That's OK," and an Out after he says "Cute" and turns back to the photo album, around 6:33:22. Edit that shot.

7. Go to the master shots for the next section. Using *0025*, mark an In at about 2:19:12, just before Michael flips the page, and an Out just after Kathy says, "It was warm," around 2:31:18. Edit that shot in.

8. Because we cut off right after Kathy's line in the previous shot, let's leave a beat on Michael's shot before he brings up dinner. In *0030a*, put an In around 6:43:19 and an Out after "… we make some food," at 6:47:08. Append that shot.

9. Let's go to Kathy's close-up *0028b* and mark In and Out points around her line, "Oh sure. What are you hungry for," wait for her to take off her glasses around 5:23:20. Append that.

10. Put the playhead over the previous close-up of Michael and press **Shift-F**. The selection is on the clip in the Browser so press **Shift-O** to go to the end of the clip. Play through Kathy's off-camera line and mark the In just after it finishes so you give Michael time to think, and put the Out after his line about 6:51:23. Append that.

11. Back to Kathy's close-up and mark In and Out points around her line, "Absolutely. I've got that," waiting for her to stand and clear the frame.

12. Take one more line from Michael in the master shot *0026* beginning at 3:38:15 and an Out at the end of the shot after Kathy has cleared the frame.

Your sequence might look something like Figure 4.8. You can add in the connected cutaway over the master shot in the middle of scene and the closing close-up of Michael as Kathy walks past the couch behind him.

This is the scene essentially cut for audio, the edit in its most pedestrian form. What makes a scene interesting is the timing of the edits, basically how the video and audio overlaps, and how we sometimes see the person who isn't talking rather than the speaker. There is absolutely no right way to edit this scene, but the way we just did it is perhaps the weakest, but it is the most common starting point for editing the scene. Pick the best takes of the best lines and edit them, one after the other, so you have the sense and pace of the dialog and the scene, and then go back and fix it.

Figure 4.8
Edited project.

> **TIP**
>
> ***Marking Edit Points:*** Many editors like to mark their Out points on the fly. This allows you to judge the pace of the shot and the sequence—doing it in an almost tactile way —to feel the rhythm of the shot. After a few tries, you'll probably find that you're hitting the Out point consistently on the same frame. Marking the In point is a little different because often you want to mark the edit point before an action begins, but judging how far in front of the action to begin on the fly is difficult. Many editors like to mark the In point while the video is playing backward. By playing it backward, you see where the action begins, and you get to judge the pace of how far before the action you want the edit to occur.

TRIMMING

I think *A Great Life* is primarily Michael's story, which is why the scene closes out with the close-up of Michael. The way the scene is currently edited, back and forth between the two characters, the scene is evenly weighted. To shift the emphasis to Michael, we need to overlap the video and audio, so that they are not cut in line, especially toward the end of the scene. This is one interpretation of the scene, and I'll show you one possible cut out of the many that you could do. At the moment, the scene is cut for audio, so we are going to leave that largely unchanged. What we'll do is to edit the picture so that the emphasis changes and Michael is more prominent. We do this by overlapping Kathy's words over Michael's picture. But first we'll put some audio underneath the opening close-up.

1. Begin by making a snapshot of the project by pressing **Shift-Command-D**, which will preserve the project with a time stamp so you can go back to it at any time.
2. Next we'll expand the video and audio. You can do this from the **View** menu **Expand Audio/Video Clips>For All**. There is no keyboard shortcut for this, but you could make one, maybe **Control-Option-S**, as **Control-S** expands a single clip (see Figure 4.9).
3. At the beginning rather than seeing Michael, we'll hear his voice underneath the photo album. Select the first *0030a* and use **Shift-Control-S** to Detach Audio.

Generally, it's a good idea to avoid the Detach Audio function and to as often as possible use the Expand Video/Audio function for most of your editing. In this instance, though it's useful, as we're not going to use the picture anyway.

Figure 4.9
Expanded opening of project.

1. Slide the audio underneath the photo album cutaway and then delete the *0030a* shot, letting the magnetic Timeline close the gap.
2. Then ripple the video as Kathy says, "Hmmm," so that slides underneath the photo album as well (see Figure 4.10).

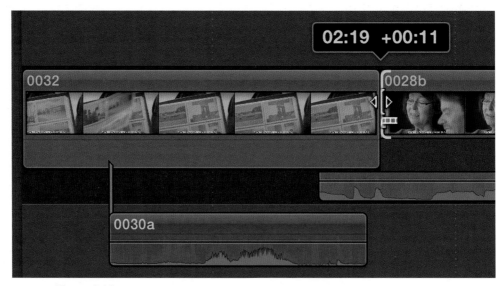

Figure 4.10
Opening edits.

Trim whatever else you feel needs tightening up, and then we'll work on the shots near the end. After the master shot of Kathy and Michael sitting side by side, there are two pairs of *0030a* and *0028b* back to back. Let's trim these so that Kathy's sound overlaps Michael's picture. We'll do that in the Precision Editor.

1. If you simply open the edit with the Precision Editor, you will trim the video and the audio together. Because we just want to edit the video portion, activate the Trim tool with the **T** key.
2. Select the video portion of the first edit after the master between the shot of Michael *0030a* and the shot of Kathy *0028b* with the Trim tool, and open the Precision Editor either from the **Clip** menu or by using **Control-E** or simply by double-clicking on the edit point (see Figure 4.11).
3. Put the skimmer over the shot of Michael and play the video. This plays the video of *0030a* beyond the edit point.
4. Now place the skimmer over the shot of Kathy underneath Michael and play that, which plays the video of Kathy outside of the edit.
5. Finally, put the skimmer on the black bar separating the two layers and play. Now you are playing the edit as it appears in the project.
6. Click the button on the black bar to select both edit points in a roll edit (see Figure 4.12).

7. With the skimmer over the black separator bar, play the edit until just as Kathy finishes saying, "Oh sure."
8. Press **Shift-X** to extend the edit, rolling it to the playhead. The edit must be executed with the keyboard shortcut, or it will not work.

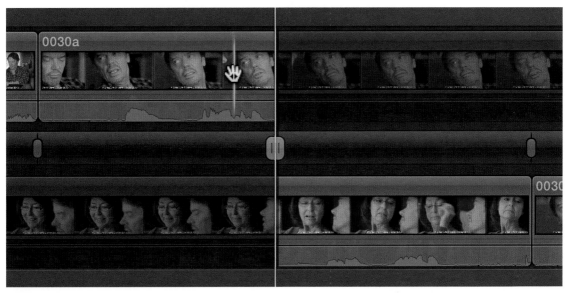

Figure 4.11
Precision Editor.

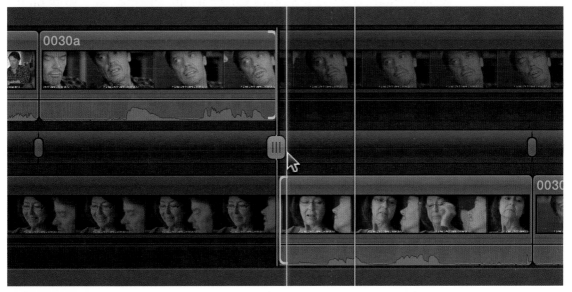

Figure 4.12
Roll edit in the Precision Editor.

You could just use the **Down arrow** key to skip down to the next edit or use the **apostrophe** key, but first close the Precision Editor with the **Escape** key to see what has happened. Because only the video portion was selected, the video has been rolled creating a split edit (see Figure 4.13). This has shortened the shot of Kathy, letting the audience see Michael longer. I should point out that at this time the Precision Editor is behaving quite erratically.

Let's do the same again for the next pair, skipping the edit of the cut from Kathy back to Michael, go down to the edit between Michael's *0030a* and Kathy's *0028b*. We could, with the Trim tool active, double-click on the video edit to use the Precision Editor again, but this time, let's do the edit right in the Timeline.

1. With the Trim tool still active, click on the video edit only to select it in Roll edit mode.
2. Play the edit until just after Kathy says, "Absolutely."
3. Press **Shift-X** to roll the edit to the playhead.

The group of edits with the split audio will look something like Figure 4.14, which brings us back to the master shot as Kathy walks from the room.

That's our edit of this scene of shared memories between the couple. You can cut it in a variety of ways, but here's one take on it. I urge you to look at the whole video on YouTube. It's a wonderful short movie.

Figure 4.13
Split edit in the timeline.

Figure 4.14
Closing shots in the scene.

SUMMARY

In this chapter, you looked at editing different types of videos, documentary montages, and scripted, narrative fictions. We used the trim functions to top and tail shots. We did Connect edits, Overwrite edits, and Append edits. We used the Audition function to put multiple takes in the Timeline, and we used the Precision Editor to create split edits as well as making them simply in the Timeline. In the next chapter, we'll look at working with audio.

CHAPTER 5
Working with Audio

Film and video are primarily visual media. Oddly enough, though, the moment an edit occurs is often driven as much by the sound as by the picture. How many times have you heard a sound and turned to look in that direction? This is essentially the behavior that drives much of film editing, whether the obvious dialog following in narrative fiction or the natural sound editing of documentary. So let's look at working with sound in Final Cut Pro. How sound is used, where it comes in, and how long it lasts are key to good editing. With few exceptions, sound almost never cuts with the picture. Sometimes the sound comes first and then the picture, and sometimes the picture leads the sound. Generally, the sound will lead the picture. You hear the sound, then you see the picture. The principal reason video and audio are so often cut separately is that we see and hear quite differently. We see in cuts; for example, we look from one person to another, from one object to another, from the keyboard to the monitor. Though your head turns or your eyes travel across the room, you really see only the objects you're interested in looking at. We hear, on the other hand, in fades. You walk into a room, the door closes behind you, and the sound of the other room fades away. As a car approaches, the sound gets louder. Screams, gunshots, and doors slamming and other staccato, "spot" effects being exceptions, our aural perception is based on smooth transitions from one sound to another. Sounds, especially background sounds such as the ambient noise in a room, generally need to overlap to smooth out the jarring abruptness of a hard cut.

To overlap and layer sound, the simplest way is to use Split Edits, which are incredibly easy to create in FCP, as the application flows the clips around each other. Nothing bumps against anything else; it simply moves out of the way, allowing us to easily cut video and audio separately from each other. We made split edits in the previous chapter to overlap dialog, now we'll make split edits to smooth out the natural sound of a scene.

SETTING UP THE PROJECT

This instruction is going to sound familiar, but it's worth repeating. Begin by loading the material you need on the media hard drive of your computer. In this

Chapter, we'll use the *BB5* library. If you haven't downloaded the material, download the *BB5.zip* from the www.fcpxbook.com website. Then do this:

1. Once the file is downloaded, copy or move it to the top level of your dedicated media drive.
2. Double-click the *ZIP* file to open it.
3. Double-click the *BB5* library to launch the application.
4. You can close any other open libraries if you wish.

The media files that accompany this book are heavily compressed H.264 files. Playing back this media requires a fast computer. If you have difficulty playing back the media, you should transcode it to proxy media:

1. To convert all the media, select the event in the Event Library, right-click on it, and choose **Transcode Media**.
2. In the dialog that appears, check on **Create proxy media**.
3. Next, you have to switch to proxy playback. You do this with the light switch popup in the upper right of the Viewer. Be warned: If you have not created the proxy media, all the files will appear as offline. In this case, you will probably have to switch back to **Optimized/Original** for your other libraries.

Before we begin, I suggest making a snapshot of the *Audio1* project so you can return to it at any time:

1. Select the *Audio1* project in the *Audio* event and use **Shift-Command-D** to duplicate it as a snapshot.
2. Double-click the original project to open it in the Timeline.

At any time, you can revert to the snapshot:

1. Simply rename the project you've been working on, something like *Audio1FirstEdit*, or make a snapshot of it and then delete the *Audio1* project.
2. From the original snapshot, remove the time stamp so that the original project is again called *Audio1*.

Snapshotting projects is a great tool because it preserves the current version of the project in a single small file, just the *CurrentVersion.fcpevent* file inside the library bundle.

THE SPLIT EDIT

A common method of editing is to first lay down the shots in scene order entirely as straight cuts, video and audio, as we did with the dialog in the previous chapter. Look at the *Audio1* project, which is the edited material cut as straight edits. What's most striking as you play it is how abruptly the audio changes at each shot. But audio and video seldom cut in parallel in a finished video, so you will have to offset them.

When audio and video have separate In and Out points that aren't at the same time, the edit is called a split edit (see Figure 5.1), a J-cut (see Figure 5.2), or an L-cut (see Figure 5.3). Whatever you call it, the effect is the same. I just call them all split edits.

FIGURE 5.1
Split edit.

FIGURE 5.2
J-cut.

FIGURE 5.3
L-cut.

The trick to smoothing out the audio for this type of project—or any project with abrupt sound changes at the edit points—is to overlap sounds and create sound beds that carry through other shots. Ideally, a wild track is shot on location; sometimes it is called *room tone* when it's the ambient sound indoors or *atmos* when it's outdoors. Atmos is a long section of continuous sound from the scene, 30 seconds or a minute or more, which can be used as a bed to which the sync sound is added as needed. Here, there is no wild track as such, but some of the shots are lengthy enough to have a similar effect.

Making Split Edits

Now let's make split edits:

1. To make it easier to manipulate the audio tracks, click the clip appearance button in the lower right of the Timeline and select the second option from the left or use **Control-Option-2**. For a list of clip appearance shortcuts see Table 5.1.
2. Double-click the audio portion of the first clip *ls valley* to expand it. You can also use the keyboard shortcut **Control-S**, which will also collapse it if it's expanded.
3. Drag the tail of the audio edit point as far as it will go in the Timeline (see Figure 5.4) underneath the audio of the second clip.
4. There is a sharp spike of wind noise at the end of the clip, so drag the audio back a little to the left to clip that off.
5. In the upper-right corner of the audio track is a small fade button. Drag it to the left to create a slow fadeout, as in Figure 5.5.
6. Double-click the audio portion of the second clip, *flowering tree*, to expand it, opening it below the first clip.
7. Drag the head of the audio to the left to stretch it out underneath *ls valley*.
8. Drag the fade button at the head of the *flowering tree* audio to the right to fade that in, as in Figure 5.6.

This method allows you to quickly and easily overlap audio to create smooth fades. Double-click the audio portion of the *drying beds* clip to expand it.

FIGURE 5.4
Creating split edit.

FIGURE 5.5
Audio fade out.

FIGURE 5.6
Overlapping faded audio.

Table 5.1	Timeline Display Shortcuts
Audio Waveform Only	**Control-Option-1** (see Figure 5.7)
Small Filmstrip with Large Waveform	**Control-Option-2** (see Figure 5.8)
Medium Filmstrip with Medium Waveform	**Control-Option-3** (see Figure 5.9)
Large Filmstrip with Small Waveform	**Control-Option-4** (see Figure 5.10)
Filmstrip Only with No Waveform	**Control-Option-5** (see Figure 5.11)
Clip Names Only	**Control-Option-6** (see Figure 5.12)
Go left through options	**Control-Option-Up arrow**
Go right through options	**Control-Option-Down arrow**

> **NOTE**
>
> ***Filmstrip and Clip Name:*** You should be aware that in the last two Timeline view options, Filmstrip with No Waveform and Clip Names Only, while they are very useful, you do not have access to audio controls and cannot raise, lower, or keyframe the audio levels.

Trimming Expanded Clips

When clips are expanded, they can be trimmed independently. Normally, to select an edit point, the **left** and **right bracket** keys and the **backslash** key will select the edit point, either in Ripple outgoing, Ripple incoming, or Roll mode, respectively. However, when clips are expanded, as we've done here, these shortcuts will only select the video portion of the edit. Similarly, clicking on an edit will select only the video portion if you click the video and only the audio portion if you click the audio. If you want to select the audio only

FIGURE 5.7
Audio waveforms only.

FIGURE 5.8
Small filmstrip large waveform.

FIGURE 5.9
Equal filmstrip and waveform.

FIGURE 5.10
Large filmstrip small waveform.

FIGURE 5.11
Filmstrip only.

FIGURE 5.12
Clip names only.

to ripple or roll the audio only via shortcuts, you can use **Shift-left bracket**, **Shift-right bracket**, and **Shift-backslash** to select the audio in, out, or center roll, respectively. You can then ripple or roll the edit as desired by nudging the edit, or numerically by typing a value, plus or minus, which will appear in the Dashboard.

When we made the split edit for the *flowering tree* shot, we overlapped the audio for the fade, but sometimes you simply want to eliminate the audio of a shot, such as the next shot, *drying beds*, which has poor audio due to wind noise.

1. Double-click the *drying beds* audio to expand it, which leaves the two adjacent shots abutting each other.
2. Press **T** to activate the Trim tool and drag the audio edit to the right to wipe out the audio of the *drying beds* shot replacing it with the audio of *flowering trees* (see Figure 5.13).
3. Double-click the next two clips *cs coffee flowers* and *luna sign* to expand them.

Because you may have an extra frame that appears when you rolled out the *drying beds* audio, the two audio layers do not appear inline (see Figure 5.14).

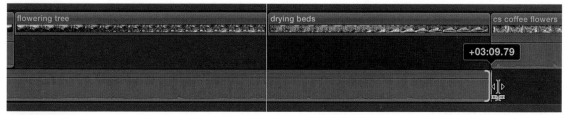

FIGURE 5.13
Rolling audio edit.

FIGURE 5.14
Shifted audio layers.

1. Drag the beginning of the *cs coffee flowers* audio to the left to overlap underneath *drying beds*.
2. Fade up the audio of *cs coffee flowers* with the fade handle and fade down the audio of the previous shot so that they cross fade.

3. Drag out the end of *cs coffee flowers* all the way underneath *luna sign* so that it overlaps underneath *sorting beans*.
4. Pull down the audio level of *luna sign* so it's down to nothing (see Figure 5.15).

Generally if it works, it's better to use continuous audio, such as the *cs coffee flowers* audio rather than cross fading.

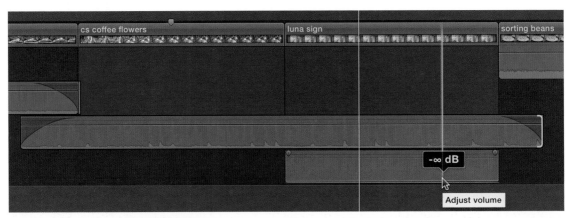

FIGURE 5.15
Reducing audio level.

FIGURE 5.16
Overlapping cross fades.

1. Double-click the audio of the *sorting beans* shot, which has quite different audio, the sound of a coffee roaster. This shot opens in line with *luna sign*.
2. With the Trim tool, you can roll the edit allowing you to create an overlap to fade up the sorting beans audio. You could also close the audio for *luna sign* to fade in *sorting beans*. Either way will have the same aural effect.
3. Because you don't actually see the roaster in the *sorting beans* shot, reduce it's audio about –18dB.
4. Double-click the *rich and roaster* audio and overlap the audios, cross fading them as in Figure 5.16.

FIGURE 5.17
Overmodulated audio meters.

Being able to roll the video independently of the audio is a very important feature, particularly when editing dialogue. The most common way to edit this material is to simply cut it in first as straight cuts showing whoever is speaking, getting the content into rough story order. In a documentary, this is sometimes called a "radio cut" or "a bed." In dramatic work, it's an "assembly edit." You see and hear, cut to cut, no B-roll, no overlaps. Once the best takes are in place showing the speaker or performers with the audio laid out and paced the way you want it, the video is then rolled separately so that the picture and the sound overlap and you don't always see the person speaking when she speaks; rather you might hear the person before you see her or switch to someone listening before he responds, or cut to relevant B-roll. The possibilities are endless, and the best way you can to learn to edit, in addition to practice, is to watch the masters—well-shot and edited documentaries and narrative fiction—to see how scenes are expertly treated for image and audio experience.

CONTROLLING LEVELS

Audio Meters

Whenever you work with audio, you need to see your audio levels. The miniature audio meters in the Dashboard are really only there as confirmation that there is audio recorded at some level. To see the real meters, either click on the tiny audio meters in the Dashboard or press **Shift-Command-8**. If your project is set work with 5.1 surround sound, the meters will display six tracks for 5.1 sound monitoring. In standard stereo projects the meters will show two tracks.

The standard audio level for digital audio is –12dB. Unlike analog audio, which has quite a bit of headroom and allows you to record sound above 0dB, in digital recording, 0dB is an absolute. Sound cannot be recorded at a higher level because it gets distorted and clipped off. Very often on playback of very loud levels, the loudness will seem to drop out and become almost inaudible as the levels are crushed beyond the range of digital audio's capabilities. It's important to keep sound in a good level, –12dB for normal speech, lower for

soft or whispered sound, and higher for shouting. Normally only very loud transients like gun shots will peak close to 0 around −2 or even −1dB. Make sure your audio does not bang up to the top of the meters or exceed 0dB so the LEDs at the top of the meters turn red as in Figure 5.17.

1. In the *Audio* event, select the clip called *rich* and play it back. The meters barely reach −20dB.
2. Open the Inspector by clicking the Inspector button near the right end of the Toolbar or by pressing the shortcut **Command**-4.
3. Switch to the Audio tab (see Figure 5.18). Here, you have controls for Volume and Pan, Audio Enhancements, and Channel Configuration.

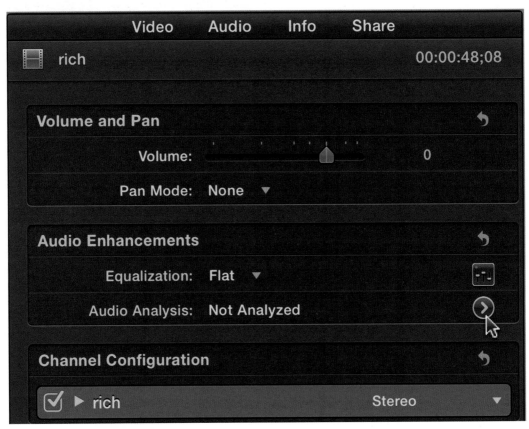

FIGURE 5.18
Audio inspector.

Audio Enhancements

In the Audio controls, you could adjust the volume by pushing up the slider, but it would barely be enough even if pushed all the way up 12dB. Because the level is so weak, in this instance, it's better to use the Audio Enhancements:

1. With *rich* selected in the event, press the keyboard shortcut **Command**-8 to open the Audio Enhancement Inspector. You can also do this from the Audio Enhancement portion of the Inspector or from the Enhancements popup in the Toolbar (see Figure 5.19.)

FIGURE 5.19
Enhancements popup.

2. Check on the blue LED for **Loudness**, and you'll see that the audio is automatically increased 40% (see Figure 5.20).
3. If this still seems a little weak, pushing up the Loudness won't help much. Rather, increase the Uniformity to around 10%.
4. This setting might increase the background noise too much. Try checking on **Background Noise Removal**. I find the noise removal can be a bit too aggressive and adds *flanging* to the sound—that slight warbling effect as if the voice is underwater or in a tunnel or both.
5. Pull back the amount to about 40% or whatever suits your ear. The sound is not great, but you can get it to a level that's useable.
6. Switch back to the main Audio tab with the arrow button in the upper-left corner of the pane.
7. Under Audio Enhancement, there is a line for Equalization with a pop-up next to it where you can select some standard equalizations, such as Voice Enhance, Music Enhance, Bass Reduce, and others.
8. Farther to the right, on the edge of the pane, is a small button icon with sliders. You can lick it to open the Equalization HUD. You can also use the Logic Pro Channel EQ that can be found in the Effects Browser.
9. Find the Channel EQ effect in the Effects Browser and drag it onto the *rich* clip. The effect will appear at the top the Audio inspector.
10. Click on the slider icon on the right side of the Channel EQ effect to open the HUD (see Figure 5.21).
11. Pull down the low end and the highs and push up the mids to help improve the voice.

There are other controls in the Audio Enhancement pane that are applied after an analysis:

1. In the Browser, select the audio file *LatinWithHum*. If the Audio Enhancements pane is not open, press **Command**-8.
2. Notice that Hum Removal has been switched on. This happens automatically on import when analysis is switched on and AC hum is detected. Try switching off the Hum Removal, and you'll hear the low-frequency 60-cycle hum that can be easily picked up from improperly grounded cabling.

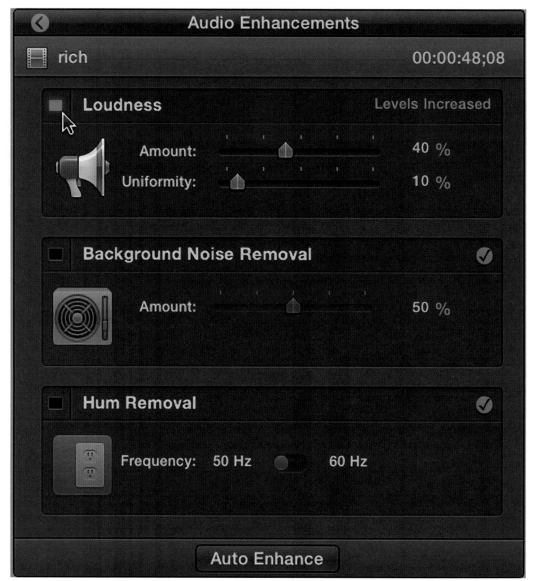

FIGURE 5.20
Audio enhancements.

3. Switch Hum Removal back on when you're done.

At the bottom of the Audio Enhancements pane, notice the button for Auto Enhance. This will check your audio and apply adjustments in the Audio pane that FCP thinks will work for your clip. You can also do this using the Enhancements pop-up menu in the Toolbar and selecting Auto Audio Enhancements or using the keyboard shortcut **Option-Command-A**.

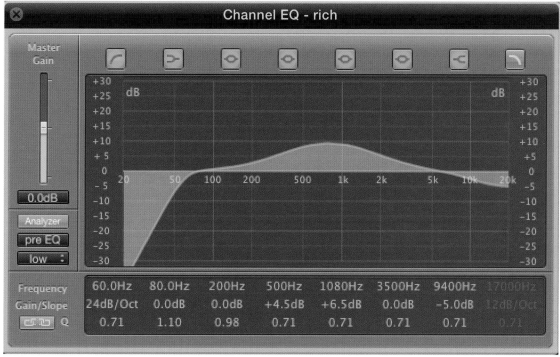

FIGURE 5.21
Channel EQ HUD.

TIP

Looping a Clip: To loop a clip or a project or a range, simply enable with **Command-L** or use the **View>Playback** menu.

Channel Configurations

Channel configurations can be set either to clips while they are still in the Browser or after they've been put in the Timeline. Of course changing the Channel configuration of a clip in the Browser after it's been put in the Timeline, does not change it in the project. However, you can select multiple clips or all the clips in the Timeline and change the channels simultaneously. The only requirement is that the selected clips all have the same number of channels. So clips that are 5.1 surround cannot be channel configured with clips that have two channels of audio. Here's how you channel configure clips:

1. Select all the clips in the *Audio 2* project.
2. Go to the Channel Configuration section at the bottom of the Audio inspector.
3. Change the Stereo popup to Dual Mono and twirl open (see Figure 5.22).

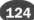

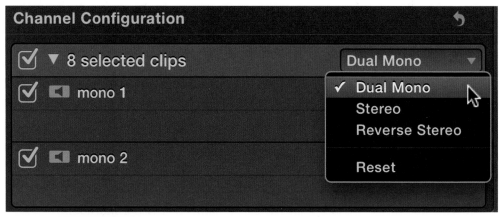

FIGURE 5.22
Channel configurations.

4. There are also checkboxes that allow you to selectively switch off tracks as needed.
5. Deselect the project clips and clip on one of the clips in the project to select it.

In Channel Configurations, you can skim the audio of each channel separately, and if you move the pointer over a channel and press the **spacebar**, you can play individual channels.

1. With one clip selected, press **Control-Option-S**, to Expand Audio Components.
2. In the Timeline, you can raise and lower the channel levels independently.
3. Right-click on one of the channel names and select **Rename Component**, which lets you assign a name to each channel independently.

Unfortunately at this time, you cannot open a clip from the Browser into the Timeline and change and rename channels prior to editing the clip into a project.

TIP

Single-Track Audio: Often you record audio on a single audio channel. Many cameras do this when you plug in an external microphone; only one of the stereo channels is used. It's worth deleting the empty track. FCP will detect empty audio tracks on import and remove them automatically. However, sometimes the second track isn't actually empty, just poor quality from a distant camera mic. If the audio is a stereo pair, change it to dual mono, and switch off the poor quality channel.

Mixing Levels in the Timeline

Let's look at adjusting levels and mixing audio in the FCP Timeline pane. There is no separate audio mixer as such in FCP, but you have direct control of the audio levels of your media in the project. We'll work in the *Audio3* project and start by duplicating it using **Shift-Command-D** to make a backup snapshot.

Let's start by adding some music to the project.

1. Select the edit point at the beginning of the Gap Clip in the Timeline and type *–215* and press **Enter** to ripple the gap two and a half seconds earlier.
2. With the playhead still at the beginning of the Timeline, find the *Latin-WithHum* clip in the *Audio* event and press the **Q** key to attach it to the Gap Clip at the beginning of the project. The playhead will zoom to the end of the Timeline, and everything will disappear because the music is much longer than the picture.
3. Press **Up-arrow** in the Timeline to move the playhead back to the end of the video.
4. With the pointer over the music press **C** to select it and then use **Command-B** to cut it.
5. Select the end portion of the music and delete it, and press the **Home** key (or **fn-Left** arrow on a laptop) to go back to the beginning of the project.

Fading Levels in the Timeline

We're about ready to start working on our audio. Although you can't see them, the split edits to create overlaps have already been done for you, so let's open them up.

1. Use **View>Expand Audio/Video Clips>For Splits** and then press **Control-Option-2** to set a good height for the audio area of the clips.
2. Grab the fade button at the beginning of the music clip and drag it to the right to get a nice fade-up of the music.
3. Right-click on the fade button, and a HUD will appear, allowing you to select the type of fade you want to use (see Figure 5.23). Select the Linear fade.

FIGURE 5.23
Fade HUD.

The default curved or logarithmic ramp is the +3dB fade, which is perfect if you are cross fading between overlapping sounds as we did in the first project. This gives what's called an equal power fade where there is no apparent dip in the audio level in the middle of the crossing fades. Generally, use a Linear 0dB

fade when you are fading up or fading down to silence, as we are here. There are four fade types to choose from, and you can use whatever's right for the sound you're working with. Sometimes fading in or out of speech with an S fade or a –3dB fade might work better.

Before you mix the body of the project, you should set the level for the primary audio, which in this case is on the primary storyline.

1. To make it easier to hear the clip, select *rich* in the Timeline. Then click the Solo button in the upper right of the Timeline, so it becomes yellow or press **Option-S**.
2. Make sure **View>Playback>Looped Playback** is turned on. If it isn't, activate it with the menu or **Command-L**.
3. With the skimmer over the *rich* clip, press **C** to select it and then use **/** (forward slash) to play the selection.
4. While the clip is playing, use **Control-=** (equals, think plus) and **Control- –** (minus) to raise or lower the audio as needed to set the level.
5. When you're finished, press **Option-S** to toggle soloing off.

> **NOTE**
>
> **Absolute and Relative:** An important audio feature that was recently added is the ability to adjust volume of a clip or a range either to an absolute level or relative to any keyframed levels. Previously volume control was always relative to where it was, now you can make an absolute change to a clip, a range, or multiple clips. You can do this from the **Modify** menu and select **Adjust Volume>Absolute** or **Relative** or use the keyboard shortcuts **Control-Option-L** for Absolute or **Control-L** for Relative. Selecting Absolute activates the Dashboard to enter a decibel value (see Figure 5.24). Selecting Relative or using **Control-L** also activates the Dashboard, with a slightly different display, again allowing you to type in a plus or minus value relative to the current value. You can also toggle between Relative and Absolute by clicking the icon on the right side of the Dashboard.

FIGURE 5.24
Absolute level in dashboard.

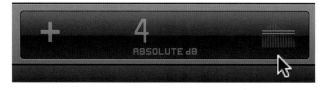

Changing Levels on Part of a Clip

We set the overall level for the clip, but often you'll want to change the audio level of a section of a piece of audio, reduce a section of music while someone is speaking, or raise a section where the level is too low. We want to reduce, or "duck," the level of the music as Rich starts to speak and then raise it back up after he's finished. To select the area to reduce, it's simplest to use the Range Selection tool.

1. Activate the Range Selection from the Tools menu in the Toolbar or by pressing the **R** key.
2. Drag an area on the *LatinWithHum* clip in the Timeline, beginning shortly before the voice begins until just after it finishes (see Figure 5.25). This is easiest to do with snapping toggled off (**N**) or the tool will snap to the start and end of the *rich* clip.
3. With that area selected, pull down the level line so that the audio is reduced about –12dB. Keyframes will automatically be added, ramping the sound down and back up at the end of range selection (see Figure 5.26).

FIGURE 5.25
Range selection.

FIGURE 5.26
Ramping audio with keyframes.

Notice that the two inner keyframes remain selected. We'll look at that in a second, but there are a few things we should do first. One is that I find the keyframes created using the Range Selection tool are too abrupt and drop off to fast. You might want to pull the outer keyframes farther apart, or instead of using the Range Selection tool to make the keyframes, manually create keyframes where you want using the **Option** key to click on the audio level line. Either way spread the keyframes.

The other thing I want to do is to shift Rich's dialog, but I do not want to shift the video that's connected to it. I will also need to shift the audio keyframes. So let's see how to do this.

1. To shift the *rich* clip in the Timeline, activate the Position tool (**P**).
2. If you drag the *rich* clip, the connected clips will move with it. To prevent this, hold the **grave** or **tilde** key and drag *rich* about two seconds to the right (see Figure 5.27). Of course the audio keyframes are now out of position.
3. Activate the Range Selection tool and drag a selection that highlights the keyframes. There are two ways to move the keyframes, by cutting and pasting them or even more simply by dragging them.
4. To cut the selected keyframes, use **Edit>Keyframes>Cut** or the shortcut **Shift-Option-X** and to paste them move the skimmer to where you want them and use the shortcut **Shift-Option-V** to paste them or the **Edit>Keyframe** menu.
5. You can also simply drag the keyframes. With the keyframes selected, the pointer changes to a four-way move tool, allowing you to raise and lower the audio levels or to drag the selected keyframes left or right. Drag them to the right so they line up underneath the *rich* clip as they were before.

FIGURE 5.27
Positioning clip without moving connections.

> **Tip**
>
> ***Precise Levels:*** Dragging in the Timeline to adjust levels can be a little crude. For greater precision, hold down the **Command** key to gear down the drag, or use the Dashboard for an exact value.

> **TIP**
>
> ***Deleting Clip Leaving Connected Clip:*** When you delete a clip from the primary storyline, any clip connected to it will also be deleted. Often you want to keep connected clip while deleting the primary clip and letting the magnetic Timeline close the gap. To do this, hold the **grave** (tilde) key and press **Delete**. The Timeline will close, but the connected clip, audio or video, will remain in place.

NOTE

Connected Audio in the Timeline: Because there are no tracks in FCP as understood in legacy versions and other applications, audio can be put anywhere in the Timeline. When you connect a piece of audio to the primary storyline, it is connected underneath the storyline, but this is really for no more reason than it's traditional. If you drag an audio clip into the project, you can put it above the video if you want. This approach does make for a messy Timeline, but it works perfectly well.

TIP

Reference Waveform: When you're reducing the audio levels of clips in the Timeline, especially to low levels, it's handy to still see what the waveform looks like even when the audio is very low. You can do this by checking on **Show reference waveforms** next to Audio in the Editing tab of user **Preferences**. With reference waveforms switched on, you see a ghost of the waveform in the Timeline, as in Figure 5.28.

FIGURE 5.28
Reference waveforms.

Match Audio

One of the great features of FCP is the Match Audio function. This compares the audio equalization of one clip and balances it to another by applying EQ settings. Here's how to use it:

1. In the Timeline, **Option**-click to select the *luna sign* shot, the third from the last Connected Clip. **Option**-clicking a clip not only selects the clip but also moves the playhead over it.

2. From the Enhancements pop-up menu in the Toolbar, select **Match Audio** or use **Shift-Command-M**. A two-up display appears in the Viewer (see Figure 5.29).
3. Move the skimmer over the shot before *luna sign*, the *cs coffee flowers* shot. The pointer will change to an EQ icon. Click on the *cs coffee flowers* shot.
4. In the Viewer, click the **Apply Match** button.

If you want to change it, you can click the **Choose** button that will appear opposite Audio Enhancements in the Audio tab. If you want to see what equalization has been applied to the clip, click the EQ icon next to it to bring up the HUD that controls the effects (see Figure 5.30). You can make any adjustments you want in the HUD to fine-tune the audio.

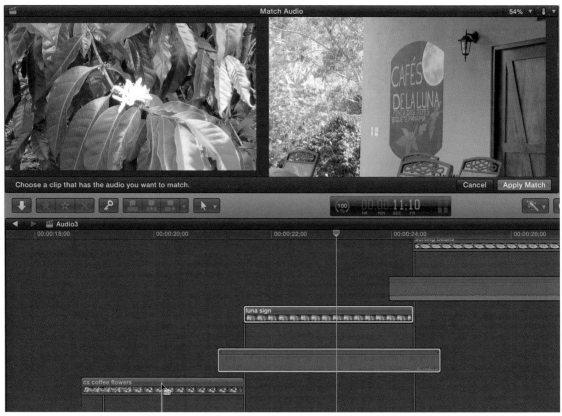

FIGURE 5.29
Match audio display.

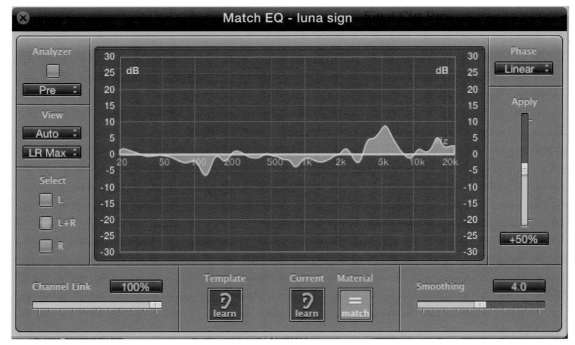

FIGURE 5.30
EQ HUD.

Subframe Precision

One of the features for editing sound in FCP is that you can do it with great precision, down to subframe accurate detail. To help you do this, you can switch the Dashboard display to show subframe amounts. In user **Preferences**, in the **General** tab, and from the **Time Display** pop-up, select **HH:MM:SS:FF+Subframes** (see Figure 5.31).

With subframes displayed in the Dashboard, you can use the **Command** key and the **Left** or **Right** arrows to move the playhead in increments of 1/80th of a frame.

If you must zoom in to the waveform in the Timeline, you can set keyframes within a single frame of video. This capability is really useful if there are spikes on the audio, you need to reduce or single sounds you want to edit out.

Toward the end of *rich and roaster* shot at the end of the sequence, there is a loud clack that we'll eliminate. There are a couple of ways to do this. Because it's such a small area, it's easier not to make a selection with the Range Selection tool, but to zoom into the Timeline and use manual keyframes.

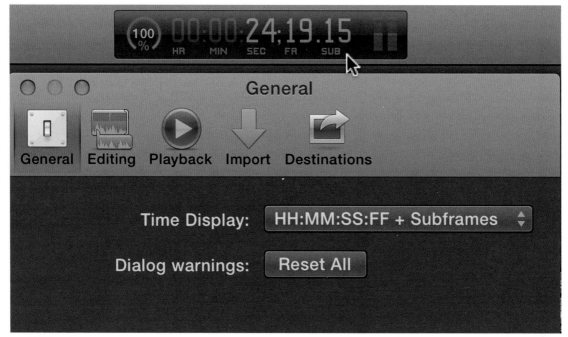

FIGURE 5.31
Subframe preference.

1. Zoom into the timeline around the 30-second point into the *rich and roaster* shot.
2. Hold the **Option** key and click on the audio level line in four places around the loud spike of audio, adding four keyframes.
3. Put the pointer between the middle pair of keyframes and pull it done as in Figure 5.32, where the pale gray area represents a single frame of video.

If you wanted to remove the keyframes at any time, you could use the Range Select tool to drag an area around the keyframes to select them and then use **Shift-Option-Delete** to delete them or the **Edit>Keyframe** menu to access the delete function.

Once you've finished mixing your audio and setting the levels, it's always a good idea to select the clips and collapse them again. You can do this from the **Clip** menu or with the same shortcut used to expand the clips, **Control-S**.

Here's another way to clean up this type of audio. In this technique, you can do the subframe edit inside the clip by opening it in the Timeline. The advantage

of this technique is that you can do these audio fixes in the Browser even before you edit the clip into the Timeline.

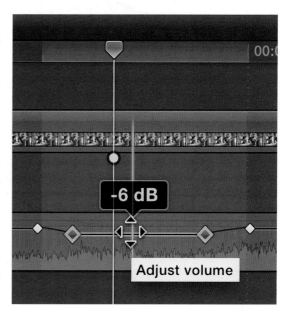

FIGURE 5.32
Subframe audio edit.

1. Begin by using the Range Selection tool to drag around the keyframes on *rich and roaster* and then use **Shift-Option-Delete** to remove them.
2. Right-click on the clip and select **Open in Timeline**.
3. Select the audio portion and zoom into the Timeline around the spike in the audio.
4. Put the skimmer just before the sound and press **Command-B** to cut the audio. Because you're skimming and cutting the audio, you can do this in subframe increments (see Figure 5.33).
5. Select the second portion of the audio and use **Command-B** to make another cut after the spike.
6. Press the **T** key to activate the trim tool, grabbing the central sliced portion of the audio, slip it to the left or right so that the spike is outside the area (see Figure 5.34).
7. Press **Command-[** (left bracket) to return to the project.

Because only the audio was cut, no cut appears on the clip in the project and the audio plays smoothly without a spike in the sound.

FIGURE 5.33
Cut audio in the timeline.

FIGURE 5.34
Slipped audio in the timeline.

> **TIP**
>
> *Zoom a Selection:* You can use the Zoom tool (**Z**) to drag a selection around a section of the waveform to zoom into just that portion of the display.

Controlling Levels with Effects

While we'll look at audio special effects later, there are a few effects that can be used specifically to control levels. In the Effects Browser, there are sections for Video and Audio. In the Audio section, there are Final Cut Pro effects, Logic effects, and OS X effects. You can pretty much forget about the OS X effects. The Final Cut Pro effects are simplified presets for the Logic effects. If you want a basic control with usually simply an Amount slider, then the audio effects listed under Final Cut Pro are for you. The Logic effects give you more controls and more presets and more options. They usually have a graphical interface as well as sliders for the parameters. If you want you can start with the Final Cut Pro effect, and from there you can click a button to access the Logic effect's graphical interface or multiple interfaces for complex effects. Let's do both, see both the Final Cut Pro effect and the corresponding Logic effect.

In the *Audio* event is a clip called *LatinLoud*, which is quite overmodulated. You can see the nasty red spikes in the waveform. You could just reduce the level,

but let's look at how to apply an audio effect in the Browser. Normally you can't apply effects from the Effects Browser to Browser clips, but you can if you open the clip into the Timeline.

1. Right-click on *LatinLoud* in the Browser and select **Open in Timeline**.
2. In the Effects Browser, select **All** under **Audio** and then type in *limiter* in the search box at the bottom (see Figure 5.35).
3. With the clip selected in the Timeline, double-click the Final Cut Pro Limiter effect or drag it onto the clip. The audio is immediately limited.

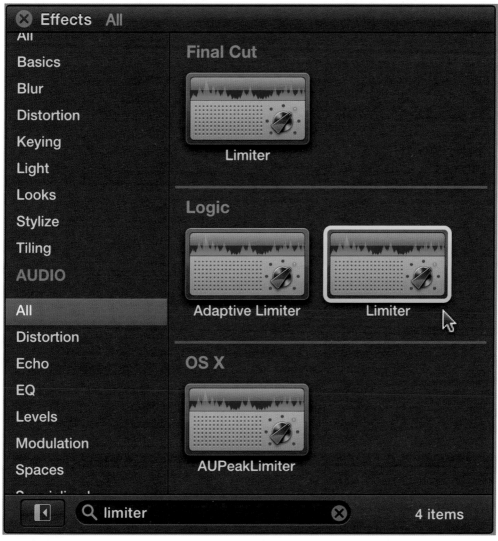

FIGURE 5.35
Limiter effects.

The Limiter has an amount slider and pretty much nothing else. Pushing up the amount will not allow it to go beyond zero, while reducing it will bring down the level. To access the Logic graphical interface, click the Limiter button (see Figure 5.36).

Either switch off the Final Cut Pro limiter or delete it and apply the Logic Limiter. In Figure 5.37, you see the Limiter controls as well as the available presets, together with the graphical interface for the effect. Notice that the popup allows you to save presets you create as well as taken you to where they are saved. This is typical of the Logic effects, which is why I prefer to use them in most cases. Also notice that the Output level is pegged to zero. Both the Classical Music and the Vocals presets will increase the levels, while still limiting the output to zero. It effectively acts as a simple Compressor.

FIGURE 5.36
Final Cut Pro limiter.

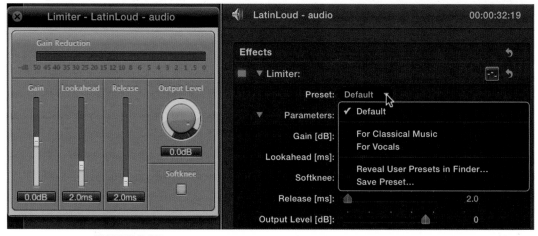

FIGURE 5.37
Logic limiter controls.

While the Limiters act to keep audio levels from increasing too much, Compressors act to both increase the audio level of sound that's too low and

keeping it from overmodulating, compressing the range of the audio. In my view, there is a tendency to compress audio far too aggressively so that everything peaks at a specific level, effectively removing all dynamic range in much speech. This is what I think of as radio compression, everything equally loud all the time.

Let's use the *rich* clip to look at how to work with compression.

1. Right-click on *rich* and select **Open in Timeline**, and with the audio selected, make sure any Audio Enhancements and Volume and Pan settings are reset with the hooked arrow reset buttons.
2. In the effects Browser, find the Logic Compressor and apply it to the clip (see Figure 5.38).
3. Lower the Threshold to make it effect a lower range of audio.
4. Increase the Ratio slider to increase the curve, making the controls effect more of the mid-range of levels.
5. Try the presets particularly Voice Compressor 01 and Voice Compressor 04 and use them as starting points.

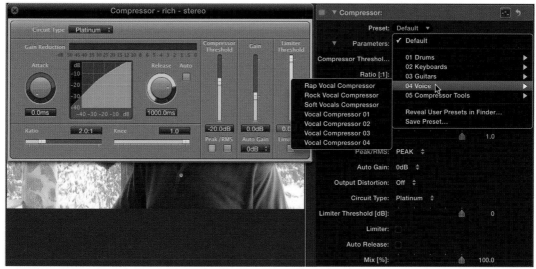

FIGURE 5.38
Logic compressor controls.

There are about 50 presets in the Compressor. Be warned, you can spend an inordinate amount of time trying different settings, adjusting them, and tweaking them. There are huge number of audio effects with an endless number of presets and options. We will look at a few more of these in Chapter 8 on effects.

> **TIP**
>
> **Phase Error:** Sometimes audio channels go out of phase with each other. They are slightly offset so one channel cancels out, or nearly cancelling out the other. There is a handy audio effect that can help this problem. If you apply the Gain effect and open the controls to access checkboxes that let you make the clips mono, or use Phase Left or Phase Right, eliminating one of the channels.

PAN LEVELS

In the Inspector, in addition to controlling the volume of a clip, you can also control the Pan mode, which defaults to None. With the pop-up, you can change it to Stereo Left/Right or other settings. When Stereo Left/Right is set, as in Figure 5.39, you have a Pan Amount slider that allows you to move the audio from left to right as you like and to animate it to move from the left or right speaker across the screen. For fun, let's do this to the music in the Timeline. You can do this entirely in the Timeline, but we'll start off by setting the first keyframe in the Inspector:

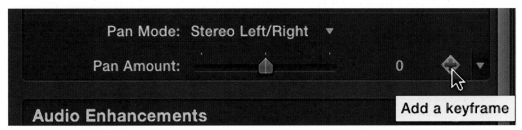

FIGURE 5.39
Stereo left/right pan.

1. Select *LatinWithHum* in the Timeline. Then move the playhead right to the beginning of the project with the **Home** key and go to the Inspector.
2. With Stereo Left/Right selected, move the Pan Amount slider all the way to the left to –100 and click the **Add Keyframe** button on the right end to the slider.
3. Drag the Pan Amount slider all the way to the right to 100, and listen to the music. You'll hear it move from the left speaker to the right speaker and the Pan slider in the Inspector will move from left to right.
4. With the clip selected, press **Control-A** to open Audio Animations.
5. Double-click Pan Amount in the Timeline to open the keyframe graph for that parameter (see Figure 5.40).

6. Move the playhead forward to about 5:00, and holding the **Option** key, click on the Pan Amount level line to add another keyframe.
7. Go forward a couple of more seconds, **Option**-click to add another keyframe.
8. Drag the fourth Pan keyframe back down to zero. The music will move from left to right, pause, and then come back to be center-panned.

Here, the effect is pretty silly, but it's often useful to move sound from one side to the other—for instance, for a car that drives across the screen.

In the Pan mode pop-up, there are also presets for 5.1 surround panning, such as Dialogue, Music, or Ambience, which spread the sound to the periphery and leave the center open for voice. Let's look at some of the surround settings.

1. Select the two video clips at the beginning of the project and go to the Inspector.
2. Change the Pan Mode to Ambience and twirl open the Surround Panner and the Advanced controls.
3. In Advanced controls, change the Stereo Spread to about 40 (see Figure 5.41). Notice that all the properties are animatable.
4. Select the *rich* clip and move the playhead to 11:20 in the project where the *rich* shot actually appears and set a keyframe for the Surround Panner (see Figure 5.42).
5. Press the **Down arrow** a couple of times to go to where the *rich* shot disappears from the screen and set another Surround Panner keyframe.
6. Go back to the very beginning of the *rich* shot when the picture is off the screen at 9:29.
7. Drag the puck in the Surround Panner to the center so sound is coming evenly from all the speakers.
8. With the clip selected, press **Control-A** to open the Audio Animation controls.
9. Set **Pan** to **Front/Back** and double-click the Pan value to open the graph.
10. Select the first keyframe where the puck is in the center of the Surround Panner and use **Option-Shift-C** to copy it.
11. Move the playhead or skimmer a couple of seconds past the third Pan keyframe and use **Option-Shift-V** to paste the same keyframe value into the Pan graph (see Figure 5.43).

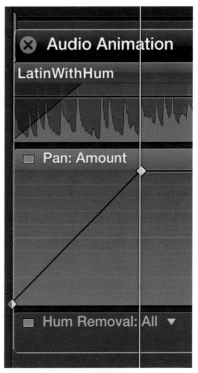

FIGURE 5.40
Pan keyframe graph in the timeline.

Notice the puck in the Surround Panner that can be revealed with the disclosure triangle. By dragging the puck around the Surround Panner, you can control the position of the audio in the surround space. Not only is the position of the puck keyframeable but also are all the advanced properties such as Surround Width, LFE Balance, and Rotation. With a proper surround monitoring system, you can

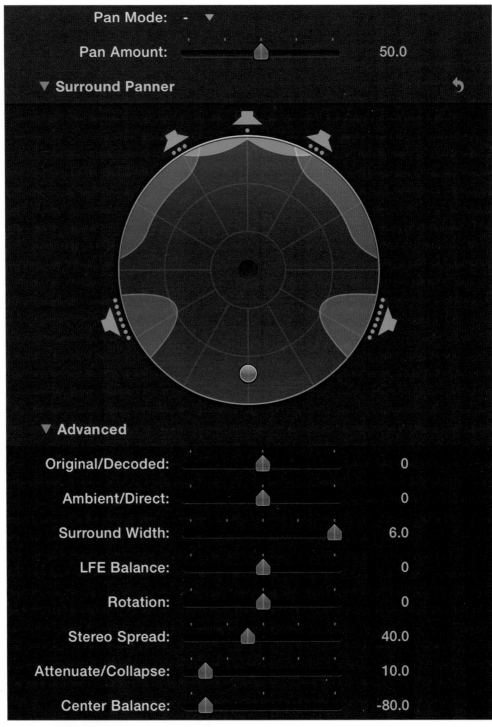

FIGURE 5.41
Surround panner and controls.

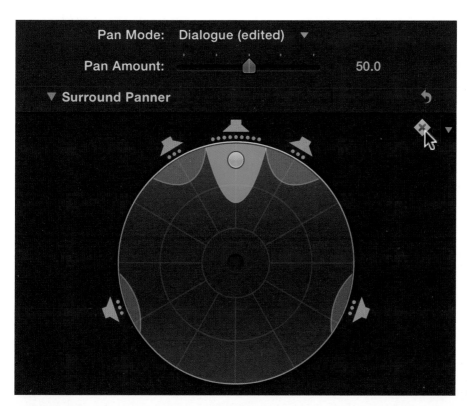

FIGURE 5.42
Surround panner
dialogue keyframe.

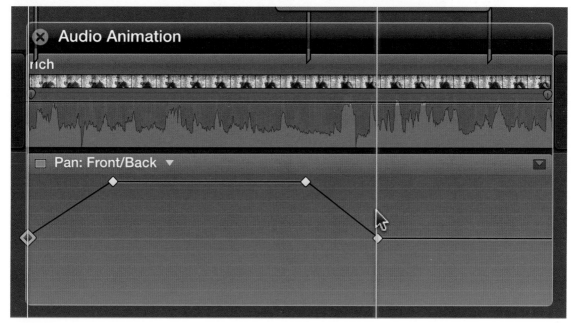

FIGURE 5.43
Pan animation graph.

lay out multiple tracks and assign an amazing variety of surround options to control your audio.

EDITING MUSIC

Editing music is very different in Final Cut Pro from earlier applications. There are a number of different ways to edit music in FCP. You can of course access iTunes and other media in the Music and Sound Browser. Here, you can see the Final Cut Pro and iLife sound effects, loops, and jingles. The search capability at the bottom of the browser is especially useful when looking for sound effects. You can drag the file into an event, or you can drag the music or effects into a project. If you drag it to a project, it will automatically added to whatever location you have set in your Import preferences.

> **TIP**
>
> ***Adding to the Media Browser:*** You are not limited to having just the Final Cut Pro, Logic, GarageBand, iLife, and iTunes media in the Music & Sound Effects Browser. You can drag any folder from the Finder into this browser, and it will appear in the list, and whenever you add any sound files to that folder, they will automatically appear in the browser (see Figure 5.44).

FIGURE 5.44
Custom folder in media browser.

Adding Markers

One of the best ways to edit music is to use markers. You can add markers either to a clip when it's in the Browser before you put it in the Timeline or to a clip after you've put it into the Timeline. Just as in many video editing applications,

you can add markers to the beat by tapping the **M** key. For a list of useful marker keyboard shortcuts see Table 5.2. You should be aware that because audio-only files like *LatinWithHum* have no real timebase in the Browser, they are treated as 59.94 frames per second material (60 fps). In the Timeline, however, they use the timebase of the project they're in. So let's make a new project and edit some music:

1. With the *Audio* event selected, press **Command-N** to make a new project and name it *Music*.
2. Select *LatinWithHum* in the *Audio* Event Browser and press **E** to append it into the Timeline.
3. Because this is an audio-only clip, a dialog will appear, asking you to set the project properties. Make the Video **1080i HD**, set the Resolution to **1920×1080**, and set the Rate to **29.97i**. You use these settings because they match the video we're working with.

The music will appear in the primary storyline ready to have clips connected to it. Although you can connect the audio to the Timeline and add the markers there, many users find it awkward to edit this type of project in the magnetic Timeline. It's easier to edit the video as connected clips, and when you need the control for trimming, to do rolls, or slide edits, you can change the connected clips to a secondary storyline. But first let's add the markers:

1. Move the playhead back to the beginning of the sequence with the **Home** key and zoom in with **Command-plus**, so it's easier to see the waveform.
2. You can either play the project and tap the **M** key as you play or add the markers at specific frames. Put the first marker at the beat at 1:07 in the Timeline.
3. Add the next marker at the beat at 2:14 and zoom in so that you can clearly see one frame.
4. Holding the **Control** key, use the **comma** and **period** keys to nudge the marker left and right on the clip in 1/80th of a frame increments. In reality, this precision is not going to help you much with editing your video, as video can be edited only in full-frame increments.
5. If the marker is in the wrong place, you can delete it by going to the marker and pressing **Control-M**. You can delete all the markers on a selected clip or a selected range of a clip with **Control-Shift-M**.
6. You can name markers in the marker HUD by either pressing the **M** key when you're on a marker or simply double-clicking it.
7. Go down to the beat at 3:20 and press **Option-M**. This not only adds a marker but also opens the marker HUD. A double-tap on **M** will do the same thing.
8. Click the middle of the three marker buttons to make a To Do item (see Figure 5.45). The marker will turn red.
9. To go to a previous marker, use **Control-semicolon**, and to go to the next marker, use **Control-apostrophe**.
10. Add more markers at 4:27, 6:04, 7:10, 8:17, 9:15, and 10:08.

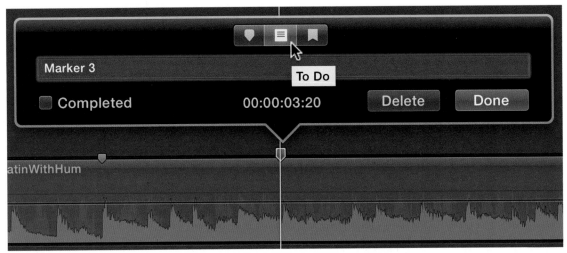

FIGURE 5.45
To do marker HUD.

Table 5.2 Marker Shortcuts	
Marker Tools	**Shortcut**
Add marker	**M**
Add marker and open dialog	**Option-M**
Marker dialog	with the marker selected use **M**
Delete selected marker	**Control-M**
Delete markers in selected range	**Control-Shift-M**
Nudge a marker left	**Control-comma**
Nudge a marker right	**Control-period**
Go to previous marker	**Control-semi-colon**
Go to next marker	**Control-apostrophe**

We don't have enough video for all the music, but we'll put in a few shots into the project.

1. Press the **Home** key to return the playhead to the beginning and tap **I** to mark a selection start.
2. With snapping turned on, drag the skimmer to the next marker and press **O** to end the selection.
3. Pick a shot in the event, maybe the wide shot at the beginning of *luna sign* and mark an In and press **Q** to connect it.
4. Press **Command-2** to switch to the Timeline, use **Control-apostrophe** to move to the next marker and press **O**.
5. Use the **Up arrow** to go back to the end of the previous edit and press **I** to mark the In point.

6. Pick another shot in the Brower, mark an In and connect it with **Q**. Or mark an Out point and use **Shift-Q** to backtime it.

Repeat the process adding more clips at each marker. Use the Replace function to swap out shots and drag them around however you like, leaving the music locked on the primary storyline as your bed. If you need to add something in front of the music, like a title, simply move the playhead to the beginning and press **Option-W** to add a Gap Clip.

NOTE

Chapter Markers: Although you can add markers to clips in FCP, you cannot add markers to the Timeline Ruler. Despite this, you can still create chapter markers for DVDs by adding markers to the primary storyline and in the marker dialog selecting the third marker type, which will turn the marker orange (see Figure 5.46). Notice that you get a pin attached to the marker, which allows you to select the video frame that appears with the chapter. These chapters will appear in QuickTime, iTunes, and of course in DVD creation.

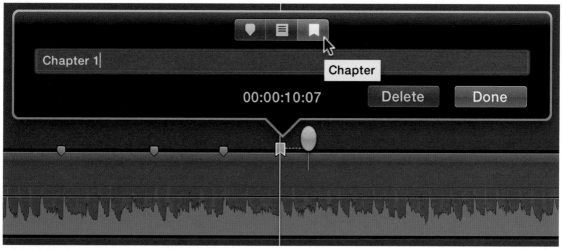

FIGURE 5.46
Chapter marker HUD.

TIP

Compound Clips for Auditions: Sometimes you have an Audition of multiple clips, such as different music tracks you want to try out, but the levels need to ride up and down around dialog or narration. To do this, select the Audition and make it a Compound Clip. Then apply the necessary fades in the project to the Compound Clip. Now when you change the music inside the compound using the Audition whatever you select will have the correct fades applied inside the project to work around your other clips.

ROLES

Because FCP has no tracks, and objects on different layers move around to accommodate other objects, keeping the content organized becomes very difficult. You want to be able to keep the same types of audio together so that you can export *stems* from your project. Stems are separate tracks of audio that are used to mix together different types of sound for different delivery purposes. So you might have separate stems for your sound effects tracks, for your music tracks, for your dialogue, and perhaps even separate stems for each character's dialogue so that the audio can be mixed and equalized separately when it's sent to a professional audio mixing suite. To make the creation of stems possible, FCP uses *roles*, which are metatags assigned to clips specifying what type of clip belongs where.

You can set the role for a clip in the Event Browser before the clip is edited into the Timeline, or you can set it in the Timeline after the clip has been edited into the project. By default FCP assigns roles to every clip when it's imported and to all material imported from the Media Browser. The default roles are as follows:

1. Video
2. Titles
3. Dialogue
4. Music
5. Effects

All imported video clips are automatically assigned Video and Dialogue roles. All music imported from iTunes or iLife Jingles is assigned the Music role. Everything else from the Music & Sound Effects Browser is assigned the Effects role. All sound imported from outside the Music & Sound Effects Browser is assigned the Effects role. All titles from FCP's Title Browser have the Titles role. Everything other then these you need to assign the roles yourself. Fortunately, you don't have to change each one separately, but you can select groups of clips and change them once. So, for instance, you could select all your B-roll video that are in keyword collections and change their roles to Video and Effects. Let's change the roles for some of our clips in the Browser first.

> **NOTE**
>
> **Project Clips Are Separate:** If you set a clips role in the Browser and then edit it into the Timeline, the role will go with it. If you assign the role in the Timeline, the Browser clip is not changed. Also if you change the role of a clip in the Browser, the copy of the clip that's in the Timeline does not have its role changed.

1. With the Brower in List view, right-click on the header and check on Roles and drag it to the left next to the clip names (see Figure 5.47).
2. If the clips are in name order, **Shift**-click to select the clips from *bananas* to *flowering tree* and then click in the Roles column to change the roles to Video, Effects. Notice you could also use the keyboard shortcut.

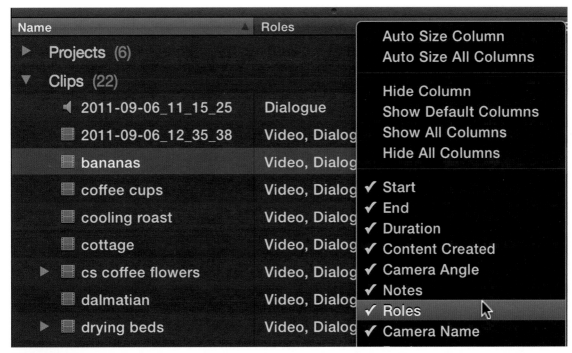

FIGURE 5.47
Selecting roles.

Let's change the roles of some of the clips in a project. We'll do it in couple of different ways.

1. Begin by opening the *Audio3* project that has the music in it.
2. Select the music, which when imported was assigned an Effects role, and press **Control-Option-M** to apply the Music role. A list of shortcuts for roles is in Table 5.3.
3. Click on the *rich* clip and go to the Info inspector, where you'll see that the clip already has assigned Video, Dialogue roles, which is fine for this.
4. Marquee drag to make a selection of all the other connected clips.
5. In the Info inspector, change the Roles to Video, Effects (see Figure 5.48).

FIGURE 5.48
Roles in the inspector.

In the Roles pop-up in the Info tab, notice the option **Edit Roles**. This brings up the window in Figure 5.49. There are two + buttons at the bottom. The one on the left allows you to add roles, and the one in the middle lets you create subroles of a

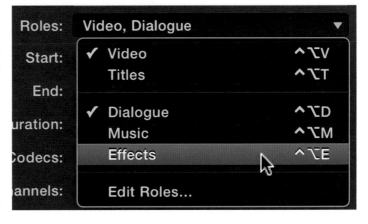

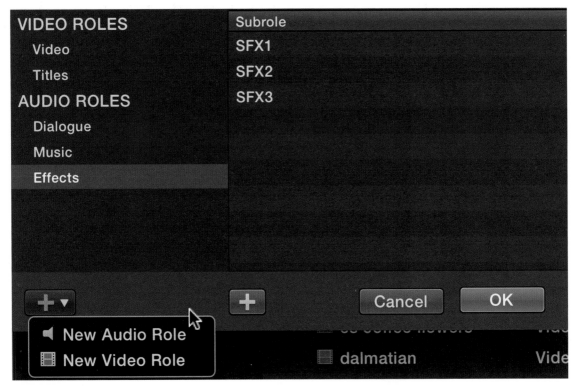

FIGURE 5.49
Editing roles.

selected role. Subroles will let you add separate roles for each character or type of music or type of effect. It's common to have multiple effects and multiple music roles, which allows the editor to checkerboard the effects and music between the roles so that the mixer does not have back-to-back effects on the same stem. It makes it much easier to mix.

Table 5.3	Roles Shortcuts
Roles	**Shortcut**
Video	**Control-Option-V**
Title	**Control-Option-T**
Dialogue	**Control-Option-D**
Music	**Control-Option-M**
Effects	**Control-Option-E**

Timeline Index

This seems like a good opportunity to look at the Timeline Index. It can be used to search the content of your project as well as to navigate in it. You can also

even use it to delete clips from your Timeline. Just select the clip in the index and press the **Delete** key.

To open the Timeline Index, either click the little index button in the lower left of the Timeline pane or press the shortcut **Shift-Command-2**.

The index has three tabs at the top for Clips, Tags, and Roles, and at the bottom selections to limit what's displayed in the tab. For instance in Clips, there are separate selections for All, Video, Audio, and Titles (see Figure 5.50), which gives you lists of the content with their project timecode locations. To move the playhead to a clip in the project, simply click on its name. Notice there is a search box at the top.

The Tags tab has a large range of options (see Figure 5.51). At the bottom, you can select All or Markers, which allows you to display markers only. This is another handy place to rename markers. Tags can also display all the clip keywords that were added in the Browser, and with the search function at the top, you can limit the display to showing only specific keywords, which can be a very useful function in the Timeline. The Gear selection displays analyzed items, while the next

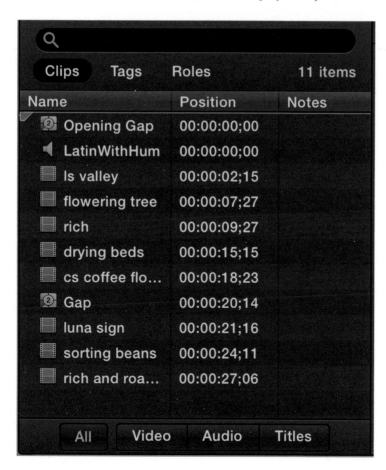

FIGURE 5.50
Clips index.

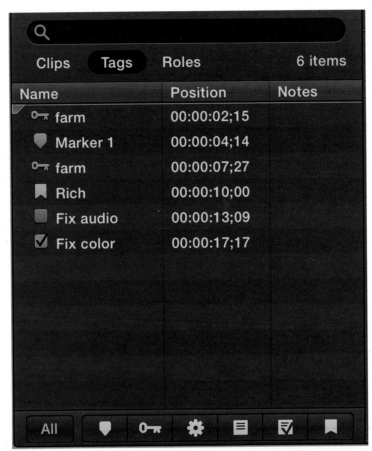

FIGURE 5.51
Tags index.

two options show To Do items that appear in red, and Completed items that appear in green. In these two, there are checkboxes that allow you to make a To Do item completed, and vice versa that allows you to check a Completed item to return it to the To Do list. The final selection displays Chapter Markers, which can also be renamed here. Notice that all the Tags have a searchable Notes section where you can enter more information about specific items. All these tags features are extremely useful when collaborating and moving projects from one user to another.

The final index tab is Roles, which allows you to control the Timeline display. Selecting a role will highlight it in the Timeline (see Figure 5.52) making it easier to find specific items. Clicking the upward pointing arrow button on the end will minimize the role. For instance if an audio role is minimized,

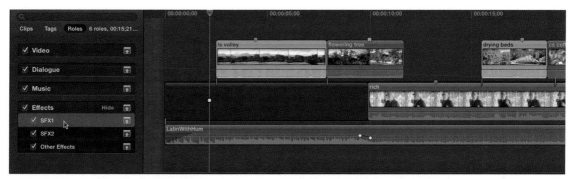

FIGURE 5.52
Highlighted role in index.

you can only longer access its level line. By clicking the checkbox at the head of the role (see Figure 5.53) will switch off the role completely. If you uncheck audio roles, they will not be heard, and if you uncheck video or titles, they will not be seen. This will only affect project playback and will not affect what is exported. Everything is exported unless it is disabled in the Timeline.

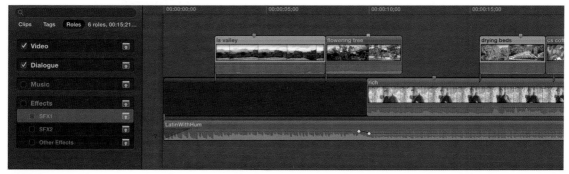

FIGURE 5.53
Switched off roles.

Roles play an important back in the export function that we will look at in the last chapter on Sharing.

SYNCHRONIZING CLIPS

More and more people are shooting video with DSLR cameras. One of the unfortunate side effects of these cameras is that they often have very poor audio recording capabilities. This is usually compounded by the complete inability to properly monitor audio, which are two fundamental functions of any video camera. Because of this, many users are recording audio using a separate recorder

like a Zoom. FCP has the ability to automatically sync up picture and sound by looking at the audio waveforms of the two items. There are two items in the *Audio* browser that aren't named; they simply have the application's assigned time stamps. One is a video file that's in the ProRes Proxy codec, and the other is an audio file that corresponds to it.

1. Play the video file. That's me, by the way. There's a handclap at the beginning for syncing, and if you're monitoring the meters, you'll see they barely rise above –30dB. Raising the level and turning on Loudness will make the level acceptable but will also bring up a lot of hiss.
2. Play the audio file. That's much better; in fact, it should be probably reduced as it's little too loud.
3. Select both items in the browser and right-click to select **Synchronize Clips** or use **Option-Command-G**.
4. A new item called *2011-09-06_12_35_38 – Synchronized Clip* is created.
5. Select the sync clip, and in the Audio tab inspector, go to Channel Configuration and uncheck the camera stereo sound called Storyline to switch it off (see Figure 5.54). They are called Storyline and Connected, because that's the way they are displayed if you open the clip in the Timeline.
6. Right-click on the sync clip and select **Open in Timeline** to see how the audio sync. If you wish, you can trim the beginning and end of the sync clip, and this will be reflected in the browser.

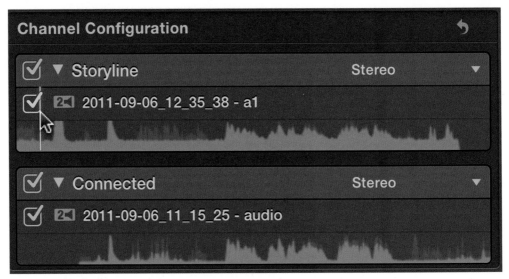

FIGURE 5.54
Channel configuration.

TIP

Open in Timeline: When you open a clip in its Timeline, you can see how the video and audio line up, and slide them independently to adjust the sync, if necessary you can change the sync by sliding the audio independently in subframe amounts. If the sync is difficult, sometimes it's useful to add markers to the video and audio by closely examining the waveforms or by syncing to something that happens in the video. It's often easy to sync to plosive sounds such as Ps or Bs on the frame where the lips separate. By adding markers, it's easy to line these up in the clip Timeline by zooming in and dragging the video or audio as needed.

TIP

Sync-Link X: This is another tool from Intelligent Assistance (http://assistedediting .intelligentassistance.com/Sync-N-Link-X/) that uses XML to process the contents of an FCP event and sync the rushes in a dual-system recording production that has been recorded with jam-synced timecode.

RECORDING AUDIO

Final Cut Pro has a very simplified audio recording feature that allows you to record directly into your project. It allows you to record narration or other audio tracks directly to your hard drive while playing back your project. This recording is most useful for making *scratch tracks*, test narrations used to try out pacing and content with pictures. Many people prefer to record narrations before beginning final editing so that the picture and sound can be controlled more tightly. Others feel that recording to the picture allows for a more spontaneous delivery from the narrator.

You can access the tool under the **Window** menu by selecting **Record Audio**, which brings up the pane in Figure 5.55.

You can adjust the recording level with the Input slider and name the file before you start recording. Under the Advanced disclosure triangle is the Input pop-up that allows you to select the recording device. Any connected USB microphone should work well. Make sure the connected microphone is selected as the input in Sound System Preferences. The built-in mics on MacBook Pros and iMacs are also recognized. From the same popup, you can select to record stereo or mono. Make sure you have headphones plugged in if you check on monitoring, or you'll create feedback. There is a slider to adjust the monitoring level.

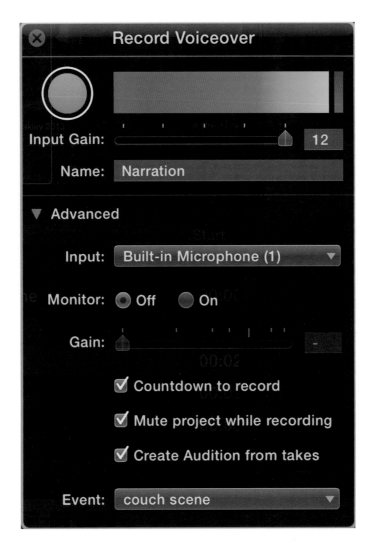

FIGURE 5.55
Record audio panel.

Notice the options at the bottom to have a Countdown, which appears as 3, 2, 1 with audible beeps in the Viewer; also the option to Mute the project, which is very useful; and to create Auditions of your takes.

The controls couldn't be simpler: There is one red button that starts recording and stops recording. You can also stop recording by pressing the spacebar. When recording is stopped, the playhead moves back to the beginning of the recorded section, ready for you to do another take.

When you start recording, the project starts to play back, and the recording begins after the countdown if you have that option selected. The recording is stored in the designated event and is added to the project, connected to the primary storyline beginning at the point the recording started.

1. Use **Command-N** to make a new project and name it recording.
2. Open the Record Audio window and set it up for your mic input and playback.
3. Select your microphone and name your track. Call it *voiceover*.
4. Click the record button, wait for the countdown, and read your script or a short section of this book and then stop recording with the spacebar.
5. The playhead returns to the start ready for you to record. When you start again, the recording is added to the Audition, and the takes are numbered sequentially.
6. When you're done selecting, the Audition and press **Y** to open it and listen to the takes to select the best one.

Each take is a separate recording in the event. There is no Audition saved in the event.

TIP

Switch Applications While Recording: A nice feature of FCP's Record Audio function is that you can switch applications while you're recording, and the record will not stop. So you can start the recording in FCP, switch to Pages with **Command-Tab** to read your script, and then switch back to FCP to stop the recording.

TIP

Playback Levels: Don't be fooled by FCP's vertical audio meters. These meters display the playback levels; they do not show the recording level.

SUMMARY

In this chapter, we looked at working with sound in Final Cut Pro. We covered working with split edits, cutting with sound, using meters, overlapping and cross fading tracks, using Audio Enhancements, settings, adjusting, and mixing levels, performing audio matching and surround panning, channel configuration, editing music, and using markers. We saw the power of roles and the use of the Timeline Index; in addition, we introduced FCP's audio recording tool. Sound is often overlooked because it doesn't seem to be that important, but it is crucial to making a sequence appear professionally edited. In the next chapter, we'll look at multicam editing in Final Cut Pro.

CHAPTER 6
Multicam Editing

Multicam editing was one of the first major objectives Apple worked on after the original release of FCPX, introducing it in version 10.0.3 just 6 months after the original release. The multicam function includes automatic synchronization based on audio or selected parameters like timecode. This function allows you to create a multicam clip that is a single container clip that holds all the angles you want to cut and switch between in your project. Multicam also supports mixed formats and mixed frame rates and allows for creation of a multicam clip with 48 camera angles, though more can be added. However, it's best to avoid multiple formats and frame rates if possible, and if necessary to use proxy media to make for easier playback.

To make it easier to use multicam in FCP, it's best to set up your shoot so that it's easy for FCP to create the multicam clip. To make it easier to create the multicam clip, set all the cameras in the shoot to the same date/time settings, same date, same time, and the same time zone. (See the Sidebar "Changing the Date/Time Stamp in FCP.") Because FCP can use audio synchronization to sync the clips, it's always a good idea to make sure all the cameras are recording sound, no matter how far away or how poor the quality. Because audio analysis has to be done to sync clips with audio, for a lot of clips, or clips with difficult sound, the synchronization process can be quite lengthy. Shooting a clapperboard with a clap strike at the beginning of recording will help enable audio sync considerably.

SETTING UP THE PROJECT

For this chapter, we'll use the *BB6* library that is available for download as a ZIP file called *BB6.zip*. If you haven't downloaded the material already, download it from the www.fcpxbook.com website.

1. Once the ZIP file is downloaded, copy or move it to the top level of your dedicated media drive.
2. Double-click the ZIP file to open it.
3. Double-click the *BB6* library to launch the application.
4. You can close any other open libraries if you wish.

The media files in this project are QuickTime DV and do not need to be optimized or proxied. In fact they can't be optimized as DV is a native I-frame codec in FCP.

MAKING THE MULTICAM CLIP

Before you create your multicam clip, which combines all your shots into a single clip, you need to determine how the clips will be synced up and how they will be assembled. The default is to sync the clips using camera audio, which in most instances works well.

Assembly of the clips allows you to have a camera that stops and starts and assign all the clips from that camera to have the same angle, so they will all appear as one camera in one angle with black between the shots. To set the camera angle, you can use the General view section of the Info tab of the Inspector (see Figure 6.1). Here, you can specify Camera Angle and Camera Name for each clip or for a batch of selected clips.

If you have a camera that's stopping and starting during the shoot, select all the clips from that camera and assign them the same Camera Angle. This will make the application try to sync the clips sequentially rather than trying to treat them as separate cameras. By setting the same camera name or camera angle to multiple shots, FCP will combine them into a single angle.

If you're shooting with a single or a few cameras repeatedly, for instance when shooting music to lip sync, then you want to make sure you assign separate camera angles for each take. If you don't, the application will see the same camera name, and assume they are all the same angle, unless you specify otherwise by assigning separate camera angles. Most recently manufactured cameras have individual camera IDs, each one different, which FCP can use to tell which camera shot which material and assemble all the shots from a specific camera into a single angle. An iPhone for instance uses the device's name as its camera ID. Camera angle numbers will take precedence over the camera name.

When cameras have no names and no angles, the application assumes each is a separate angle.

Let's see how to create the multicam clip:

1. In the *Multicam* event, select clips *Cam1* through *Cam4* together with the audio file *Output*, leaving aside *Cam5*.
2. Right-click on the selected items, and from the shortcut, choose **New Multicam Clip** or use the **File>New** menu.
3. In the sheet that drops down, name the multicam clip *Jazz*. You can save it to any event you have in the library.
4. Notice **Use audio for synchronization** is checked on by default. Click on the **Use Custom Settings** button to see all your options (see Figure 6.2).

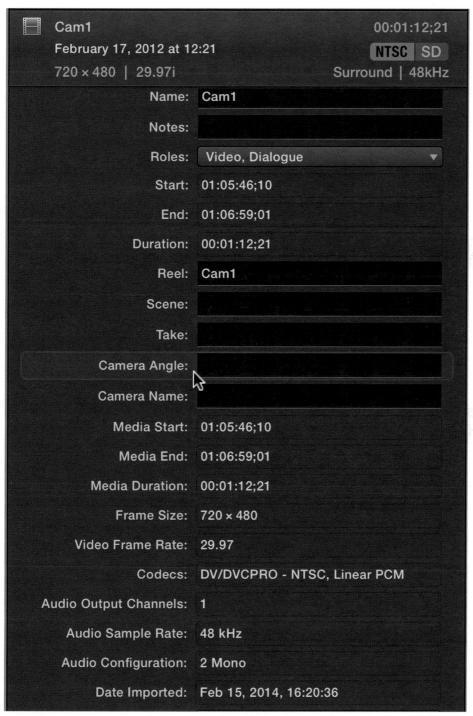

FIGURE 6.1
General view info inspector.

Multicam Clip Name:	Jazz
In Event:	Multicam
Angle Assembly:	Automatic
Angle Clip Ordering:	Automatic
Angle Synchronization:	Automatic

☑ Use audio for synchronization

Starting Timecode:	00:00:00:00
Video Properties:	○ Set based on common clip properties
	NTSC SD, 720x480 DV, 29.97i
	⦿ Custom

720p HD	1280x720	23.98p
Format	Resolution	Rate

Audio and Render Properties:	○ Use default settings
	⦿ Custom
Audio Channels:	Automatic
Audio Sample Rate:	Automatic
Render Format:	Apple ProRes 422

Use Automatic Settings Cancel OK

FIGURE 6.2
Multicam clip options.

Angle Assembly determines how clips will be put together in the multicam clip (see Figure 6.3). Camera angle, first, then camera name, using the information assigned in the Inspector, or from the camera metadata. If you use the Clips option to assemble, separate angles will be created for each clip.

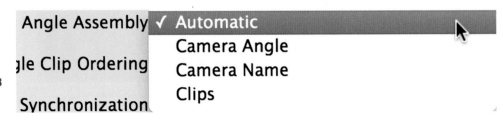

FIGURE 6.3
Angle
assembly.

Angle Clip Ordering is the basis for making the stack in the multicam clip, which can be changed later as we'll see. It can be Automatic, Timecode, or Content Created. Timecode is the most accurate of course as Content Created uses the date/time stamp and is usually no more accurate than one second.

Angle Synchronization can be based on Timecode, which is great if you have shot your project with multiple cameras that have slaved, frame accurate time-code. If you have that, you can switch audio synchronization off. The other options Content Created, Start of First Clip, and First Marker on the Angle can be used as guides for audio synchronization. So if the cameras are running with matched date/time stamps, the application has a guide on what to try to base its audio sync. If you roll cameras simultaneously or close to it, the camera start can be used as a guide for audio syncing. You can also add a marker, such as on a clapperboard strike, and use that as a guide. It does not have to be frame accurate if it's being used in conjunction with audio syncing. If you have a clear clap strike to sync to, you can set a marker there and switch off audio syncing if you wish.

In the new multicam clip dialog, you can set the start timecode for the clip, though many users if using time of day timecode will set that as the start timecode for the multicam clip.

You can also set the format of the multicam clip based on the most common video format used, or just as in the new project dialog you can set custom formats and custom render and audio properties. Setting the multicam clip format is useful if you want to specify a format type, especially if it's different from the majority of cameras in the multicam clip.

If you're working in a format that uses a codec that is difficult to process, your clips should be optimized. By default the user Playback preferences is set to create optimized media for multicam clips. Personally I don't think this is really useful for most instances, unless you have a number of different formats and frame rates that you're working with. If you have a lot of clips or having difficulty working with the media, it's really a good idea to create and use proxy media in the multicam clip. The simplest way to convert your media is to select the multicam clip in the Browser, right-click on it and select **Transcode Media**. The application will transcode all the clips built into the multicam clip into proxy and/or optimized as selected. Remember if you're working with proxy files that you have to switch your Viewer settings to proxy, and when you're done, don't forget to switch it back to original/optimized for output.

If you are working with clips with separate audio, such as DSLR cameras, you can use the Synchronize Clips function to combine the video and audio, and then use the synchronized clips that FCP created when making the multicam clip. If there's only a single audio track with multiple DSLRs, then it's better to simply combine the clips, video and audio, into a single multicam clip without synchronizing first.

> **TIP**
>
> *Events and Keyword Collection:* If you have your clips in a Keyword Collection, select them, and make a multicam clip, do not be surprised if the multicam clip disappears from the Keyword Collection. It will be in the event itself, but it's not automatically keyworded. Also you cannot make a multicam clip across multiple events. All the clips have to be in the same event. If they aren't, you either have to move them or make copies by **Option**-dragging the clips.

> **TIP**
>
> *PluralEyes 3:* Sometimes FCP's multicam sync function just can't manage to create the multicam clip. In these instances, you should try using Red Giant's Plural Eyes 3, which is an excellent tool (www.redgiant.com/products/all/pluraleyes). It also has a free 30-day trial. You simply put your clips to sync, stacked vertically in an FCP project and export an XML file. Import the XML into Plural Eyes 3 and let it do its thing. You can then export an XML that will create an FCP multicam clip and bring it into the application.

Sidebar

CHANGING THE DATE/TIME STAMP IN FCP

If the date/time stamp is incorrectly set on your camera, it is possible to adjust this for multiple clips. This is an important feature in the application especially for multicam projects, where the content creation date is used for syncing. You can do this by selecting the clips and going to **Modify>Adjust Content Created Date and Time**, where you can batch offset this for multiple clips (see Figure 6.4).

Notice two things in this dialog. This is not an absolute change for selected clips. By this I mean, you are not setting an exact date and time for all the selected clips. If the clips are sequential or are offset, the other clips will change the amount of time, days or months or hours, relative to the amount you are changing the first clip. The other important thing to note is that this is not in the Undo queue. Once you change it, **Command-Z** will not help you. This is a destructive function as it's changing the metadata on the QuickTime file on your computer.

The Angle Editor

Once you've created the multicam clip, it appears in the Browser with the little quad split icon in the upper left corner. This icon will appear in the Browser, on the clip in the Timeline, and also in the Angle Viewer and Angle Editor.

You can double-click it to open it into the Timeline panel in what it's called the Angle Editor (see Figure 6.5). To see how your multicam clip looks, open the

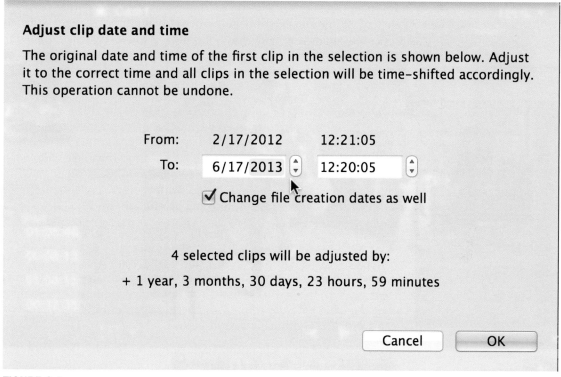

FIGURE 6.4
Adjust creation date and time.

Angle Viewer. Open the Angle Viewer with **Shift-Command-7** or from the light switch popup in the upper right of the Viewer.

In the Angle Editor, you will see all the clips in the multicam clip stacked on top of each other. When you skim the Angle Editor, you only see the monitoring angle. This can be set with the video and audio buttons at the head of each lane

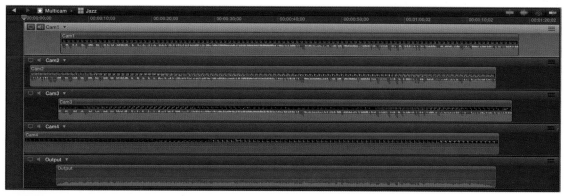

FIGURE 6.5
Angle editor.

that allows you to set which angle you see and which you hear during playback (see Figure 6.6). While you can only have one video monitoring angle switched on at a time, you can have as many audio monitoring angles switched on. Being able to switch on two audio monitoring angles allows you to judge sync of the clips.

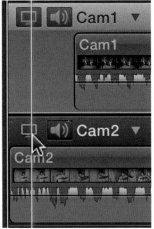

FIGURE 6.6
Video and audio monitoring angles.

The Clip Skimmer is very useful in the Angle Editor and is automatically turned on for skimming all angles aside from the video monitoring angle. This allows you to skim each clip separately and to hear the audio from each clip separately. If you are using the clip skimmer on an angle, **Shift-V** will select that angle for video monitoring. The angle with video selected will appear in light gray. The audio monitor is highlighted to show which audio is being monitored. **Shift-A** on an angle that is being skimmed will toggle audio monitoring on and off.

To check audio sync from multiple angles, turn on audio monitoring for a pair of angles or more and listen to the audio. You can toggle all the angles to a single angle by **Option**-clicking on one of the speakers at the head of the track. If there's an echo, they're out of sync. Slip the clips in the lanes as needed to sync the audio precisely. You can nudge the clips left and right along the lanes with the **comma** and **period** keys, and in 10 frame increments with **Shift-comma** and **Shift-period**.

You can rename an angle in the Angle Editor by double-clicking on the name in the lane. That will not change the clip name, but will change the name in the Angle Viewer.

To change the order of the clips, grab the handle icon that appears at the end of the lane and drag the angle up or down in the lanes. This will change the order in the Angle Viewer. This is especially useful if you're working with a music clip for instance that has no video. You can drag the music to the bottom of the stack order so it's out of the way.

In addition to reordering clips, you can also combine clips that might be synced on separate angles into a single angle. Simply grab the clip, and using the Position tool, hold the **Shift** key and drag it vertically so it drops into another angle. This will overwrite whatever's in the angle so be careful how you use this feature. This feature is great for cameras that stop and start as all the clips from a single camera can be combined in a single angle.

This is useful if you were not able to combine the clips into a single angle using FCP's Angle Assembly function, where you can set to combine the angles using the various criteria we saw earlier.

You can add another angle to the multicam clip by clicking on the drop-down menu at the head of each clip and selecting **Add Angle** (see Figure 6.7).

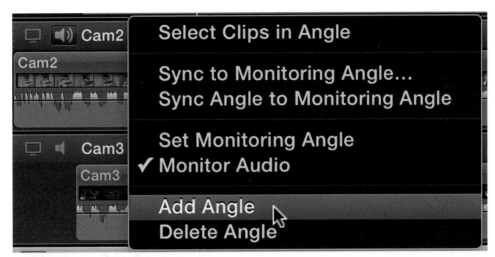

FIGURE 6.7
Add angle.

1. In the Angle Editor, click on the triangle popup for *Cam4* and select **Add Angle**. An empty lane is created into which you can drag any clip you want.
2. From the Browser, drag *Cam5* anywhere into the empty lane.
3. Change the angle name from *Untitled Angle* to *Cam5*.
4. Click on the video monitoring button for *Cam3* so that it's highlighted in gray.
5. From the triangle popup at the head of *Cam5*, select **Sync Selection to Monitoring Angle** (see Figure 6.8). This will shift the angle to sync with *Cam3*.

Normally you use video and audio clips in a multicam clip, but you can add graphics files, stills, generators, pretty much any kind of a clip, including unrelated, non-sync clips like B-roll, that you might want to switch to in your multicam edit. You can just keep adding angles in the multicam clip. You can also disable clips in the Angle Editor; simply press the **V** key just as in the project timeline.

If you play *Cam4* in the Angle Editor, you'll notice that you don't hear any audio with it, though you see a reference waveform. The audio is just incredibly low in level. If you select the *Cam4* clip in the Browser and go to the Audio Enhancements panel in the Audio inspector (**Command-8**), turn on Loudness and push up Amount and Uniformity, you'll just be able to make out some very faint sound. This is a good example of how little FCP is able to work with to create sync audio and multicam clips.

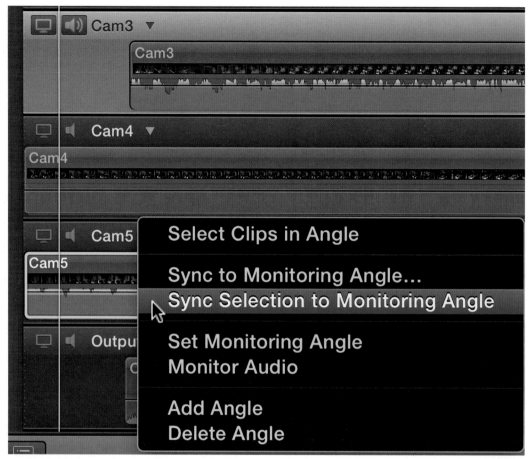

FIGURE 6.8
Sync angle to monitoring angle.

EDITING THE MULTICAM CLIP

Angle Viewer

Once you've created the multicam clip, and prepared it in the Angle Editor, it's time to edit it into a project, but before we do that, take a look at the Angle Viewer.

1. Make sure the *Jazz* multicam clip is selected in the Browser, and if it's not already open, press **Shift-Command-7** to open the Angle Viewer (see Figure 6.9).
2. In the Settings popup in the upper right of the Angle Viewer, you can change the display (see Figure 6.10). Notice in the Settings popup, you can also turn on overlays like Timecode and change the clip name display.

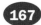

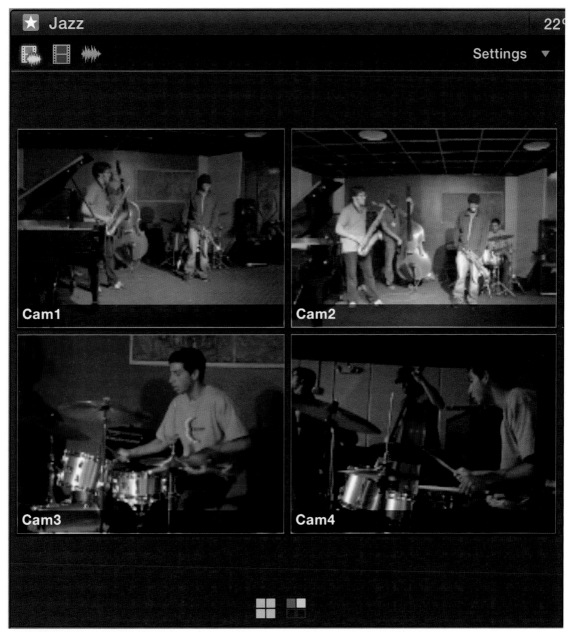

FIGURE 6.9
Angle viewer.

3. Change the number of angles to 9. You can display up to 16 angles at a time in the Angle Viewer, though the multicam clip can hold many more.

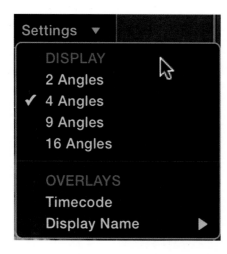

FIGURE 6.10
Angle viewer settings.

4. If you switch back to two or four angles, you'll see multiple displays at the bottom that you can click to select (see Figure 6.11). The icons give you access to the additional pages of angles you can have in the clip. Just click on the page you want to see the angles on that page.

5. Set the number of angles to four and make the Angle Viewer narrow, this will move the display into a vertical layout (see Figure 6.12). In four-up or two-up display, you can stack the clips vertically so the Angle Viewer takes less horizontal screen space.

FIGURE 6.11
Angle viewer display buttons.

The Angle Viewer gives you three cutting/switching options at the top. It will effect what happens in the Timeline, but in addition, it will also change what is displayed and played in the Browser.

1. With the Browser multicam clip selected, switch back to the nine-up display in Settings.

2. With the first of the three buttons selected, the yellow filmstrip with waveform (see Figure 6.13), click on the *Output* angle, which is audio only. When you play the Browser, you see nothing but you hear that track. The yellow button, the default, cuts and switches video and audio together.

3. Select the second button, the filmstrip, which will turn blue.

4. Click on *Cam1*, switching the video to that angle, but leaving the audio on *Output*.

5. Play the Browser clip. You see *Cam1* but you hear *Output*.

The second option enables video only. When you select an angle, it will be highlighted in blue and whatever audio is active will remain in green (see Figure 6.14). Finally, if you choose the waveform icon, you will be cutting/switching audio only. An angle selection you make will be highlighted in green.

You can change these options with keyboard shortcuts. **Shift-Option 1** will select the yellow video/audio button; **Shift-Option-2** will select only the blue video button; and **Shift-Option-3** will select only the green audio button.

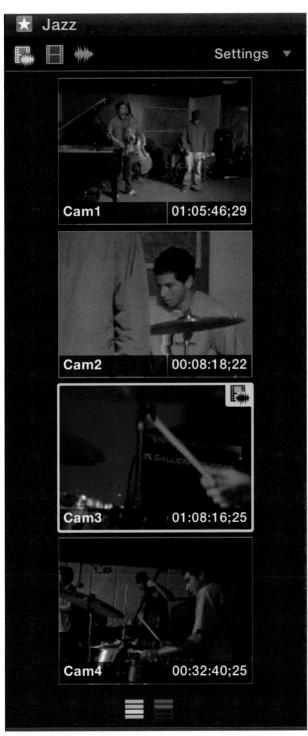

FIGURE 6.13
Edit selection buttons.

FIGURE 6.12
Angle viewer vertical display.

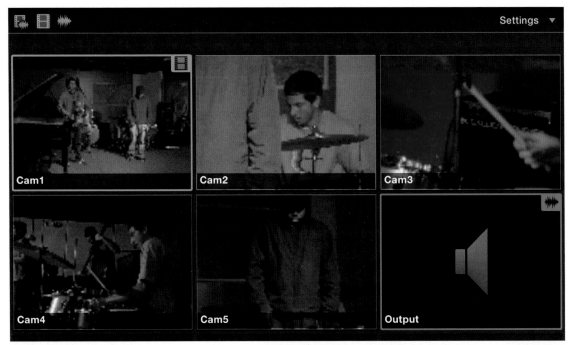

FIGURE 6.14
Separate video and audio.

You can also change the selected audio channel in Channel Configurations of
the Audio inspector.

1. With the multicam clip selected in the Browser, set the Angle Viewer to the
 video and audio button **Shift-Option-1**.
2. Open the Inspector with **Command-4**. Notice the multicam clip has only
 an Audio inspector and no Video inspector.
3. In the Audio inspector, uncheck *Cam1* and check on *Output*. This will
 also split the selection with video on *Cam1* while putting the audio on
 Output.

Editing

So far we've only been switching. Now it's time to edit. We'll start by making a
new project and marking a selection in the Browser and edited into project. You
can mark up a multicam clip with In and Out points just like any other clip to
make a selection to trim off the beginning and end as you need and then press
W to Insert, **E** to Append, or even **D** to Overwrite into your storyline.

1. With the *Multicam* event selected, press **Command-N**, name the project *Jazz*,
 and use the default automatic settings to make the properties based on the
 first clip.
2. Select the multicam clip in the Browser and as before make sure in the Angle
 Viewer video is set to *Cam1* and audio set to *Output*.

3. In the Browser, play the multicam clip *Jazz* and mark an In right near the beginning around 5:00. At this point, there are only three camera angles.
4. Mark an Out at 1:09:19 before the cameras start to shut off.
5. Press the **E** key to Append the multicam clip into the empty Timeline.
6. Make sure the blue button is active **Shift-Option-2** because we want to edit the video only leaving the audio untouched in the Timeline.
7. Move the playhead back to the beginning of the Timeline and click *Cam4* in the Angle Viewer, which will cut to that angle. Notice the razor blade that appears when cutting the multicam clip in the project Timeline.
8. Press the spacebar, and while the Timeline plays, click the Angle Viewer on the angle you want to cut to.

The clip name that appears in the Timeline is made up of the name of the active video and audio angles (see Figure 6.15). If both are the same, you'll see the video clip name. Notice the dotted black line in the video portion of the storyline and the dotted white line in audio portion. This indicates that only the video is being cut and the audio is a through edit.

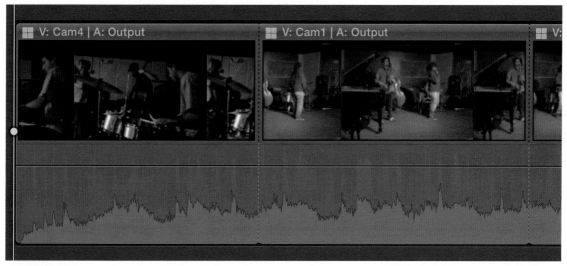

FIGURE 6.15
Multicam edits.

FCP calls this type of an edit a through edit, because the multicam clip is continuous. Any through edit can simply be selected and deleted with the **Delete** key. The left side of the multicam clip will roll over the right side erasing it.

The default behavior for the multicam clip in the Timeline is to cut the clip wherever the playhead is. If you only want to switch an angle, hold the **Option** key.

1. Move the playhead in the Timeline over any of the edited clips in the storyline. Make sure you see the white dot on the clip in the playhead.
2. The Angle Viewer will show you the selected video and audio under the playhead.

3. If you click on a different video angle, the clip will be cut, so undo that.
4. Hold the **Option** key and click on a different video angle. The video portion of the clip in the storyline will be changed to the selected angle.

You can also edit the multicam clip in the Timeline using solely the keyboard.

1. Select everything in the *Jazz* timeline and delete it.
2. Click on the *Jazz* multicam clip in the Browser, which should be still set up with the same In and out points, and press **E** to Append.
3. Switch to the Timeline (**Command-2**) and move the playhead back to the beginning (**Home**).
4. Press the spacebar, and while the Timeline plays tap the **1, 2, 3, 4,** or **5** keys to cut the video to that angle. You can do that with either the numbers across the top of the keyboard or with the keypad on an extended keyboard.

You can stop play back and undo previous edits by repeatedly pressing **Command-Z** and then you can pick up editing where you left off by clicking the Angle Viewer or using the keyboard.

After you've made your edit, you can change any shot by selecting it and pressing **Option** and the number you want to switch to. So if the selected shot is *Cam3* and if you want *Cam2*, just select the shot and press **Option-2**. You can also right-click on any shot and change the angle from the shortcut menu (see Figure 6.16). You can also change the active video and audio angles in the Info tab of the Inspector (see Figure 6.17).

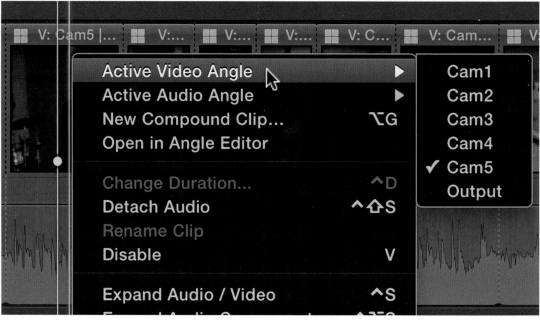

FIGURE 6.16
Changing active angle in the timeline.

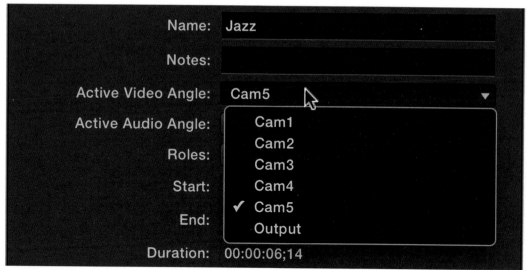

FIGURE 6.17
Changing active angle in the info inspector.

You can add any transition at any edit point. Just be careful you have sufficient media for the overlap or the multicam clip can be pulled out of sync. Because of the way FCP adds audio transitions, in this instance with continuous audio, it's best to expand all the audio before applying the transition.

When you move between edits in the multicam clips, the pointer does not change to the ripple function as it normally does, but it changes to the roll function. It doesn't allow the ripple function as this would pull the material out of sync. If you really have to ripple a clip, activate the Trim tool and then the ripple function will again be available. The slip function can be activated using the trim tool but it should not be used, because, again, this tool will slip the multicam clip out of sync. The slide function can be used as this rolls two edit points at the same time.

Once you've finished editing the multicam clip in your project, don't forget to close the Angle Viewer as this will greatly improve playback performance in the Timeline.

TIP

Hiding the Browser: Once you have the multicam clip into the Timeline, you don't really need to see the Browser or Inspector anymore. Close the Inspector if it's open with **Command-4** and close the Browser, which hides the library as well, from the **Window** menu or with **Control-Command-1**. This is especially useful when working on a MacBook Pro and will give you a great deal of space for the Angle Viewer and Viewer (see Figure 6.18).

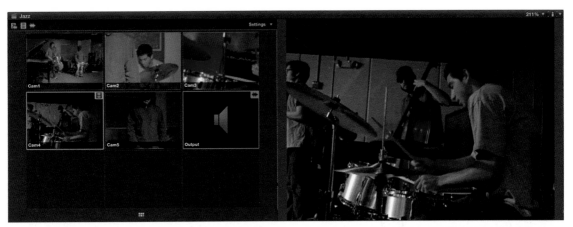

FIGURE 6.18
Angle viewer and viewer.

Effects

Multicam clips have a parent–child relationship. This is different from other clips that you edit from the Browser into the Timeline. Normally any clip edited into the Timeline takes the Browser clip's properties and settings, but once it's in the Timeline, it is completely independent. In the multicam clip, any changes made in the Angle Editor in one clip, whether the multicam clip has been opened from the Browser or a project, is applied to all instances that uses that multicam clip. Whether it's color correction, sync adjustment, effects, they will apply to all instances of the multicam clip in any project and to the multicam clip in the Browser. Color correction and other effects applied to an individual clip in the project will not affect the master multicam clip in the Browser, but any changes made in the Angle Editor will effect everything, so making a copy of the multicam clip in the Browser is a good idea. This does not duplicate the number of clips or increase the drive space. On the other hand, doing color correction in the Angle Editor has the advantage that every instance of a shot used will have the same color correction applied. Let's look at this:

1. Start by selecting the *Jazz* multicam clip in the Browser and duplicating it with **Command-D**. A new multicam clip is created called *Jazz copy*.
2. Switch to the Timeline and select the first clip in the *Jazz* project, which should be *V: Cam4 | A: Output*.
3. Open the Effect Browser (**Command-5**), and find the **Bokeh Random** effect and double-click. The effect is applied to the first clip.
4. Skim through the Timeline and see whether there are other uses of *Cam4*, and you'll see that no effect has been applied.
5. Switch back to the Browser (**Command-1**) and double-click the *Jazz* multicam clip, not the *Jazz copy*. You want the one that's used in the Timeline.

6. In the Angle Editor, select *Cam1*; make sure it's set as the monitoring angle, and go to the Color Board (**Command-6**).
7. In the Color tab that opens, drag the puck that's farthest left up into the green, giving the image an overall nasty green tint.
8. Use **Command-[** (left bracket) to switch back to the *Jazz* project.
9. Skim through the Timeline, and you'll notice that the green color has been applied to every time you have cut to that angle.
10. Right-click on one of the other angles and select **Activity Video Angle>Cam1**. The shot will be switched to that angle, and the green color effect will have been applied (see Figure 6.19).

FIGURE 6.19
Color-effected angles in the timeline.

This is obviously an exaggerated effect, but this is the best way to do color correction for multicam clip. Simply do it in the Angle Editor.

We opened the Angle Editor by opening the clip from the Browser, but if you want, you can also open the Angle Editor directly from the Timeline with either the shortcut menu or simply my double-clicking on one of the shots in the Timeline.

Channel Configurations

Sometimes you may need to change the audio for a specific angle or even to add audio from another angle into a shot in the Timeline.

1. Select one of the angles in the Timeline and use the **Clip** menu to **Expand Audio/Video Components** or use the shortcut **Control-Option-S**.
2. In the Audio inspector's Channel Configuration area, you should see only *Output* checked on.
3. In Channel Configurations, notice that *Cam1*, *Cam2*, and *Cam3* are Dual Mono. Click on the Dual Mono popup and first uncheck **Use Event Clip Layout**.
4. Then for each angle *Cam1*, *Cam2*, and *Cam3*, select **Stereo** in the popup (see Figure 6.20), which will change Dual Mono to Stereo and automatically activate the channel.

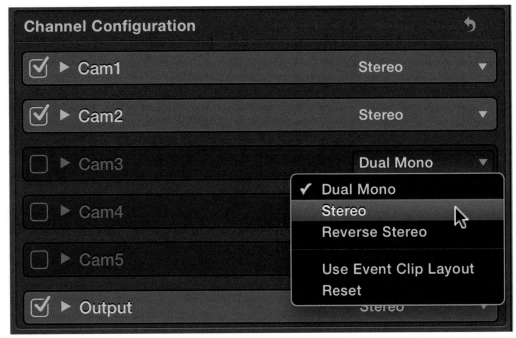

FIGURE 6.20
Channel configurations.

This is only for demonstration purposes as this is something you really don't want to do in this project. This will activate the sound for those angles, and they will appear in the Timeline (see Figure 6.21). Here, you can adjust the audio levels for each angle and animate them as needed, fading them in and out. You can also extend channels to do split edits, and if necessary, you can also use **Detach Audio** to give you even greater flexibility and control of your audio.

When you're done, you can use **Collapse the Video/Audio Components** to close the channels, or the same shortcut can be used to expand them, **Control-Option-S**.

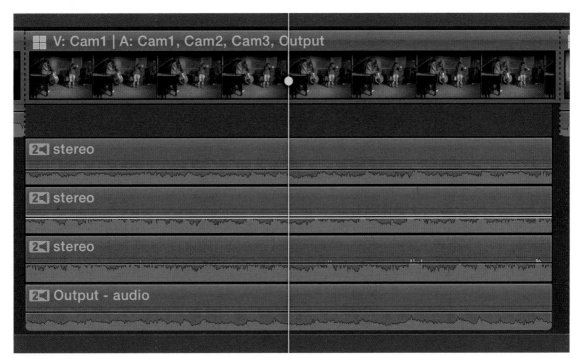

FIGURE 6.21
Channels in the timeline.

SUMMARY

In this chapter, we looked at FCP's multicam editing features, creating the multicam clip, using the multicam editor, and working in the angle viewer to edit our project. We also looked at applying effects and working with Channel Configurations. In the next chapter, we will look at some titling effects and working with still images in FCP.

Adding Titles and Still Images

Every program is enhanced with graphics, whether they are a simple opening title and closing credits or elaborate motion-graphics sequences illuminating some obscure point that can be best expressed in animation. This could be simply a map with a path snaking across it or a full-scale 3D animation explaining the details of how an airplane is built. Obviously, the latter is beyond the scope of both this book and of Final Cut Pro alone, but many simpler graphics can be created easily within FCP. More advanced motion graphics can be done in FCP's companion application, Motion, but that would be the subject for another book. In this chapter, we'll look at some typical titling problems and how to deal with them and details on how to enhance your titles. In addition, we'll look at working with still images. As always, we begin by loading the project.

SETTING UP THE PROJECT

For this chapter, we'll use the *BB7* library. If you haven't downloaded the material, download *BB7.zip* from the www.fcpxbook.com website.

1. Once the file is downloaded, copy or move it to the top level of your dedicated media drive.
2. Double-click the ZIP file to open it.
3. Double-click the *BB7* library to launch the application.

> **NOTE**
>
> *H.264:* The media files that accompany this book are heavily compressed H.264 files. Playing back this media requires a fast computer. If you have difficulty playing back the media, you should transcode it to proxy media as in the previous chapters.

TEXT STYLES

Let's look at FCP's titling options. We'll begin by applying the Basic Title and working with its controls.

Text styles can be easily built and saved in FCP. Each title has two inspectors, a Title inspector, which is different for each title, and a Text inspector, which is common to all titles. The Text inspector has separate controls for Face, Outline, Glow, and Drop Shadow. Let's apply some text and look at making styles.

1. Open the *Snow* project and make sure the playhead is at or near the end of the project.
2. Put the pointer over the second shot, *Mike run three tables,* and press the **X** key to make an edit selection.
3. Press **Control-T** to apply the Basic Title. Normally Basic Title is 10 seconds, but it has taken its duration from the edit selection. There is a Basic Lower Third (**Shift-Control-T**). These simple titles can be useful as place holders.
4. Double-click the Basic Title in the Timeline, which does three things, selects the title, moves the playhead over the title, and selects the text in the Viewer ready to edit.
5. Type *snow*, lower case, and press the **Escape** key.
6. In the Inspector, switch from Title to Text. At the top is the text entry box where you can change the text. It includes a spellchecker and will offer spelling suggestions. Incorrectly spelled words that aren't proper names will appear with squiggly red lines underneath them.
7. Change the font to something bold like Adobe Gothic Std or Ariel Black, which is very widely used because of its easy legibility.
8. Push Size up to about 350, which is beyond the slider range. Either dial into the value box or double-click in the box and use the scroll to make it nice and large.
9. Double-click in the Tracking value box and using the mouse scroll wheel (or stroke on a Magic Mouse), tightening the tracking a little to about −10 or −12. Not too much as we'll be adding other elements.
10. A little lower down check on All Caps.
11. Try the All Caps Size, which has a different effect from the font Size controls.
12. Use the triangle pop-up at the end, which every parameter has, to **Reset Parameter** (see Figure 7.1).

FIGURE 7.1
Titles browser.

Let's move the text lower in the frame, but before we do that, we'll change the color, or the white text will get lost in the white snow.

1. From the Viewer options, the switch in the upper right corner, select at the bottom of the list **Show Title/Action Safe Zones**.
2. With the text block selected in the Timeline, grab the text in the Viewer and drag it down so that the text sits on the safe title line and the alignment guide keeps it centered (see Figure 7.2).
3. Double-click the Face bar to open it or click on the **Show** button. Here are basic color controls including an Opacity slider and a Blur slider that allow you to adjust the look and create interesting compositing effects.
4. In the Fill With Popup, select **Gradient** and twirl it open with the disclosure triangle (see Figure 7.3).

There are four color swatches for gradients and more can be added. The two on the top bar that's white effect the transparency of the gradient; the two on the bottom effect the colors. By adding more stops in the gradient, you can make a rainbow gradient if you really wanted to. You can use the RGB sliders to colorize any of the colors. You can change the interpolation of the gradient, the type of gradient from Linear to Radial, and the Angle of the gradient. We're not going to do everything, but let's add some color to the gradient.

1. Select the lower left gradient to change its color. With it selected, you can use the color swatch underneath it, or you can right-click on the color stop that's called RGB1 to open the color HUD (see Figure 7.4).
2. Make the gradient start color bright yellow, and by right-clicking on the color stop at the end, make the color bright red.

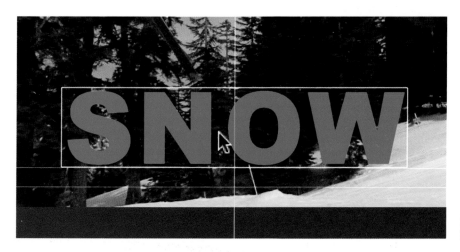

FIGURE 7.2
Positioning text.

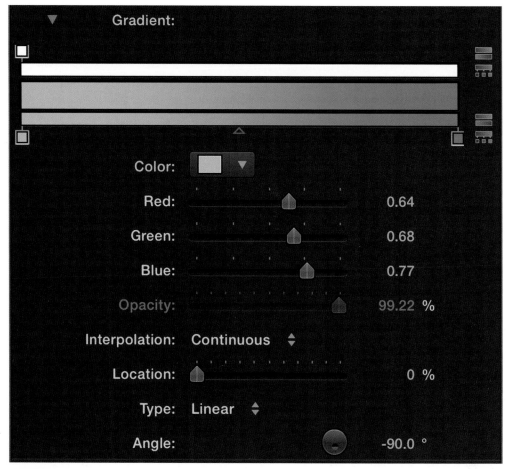

FIGURE 7.3
Gradient controls.

FIGURE 7.4
RGB1 color
gradient start.

3. Click on the lower bar to add another color stop about halfway down the bar (see Figure 7.5).
4. Try different colors for the middle stop, but rather than keeping the color, just drag the middle stop down away from the bar so that it disappears in a puff of smoke.
5. Move the red end color to the left so that it's more prominent, and move the central triangle a little to the left so that there's less of the yellow (see Figure 7.6).
6. Right-click on the white color stop at the end of the upper bar and set the color to black. You can set any color you want but only the luminance values are effected. This will make the bottom edge of the title transparent.
7. Move the black end stop a little to the left so that the transparency falls off more quickly (see Figure 7.7).

FIGURE 7.5
Adding a gradient color.

FIGURE 7.6
Adjusting the end color position.

FIGURE 7.7
Adjusting the end transparency.

You can go on playing with this, but let's move on to Outline and Glow.

1. First remove the transparency control in the Gradient so that the title is opaque. Do this by pulling the black end stop off the transparency bar so that the whole bar is white.
2. Open Outline and activate it with the blue LED button on the left end of the bar. Outline has basically the same controls as Face except it defaults to bright red.
3. Leave the color and push up the Width to about 4.
4. Activate Glow and push up the Radius to about 25.
5. Double-click the Blur value and use the scroll function to make the value about 100 to add a soft yellow halo to the image.
6. Activate Drop Shadow and make the Distance about 50 and soften it a little with the Blur slider.

Your title should look something like Figure 7.8. So this is not something you're likely to use everyday, but you may have spend quite a bit of time tinkering with it, so you want to save it.

1. At the top of the Text inspector is a large button that says Normal, even if the text doesn't look it. Click on it, and you get three options: **Save Format Options**, **Save Style Options**, and **Save All Format+Style Options**.
2. Select the third one and name it *Yellow-Red Gradient with Glow & Drop*.
3. To apply the Format and Style to another title, simply select it from its alphabetical location in the list (see Figure 7.9).

If you saved format only, this would apply the basic functions to the text, font, size, tracking, alignment, and so on. If you saved the style, it would save Face, Outline, Glow, and Drop Shadow, allowing you to apply the colors and look of the title to other fonts and sizes. If you work a lot with this, you can quickly build up a great many styles and formats. At some point, you might want to clear some of them out.

1. In the Finder, hold the **Option** key, and from the **Go** menu, select **Library**, which takes you to the hidden home Library.
2. Go to *Application Support* and find the *Motion* folder. This folder is shared with the Motion 5 application, but it is available even if you do not have Motion installed.
3. Go to *Library/Text Styles*, and you'll find the saved styles and formats. There'll be two files for each, a .molo file, which is the style itself, and a .png file, which is the icon display in the Text inspector menu.
4. Select the ones you no longer need and send them to the Trash.

FIGURE 7.8
Snow title.

FIGURE 7.9
Saved format and style.

> **TIP**
>
> *Moving Text Up or Down:* In addition to moving the text up or down by dragging it, you can also raise and lower the text by adjust the Baseline value. This is handy when using oversized fonts such as we're using and the text is sitting too high in the frame, not appearing centered as you might like.

TITLES

The Title browser is broken down into groups of titles. In all, there are 177 titles including sets of titles that are grouped thematically. Obviously we can't go through every single title as there are so many, but I would like to point out a few which have special behaviors or are representative of certain types of title in FCP.

Title Groups

The first group is called Build In/Build Out? What is Build In/Out you're probably asking. You need to understand that all the titles and effects and transitions in FCP are created using Motion 5. Almost all of them involve some sort of animation to bring the text onto the screen and to take the text off the screen. The Build In function moves or fades the text into place. The Build Out function takes it away.

Select the very first title **Assembler**, which is a complex Build In/Build Out title. To preview the animations, you can either skim over it with the pointer or, better yet, click on it and press the **forward slash** key, which plays the title from the beginning. The preview will play in a looped mode in the Viewer. There are a number of titles such as this that have multiple lines of text that come onto the screen sequentially. Let's look at how to work this one.

1. Move the playhead to the beginning of the third clip, *trash can2*, and double-click **Assembler** to connect it to the storyline. At 10 seconds, it is one of the longer titles.
2. Drag the end of the title to shorten it so that the end snaps to the end of the fourth shot, *Kevin 3 tables*.
3. Double-click the title in the Timeline, which moves the playhead and highlights the first of the five text blocks.
4. Open the Face controls and click the color swatch, not the popup color HUD.
5. In the Apple Color Picker, select a nice red color for the text and drag it from the bar at the top into the swatches drawer to save it (see Figure 7.10). This is a system-wide color picker so this color is saved for use in every application that can use this color picker, including Photoshop.
6. Double-click the next text block, *SUBTITLE*, and click the color swatch in the Face controls and then click the saved color swatch to make them all the same red.

FIGURE 7.10
Apple color picker.

7. Do the same for *DESCRIPTION*, make Face the same red, then make the font Bold and the Size 45.
8. Double-click *INFORMATION* and delete it, and do the same for *MORE*.
9. Double-click *DESCRIPTION*, and with the other line gone, grab the target button at the head of the text and drag it up closer to *TITLE* and *SUBTITLE*.
10. The title fades out at the end, but I would like it to just cut out with the end of the shot. In the Title inspector are two checkboxes, one for Build In and one for Build Out. Uncheck Build Out to switch off the fade.

This is typical of the type of controls you can use to adjust some titles that have multiple lines of text. Let's look at another of the Build In/Build Out titles that has more complex controls. Let's try Fold in the same category, which has a drop zone.

1. Move the pointer over the next clip, *trash can3*, and press the **X** key to make an edit selection.

TIP

RGB Colors in the Color Picker: If you need to set exact RGB or HSB values for a color, you can do that in the Apple Color Picker. Click on the second button on the top row and change the sliders popup to RGB or HSB sliders (see Figure 7.11). Type in the exact values you need to enter.

FIGURE 7.11
RGB controls.

2. Find the **Fold** title and double-click it to connect it to the clip with the same duration. The titles Build In and Build Out animations will just fit in clip duration.
3. Double-click the title in the Timeline, which moves the playhead and highlights the first text block.
4. Type in *SNOW* in caps and press the **Escape** key to drop the text editor.
5. Open the Title inspector to give you the controls (see Figure 7.12), which are more extensive than **Assembler**.
6. Change the font to something bolder like **HeadLineA** or something else you prefer.
7. Increase Size with the slider or scroll function so that it is as large as the box it's adjacent to.
8. Change the color to something bright that will stand out against the background.

FIGURE 7.12
Fold controls.

9. Change the Subtitle Font to the same as the title and make it much bigger.
10. Double-click *INFORMATION* and delete it, and do the same for *DESCRIPTION*, then make *SUBTITLE* even bigger.
11. Double-click *SUBTITLE* and type in *VALLEY*, using the target to align it with the center of the adjacent block.
12. Click the Subtitle Color popup and use the color HUD to select a nice bright color that will stand out against the bright snow.
13. Click the Shape Fill Color swatch, not the popup for the color HUD, and in the Apple Color Picker, either use the magnifying glass to pick the same color as *VALLEY* or try a different color.

Now that we've got the text set up nicely, let's look at putting something in the Drop Zone.

1. Click in the Drop Zone Well in the Title inspector.
2. In the Browser, find the *Sutton* still image (it's in the *Graphics* Smart Collection) and select it.
3. In the Viewer, click the **Apply Clip** button in the lower to load the image into the Drop Zone (see Figure 7.13).

You can load any image you want including moving video; however, you have to be careful how it aligns in the box.

Next we'll take a quick look at **Keynote** in the Bumper/Opener category.

1. Put the playhead at the beginning of the next clip, *ryan mike n tyler*.
2. In the Bumper/Opener category, find the **Keynote** title, select it, and press the **Q** key.

This is another long informational title. You can shorten it somewhat, but if you shorten it too much, the build out gets cut off. What seems to confuse people

FIGURE 7.13
Selecting the drop zone.

FIGURE 7.14
Keynote.

with this title is that the area on the left is not the Drop Zone (see Figure 7.14). The title appears with the video embedded in it, swinging open at the start to reveal the title together with the underlying video. In the Title inspector (see Figure 7.15), you can use the Text Placement popup to flip the text from the

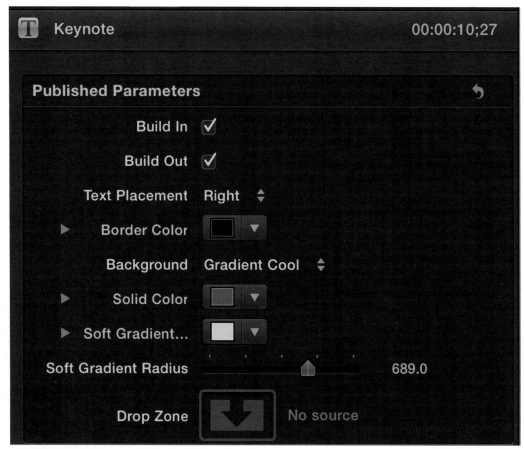

FIGURE 7.15
Keynote controls.

right to the left, use Border Color to change it from the default black, and you have various other gradient controls to adjust the shading of the background. And there's the Drop Zone at the bottom. Let's use that:

1. Change the Background popup from one of the gradients to Drop Zone.
2. Click in the Drop Zone well at the bottom.
3. In the Browser, find the *Sutton2* image, select it, and in the Viewer, click the **Apply Clip** button, which places it as the background for the text.

Another Bumper/Opener title I really like is Pull Focus, which racks the focus from the background image to the foreground title and then back again, throwing the title out of focus and bringing the background video back into focus.

Many of the Bumper/Opener titles are full screen titles as you might expect. Quite a number are mainly full screen, but then open up to reveal the underlying

video. In the Event group is Ribbon, which isn't quite appropriate for this video, but very popular for weddings and typical of the revealing open type of title. Let's see how to work with it as an open.

1. Move the playhead to the beginning of the project and press **Option-W** to insert a Gap Clip. This is one of the few edits that doesn't move the playhead regardless of your Editing preference.
2. Find the **Ribbon** title in the Event group in the Bumper/Opener category and press the **Q** key to connect it to the beginning of the project.
3. Switch to the Timeline with **Command-2** and use the **Up arrow** key to move back to the edit at the end of the Gap Clip.
4. Press the **left bracket** key to select the left side of the edit in ripple mode.
5. Hold down the **Right arrow** key to step through the title until the curve sweeps down from the top of the frame and then with the **Left arrow** key back till just before the curve sweeps into the frame.
6. Press **Shift-X** to do an Extend edit to move ripple the Gap Clip underneath the title so that it ends just before the first shot begins and the curve moves across the frame to reveal the underlying shot (see Figure 7.16).

FIGURE 7.16
Ribbon title edit.

The Credits group includes a basic two-column scrolling title template as well as the basic movie trailer template. Let's look at working with Scrolling first and see some of the adjustments that can be made there.

1. Move the playhead to the end of the project, and in the Title browser's Credits category, select Scrolling.
2. Press the **E** key to append it to the end of the project. The title is actually transparent, so over nothing, it appears as white on black. You could scroll it over video or a background if you wished.
3. The only Title parameters are Reduce Flicker, which lets you set the field type used, whether progressive or interlaced, and Blur. The faster the title, the more blur you should add.
4. Double-click the middle of the Scrolling text block in the Timeline to place the playhead and select all the text.
5. If you want to delete the large *TITLE*, double-click and delete it and the line below it to bring up the rest of the text.

FIGURE 7.17
Scrolling title.

6. Double-click the first *Name* and the last *Description* and click the ruler button in the upper right of the Viewer, which shows the ruler and the two tabs used for the gutter (see Figure 7.17).

7. Adjust the size of the gutter as desired by moving the tabs closer or farther apart.

8. To add more lines, use the **arrow** keys to move the cursor to the end of the last *DESCRIPTION* and press the **Return** key and then **Tab** key to move to the alignment gutter.

9. Type in left side text, then press the **Tab** key to go to the right side, and type in right side text.

10. Once you have the text loaded in, press the **Escape** key to drop the text block in the Viewer and select the Scrolling text block in the Timeline.

11. Press the **forward slash** key to preview the scroll and set the speed. To slow down the scroll, drag the end of the text block to make it longer. To speed up the text, block the end to make it shorter.

In Scrolling, names are on the left and descriptions are on the right, although it is more traditional to put the job title on the left and the name on the right.

> **TIP**
>
> *Photoshop Scroll:* Another popular way of creating a long scrolling title is to build it in Photoshop as a very long image. When you place it in the Timeline, you have to make sure the Spatial Conform in the Video inspector is set to None, and then you can animate the Position of the file to move it up the screen.

> **TIP**
>
> *Background:* If you place text over nothing in the Timeline, the blackness you see in the Viewer behind the clip is the emptiness of space. To make it a little easier to see some of the text types, go to user **Preferences**, and in the **Playback** tab, set **Player Background** to **Checkerboard**.

> **NOTE**
>
> *Video RAM:* When working with large format still images, make sure you have a good video card and at least 1G of VRAM. The integrated graphics card that sometimes comes with 512MB will not be sufficient, even though it meets FCPX's minimum system requirements. In this case, you should reduce the size of the image to less than 4000 pixels across or perhaps smaller.

Another common Credits title is the Trailer. The title comes with a number of graphically interesting, but limited choices. One thing trailer cannot do is to make the basic white on black text. To make that, you would need to modify the Trailer title in Motion 5. If you don't have Motion, you won't be able to follow along with the next couple of titles, but let me show you how you can make this title the way you want it to give you an idea of what the combination of Final Cut Pro and Motion can do.

1. Find the Trailer title in the Title Browser, right-click on it and select **Open a copy in Motion**, which launches that application.
2. Make sure the Layers panel is open by pressing **Command**-4.
3. Twirl open the Text group with the disclosure triangle and using **Shift**-click, select all the text blocks in the group (see Figure 7.18).
4. If it's not open, open the text HUD with **F7** (or **fn-F7** depending on your keyboard). The HUD gives you basic text controls like text, size, alignment, and tracking. There is also a color swatch and a color popup. Select that and make the text white.
5. In the Layers panel, uncheck the Background layer to switch it off.
6. Use **File>Save As** (**Shift-Command-S**) to bring up the Save dialog.
7. Name the Template **B&W Trailer**, set the Category set to Credits, Theme to None, uncheck **Include Unused Media** and **Save Preview Movie**.

FIGURE 7.18
Motion text layers.

8. Click **Publish** and switch back to FCP.
9. Put the playhead at the end of the project, select the **B&W Trailer** in the Credits category, and press **E** to append the text.

All that's left for you is to fill in the text in the Viewer.

Another common request is to change the colors used in the Sports themes from the basic blue to red or green or yellow or some other team color. This is a bit more complicated, but not that difficult to do. Even I, who am far from an expert in Motion, have been able to figure out at least one way to do it. I'm sure there are others.

1. In the Elements category, find the **Stats** title in the Sports theme right at the bottom of the category, right-click and again use **Open a copy in Motion**.
2. Again make sure the Layers panel is open by pressing **Command**-4.
3. Twirl open the *Stats* group and inside it the *Group* section.
4. **Command**-click *Glints*, *Boxes*, *Swooshes*, *Stats Glass*, and *Title Source* to select them (see Figure 7.19).
5. With layers selected, go to the **Effects** button in the Toolbar (same icon as Effects in FCP), and click on it to go to **Color Correction>Colorize** (see Figure 7.20). You have applied five copies of the effect to five different layers.
6. You need to twirl each of the separate layers to find the Colorize effect that has been applied to them. Start by selecting the Colorize effect for *Stats Glass* layer.
7. If it's not open, open the text HUD with **F7** (or **fn-F7** depending on your keyboard). The HUD gives you basic Colorize controls to **Remap Black to** and **Remap White to**. Make the black color a very dark shade of the color your want, like a very deep red, and make the white color a light shade of the same color (see Figure 7.21).
8. Open the Apple Color Picker and select each of the colors you used and save them in swatches drawer.
9. Repeat by selecting the *Glints* Colorize effect in the Layers panel and clicking on black and applying the saved dark color, and clicking on white and applying the saved light color.
10. Repeat for the *Boxes* Colorize effect and the *Swooshes* Colorize effect.
11. Do the same for the *Title Source* Colorize effect, but this time map white to an even brighten almost white color. Your completed title might look something like Figure 7.22.
12. Use **Shift-Command-S** and name the Template **Red Stats** (or whatever color you used), set the Category set to Elements, Theme to Sports, uncheck **Include Unused Media**, but check on **Save Preview Movie**.
13. Click **Publish** and wait for the movie to be processed. This gives you the animation in the Title browser.
14. Switch back to FCP, put the pointer over the *tracking* clip, and press the **X** key.
15. Double-click **Red Stats** to add it to connect it to the shot.

Add in the skier's name, and when you get his headshot and the ski area logo, put them in the Drop Zones.

The custom titles, as well as any effects, transitions, or generators you customize or create for FCP, are stored in your home Movies folder. They are inside the Motion Templates folder (see Figure 7.23). If you ever need to modify the **Red Stat** title or any other custom Motion project, either right-click on it inside FCP or open the Motion project file found inside Motion Templates.

FIGURE 7.19
Selected stats layers.

Text and the Screen

Unless you're going to make text fairly large, it's best to avoid serif fonts. You should probably avoid small fonts as well. Video resolution is not very high—the print equivalent of either 72 dpi or 96 dpi. You could read this book in

FIGURE 7.20
Effects>Color
Correction>Colorize.

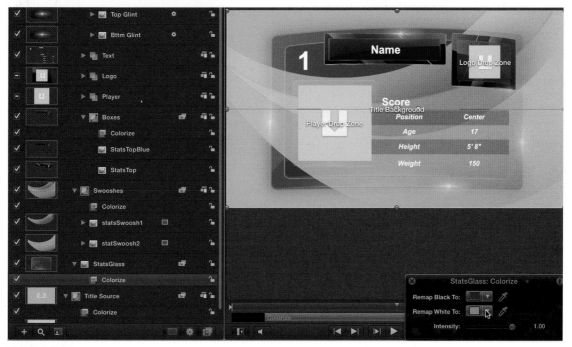

FIGURE 7.21
StatsGlass colorized.

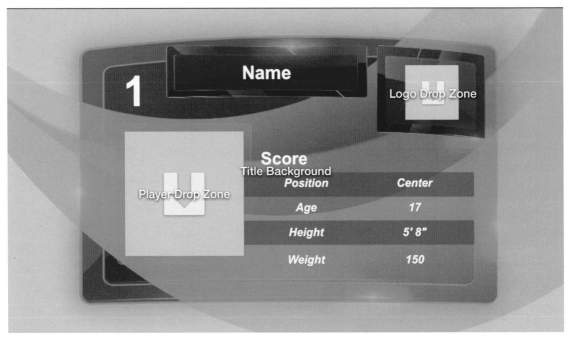

FIGURE 7.22
Red stats.

Compositions ▸	Credits ▸	Sports ▸	Red Stats ▸	large.png
Effects ▸	Elements ▸			Media ▸
Generators ▸				Red Stats.moti
templateThemes				Red Stats.mov
Titles ▸				small.png
Transitions ▸				

FIGURE 7.23
Motion template folder contents.

10-point type comfortably, but a 10-point line of text on television would be an illegible smear. I generally don't use font sizes smaller than 24 point and prefer to use something larger if possible, depending on the font structure and clarity.

Most of the titling tools in FCP do not have word wrapping. This means that as you type the text, it will type right off the screen. For your video to wrap the text onto another line, you need to manually enter returns in your text as you type across the screen when you get to the edge of the Safe Title Area. What you see in the Viewer is not what you get and can vary substantially from television to television. What's within the Safe Action Area will appear on every television set. A smaller area is defined as the Safe Title Area in which text could appear without distortion if viewed at an angle. Titles should remain,

if possible, within the STA. This is not important for graphics destined only for web or computer display, but for anything that might be shown on a television within the course of its life, it would be best to maintain them. That said, you will often see titles that are well outside the STA and lying partially outside even the SAA. Even with modern digital 16:9 flat screens, observing STA and SAA is best practice.

If you're editing in 16:9, FCP only shows 16:9 safe action and title. Unfortunately TV stations have to allow for the many people who have 4:3 TVs and insist on using "center cut" in their setup because they don't like letterboxing. This is the bane of all television and makes editing a horrible nightmare and often produces less than optimal results. Actors have to be framed for center cut. You have to allow for entrances and exits based on center cut or some compromise. There is no good way around this. To help you, you should probably make up a transparent Photoshop file with center cut markings that you can add on top of your video while you're working.

Find and Replace

A great feature in FCP's titling tools is the ability to easily change text that perhaps was misspelled or had the wrong title.

1. Use **Find and Replace Title Text** from the bottom of the **Edit** menu.
2. In the dialog that appears, type in *SNOW* in the Find box and *SQUAW* in the Replace box.
3. Click the **Next** button to find the word and then click **Replace** to change it.

If you have multiple instances, you could check each in turn or globally replace the word.

CUSTOM ANIMATION

One of the features of the **Custom** title is its ability to be customized, hence its name. Let's apply the title and see how we can use the Build In/Out tools to bring the text onto the screen. Unlike keyframing, the build durations are set in Motion. Here, no keyframes are added because the animation brings the title onto the screen to its presentation setting, and from that, off the screen. First, let's set up the background and text:

1. Start by removing the **Keynote** title from the long *ryan mike n tyler* shot in the project.
2. Put the pointer over the shot in the Timeline and press the **X** key to make an edit selection.
3. Find the **Custom** title in the Build In/Out group, select it, and press the **Q** key to connect it.

4. Double-click the text block in the Timeline and type into the Viewer *Ryan Mike & Tyler*.
5. In the Text inspector, triple-click the text at the top to select it all.
6. Set the font to Arial Black, the Size to 100, and turn on the **Drop Shadow**.
7. Push the **Drop Shadow Distance** up to 18 and set the **Opacity** to 100%.

That's the text and video set up. You're now ready to create the custom Build In and Build Out in the Title tab of the Inspector. The controls look daunting (see Figure 7.24), but using them is easier than it appears. The controls are broken into two equal halves—the first set from In Opacity to In Duration controls bringing the text onto the screen, and the same controls from Out Opacity to Out Duration controls taking the text off the screen. When you're setting up the In controls, you're setting up the start of the Build In; the end of the build is where the text is now—in the center of the screen. Similarly, when you're applying the Build Out, you're applying its end position; its start position for the Build Out is its current position in the center of the screen. The default durations for the animations are 40 frames; you can change that with the In Duration and Out Duration sliders. Let's build a little Custom animation:

1. Start by moving the playhead near the beginning of the text block so you can see what's happening in your animation.
2. The Title inspector **In Unit Size** defaults to **Character**, which means each letter is handled separately. Set this to **Line**, which means the line of text will be handled as one unit.
3. Leave the **In Sequencing** set to **From**, so we'll be setting the position from which the animation will sequence.
4. Change **In Speed** from **Constant** to **Ease Out** so that the animation will have some deceleration as it comes to a stop.
5. Set the **In Blur** to 50, which will start the image as very blurry.
6. Set the **In Tracking** to 300, which will make it very wide.
7. Set the **In Scale** value to 300%, which will make it very big.
8. Set the **In Position** Y value to 55, which will take it out of the frame.
9. Set the **In Duration** to 60.
10. Play back your Build In animation.

Let's repeat the process, only in reverse. Let's do the Build Out:

1. Change the Out Unit **Size** to **Line**.
2. Change the **Out Speed** to **Ease In** so it accelerates.
3. Set the **Out Blur** to **50** and the **Out Tracking** to **300**.
4. Set the **Out Duration** to **60**.
5. Set the **Out Position** Y value to −65 so the text goes off the bottom of the screen.

That's it! You've done your first Custom animation. We'll do more animations using keyframes in the chapters ahead.

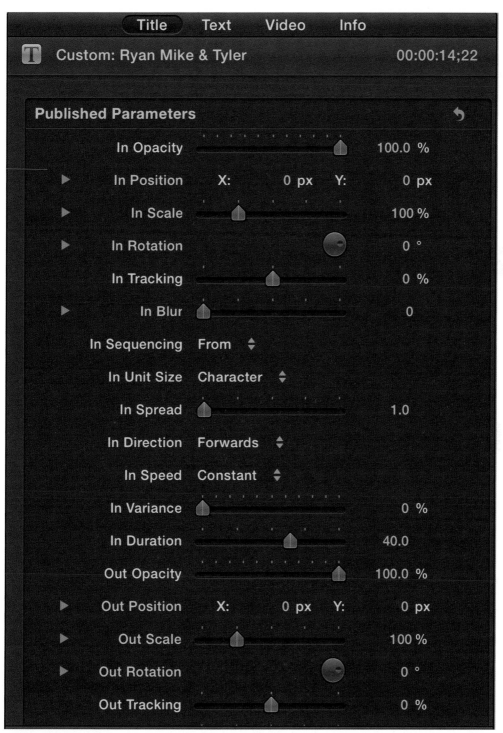

FIGURE 7.24
Custom title controls.

COMPOUND TITLES

One of the strengths of Final Cut Pro has always been its ability to make complex layered titles. That is still the case in FCPX. Let's start with a new project, and we'll create a custom title composite that will give you some idea of what you can do with these title tools.

Text

1. Start by making a new project called *Compound Title* and saving it in the *Snow* event.
2. In the browser, find *Mike run 3 tables* and append the whole shot into the Timeline with **E**.
3. Put the playhead at the 2:00 point in the project. That's where we'll add the title.
4. In the Build In/Build Out category, find the **Fade** title and double-click it to add it to the Timeline on top of the picture. This title has some parameter controls.
5. In the Title inspector, set the **In Size** to **Line** and the **Out Size** to **Line** as well.
6. Double-click the text in the Viewer to select it and type in *BEAR VALLEY* to replace *Title*.
7. You can use whatever font, color, or settings you want, but for this demonstration, I'm going to use the following settings:

Font	Arial Black
Size	120
Face	White
Outline	Black
Outline Width	4
Outline Blur	1.5
Drop Shadow Opacity	100
Drop Shadow Blur	3
Drop Shadow Distance	16

Texture

1. Put the pointer over the title in the Timeline and press the **X** key to make an edit selection.
2. From the Generators browser in the Textures category, find the **Grunge** texture and press the **Q** key to connect it to the primary storyline.
3. The texture is on top, so grab the title and drag it straight up so that it's on top of the texture. Hold the **Shift** key to constrain the vertical drag.

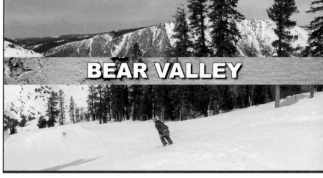

FIGURE 7.25
Crop controls.

4. We'll look at cropping in more detail in Chapter 10, but for now select the texture in the Timeline, and in the Video inspector, double-click the **Crop** function (or click **Show**) to open the controls (see Figure 7.25).
5. With the texture still selected, go to the Generator inspector and change the **Texture** to *texture 12*.
6. In the Video inspector, set the **Opacity** to 60%.

Because we have the text fading in, we want to fade in the background as well:

1. With the texture selected in the Timeline, press **Control-V** to open Video Animations.
2. Double-click **Opacity** to open up the graph area and drag the start fade button to the right to 1:10, which is 40 frames, the same as the title fade (see Figure 7.26).
3. Drag the fade button at the end to the same 1:10 to fade out the texture.
4. Close Video Animations with **Control-V**.
5. To lengthen the two items, select them and press **Control-D** for the duration in the Dashboard.
6. Type in *+100* and press **Enter** to make the title elements one second longer.

FIGURE 7.26
Opacity fade button.

Because the animations are not based on keyframes, they are not linked to a specific time reference, the animations are still the same length.

Putting It All Together

1. Select both items in the Timeline by drag-selecting through them or **Command**-clicking them.
2. Use **File>New>Compound Clip** or press the keyboard shortcut **Option-G** to convert the title elements into a Compound Clip.

3. Name the compound *Bear Valley* and save it in the *Snow* event.
4. Select the *Bear Valley* Compound Clip in the Browser and duplicate it with **Command-D**.
5. Rename the duplicate *Squaw Valley*.
6. Double-click the *Squaw Valley* Compound Clip, which opens it into the Timeline, and change the text layer to read *SQUAW VALLEY*.

A Compound Clip is like a sequence, but it is also like a clip in a sequence. If you want to apply an effect to it or reposition the block—lower in the frame, for instance—you can do this without adjusting each layer individually. We'll look at applying effects in the next chapter, as well as animating images about the screen in Chapter 10.

STILL IMAGES

Often you must work with still images, photographs, or graphics generated in a graphics application such as Photoshop or Pixelmator. FCPX will accept images in different modes including 16-bit RGB, CMYK, and grayscale images, but not Lab mode. FCP works with a variety of different formats, JPG, TIFF, PNG, Photoshop, and others. It can also import multilayered Photoshop files as well as Canon RAW files; however, because of their large size, it's better to convert the RAW files to something like PNG at a size closer to the video format you're working in.

The Photoshop file can be edited into any project. It behaves just like a Compound Clip, although it does have a different icon.

1. Find the *Curtain.psd* file in the Browser.
2. Double-click it to open it into the Timeline or right-click and use **Open in Timeline.**

When the file is open in the Timeline, you can access the layers and manipulate them as you like using the transform function. You can change the transparency and reorder the layer stack. You can use the transform functions, and even add effects to individual layers. You can even add other elements like titles and other graphics; however, when you do that the Photoshop file can no longer be opened in Photoshop and the layers icon will change to a regular compound clip icon.

Changes made to images in Photoshop or other image editing application will be recognized in FCP. You should not reorder or add or remove layers or switch off transparency in an application outside of FCP. Any other changes will be updated in the FCP event and Timeline automatically. The only thing that will not be tolerated is if the file is renamed.

1. Right-click on the *Curtain.psd* file in the Browser and use **Reveal in Finder (Shift-Command-R)**, which will take you to the *Original Media* folder inside the *Snow* library bundle.
2. Right-click on it and select **Open With** and select the image editing application you prefer. For this, I'll be using Photoshop. Your application will probably have different options.
3. Select *Layer 1* and select **Image>Adjustments>Hue/Saturation**.

4. Check on **Colorize** and **Preview**.
5. Adjust the HSL settings to tint the curtain a deep, royal blue.
6. Double-click the *Curtain* layer Drop Shadow effect, and in the controls, add in Bevel Emboss and Satin.
7. With the *Curtain* layer selected, use **Layer>Smart Objects>Convert to Smart Object**.
8. Save the file and switch back to FCP.

All the changes you made in Photoshop will appear in the FCP Browser and anywhere you used the clip in the application.

Recent versions of Photoshop have presets for working in DV, NTSC and PAL, 4:3, as well as widescreen. You should use these presets whenever you're making a multilayer or transparent image for use with FCPX. For HDV material, use either the HDV 1440×1080 anamorphic preset if you're working in 1080i or the HDV 720 preset if you're working in 720p. For other HD formats, use HDTV 1080p or HDV/HDTV 720p.

You will not always be working with images that conform to video formats. Sometimes your graphic will be much larger, one you might want to move around or to make it seem as if you're panning across the image or zooming in or out of the image. To do this, you need an image that's much greater in size than your video format. How much bigger depends on your creative needs, based on how much the image will need to be magnified. Magnification always requires more data, a larger frame size, to keep the image sharp.

When you import a graphic file into FCP and place it inside a project, FCP will scale the image to fit the dimensions of the format you're working in, scaling up if the image is smaller than the project and scaling down if it's larger. Here's how this works:

1. Go back to the *Compound Title* project in the Timeline.
2. In the Smart Collection *Graphics,* select the image called *Sutton* and go to the **Info** tab of the Inspector. The image is 5191×1497 pixels at 60fps, which is the maximum frame rate FCP uses.
3. Click on the preview in the Browser so that the user preference duration is selected; four seconds is the default. Then append the image into the project (see Figure 7.27). Because the aspect ratio is very different from the HD frame, the image is letterboxed, showing space at the top and bottom.
4. In the Video tab of the Inspector, you'll see that **Spatial Conform** is set to Fit. Change it to **Fill**. Then try **None**. With None set, the image is enlarged because the pixels in the image are spread out to their normal width.
5. Click in the preview to select the *Sutton2* image in the Browser and append that into the project. Because the aspect ratio of the image is 4:3 rather than wide screen, pillarboxing will appear on the sides of the image.
6. Set the **Spatial Conform** to **None**, and you can see the image is quite a bit larger than the frame. Set it to **Fill** so that the image fills the frame with no pillarboxing.
7. Finally, click in the preview to select the *Sutton3* image in the browser and append that into the project. This image will also be made to fit the frame.

8. If you set its **Spatial Conform** to **Fill**, the image will be scaled up further. Now set the **Spatial Conform** to **None**. The image is much smaller than the frame. Once again, the system displays the image at the normal size, but there aren't enough pixels to fill the frame, much less provide additional space to support zooms.

Because FCP is scaling the *Sutton3* image to fit inside the frame, it may not be very sharp. Unfortunately, there is no easy way to tell how much scaling is being applied to an image. Generally, it's not considered a good idea to scale up an image over about 110%–115%. This image is clearly being scaled a lot further than that.

> **TIP**
>
> ***Still Image Duration:*** If you drag a still image into a project from the Finder or the media browser, it comes in at the default four-second duration, or whatever the user preference is set to. If you select a still in the browser, the selection is four seconds, and that's what's edited into the Timeline. But if you drag a still from the Browser to the Timeline without making a selection, or drag a group of still images from the browser into the project, they will be all 10 seconds in length. If you need to change the durations of the stills in the Timeline, simply select them, double-click the **Dashboard** for the duration dialog or press **Control-D**, type in a time value, and press the **Enter** key. All the selected stills will have their durations changed. You can also right-click on the selected images and use **Change Duration**.

FIGURE 7.27
Wide image in the viewer.

Resolution

For people who come from a print or photographic background, an important point to note is that video doesn't have a changeable resolution. It's not like print, where you can jam more and more pixels into an inch of space and make your print cleaner, clearer, and crisper. Pixels in video occupy a fixed space and have a fixed size, the equivalent of 72dpi in the print world. Dots per inch are a printing concern. Forget about printing resolution. Think in terms of size: The more pixels, the bigger the picture, just the way digital still cameras work. Don't think you can make an image 720 × 480 at a high resolution such as 300 dpi or 600 dpi and be able to scale it up and move it around in FCPX. Certainly, you'll be able to scale it up, but it will look soft, and if you scale it far enough—to 300%, for instance—the image will start to show pixelization. FCP is good at hiding the defects by blurring and softening, but the results are not really as good as they should be and become painfully evident on large-screen projection. FCP is a video application and deals only with pixel numbers, not with dots per inch.

Scanners, on the other hand, generate lots of dots, and dots per inch can be considered roughly equivalent to pixels per inch. This is very handy for the person working in video. This means that you can scan a four-inch by three-inch image, which at 72 dpi scan is a quite small image, but at, say, 300 dpi or 600 dpi, your scanner will produce thousands of pixels, which will translate in video as a very large image that remains sharp in the HD frame.

If your scanner can generate an image that's 3840 pixels across, it's making an image twice as large as an HD video frame. The advantage of importing "rich scans" like this for video is that you can now move that very large image around on the screen and make it seem as if a camera is panning across the image. Or you can scale back the image, and it will look as if the camera is zooming back from a close point in the image. Or you can reverse the process and make it look as if the camera is zooming into the image, and the result will be as sharp as the original image allows.

When it comes to increasingly popular digital stills, the same rules apply, except scanners are irrelevant: You only need to see how large the original camera image measures in relation to your chosen video format. Today's multi-megapixel cameras can capture huge images, three or four times wider than the 1920 pixels needed for HD 1080—and thus support zooming into the image three or four times, and often more.

SUMMARY

In this chapter, we looked at FCP's Title Browser, working with text styles and looking at some of titles and the title controls. We learned how to customize titles using Motion 5. We built a Compound Clip as a complex title, adding text and textures, putting it together into a title composite. We also looked at how FCP handles still images and the issues for still image resolution. In the next chapter, we will look at the working with the effects available in the application.

CHAPTER 8
Adding Effects

In this chapter we look at and work with some effects of FCP. FCP offers a great variety of excellent effects, including great color correction tools, which aren't technical effects and which we'll look at in the next chapter. These effects rely heavily on the graphics card for processing. What this means is that on slower computers, you won't get very good performance with them, and on some marginal computers, they'll be practically impossible to work with.

In addition to the effects included with the application, other programmers are creating effects to add to FCP. Be sure to check out companies such as GenArts and its amazing Sapphire Edge plug-ins or FxFactory and its range of tools and CoreMelt who make Lock and Load X for stabilization and TrackX and SliceX for tracking and masking. There are also a great many free effects generated using Motion. The best list of them can be found at www.fcp.co/forum/9-free-fcpx-plugins-and-templates.

SETTING UP THE MEDIA

For this chapter we'll use a couple of libraries. We'll use the *BB7* library from the preceding chapter and the *BB8* library. If you haven't downloaded the material, download it now from the www.fcpxbook.com website.

1. Once the ZIP file is downloaded, copy or move it to the top level of your dedicated media drive.
2. Double-click it to open it and double-click the *BB8* library to launch the application.

> **NOTE**
>
> *H.264:* The media files that accompany this book are heavily compressed H.264 files. Playing back this media requires a fast computer. If you have difficulty playing back the media, you should transcode it to proxy media as in previous chapters.

You probably thought there were an awful lot of titles. Well, there are even more effects—228 of them in fact. Truth be told, some of these effects aren't very useful, but a lot of them let you do some pretty amazing things with video. In this chapter we'll look at some of the useful FCP effects and how to work with them.

APPLYING AN EFFECT

Effects are accessed from the Effects Browser (**Command-5**) and are divided into two main groups, video and audio. Each of these has categories within them, like Basic and Blur, and Distortion and Echo.

Effects are generally applied to clips in a project, though they can be applied to clips in the Browser by using the **Open in Timeline** function in the shortcut menu and adding them there. One of the nice features in FCP is that you can preview an effect with the clip before you apply it.

1. Start in the *BB8* library by selecting the *Effects* project in the *projects* Smart Collection and making a backup snapshot of it with **Shift-Command-D**.
2. Select the original *Effects* project and double-click it to open it in the Timeline.
3. Move the playhead over the first clip in the Timeline and in the Effects Browser select the Basics category and skim over **Black & White**.
4. Try skimming over some of the others.
5. Click on the **Tint** effect and press the spacebar.

The effect will appear not only on the little icon in the Effects Browser but will also appear full size in the Viewer. With the effect selected, playing in the Effects Browser will play in looped mode so you can see the effect again and again.

> ## TIP
>
> ***Filmic Black & White:*** A tip from Denver Riddle of Color Grading Central: in the Black & White effect, pull down the green slider under Color and push up the red slider to create a black and white image that more closely resembles black and white film response.

Any number of effects can be added to a clip, but the order in which the effects are applied to the clip can be important.

1. Apply the **Background Squares** effect from the Distortion category to the first clip.
2. With the clip still selected, find **Gaussian** in the Blur category and skim over it to see the result of the two effects applied together.
3. Double-click the Gaussian effect to apply it to the clip.
4. Push up the Gaussian amount to about 70 so it's very blurry. The Background Squares are hardly visible.

5. Drag the Gaussian effect in the Inspector so it's above the Background Squares and see the result in the Viewer as in Figure 8.1.

Because the Gaussian blur is applied to the image before the Background Squares, the clip is blurred first, but the squares show sharp edges as they are applied after the blurring effect.

FIGURE 8.1
Viewer and effect ordering.

Copying and Pasting

Effects can also be copied and pasted from one clip to another. You can also paste selective effects.

1. Select the first clip, with the two effects applied to it, and copy it (**Command-C**).
2. Select the second clip in the Timeline and use **Edit>Paste Effects** or the keyboard shortcut (**Option-Command-V**) to paste the same effects with the same settings to those clips.
3. Select the third clip and use **Edit>Paste Attributes** or **Shift-Command-V**.
4. In the Paste Attributes dialog check on Background Squares, but leave Gaussian unchecked (see Figure 8.2).

This is the easiest way to apply the same effect with the same settings to multiple clips. Copying and pasting attributes does not only apply to effects, but will also paste color correction and the transform properties that we will see later.

Audition Effects

We looked at the Audition function earlier in the chapter on editing. Auditioning is most commonly used with the Replace edit function, but it is also a great tool for trying out different effects as well as different settings of the same effect. Let's apply an effect and make some variations to try out:

1. In the *Effects* project select the first use of *posing with doors,* and in the Effects Browser go to the Basics group.
2. Find Colorize and double-click it to apply it. The effect in its default settings maps white to bright red.

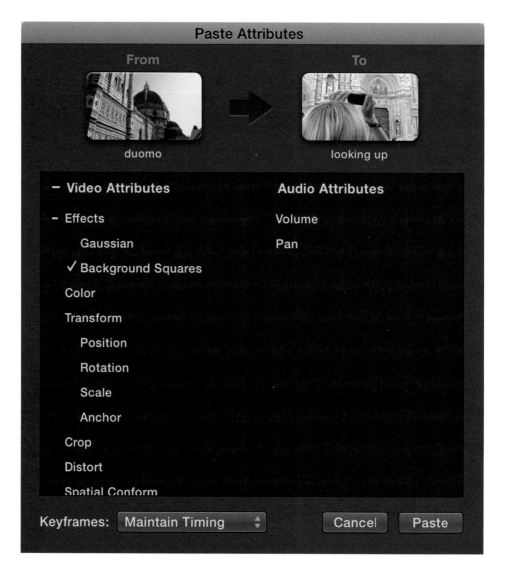

FIGURE 8.2
Paste attributes
dialog.

3. Duplicate the clip as an Audition, either by using **Clip>Audition>Duplicate as Audition** or pressing **Option-Y**.
4. The Inspector will now display the duplicate. Use the **Remap Black** control to change the color from a deep red to a deep blue, creating a duotone effect.
5. Open the **Audition HUD** by pressing the **Y** key.
6. Click the **Duplicate** button to duplicate the copy. This time, change the white to bright orange, giving you three available options in the Audition HUD to choose from, as in Figure 8.3.

This is a very powerful tool for trying out different effects in the Timeline and storing them for possible use.

> **TIP**
>
> **Duplicate from Original:** If you want to try a complete different effect, rather than simply duplicating the clip with the currently applied effect, use **Duplicate from Original** or the shortcut **Shift-Command-Y**.

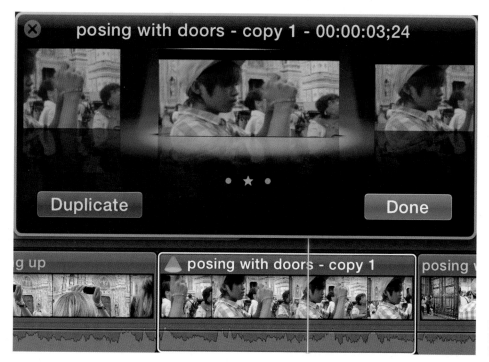

FIGURE 8.3
Effects audition
HUD.

Animating Effects

Many effect values can be animated just like audio parameters by adding keyframes so they can be altered over time. Let's do a simple animation of the blur value on the second clip in the Timeline. There are two ways to do this, either entirely in the Inspector or in the Timeline; we'll do both starting with the Inspector.

1. Make sure the playhead is at the beginning of the second clip in the Timeline and that nothing is selected (**Shift-Command-A**).
2. In the Video inspector move the Gaussian Amount down to zero.
3. To the right of the slider and the value box is a diamond button with a plus. Click on it and the button will go orange indicating a keyframe has been applied (see Figure 8.4). Clicking on it again will delete the keyframe.

4. Press **Control-P** and type **+1.** (that's plus one period) and press **Return** and drag the Amount slider up to 70.
5. Move forward one more second into the Timeline and click the keyframe button to add another keyframe. If you don't change the value, the effect will remain blurry for that one second.
6. Now go forward one more second and drag the Amount slider down to zero or type **0** in the value box. The image will now get blurry, hold blurry, and then go back to being clear.

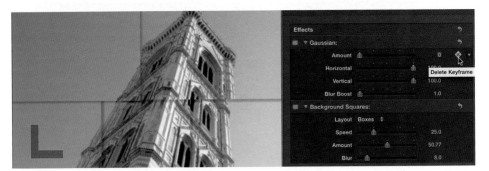

FIGURE 8.4
Adding keyframe.

Let's do a similar animation to the first clip in the Timeline, but we'll do it entirely using the Timeline controls.

1. Select the third clip in the Timeline and apply the Gaussian blur.
2. Press **Control-V** to open the Video Animations control and double-click Gaussian Amount to reveal the keyframe graph. The Amount line should be 50% of the way up the graph.
3. Hold the **Option** key and click on the line right at the start to add a keyframe. Zooming into the Timeline will make it easier.
4. Move the playhead forward about one second and **Option**-click on the line to add a second keyframe.
5. Drag the first keyframe at the beginning of the clip down to zero (see Figure 8.5).
6. Move forward one more second then **Option** click on the line to add another keyframe to the Timeline.
7. **Option** click a fourth time to add another keyframe at the end of the line, and drag the keyframe down to zero to complete the animation. The graph should look like Figure 8.6.
8. Close the Video Animation HUD with **Control-V**.

Play your animations to see how they look. Many effects have parameters like these that can be animated.

Adjustment Layer

An option available in many motion graphics and animation applications is to apply an adjustment layer to your project. An adjustment layer is an empty

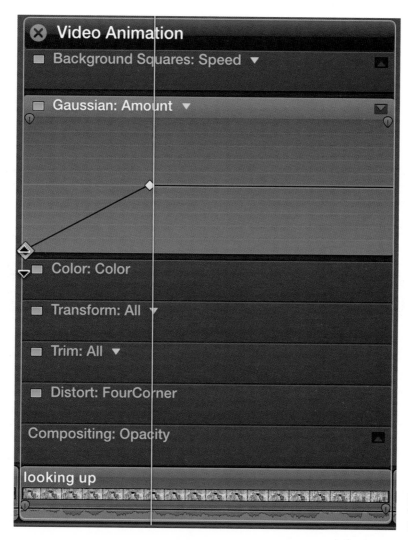

FIGURE 8.5
Video animations keyframe graph.

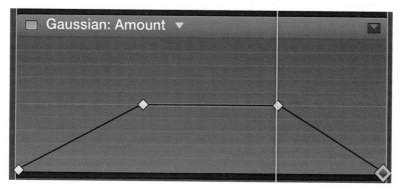

FIGURE 8.6
Complete keyframe animation graph.

container to which you can add effects, transformations, color grades, and more, and have it affect everything underneath it in the Timeline. This is a way to apply effects and color grades to multiple clips without having to combine them into a Compound Clip. To do this you need to create a Title project in Motion. You cannot simply use one of the available Titles in FCP. So let's make an adjustment layer using Motion:

1. Launch Motion and in the Project Browser that appears select a new **Final Cut Title** and make it the largest size available **4k - Digital Cinema** and set the frame rate to the highest available 60 fps (see Figure 8.7). It doesn't matter that the size is larger than or a higher frame rate than you're using; you've made the title so it can accommodate anything FCP is capable of. Also do not worry about the length as the adjustment layer has no actual content and can be as long as you need in FCP.

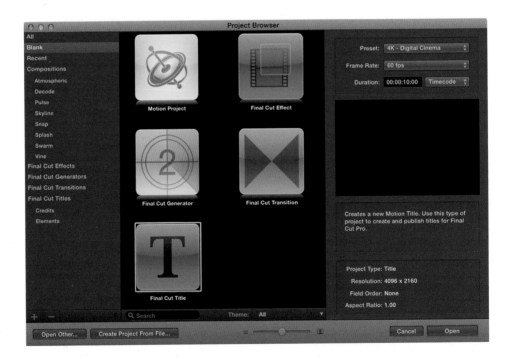

FIGURE 8.7
Motion project browser.

2. If the Layers panel doesn't appear press **fn-F5**. Figure 8.8 shows the basic layer structure, a blank title with a placeholder for the video underneath.
3. The Group has two layers. Select and delete the text layer, **Type Text Here**.
4. All you have left is a placeholder that sees the video underneath the layer. Save it with **Command-S**, name it *Adjustment Layer*, and add it to a new category that will appear inside FCP called *Adjustment* (see Figure 8.9). There is no need for any media or for a preview movie as there is nothing to preview.

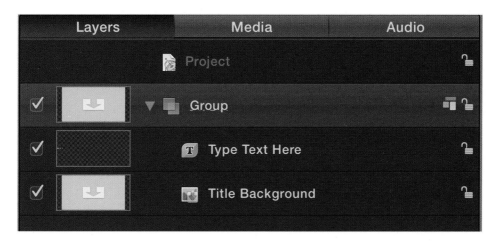

Layers	Media	Audio
Project		
☑ ▼ Group		
☑ T Type Text Here		
☑ Title Background		

FIGURE 8.8
Layer structure.

Enter a name for the Final Cut Pro Title, and choose which folder to keep it. You may also assign a theme to your template.

Template Name: **Adjustment Layer**

Category: **Adjustment** ⬍

Theme: **None** ⬍

☐ Include unused media
☐ Save Preview Movie

[**Cancel**] [**Publish**]

FIGURE 8.9
Saving Adjustment Layer.

That's it. Your *title* is saved inside the *Motion Templates* folder in your home *Movies* folder. It will appear inside the Adjustment category in the Title Browser the next time you launch FCP.

If you don't have Motion or don't want to take the few minutes to make your own, I have saved the Adjustment Layer effect for you inside the *BB8.zip* file on the fcpxbook.com website. To add it to FCP, drag the folder called *Adjustment* into *Movies/Motion Templates/Titles*. This will add the Adjustment category to the Title Browser and include the Adjustment Layer effect.

Now that you've got it made, let's see how you use it.

1. In the Title Browser, select the **Adjustment Layer** title in the Adjustment category and use the **Q** key to connect it to whatever clip you want to apply it to.

2. If you need it to span multiple clips, drag it out or select the end and use **Shift-X** to do an Extend edit.
3. If you want to apply an effect, select the clip underneath the Adjustment Layer and skim the effect in the Effect Browser to preview it.
4. To apply the effect, drag the effect onto the Adjustment Layer or select the Adjustment Layer and double-click the effect you want. The effect will be applied to all the clips underneath the Adjustment Layer. The applied effect appears in the Video inspector of the Adjustment Layer.
5. To apply a color grade to the clips underneath the Adjustment Layer, go to the Adjustment Layer's Video inspector to access the Color corrections or press **Command-6** for the Color Board.
6. Make whatever adjustments you want in the Color Board and these will appear on the clips underneath it. The is an excellent way to apply an overall tonal look to images that have been color matched and color balanced, but more on this in the next chapter on Color Correction.

Adjustment Layer is an extraordinarily powerful tool in FCP that can be adapted to a number of different uses.

VIDEO EFFECTS

Because there are so many effects in FCP, it would take a whole book to cover them, and there are more being produced every day. Let's look through the list of what's available and pick out some of the highlights that are exemplary of the controls you get with FCP's effects. There are many more so I suggest spending time just playing with them to see what they can do.

Basics

There are 11 Basics effects starting with the simple **Black & White**. It's the easiest way to make video black and white. **Broadcast Safe** is usually applied to whole projects to remove any excess luminance in the images.

1. Select all the clips in the Timeline and press **Option-G** to make them one long Compound Clip.
2. Select the Compound Clip and double-click the Broadcast Safe effect to apply it to all the clips.
3. Or add Adjustment Layer to the project, stretch it out for the duration of the project, and add the Broadcast Safe filter to the Adjustment Layer.

Blur

There are five blur effects in the new FCP and one **Sharpen**. You should be careful with Sharpen in video as it creates high-contrast edges that can be very difficult to compress and can easily turn into pixelated edges.

The most commonly used blur is **Gaussian** (pronounced *gowsian*), named after the nineteenth-century German mathematician Karl Friedrich Gauss, which in its default settings produces a smooth blurring of the image. It also allows you to blur the images horizontally and vertically separately through a pop-up menu. This can be very useful to reducing flickering in an image caused by fine lines and patterning.

1. Set the Horizontal blur to zero while leaving the Vertical blur at 100.
2. Set the Blur amount to a very low number like 1.0 or even 0.5.

The **Directional** blur is one of the many effects that have on-screen controls in the Viewer (see Figure 8.10). Dragging the arrow around the circle will change the direction of the blur, while pulling the arrow farther from the center will increase the blur amount. The wonderful thing about these types of controls, which we will see more of later, is that you can make adjustments right in the Viewer while watching the effect on your video. **Prism**, **Zoom**, and **Radial** also have these on-screen controls.

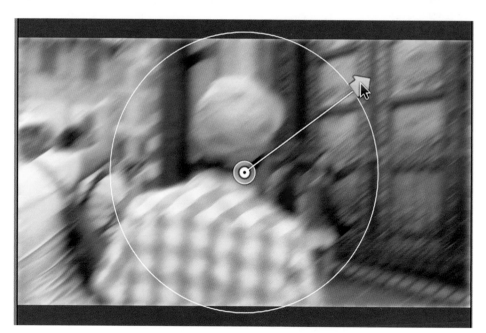

FIGURE 8.10
Directional blur controls.

Distortion

Distortion effects are for the most part more gimmicky than useful, though some, such as **Crop & Feather**, can be. The effect gives you controls for cropping the sides of an image as well as controlling the Roundness, Feather, as well as the

X and Y positions of the cropped area (see Figure 8.11). Many of the effects have values that greatly exceed those shown in the slider. Double-click in the value box for Roundness for instance and use the scroll wheel to increase the value. Though the slider control only goes to 50, the scroll wheel will take the value to 1000. This is often the case with many of the value boxes. If the maximum limit of the slider doesn't seem enough, try increasing the value further by scrolling or simply typing a higher value.

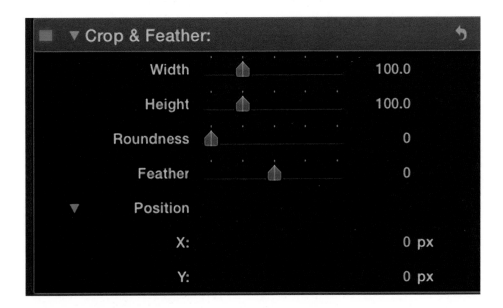

FIGURE 8.11
Crop & Feather
controls.

The real distortion effects are those like **Background Squares**, which we've seen, **Droplet, Tinted Squares, Fisheye, Fun House, Insect Eye, Mirror, Scrape, Underwater, Wave,** and **Glass Blocks**. These create fun effects that distort the clip and are often seen in extreme sports videos.

There are some hidden in the Distortion group that are of actual, practical value. **Flipped** is most commonly used in its default settings, where it flips an image from left to right. This is really useful if something has been shot in the wrong direction, someone should be looking from right to left and instead was shot looking left to right. Flipped will fix that. But not only can Flipped reverse the image it can also flip it vertically, and both vertically and horizontally, as well as can control the amount of flipping, a value which can be animated to rotate the image on screen (see Figure 8.12).

Water Pane produces a very realistic water droplets running down glass effect that also gives the shot a bluish cast to emulate a rainy day (see Figure 8.13).

FIGURE 8.12
Flipped.

FIGURE 8.13
Water Pane.

> **TIP**
>
> **Nudging Values:** If you have a value selected in a box like the Roundness amount and use the **Up** and **Down** arrow keys, you can raise and lower the value in one-unit increments. This is an excellent way to fine-tune your settings and control them with great precision.

Keying

Keying is used to selectively cut out areas of an image. The most efficient way to do this is chromakeying, the technique of removing one specific color from an image. The two most commonly used colors are blue and green. Generally, green rather than blue is used for chromakeying video; blue is sometimes used

5. Push up the **Spill Level** slider to take out some of the green color cast on her arm.
6. Check the Matte view to see that some of the wisps of hair are still there.

The **Color Selection** has advanced chromakeying tools to improve color sampling and edge quality. In addition to the color wheel, where you can drag the lines to adjust the color selection if necessary, there are also separate Luma controls below it and sliders to control roll-off (see Figure 8.15).

The color wheel graph allows you to select the core color of your key, and using the angle controls allows you to adjust the edge transparency. You can use the color wheel separately to select your color or in conjunction with the original tool set, which work remarkably well in many instances. For more difficult keys, these tools will give you finer control. The color wheel has two modes: the default, **Scrub Boxes** lets you adjust the limits of the color selection (see Figure 8.16) and the **Manual** button gives you precise control of the core color selection (see Figure 8.17). In Manual mode, make sure the **Strength** slider is at a value greater than zero. The Manual control disables the **Refine Key** controls and the **Strength** slider. Notice that the color selections are keyframeable, with the diamond keyframe button on the right, a useful feature for clips where the background lighting and color changes.

> **NOTE**
>
> *Switching Color Selection Modes:* It's generally a good idea to start with the standard controls and Scrub Boxes. If you need to switch to Manual, it's best to leave it there and adjust the matte using the Chroma and Luma controls, and not to switch back to Scrub Boxes, especially if you've keyframed the color selection.

> **TIP**
>
> *Zoom into Color Selection:* You can zoom into the Color Selection wheel for more precise control by holding the **Z** key and dragging across it. **Shift-Z** will reset it to the normal size.

Together with the Color Selection tool you also have **Matte Tools**, which allow you to adjust the selected area (see Figure 8.18). The key controls here are the **Shrink/Expand** slider and the **Erode** slider at the bottom. These allow you to adjust the edges of the matte, tightening it or expanded if needed. **Soften** blurs the edges of the matte, which can be very useful.

Spill Suppression lets you knock down reflected light from the screen that falls on the subject. The **Spill Levels** slider is on by default and set to 46%. You can adjust the amount of spill suppression with the **Spill Levels** slider, while the suppression controls adjust the contrast and tint effect. By default, a little magenta is applied to the image to counteract the green. You can adjust the color of the suppression with the **Tint** slider.

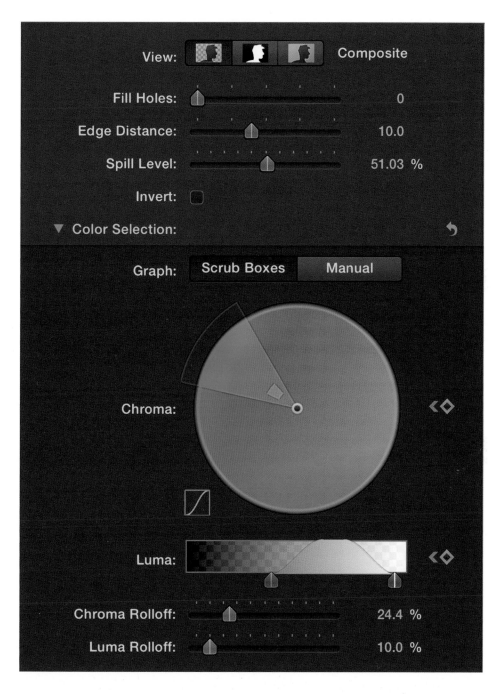

FIGURE 8.15
Color Selection.

Light Wrap takes the background luminance from the underlying image and tries to adjust the edges of the foreground object to match that.

It takes a great deal of practice and skill to use these tools effectively, but they are very powerful additions to the Keyer.

FIGURE 8.16
Scrub Boxes color
control.

FIGURE 8.17
Manual core color
control.

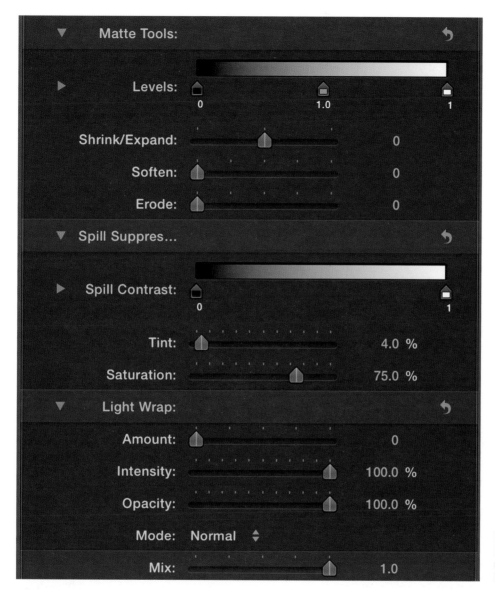

FIGURE 8.18
Matte tools, spill suppression, and light wrap.

One problem that occurs quite often is that the camera shoots off the edge of green screen, while still keeping the subject within the green screen area. You can see this a little in the shot we've been working on, but you can see it more clearly in the *GreenScreen_MED_PR* clip. There are really two techniques for this, one using the Crop function and the other an effect.

1. Start by extending the *Blobs* generator and then connect the *GreenScreen_ MED_PR* clip into the Timeline after the first shot.
2. Move the playhead over the second clip and then click the first clip to select it and copy it.

3. Use **Shift-Command-A** to **Deselect All**, and then press **Shift-Command-V** to **Paste Attributes**, checking on the **Keyer**.
4. With the second clip targeted in the Timeline, activate the **Crop** function in the Viewer.
5. Pull in the left and right sides to trim the edges. That's one way. Undo that.
6. The second way is to use from the Keying category of the Effects Browser the **Mask** effect. This allows for a more complex crop if necessary. Drag the **Mask** effect onto the clip and adjust the handles in the Viewer to cut out the edges of the frame as needed. Make sure you don't crop the bottom of the green screen shot.

For more complex shapes that need to be cut out more carefully, there are third-party tools such as CoreMelt's SliceX powered by Mocha, which can create a very refined and animatable mask (www.coremelt.com/products/slicex-powered-by-mocha.html).

Sidebar

SHOOTING GREEN SCREENS

Here are some tips for shooting a better green screen shot, and the better the shot, with the better equipment, the easier it will be to key.

1. Keep the subject as far away from the screen as you can to give maximum lighting separation and to minimize the amount of spill falling on the subject from the green screen. Try to get the subject at least eight feet away from the green screen.
2. Light the subject and the background independently. The green screen needs to be lit evenly and without shadows regardless of the lighting used on the subject. If you do not have a waveform monitor or vectorscope attached to your camera on set, then take a sample and load it into FCP and check the scopes. You want the lighting flat and even across the image and you want the vectorscope pointing to green and not somewhere else.
3. Use a backlight on the subject that's pale magenta for green screen (or pale yellow for blue screen) to help knock down any reflected spill off the green screen falling on the subject.
4. Avoid depth-of-field effects if possible. Making the green screen soft focus by no means makes it easier to key. Making the parts of the foreground subject soft makes it more difficult to key. Sharp edges are easier to key than blurred, wispy edges, or smoke or glass.
5. If possible shoot with a camera that has 4:2:2 color space. If possible avoid using AVCHD or HDV. Ideally, if you can record directly from the camera to ProRes 422 that would be best.
6. Avoid shooting with an interlaced format. Always shoot in a progressive format if at all possible. Rent another camera if all you have is a Sony that shoots 1440×1080i, or anything else that's interlaced.
7. Avoid low frame rates and low shutter speeds. These will increase motion blur making any action more difficult to key.

Mask

The **Mask** effect is far more useful than its simple controls would lead you to believe (see Figure 8.19). The on-screen target buttons position the corners of the four points of the matte shape. Feather softens the edges, and Roundness smoothens out the shape. Notice in the graphic that these two controls go to

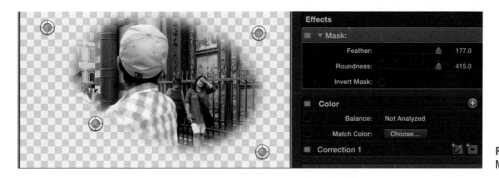

FIGURE 8.19
Mask controls.

much higher values than the slider and allow you to create organic shapes and effects that let you layer multiple images over a background effectively. This is an excellent four-point "garbage matte" tool.

Luma Keyer

The **Luma Keyer** effect works best on images with a bright white background. It's much easier to key white than black because almost every image will have some degree of shadow area in it, which keys out. The Luma Keyer can be useful to create ghostly overlay effects.

1. In the *Effects* project, lift the *campanile dutch* clip and connect it top of the *looking up* clip.
2. **Option**-click the *campanile dutch* clip and then double-click the **Luma Keyer** effect in the Keying category.
3. Adjust the controls as you like to try different effects.

While the Luma Keyer only affects luminance values to key out, it nonetheless has many controls similar to the Keyer effect, including **Matte Tools**, **Fill Holes**, and **Light Wrap** (see Figure 8.20).

Light

There are 15 Light effects that you can try out for yourself with FCP's preview functions. I'd suggest you not only to skim the effects but also to use the play feature by selecting the effect and pressing the spacebar. Some of the effects, such as **Intro Flashes** and **Quick Flash/Spin**, which are very similar, affect just the beginning of the image, almost like a transition, zooming into them, twisting and flashing the picture at the start.

Many of the effects have interesting controls that allow you to alter the position and color of the light effects. Some of the effects, such as **Artifacts**, **Highlights**, the **Flash** effects, **Side Lights**, **Subway Shadow**, and **Bokeh Random**, have motion built into the effect by the movement of light. The others, such as **Aura**, **Bloom**, **Dazzle**, **Shadows**, **Spot**, and **Glow**, are static and take their effect from the highlights in the image.

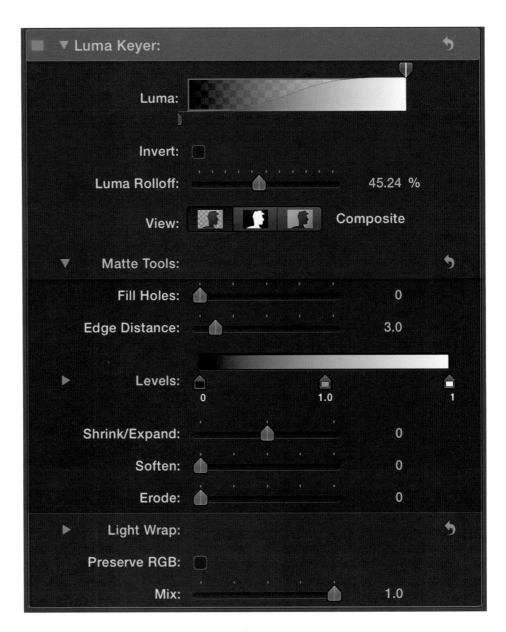

FIGURE 8.20
Luma Keyer controls.

Some effects, such as the **Flash** effects, have little or no controls at all, whereas other effects like **Bokeh Random** have quite a few controls (see Figure 8.21). These include changing the bokeh type as well as any of the extensive composite modes in FCP. You can also control the size and number and pattern and speed and blur and opacity of these bokeh objects, resulting in looks from authentic-looking lens flare to patterns resembling Japanese lanterns floating through the frame. It is really a lot of fun to play with the effects they produce, particularly on telephoto shots that often produce the effect naturally.

FIGURE 8.21
Bokeh Random controls.

Spot can be useful to highlight someone or something on the screen (see Figure 8.22). It's much more subtle than just a circle; yet, by increasing the contrast and controlling the radius and the amount of feather in the image, it quickly leads the viewer to the point of interest. The target position, as well as other controls, is easily animatable if the subject moves around the screen.

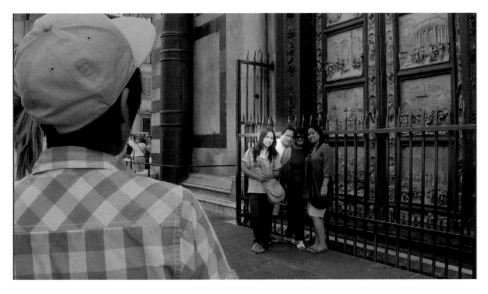

FIGURE 8.22
Spot image.

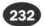

> **NOTE**
>
> **Bokeh:** Bokeh is a Japanese word that means blur or haze and refers to very out of focus highlights in the frame that appear as shapes of light with no definition. The shape of the bokeh, usually circular or hexagonal, can be caused by aberrations in a camera lens.

Looks

Most of the Looks are really color effects, and most have very few controls except for an Amount slider. Many of them also have an important slider to protect skin tones.

50s TV is basically low-contrast black and white, whereas **Bleach Bypass** is high-contrast desaturated video made popular in the movie *Saving Private Ryan*. **Combat**, **Strife**, and **Numerik** are similar with more controls as well as skin protection.

Cold Steel and **Cast** have skin protection sliders, which you need to push up to take effect. **Cast** allows you to change the color shading, so it's almost a tint effect with some skin tone protection. **Dry Heat**, **Faded Sun**, and **Indie Red** also have skin protection to prevent the flesh tones from going too brown. The slider adds more blue back into flesh colors. This is true also of **Teal & Orange**, which is an essential effect for every Michael Bay movie, or if you're trying to emulate the *Transformers* look.

Some of warmer looks such as **Desert Glare** and **Heat Wave** don't have a skin protection slider.

Cool Tones and **Day into Night** are very similar, very cold and dark. The first has more controls with less overall blue.

Glory, **Romantic**, and **Memory** are a cross between a color look and a light effect. The first gives a light rays effect that has an on-screen control that you can position where you like, and animate if you wish.

Isolate is different, with a pop-up that allows you to desaturate either skin tones or shirts. With shirts selected, it removes all colors except for skin tones. The default, which is to desaturate skin and make it gray scale, I find rather ugly.

Night Vision is a unique look. It's a deep green color effect together with a matte, binoculars, a circle, an ellipse, or no matte at all. There's a Size slider to adjust the size of the matte, a Grain slider, which I think helps the effect, and a Light slider, which controls the brightness. The Amount dims the matte, so I don't think it works very well with the effect.

Stylize

The Stylize category is a real grab bag of effects. Some are very stylistic, others are very practical, many of them based on film style effects such as the **Super 8mm** effect.

Add Noise is one of the stylized effects. It lets you add different types of grain from horizontal TV graining to film grain in different colors. It works well when

combined with Looks. **Bad TV** has some of the same grain effects, plus scan lines, and horizontal shakes. It's really pretty bad TV. **Raster** is similar without the wobbly image. Add Noise also works well when used after **Aged Film**, which gives your video a sepia tone and adds film scratches. **Projector** gives film flicker, but without the sepia tone. **Aged Paper** takes sepia to an extreme adding a paper mask over the image. The one slider makes the mask size bigger and smaller. At zero you only see the paper and no image, while at 100 you see the whole image blended with the aged paper. **Film Grain** and **Cross Hatch** are also of the sepia tinted effects. The latter combines with a crisscross line pattern. Be careful with this one as it is very difficult to compress well and will pixelate easily. Be careful also with **Graphic**, **Halftone**, **Sketch**, and **Line Screen**.

Camcorder gives you a camera viewfinder look, with a blinking red record light.

The **Drop Shadow** effect is very powerful and features the ability to add shadows that are Perspective Front and Perspective Back. Front lets you to put a drop shadow in perspective as if the object is being lit from behind, throwing the shadow to the foreground toward the viewer.

Frame is a stylized border effect that reduces the size of the image and adds a choice of one of a dozen different border looks. These aren't simple colored edges, but actual picture frames. For a simple color border, use **Simple Border**. **Photo Recall** is a similar border effect, not only over transparency, but over a blurred version of the image.

Letterbox lets you take a standard 4:3 video and crop it to one of the five standard cinema shapes to create a letterbox effect. This is a crop, not an overlay, so the area outside the image is empty. If you want to place a color there, you should put one of the color Generators underneath it.

If you want to make a whole project widescreen—which is probably the point rather than applying it to individual clips—convert the project to a Compound Clip, and apply the effect to the Compound Clip, or use the Adjustment Layer.

1. From the Title Browser, connect the *Adjustment Layer*, which should be in the Adjustment category.
2. Drag it out for the length of the project.
3. With the Adjustment Layer selected, find the **Letterbox** effect in the Stylize category and double-click it.
4. Change the Aspect Ratio effect controls in the Video inspector.

The main benefit of using an adjustment layer for this is that you have control of the underlying images and are able to use the Transform function to move the images up and down to adjust the framing as you like to accommodate the Letterbox effect.

Vignette has complex on-screen controls (see Figure 8.23) that allow you to darken the edges of the image, control how much dark appears, and how rapidly it falls off. You can also position the Vignette so it does not have to be centered. It's a very popular stylistic feature that's used to some degree in a great many shots. You can also do this in the color controls as we'll see in the next lesson.

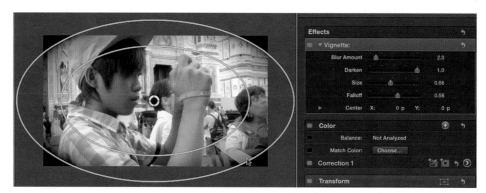

FIGURE 8.23
Vignette and controls.

Censor lets you blur or pixelate a portion of the screen. It can be someone's face, a T-shirt, a license plate, anything.

1. In the Timeline, select the first *posing with doors* clip and delete any effects that have been applied to it.
2. With the Timeline clip selected, double-click the Censor effect in the Effects Browser to apply it.
3. Make sure the clip is selected in the Timeline, which makes the on-screen controls visible in the Viewer.
4. Drag the center target to position the pixelization over the boy's face.
5. In the Inspector controls, you can change it to Blur or Darken.

Tiling

Tiling is a category of four effects and includes **Kaleidoscope** and **Kaleidotile**, which can be animated to produce kaleidoscopic effects. They work especially well on images with motion in them as they rely on movement in the frame to create movement in the effect. With a still image, the kaleido effect will simply be stuck on the image unless you animate the properties.

The **Tile** effect is the Replicate effect of previous versions and can be changed from one, which is no effect, up to 20, which is 20 rows of very small images.

> **TIP**
>
> *Adjusting Settings:* In the Effects Browser, if you **Option**-skim a preview, you will see how the primary control can be adjusted and modified. As you skim with the **Option** key, adjusting the parameter, you will only see one frame, but when you release the **Option** key, you can skim the image to see the effect on the whole clip with the new settings. If you then apply the effect, it will be applied with the adjusted settings and not the default settings.

AUDIO EFFECTS

There are over a hundred audio effects, many the province of the serious audio-phile, which I confess I am not. There are so many effects in part because of

some redundancy between FCP effects; Logic effects, which have been ported to this application; and Mac OS X effects, which also appear.

There is a short project in the *BB8* library, the *projects* Smart Collection, called *Audio* that we will use to apply some effects.

You apply an audio effect just like you do a video effect. You can preview it by playing or skimming the effect.

The **Distortion** group of effects includes popular favorites such as **Car Radio** and **Telephone**. You use it like this:

1. Start by making a backup snapshot of the *Audio* project with **Shift-Command-D** and open the original.
2. Select the last clip in the *Audio* project, and in the Distortion group of audio effects, find **Telephone**.
3. Press play to preview the effect and hear the way the voice has been reduced to a narrow telephone frequency range.
4. To apply the effect, double-click it.
5. To access the Telephone controls, go to the Audio inspector (see Figure 8.24).
6. Try different telephone types from the preset pop-up.
7. Click the Channel EQ and Compressor icons that bring up HUDs showing you what's being done to the audio and giving you even further control of the effect.
8. The Amount slider will adjust how strong the Telephone effect is. As you adjust the slider, notice how it alters the EQ and Compressor controls.
9. With the clip selected in the Timeline, press the **forward slash** (/) key to play just the selection.

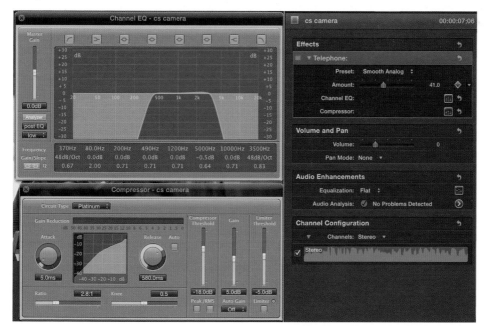

FIGURE 8.24
Telephone controls.

There are many powerful and varied distortion effects. From the Logic sub-category, try the **Clip Distortion** effect, which itself has a great many distortion presets. In fact, all of the Logic effects have many presets. It will take you hours to try them all out. **Ringshifter** alone has three submenus of presets with a total of 30 effects. Have fun!

The **Echo** group has nine effects, all with a subtle difference in the tonal quality they apply. Many of them, such as the Logic effects **Delay Designer**, have many more presets for you to try and to adjust further with the Delay Designer HUD.

1. In the *audio* Keyword Collection, find the jazz piece called *Music*.
2. Append it to the project with the **E** key.
3. Select the music in the Timeline and press the **forward slash** key to play a little of it.
4. Stop playback and select one of the Logic effects like **Delay Designer** or **Stereo Delay**.
5. Press the **spacebar** to hear the effect.
6. Double-click the effect to apply it and use the **forward slash** key to play the music while you try different presets.

Most of the Final Cut EQ effects are basically handy presets for one of the available equalizers, usually **Fat EQ**, which gives the most range of controls.

The Logic subgroup of EQs simply gives you direct access to **AutoFilter**, **Channel EQ**, **Fat EQ**, and **Linear Phase EQ**, all set flat for you to adjust as desired. Personally, I like the frequency dragging controls of the Channel EQ HUD the best (see Figure 8.25).

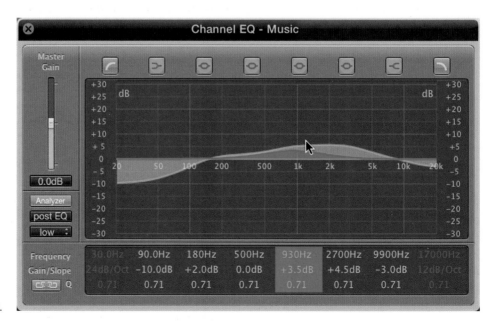

FIGURE 8.25
Channel EQ HUD.

In the **Levels** group of effects, the Logic **Adaptive Limiter** at its default settings applies a little compression to the audio that's very useful. It has the overall effect of providing a little gain without increasing background noise. Because of this boost in the gain, you might need to pull down the level a few decibels. For music such as the jazz piece in the project, try the **Adaptive Limiter** with the **Add Density** preset.

The **Modulation** group has mostly special effects for music such as **Tremolo**, **Flanger**, **Chorus**, and **Vibrato**. The Logic Tremolo is pretty extreme even in its default settings. You probably don't want to use any of these on voice, but they make some interesting sounds for music.

Spaces creates different types of room reverberation.

1. Select the *looking up* clip in the project and press **backslash** to play it.
2. Stop playback of the clip, and in the Spaces group of audio effects, click on **Cathedral**.
3. Press the **spacebar** to play the clip with the effect.
4. Try the **AUMatrixReverb**.

The best tool for creating room acoustics is Logic's **Space Designer**. In addition to having its own design HUD, it has a staggering number of presets (see Figure 8.26) for all types of large, medium, and small spaces, with different types of rooms and halls, from Michaelis Nave to Villa Bathroom, and everything in between.

Although there are no bars and tones available in FCP, any clip with audio can be used with the **Test Oscillator** in the **Specialized** group of audio effects:

FIGURE 8.26
Space Designer presets.

1. Select the *Music* clip in the project, and in the Specialized category, find the **Logic Test Oscillator**.
2. Double-click the effect to apply it and play the clip in the Timeline. You hear the default 1000 Hz tone at −12dB.
3. In the Inspector, you'll find a whole list of different presets (see Figure 8.27), including sweep tones and a HUD to set your own tone presets.

Default

OSC Pink Noise -6dbFS
OSC Pink Noise 0dbFS
OSC Sine 1kHz 0dbFS
OSC Sine 2kHz 0dbFS
OSC Sine 10kHz 0dbFS
OSC Sine 15kHz 0dbFS
OSC Sine 20kHz 0dbFS
OSC Sine 32Hz 0dbFS
OSC Sine 40Hz 0dbFS
OSC Sine 63Hz 0dbFS
OSC Sine 80Hz 0dbFS
OSC Sine 100Hz 0dbFS
OSC Sine 125Hz 0dbFS
OSC Sine 160Hz 0dbFS
OSC Sine 200Hz 0dbFS
OSC Sine 500Hz 0dbFS
OSC Sine Sweep 2kHz-5kHz
OSC Sine Sweep 20-200Hz
✓ OSC Sine Sweep 200Hz-2kHz
OSC White Noise -6dbFS
OSC White Noise 0dbFS
Pink Noise
Sine Sweep
Square Wave
White Noise

Reveal User Presets in Finder...
Save Preset...

FIGURE 8.27
Test Oscillator presets.

Strangely, in the **Voice** group, most of the Final Cut effects are comic effects, like **Alien**, **Cartoon Animals**, **Robot**, and **Helium**. In special cases, you might find **Disguised** useful.

One useful effect in the Logic subgroup is **DeEsser** for voices that are too sibilant. **Vocal Transformer** has some interesting presets as well.

There's a lot to try, so take your time and play with the different effects. Try them with your own recordings and see what you can do to enhance them.

RETIMING

Though Retiming isn't really an effect in the true sense, these controls are used as special effects, so I've included FCP's Retiming functions in this chapter.

Constant Speed Changes

Retiming can be accessed from either of two menus or in the Timeline itself. You can access Retiming from the **Modify>Retime** menu, or the Retime popup in the Toolbar, or for basic controls, by simply selecting a clip or a targeted clip and pressing **Command-R**.

To work with the Retiming tools, we're going to use some of the winter clips from the *BB7* library.

1. Start by making a new project called *Retime* in the *Snow* event.
2. In the *Snow* event, find the *trash can1* shot.
3. Drag a selection from around 6:21, just before the snowboarder enters the frame, to 8:17, just after he disappears.
4. Append the shot into the Timeline.
5. Make a selection in *trash can2* starting at about 3:13 and ending about 5:12.
6. Append that shot into the Timeline.
7. From *trash can3*, make the selection from 29:28 to 32:20 and append that shot.
8. Select all the clips in the Timeline, and from the Retime menu in the Toolbar, select **Slow 50%**.

All the shots will slow down to half speed and will appear in the Timeline showing the orange retiming bar. You're not confined to the slow and fast speeds that appear in the Toolbar, however.

To make the last shot in the project a bit faster, grab the drag handle at the end of the Retiming bar and pull it to the left to speed up the clip, as in Figure 8.28. The speed is now 60%, as indicated on the Retiming bar.

> **NOTE**
>
> **Pitch Shifting:** You may have noticed that, at the bottom of the Retime menu, **Preserve Pitch** is checked on by default, which is probably what you want. Though the clips may change speed, the audio is automatically adjusted and phase shifted so it does not sound like Mickey Mouse when it's speeded up, nor does it become deep and drawn out when slowed down. In fact, voices are quite understandable when speeded up or slowed down.

To make the clip play backward, select it, and from the Retime menu, select **Reverse Clip**. The Retiming bar in the Timeline will have backward arrow marks on it and the speed will be displayed as −60% in this case.

FIGURE 8.28
Retiming bar.

Custom Speed Settings

From the Retiming popup in the Toolbar you can now select **Custom**, or use the shortcut **Control-Option-R**, or click the pop-up triangle in the Retiming bar and select **Custom**. A dialog appears above the clip allowing you to set a specific speed percentage (see Figure 8.29).

Notice you now also have the option to ripple the project or not ripple the project. If you uncheck ripple, the clip will either be cut off if you slow it down, or the project will be filled with a gap clip to keep the project duration constant.

You can also dial in a specific speed, or a specific duration. So if you want a clip to be two seconds, you can make the Duration two seconds, and the speed of

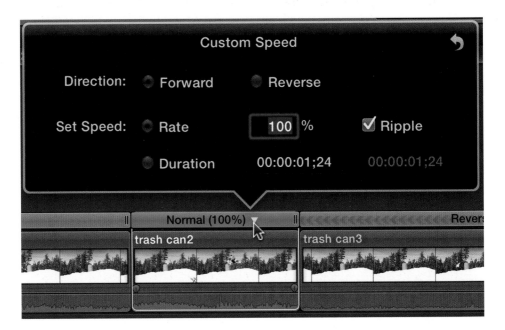

FIGURE 8.29
Custom speed
control.

the clip will be adjusted to accommodate that, rather than the clip be shortened or lengthened.

> **NOTE**
>
> *Automatic Speed:* What in all previous versions has been called **Conform** has been renamed **Automatic Speed**. This allows you to set the frame rate of a clip to its original frame rate regardless of the frame rate of a project. What this means in practice is that 120 fps GoPro media can be put in a standard 29.97 fps project, have **Automatic Speed** applied to it, and become a very clean slow-motion shot. Using a high frame rate camera is really the best way to achieve good looking slow motion.

Speed Blade and Transitions

Another retiming feature that has been added is **Speed Transitions**. To apply these, you will have to have separate speed segments so the speed isn't constant. You can do this by using the **Range Selection** tool (**R**) and dragging a selection. Then apply a different speed to the selected range. This will automatically apply Speed Transitions, which can be switching off in the **Retiming** menu. They are turned on by default. Another way to create speed segments is to use the **Speed Blade** function.

1. Move the playhead over the first clip in the project that has been retimed to 50%.
2. With the playhead at one second in the project, press **Shift-B** to use the Speed Blade to split the Retiming bar.
3. Move forward to about 2:15 and press **Shift-B** again to cut the Retiming bar again, creating a separate speed segment in the middle.
4. Click the triangle pop-up in the middle speed segment and select **Custom**.
5. Click the **Duration** button and type in *200* for two seconds, leaving ripple checked on. The speed segment is lengthened and speed transitions are added to ramp the speed down from 50 to 37 and then back up to 50% (see Figure 8.30).

FIGURE 8.30
Speed transitions.

Speed transitions are added to the clip to smooth the speed change. The handles in the Speed Transition can adjust the length of the transition and the speed of the segment (see Figure 8.31). A ripple tool appears at the end of the middle segment that allows you to shorten or lengthen the segment (see Figure 8.32).

Retime to Fit

Another great feature is the implementation of **Retime to Fit**, which legacy FCP called Fit to Fill. This has been added to the Replace popup menu when you drag one clip onto another clip.

FIGURE 8.31
Adjusting speed transition.

FIGURE 8.32
Rippling speed segment duration.

1. In the *Snow* event, find *Mike run 3 tables* and make a selection from about 4:20 to 7:00, about two seconds long.
2. Drag the selection onto the third clip in the project, hold till the clip goes white, and select **Replace with Retime to Fit**. Because the clip that was in the Timeline was about four and half seconds, the clip is slowed down to accommodate the length of the original clip in the Timeline.

You can also bridge a segment using the **Retime to Fit** function.

1. In the Timeline, move the playhead about a second into the last clip and use **Command-B** to split it.
2. Select the middle clip and the bladed segment (see Figure 8.33) and then press **Option-G** to make a Compound Clip. The name is unimportant as the compound will be discarded.

FIGURE 8.33
Clip selections.

3. In the *hand held trash can* clip select a section starting at about :20 and ending at 2:04.
4. Drag the selection onto the Compound Clip and select **Replace with Retime to Fit**. The new clip has its speed adjustment to match the length of the segment.
5. **Command-delete** the Compound Clip from the Browser if you wish as it isn't needed any longer and only exists in the Browser.

Speed Tools

Other features in the Retime menu are special effect tools such as **Instant Replay** and **Rewind**.

1. Select the second clip in the project, and from the Retime menu, select **Instant Replay**. The clip plays twice.
2. Select the second clip that we just used Retime to Fit, and from the Retime menu, choose **Rewind>2x**. The clip plays, rewinds at twice normal speed, and then plays again.
3. Select the first segment of the clip that's at half speed and click the disclosure triangle to choose **Normal (100%)**, or click on the orange bar in the first segment to make a selection and press the shortcut **Shift-N** to reset that segment of the clip. Now the clip plays forward at normal speed, rewinds at double speed, and then plays forward in slow motion.
4. To reset all the clips back to normal so that we can look at other features, select them all and use **Option-Command-R**. Then press **Command-R** to close the Retiming bars in the Timeline.

FCP has the ability to ramp the speed from zero to the set speed or to ramp down from the set speed to zero. You do this using the Speed Ramps:

1. Select the first clip, press **Command-R** to open the Retiming bar, and with the pop-up set the speed to **Slow 50%**.
2. From the Retime menu in the Toolbar, select **Speed Ramp>to 0%**. The clip is broken down into segments, each getting progressively slower over the course of the clip (see Figure 8.34).

FIGURE 8.34
Speed ramp.

3. Select the second clip and put the playhead right where the skier's hand touches the trash can. Then, from the Retime menu, select **Hold** or press **Shift-H**. A hold frame is created that's two seconds long. The clip plays in normal speed, stops, and then plays forward.
4. Drag the handles on the ends of the red retiming bar for the hold segment to adjust the duration of the freeze.
5. Hold the **R** key and drag a range selection in the third clip beginning just as the skier reaches the peak of his jump until he leaves the frame, about 24 frames. When you release the **R**, the pointer will return to the Select tool.
6. From the Retime menu, select **Slow>50%**. The middle segment is slowed down.
7. Drag out the end of the orange/gray transition segment in the Retiming bar to make the speed of the middle segment even slower.
8. Once you have the speed as you like it, double-click the orang/gray transition segment and from the HUD that appears, where you can switch off the **Speed Transition**, click the **Edit** button for **Source Frame**.
9. A frame icon appears at the end of the segment (see Figure 8.35). Drag it to adjust the end frame. The speed of the segment doesn't change, but the last frame before speed resumes is altered.

FIGURE 8.35
Changing end frame.

Another option you'll see in the Retime menu is the **Video Quality** submenu. You have three quality options: **Normal**, **Frame Blending**, and **Optical Flow**. Normal simply duplicates or discards frames as needed. Frame Blending creates intermediate whole frames as needed and generally should be used for slow-motion effects. Optical Flow will produce the best results. It's based on the analysis of the image content, calculating frames based on what's moving in the frame to create the smoothest motion. This should be used for extreme slow-motion effects. This can be very slow to render, however.

STABILIZATION

Stabilization analysis can be done to either the clip in the event or in the Timeline. It makes no difference; it's done to the entire clip, and the analysis files are used by every instance of the clip you work with. You can activate Stabilization in Video inspector for either a clip in a project, which is where it's more commonly done or it can also be done to a clip in the Browser. Let's apply it to a clip in the Browser. To stabilize the clip and run the analysis, we'll use the *hand held trash can* clip in the *Snow* event.

1. Right-click on the clip in the Browser and select **Open in Timeline**.
2. In the Video inspector, scroll down to Stabilization and check on the blue LED.

There are three stabilization options: **Automatic**, **InertiaCam**, and **SmoothCam** (see Figure 8.36). Automatic is just that and works well for most static cameras. InertiaCam is a little more aggressive and produces, I think, a slightly better

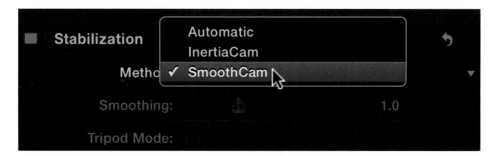

FIGURE 8.36
Stabilization.

result. Both Automatic and InertiaCam have the **Smoothing** slider to adjust the effect. SmoothCam works best for most shots, though I find it tends to produce a little rolling shutter type wobble if the camera is panning, where InertiaCam works better. Notice at the bottom the option for **Tripod Mode**. This is only available when the analysis shows the camera is effectively static, without any panning or zooming. For the right clips, it will make the shot rock solid.

SUMMARY

This chapter covered just the tip of the iceberg of some of the video and audio effects in FCP. I urge you to look through them and explore their capabilities for yourself. In addition to the Effects Browser content, we looked at working with Retiming and with Stabilization. Although Color Correction is often thought of as effects, they use an entirely separate utility that's built into every clip, which we'll see in the next chapter. By now, you should have a fairly good idea of what you can do with this application and should be well on your way to creating exciting, interesting, and original video productions.

CHAPTER 9
Color Correction

Color correction in FCP, unlike in previous versions of Final Cut, is not done using effects, or filters as they were called. Instant color correction is an integral component of every video clip and accessed like so much else in the application—using the clip's Inspector.

In this chapter, we'll use the *BB8* library, which we used in the preceding chapter, as well as the *BB4* library with the scene from *A Great Life*. If you haven't done it already, you can download the material from the www .fcpxbook.com website.

> **NOTE**
>
> *H.264:* The media files that accompany this book are heavily compressed H.264 files. Playing back this media requires a fast computer. If you have difficulty playing back the media, you should transcode it to proxy media as in the previous chapters.

Before we get started, let's make a new project to work with:

1. In the *BB8* library, select the *Color* event and use **Command-N** to make a new project.
2. Name the project *Color*, and from the *fix* Keyword Collection in *Color*, select all the clips and append them into the Timeline. They will go into the project in the same order they are in the Browser.

COLOR CORRECTION

Good exposure and color begin in the shooting. It's always easier and better if you shoot correctly from the beginning rather than try to fix these issues in postproduction. That means lighting the scene well, exposing it correctly, setting your white balance correctly, and not leaving the camera's auto exposure and white balance to do the guessing.

The color correction tools in FCP are professional strength tools, so use them carefully. A new feature in FCP is to rely on Apple's ColorSync to coordinate the color display and keep it consistent throughout the production process, from first importing, through editing, and for final sharing and export.

Color Balance

FCP has automatic color balancing tools that can be activated in the Video inspector or the Enhancements menu of the Toolbar or with the shortcut **Option-Command-B**.

When Color Balance is applied, the clip is automatically adjusted based on a mathematical formula. For many users, this will be their one stop to color correction, and it will be good enough. If you are used to working with Sony cameras, the look Color Balance produces is probably acceptable. Sony cameras tend to produce results like these. For me, this feature is a little desaturated, but more importantly, it seems to have a bluish cast to it. Here's how to use it:

1. Move the pointer in the Timeline over the *silhouette with doors* clip near the end, and **Option**-click to select it and move the playhead.
2. In the Video inspector, find the **Balance** function under Color. If it's not visible, double-click **Color** to open the correction tools.
3. Check on the **Balance** button so that the LED is blue (see Figure 9.1).

The arm of the woman holding the camera has a decidedly bluish cast to it. There should be really no blue in human flesh tones unless the light has a bluish tone, such as at dusk, either before sunrise or well after sunset. Normally, flesh tones do not exhibit any blue. I also find the color a little weak. That said, the tool is very good at making an instant correction of problem footage, but for most shots, you would be well served to color correct your images manually. Not only will your video look great but also it's great fun to add special color looks and effects to your video.

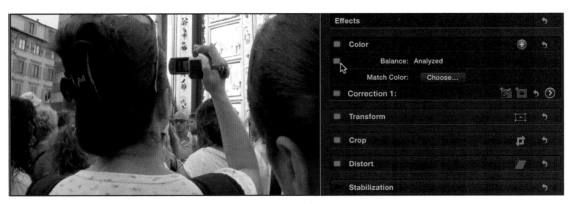

FIGURE 9.1
Color balance.

> **TIP**
>
> *Compressed Video and Color Correction:* If you're working with proxy video or heavily compressed video formats like AVCHD and MPEG-4, it's a good idea to transcode the media to ProRes, as this will handle heavy processing much better than compressed files.

Video Scopes

To adjust your color, you need to use the tools that FCP provides for assessing the color. These are the Video Scopes, which can be called up from the **Window** menu or with the keyboard shortcut **Command-7**. You can also open the Video Scopes by using the switch in the upper right of the Viewer and selecting **Show Video Scopes**.

> **TIP**
>
> *Close Browser:* When you're doing color correction, screen space is at a premium, and at this stage, you rarely need to access the libraries and the Browser. It's a good idea to close them, which you can do from the **Window** menu or using **Control-Command-1**. If you have to access the Browser with **Shift-F** (Reveal in Browser), it will open automatically. Note though that you cannot use the import function while the Browser is closed. You have to open it first.

The default video scope that opens is the **Histogram**. It can also be selected with **Control-Command-H**. This shows the percentages of different luminance and colors in the image. Figure 9.2 is the histogram of the *cheese* clip. Notice the controls at the bottom of the drop-down menu that allow you to adjust the brightness and to set the display vertically underneath the Viewer, which can be useful depending on your screen space (see Figure 9.3). In the histogram, pure black is zero and is on the left. Peak white is 100 and is on the right. Notice that this shot, and every shot here, and most every shot taken by most every consumer camera will always record at video levels that exceed peak white and are not broadcast legal. If you are planning to put your video on a television set, every shot will need to be corrected. By the way, the built-in automatic Color Balance does not correct sufficiently for these types of cameras in many cases, and peak levels still exceed television legal standards, which is yet another reason to manually color correct your video. Apart from the video that exceeds 100% white, you can see from the histogram that this is a fairly even distribution of light to dark across the image. Figure 9.4 is the histogram of the second shot in the project, *ms musician*. As you can see from the image and the histogram, the majority of the luminance values and even of the color values are all to the left, and almost nothing is to the right of 50%.

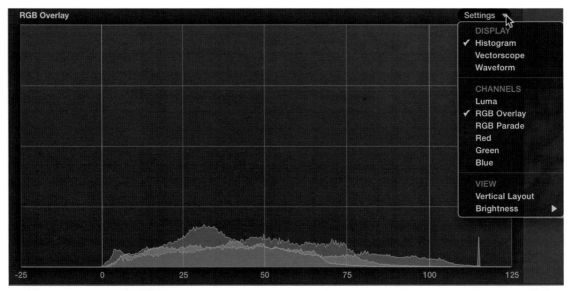

FIGURE 9.2
Histogram.

Although the histogram is the first video scope that appears, it is perhaps the least used in video production. It's more commonly used in still photography, and photographers moving to video like working with it. Perhaps the most important scope for video is the **Waveform Monitor**, which you switch on from the Settings menu at the top left of the scopes or **Control-Command-W**. Figure 9.5 shows the *silhouette* shot on the right and its waveform on the left set to Luma. This is a representation of the luminance values in the image, but displayed just as it is on the screen, reading across the image from left to right. The bottom of the trace is zero, which is black, while the top is 100. Again, the bright areas in the image exceed 100 units or IRE, which is your target for peak white, while zero is your target for pure black. You can see in the waveform the bright vertical sections in the trace that correspond to the bright areas of the wall behind the woman. The Waveform Monitor is your guide to setting your exposure and your video levels and is a critical tool in the color correction process. You can also set the waveform using the Settings menu in the upper right to display with an RGB Overlay that should be the amounts of color values in the image (see Figure 9.6).

With the Settings Display still set to the Waveform Monitor, under Channels, select **RGB Parade** (see Figure 9.7). Unfortunately there is no shortcut for this, nor an option for this in the Command Editor. This is an important tool for color balancing. It displays three separate views of the image, showing amounts of red, green, and blue in the image. In this parade, you can see that the brightest areas of the image have a great deal of red in them, while there is very little blue that's

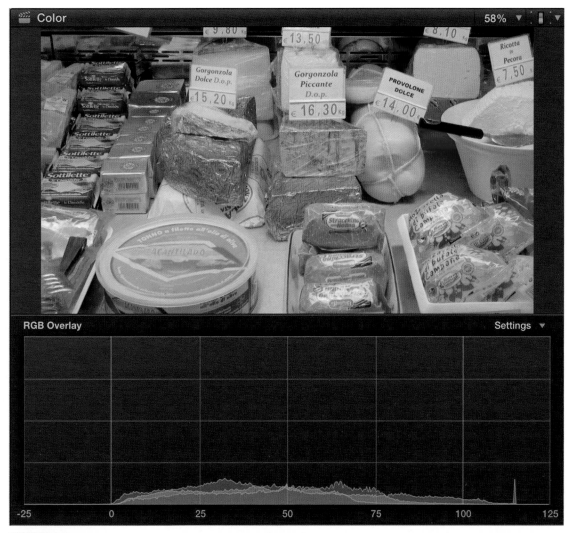

FIGURE 9.3
Vertical scopes and viewer.

in the bright areas of the image. If you had an image with a very bright, blue sky, the parade would look the opposite, probably less in the red and a great deal in blue. Ideally, you would like to have equal proportions of red, green, and blue in the shadow areas of your image, black being the absence of color. If the three colors are balanced in the shadow areas, they are neutralized, and the image will show no color cast in the blacks. This image has a slight elevation in the blue levels at the bottom of the display, slightly higher amounts of blue than of red and green, probably not something you would notice with your eye, but something the scopes clearly see. If you use the automatic Color Balance, this blue

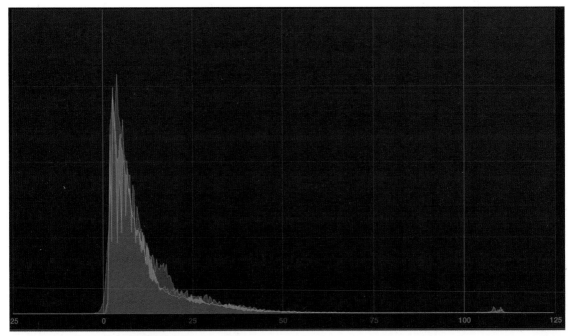

FIGURE 9.4
Histogram of dark image.

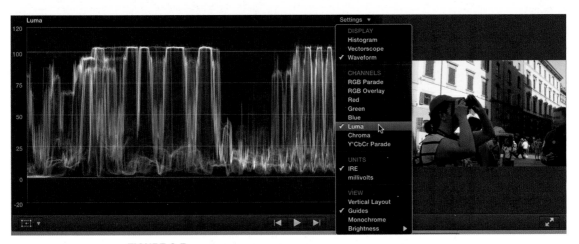

FIGURE 9.5
Waveform monitor and image.

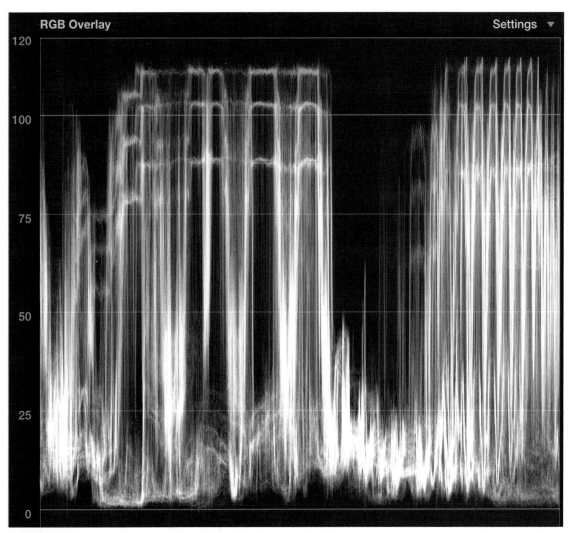

FIGURE 9.6
RGB Overlay.

elevation in the shadow areas becomes even more pronounced. On the bright end, it's generally not possible to balance the reds, greens, and blues so that equal quantities appear in the highlights, unless the highlights are actually white, like a close-up of a white shirt, where you do not want to color cast in the whites, so that white is white and not some shade of a color. Similarly anything that's gray in the image should also show equal proportions of red, green, and blue.

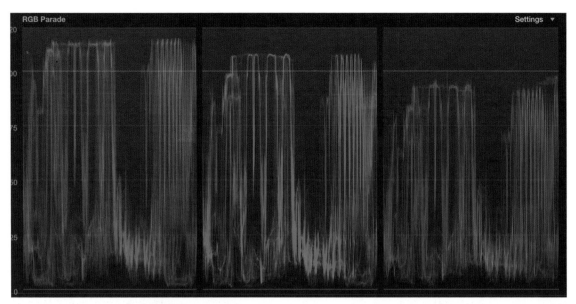

FIGURE 9.7
RGB parade.

The fourth scope used in video is the **Vectorscope**, which you select in the Settings menu or using **Control-Command-V** (see Figure 9.8). This is not a representation of the image at all, but a display of the amount of which colors are in the image. If you right-click in the scope, you can scale-up the display. You can see a faint color wheel ringing the scope and the target boxes for pure colors that would be hit by an SMPTE color bar chart, starting with red, just to the right of 12 O'clock, and going clockwise to magenta, blue, cyan, green, and yellow. Notice the diagonal line that goes from the upper left to the lower right through the circle of the scope. This is the flesh line. Any human skin in the image, if lit by neutral light, correctly balanced, will fall on this line. If it doesn't, you have a color imbalance. There is a large color area in the *silhouette* clip that has a near flesh-tone color. The amount of actual flesh in the image is relatively small. If you use the automatic Color Balance, it will pull that near skin tone color onto the flesh line, push the real skin areas to the image toward magenta-blue.

These are the scopes that we'll be switching between as we correct our color.

TIP

Selecting Pucks: In the Color Board, sometimes the pucks can get clustered in the same area making it difficult to select individual pucks. A handy trick is to select the puck you want in the list underneath the Color Board and then use the arrow keys to move them around.

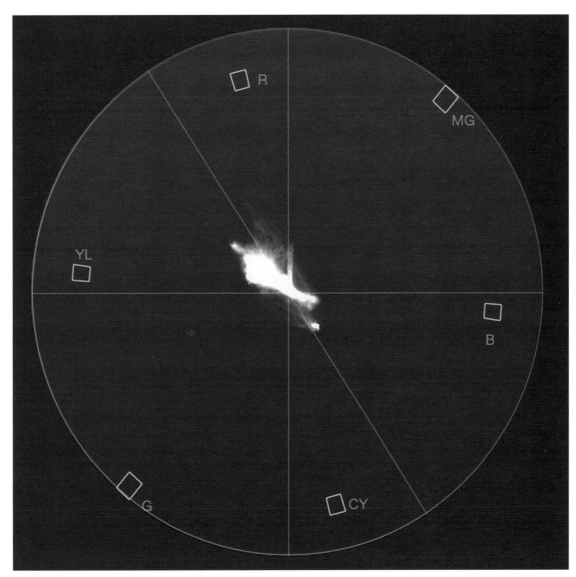

FIGURE 9.8
Vectorscope.

Color Board

The primary tool for color correction in FCP is the **Color Board**, which is accessed with the arrow button opposite **Correction 1** in the Inspector (see Figure 9.9) or more simply with the keyboard shortcut **Command-6** (see Figure 9.10). To close the Color Board, you can return to the Video inspector by using the arrow button in the upper left or pressing **Command**-4 twice, once to close it and again to open to the Video inspector.

FIGURE 9.9
Arrow button to the color board.

The Color Board has three tabs. The first that we see when we open the tool is the **Color** tab. The second is the **Saturation** tab, and the third is the **Exposure** tab (see Figure 9.11). The last two look almost identical. When the Color Board is the active panel, you can switch between the three tabs with keyboard shortcuts, **Control-Command-C** for Color, **Control-Command-S** for Saturation, and **Control-Command-E** for Exposure. A list of the color control shortcuts can be found in Table 9.1.

The Exposure tab has four buttons or pucks, which can only move vertically. On the left, the larger puck controls the overall exposure of the image, globally raising and lowering the brightness. Inside the Exposure board are three separate pucks to raise or lower the Shadows, Midtones, and Highlights. These are not sharply defined regions but ones that have considerable overlap. The Shadow control will effect the luminance from 0 to about 70. The closer to zero, the greater effect the control will have; the higher the luminance value, the less the effect. The Midtones cover a range from about 30 to 70 and effects the mid-portion most, having less effect at 30 and 70, essentially bending the luminance in a curve. The Highlights effect the range from 30 and above, again effecting the top end of the range more than the bottom. Let's see this in action.

1. Open the project called *Exposure*, which contains a single graphics file *Gradient.png*.
2. With the playhead over the clip, press **Control-6** and then go to the Exposure tab (**Control-Command-E** or **Control-tab** twice).
3. Make sure the waveform monitor is open (**Control-Command-W**) and pull down the Global puck on the left (see Figure 9.12).
4. Reset the control by either using Undo or by selecting the puck and pressing the **Delete** key.
5. Push the Shadows puck up and the black level will go up while the highlights remain pegged (see Figure 9.13).
6. Reset the Shadows puck with **Delete** and pull down the Highlights puck. Black is pegged, when the highlight area goes gray (see Figure 9.14).

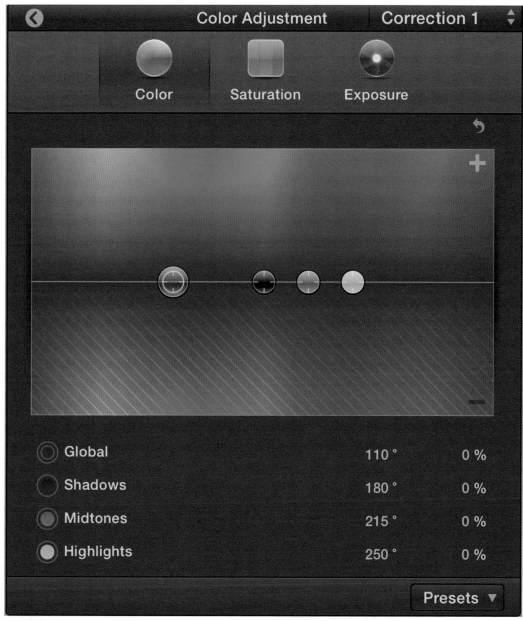

FIGURE 9.10
Color board.

7. Reset the Highlights and try the Midtones puck. Push it up to reduce the contrast and pull it down to increase the contrast, making the image more black and white, with very little in the mid luminance range (see Figure 9.15).

FIGURE 9.11
Exposure tab.

Saturation is the amount of color in an image, whether it's colorful or washed out, or even black and white. The Saturation tab looks the same as the Exposure tab, with four pucks. The large one on the left controls the Global saturation, and the three others control how much color there is in Shadows,

Table 9.1	Principal Color Shortcuts
Color Scopes and Panels	**Shortcut**
Color Board	**Command-6**
Video Scopes	**Command-7**
Waveform Monitor	**Control-Command-W**
Histogram	**Control-Command-H**
Vectorscope	**Control-Command-V**
Color tab	**Control-Command-C**
Saturation tab	**Control-Command-S**
Exposure tab	**Control-Command-E**
Cycle through color tabs	**Control-tab**
Cycle backward through color tabs	**Shift-Control-tab**

FIGURE 9.12
Decreasing global exposure.

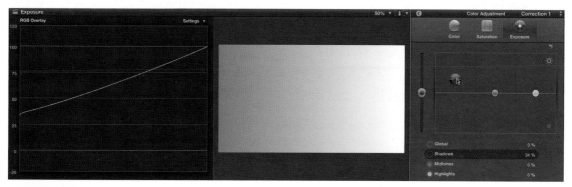

FIGURE 9.13
Increasing Shadows.

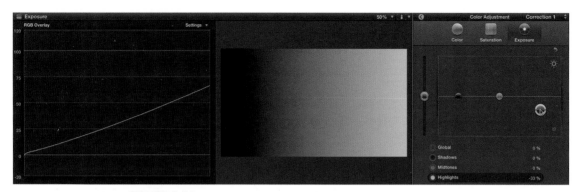

FIGURE 9.14
Decreasing Highlights.

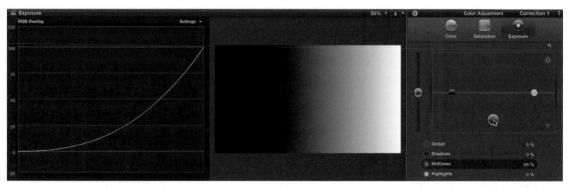

FIGURE 9.15
Decreasing Midtones.

Midtones, and Highlights. The controls in the Saturation tab work similarly to the Exposure tab, increasing or decreasing the Global amount of color in the image, or the color in the Shadows, Midtones, or Highlights. Decreasing the Saturation in the Shadows is useful as it helps to mitigate any color casts in the blacks.

The **Color** tab also has four controls. The larger puck raises and lowers the Global color in whatever hue you want. While the Exposure and Saturation pucks only move vertically, here, the pucks also move horizontally. If you want to add more blue to the overall look of an image, take the large puck, move it to the blue section of the Color Board, and push it upward. Up will add more of a certain color, and down will remove a certain color. There are three smaller pucks that let you change the color values in specific luminance ranges: Shadows, Midtones, and Highlights.

Using the Color Board

Though the Color Board is laid out from left to right—Color, Saturation, Exposure—you should always make your color correction in reverse order. Always set the Exposure first using the Waveform Monitor displaying Luma, then set the Color using the Waveform displaying the RGB Parade and the Vectorscope, and finally set the Saturation using the Vectorscope. Though you have the scopes in FCP to guide you, your primary tools for color correction are your eyes and, ideally, a properly calibrated display. If you watch television or go to the movies, you know that color in video and film can be anything you want it to be. The only goal you should try to maintain is to make sure your images are within specification. Fortunately, you have an effect, the Broadcast Safe effect, which makes this easy for you.

That said, let's start our color correction with one of the images in the *Color* project, the *cheese* shot. The order in which your browser is set may determine the way the project displays. In my project, the *cheese* shot is the first shot. Proceed like this:

1. Select the *cheese* shot, open the Video inspector, and opposite Correction 1, click on the arrow button for the Color Board.
2. Set your scopes to the Waveform Monitor, and in the Color Board, go to the **Exposure** tab.
3. There's nothing really wrong with the overall luminance levels of this shot. Pull down the Shadows puck to bring the blacks down to zero.
4. Pull down the Highlights a little to keep the whites under 100 IRE.
5. Push up the Midtones to brighten the look of the image and add a little pop to it. After you adjust the mids, you'll probably have to adjust the Shadows and Highlights again.

The process of color correction is a constant ping-ponging of pushing and pulling, raising one value and pulling down another to offset it in some areas.

Let's switch to the Saturation tab. The saturation for the image is pretty good. I suggest just pushing up the Global chrominance level a little to give it a little more vibrancy.

And now we come to Color. Again the color isn't bad, except for a slight blue cast in the highlights and a little too red in the shadows. To correct this:

1. Switch to the Color tab, with your scopes set to the Waveform Monitor, in Settings, under Display, select RGB Parade.
2. Take the **Shadows** puck over the right side in the red and pull the red down a bit.
3. Take the **Highlights** puck and put it to blue and pull it down a little.
4. Finally, to warm the image a little, take the **Midtones** puck over to yellow and push it up a little so that the Color Board looks something like Figure 9.16.

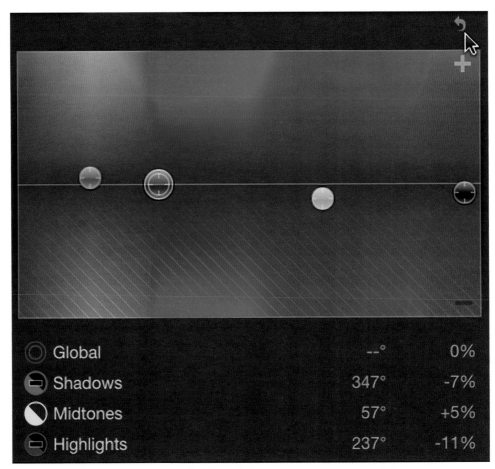

FIGURE 9.16
Corrected color board.

TIP

Nudging the Pucks: The pucks can be moved around the Color Board with the arrow keys. Select a puck and use the **Left** or **Right** arrow keys to move it horizontally and the **Up** or **Down** arrow keys to move it vertically. This lets you move the puck with much greater precision than you can simply by dragging it, though it is probably not nearly precise enough for a professional colorist.

Notice at the bottom of the Color Board the display that shows you the color values you're using, also indicating with the icon that shadows are in negative red, mids in yellow, highlights in negative blue, and global is unchanged.

If you want to reset the Color tab, click the hooked arrow button in the upper left. There's a separate reset for Color, Saturation, and Exposure. To see a before-and-after look or to reset the entire Color Board, go back to the Inspector and use the reset button opposite Correction 1. To toggle a before and after, click the blue LED next to Correction 1.

> **TIP**
>
> ***Before and After:*** Because it is awkward to return to the Video inspector to toggle, it's easy to use Auditions for this. With the playhead over the clip and nothing selected, press **Shift-Command-Y** to **Duplicate from Original**. Then press the **Y** key to open the Audition container, and use the **arrow** keys to switch back and forth between the original and the color corrected, watching the change in the Viewer and the scopes.

White Balance

Let's look at an image with the opposite problem—a white balance with too much yellow. The shot we're going to work on is the last shot in the project, the clip called *statue dutch*. This shows a fairly common problem with consumer cameras. They often read a scene's color as either too warm or too cold. In this instance, the camera made the image overly yellow. Try the automatic Color Balance, but I find it quite unsatisfactory. While it corrected the yellow cast, it added a little too much blue and desaturated it too much. Let's see if we can fix this better using the Color Board:

1. As always, we'll start in the Exposure tab of the Color Board. Using the Waveform Monitor displaying Luma as a guide, take down the Shadows a unit or two with the **Down** arrow.
2. Take down the Highlights so that the white sky in the upper left of the scene is touching 100%.
3. Push up the Midtones to brighten the shot to taste. Try about 10 taps on the **Up** arrow.
4. Now move to the Color tab. Switching back to the Waveform Monitor, display the RGB Parade. In the bottom of the three traces, we can see that the red channel is a little high in relation to the others.
5. Move the Shadows puck to the left side and pull it down just a little to neutralize the blacks. I used 6°, and went to –4% or 4 taps on the **Down** arrow.
6. Move the Highlights puck to the left side to yellow-orange around 32° and pull it down a little to about –13%.
7. Warm up the mids with a little yellow, something like +2% at 52°.
8. Though the shot is fairly weak in color, using the Vectorscope as a guide, push the Global Saturation up a little, to about 20% or dial that value into the Global value box.

There is no right way to fix this as long as you set your exposure correctly, neutralize the blacks, and take some of the yellow out of the sky.

> **NOTE**
>
> ***Dutch: Dutch*** here means a shot that's tilted. The term goes back to the 1920s and is a corruption of ***deutsch***, used because of German expressionist filmmakers' habit of shooting with a tilted camera to make shots more dynamic, intense, or disorienting.

> **TIP**
>
> *Scroll:* To move a value up and down, just as in other value boxes, you can double-click in Global Saturation value box, for instance, and use the scroll on your mouse to move the value up and down as you like, letting you change the value while watching the Viewer and the scopes.

Silhouette

Let's do a more complex image, with different problems, particularly in the light levels. Let's look at the *silhouette* clip in the project:

1. Put the playhead near the end of the clip when the woman holding the camera is pretty much in silhouette against the pale wall.
2. If necessary, press **Command-7** to open your scopes, and from the Settings pop-up, select the Waveform Monitor displaying Luma.
3. Some like to adjust the Global puck and then fix the individual Luma ranges, but I prefer to work largely with the individual pucks. Start with Shadows, bringing them down a little to touch zero.
4. Next, pull down the Highlights a little to get the brightness under control and peaking at 100 IRE or 100%.
5. Then push up the Midtones. You can afford to push it up quite a lot to bring out the detail in the woman's face. I pushed it as high as 40% or 45%.

Here's a little problem this raises. Video cameras shoot what's called Y'CbCr. The b and r represent the blue and red channels, and the Y stands for the luminance channel, which is also the green channel. In most video editing applications, like previous versions of FCP, the application worked internally in Y'CbCr, just like your video. The current version of FCP works internally in RGB. What that means for us is that when we start to push the luminance values around, instead of being tied to a single channel, they're tied to all the channels, so moving the midtone Luma as much as much as we do, we move the color channels as well. To see that, switch the Display to the Y'CbCr Parade and start pulling the Midtones Exposure puck up and down. Watch what happens to the color values, which should not be effected by changes to the luminance. These changes can be significant. Consequently, we have to make adjustments for this in the Color Board:

1. On our way to Color, first stop quickly in Saturation and push up the Global values a bit.
2. In the Color tab, take the Midtones puck and pull the blue down just a bit to take a little of the blue cast off the walls and the woman's arm.

You can tinker with this example for quite a while, but I think we should leave it there for the moment.

Night

Let's look at the night shots. They are especially difficult because of the extreme low-light conditions. One of the problems, which really cannot be fixed, is that increasing the luminance levels will bring out a huge amount of grain. This can be improved to some degree by transcoding the media from the native AVCHD to ProRes. The grain will be still pretty bad. This is where a large sensor camera will make a world of difference. With a little work, however, you might be able to save shots that are otherwise unusable. Let's start with the *ms musician* clip in the Timeline:

1. With the Waveform Monitor open, start in the Exposure tab by pulling down the blacks a drop or two so that they're at zero or maybe even a touch below.
2. Leave the Highlights where they are even beyond 100%. These two will help to increase the contrast—blacker than black and whiter than white.
3. Use the Midtones puck to push up exposure to about +33% to bring something back to the picture.
4. Generally, night scenes are not heavily saturated, so we'll bypass Saturation for the Color tab. Night scenes usually have a slight bluish cast, a little colder than normal, so push the Highlights puck up about +20% right in the middle of pure blue. Note that as you push up the blue in Highlights, the luminance value will come down.
5. Finally, take the Mids puck and put it right below the Highlights and pull it down just a bit, about −4%, to counter the highlight and to take a little of the blue out of the musician's skin.

That's the image, perhaps as good as can be salvaged. Figure 9.17 shows the before and after of the color correction. What would help it, of course, would be a better camera, with higher resolution, which did not exhibit the tremendous amount of grain introduced in the low-light conditions.

TIP

Adjusting a Clip Before You Edit It: Sometimes you want to correct a clip before you put it into a project. A shot such as an interview that's going to be reused multiple times might be better corrected before you edit it into the Timeline. To do this, select the clip in Browser, right-click on it, and select **Open in Timeline**. In the Inspector, you now have access to the Color Board for Correction 1. Whenever you edit a piece of the shot from the Browser into the Timeline, that color correction will be applied. Note that after you edit the shot into the Timeline, any subsequent changes made in the Browser to the color balance for that shot will have no effect on clips already edited into the project.

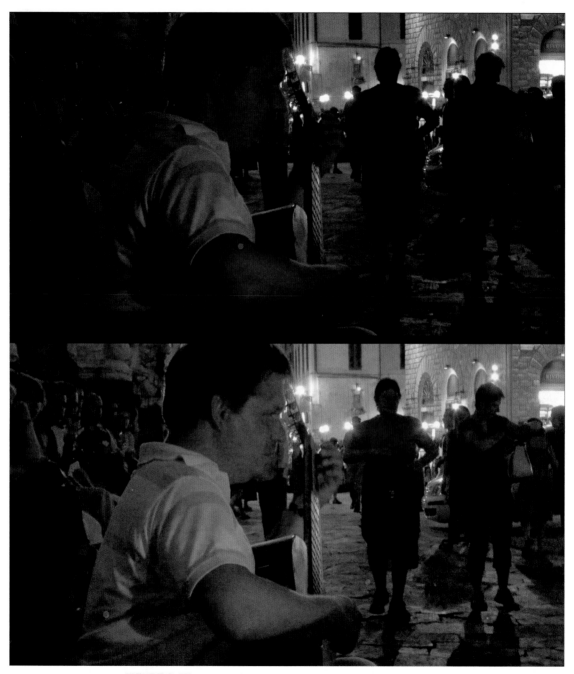

FIGURE 9.17
Before and after correction.

Broadcast Safe

Broadcast Safe is an effect that should be added to the *ms musician* shot. It's used to clip off any high luminance levels that appear on a clip.

1. Select the *ms musician* clip in the Timeline and open the Effects Browser with **Command-5**.
2. With All Video & Audio selected, type *broad* in the search box at the bottom. The Broadcast Safe filter will appear.
3. Double-click this filter to apply the effect to the clip. If you have the Waveform Monitor open, you'll see the bright street lights that are exceeding 100 IRE being rounded off by the filter to 100 IRE.

The Broadcast Safe effect can be something of a magic bullet and works well at the default setting. In the effect controls (see Figure 9.18), you'll see you have separate options for reducing the luminance, the most common usage, or reducing the saturation. There is also a pop-up to select whether you're applying NTSC, the North American standards, or PAL, the European standards.

FIGURE 9.18
Broadcast safe controls.

A common way to apply Broadcast Safe is to apply it globally to an entire project. You should select all the clips and make them into a Compound Clip, applying the effect to the compound.

Another option is to apply the Broadcast Safe filter to an adjustment layer. As we saw in the previous chapter on effects, you can apply any number of effects to an adjustment layer. A useful advantage of an adjustment layer for Broadcast Safe is that it allows you make settings of the effect for a group of clips and a separate adjustment layer with different settings for another group of clips.

An adjustment layer can also be used to add an overall grade to multiple clips, warming up or increasing the contrast for an entire scene or group of clips

without effecting color balancing done to individual clips. Remember that luminance grades can effect RGB values, which you might want to adjust on a clip by clip basis. It will be applied globally to all the clips in the project. If you have the Waveform Monitor, open and skim across the project, you'll see that the bright night shots that we haven't corrected will also have their luminance values chopped off so as not to exceed 100 IRE.

Generally, the process of converting the project to a Compound Clip and applying the Broadcast Safe effect is the last step before you export or share your finished work.

Match Color

The **Match Color** function in FCP is a really useful feature. Sometimes it just seems to have almost magical properties, although sometimes it doesn't work as well as you might like. In that case, you can use FCP's extensive color correction tools to fix the problem manually. The simplest ways to apply the Match Color function are from the Enhancement menu in the Toolbar, or by clicking **Choose** opposite Match Color in the Video inspector, or with the shortcut **Option-Command-M**.

We've already fixed the medium shot of the musician as best we could, but there are two other night shots: a wider shot of the musician and a shot of a photographer with a decidedly greenish cast to it. Let's see what the Match Color function does for us:

1. If you have made the project into a Compound Clip to apply the Broadcast Safe effect, that's not a problem. Simply double-click the Compound Clip to open it into the Timeline.
2. Select the *musician night* clip and activate Match Color with one of the four ways just described.
3. A two-up display appears. The one on the right is the image you want to fix; on the left is whatever underneath the skimmer.
4. Move the skimmer over the *ms musician* clip and click on it. Try different frames. Try one near the beginning of the shot and try another near the middle of the shot. The Match Color effect will match the shot on the right to the shot on the left (see Figure 9.19).
5. Click on **Apply** in the dialog to apply the selection.
6. Select the *night shot* with the green cast and activate Match Color.
7. Again skim over *musician night*, click on it, and apply it to the green shot.

The effect is quite remarkable. The green is gone, and the image's luminance values match that of the first shot. Unlike the Broadcast Safe effect, the Match Color function is not so much of a magic bullet and sometimes doesn't work that well.

One thing you should be aware of is that the Match Color function does not actually use the Color Board to correct the color and luminance of the image. It simply makes mathematical calculations and applies them based on which

FIGURE 9.19
Match color display.

frame you click in the sampling image, so nothing it has done is reflected in the Color Board. You may want to experiment by clicking in certain sections of the shot, such as the beginning, middle, or end, for better matching values. Also, the Color Board controls are downstream on the Match Color function, which is probably a good thing because it allows you to make additional changes to what Match Color has already applied. For instance, I don't quite like what it did to the *musician night* clip. Let's fix it like this:

1. Open in the Color Board, and in Exposure, take down the black a little to bring it down to zero and even crush it a little.
2. In the Saturation tab, push the Midtones up about 10% to bring more color back to the flesh tones.
3. Use the skimmer to compare the adjacent shots.
4. To return to the project from inside the Compound Clip, use the back button in the upper left of the Timeline or the shortcut **Command-left bracket**.

Looks

Looks in film and video are created by talented, creative colorists who bring magic to the movies. Some looks, such as Bleach Bypass, have become popular to the point of cliché. Some presets are provided as effects in FCP, but there are more available in the Color Board, and more importantly, you can make and save your own. Let's see how this process works:

1. Inside the *Color* project if you made the Compound Clip to apply Broadcast Safe, break the Compound Clip apart. Select it and use the shortcut **Shift-Command-G**.

2. Select the *silhouette with doors* shot and do a little basic correction to it in the Exposure tab of the Color Board.
 a. Pull down the Highlights a little, say –7%.
 b. Pull down the Shadows a little, about –1%.
 c. Push up the Midtones about +7%.
 d. Increase the Global Saturation by +10%.
 e. In the Color tab, shift the Global puck to yellow-orange in the image, about 38°, and increase by +5%.
 f. Move the Midtones to about 197° and up +9%.

3. After tweaking the image, go back to the Video inspector and click the + button opposite Color to add a second color grade.

Correction 2 is added beneath Correction 1. Generally, the basic color correction for an image—setting its Luma and Chroma levels, and matching it to other clips—should be done in one grade or correction, and any additional special looks or secondary color corrections should be done in additional grades that can be tweaked separately and switched on and off as needed. This also allows you to try different looks. Remember, you also have the Audition feature that allows you to make duplicate copies of clips to which you can apply separate looks and grade effects:

1. To apply the looks or to create your own, open the Color Board for Correction 2. Notice the pop-up in the upper-right corner that allows you to switch easily from Correction 1 to Correction 2.
2. To access existing presets, click on the **Presets** button in the lower right of the Color Board for a list you can choose from (see Figure 9.20).
3. Select **Summer Sun**. It's a warm, bright, high-contrast look.

Like most of them, the Summer Sun preset is pretty extreme, but notice that unlike the Match Color function and the Color Balance function, these presets actually move the Color Board controls so you can see what it's doing. Because it's designed for all material, so it uses extreme settings. All of them need to have their luminance levels fixed. The best way to fix these levels is to apply the Broadcast Safe effect, which clamps the levels without affecting the quality of the look across the central dynamic range of the shot. However, the Broadcast Safe effect does not control a clip that has a Correction. The color adjustments happen after the effect, as you can see in the Video inspector. The order in which items appear in the Video inspector is the order in which they're applied. Effects are first, then Corrections, then Transformations, and so on. To apply the Broadcast Safe effect, you need to make the clip or the whole project with multiple corrections into a Compound Clip first, before applying Broadcast Safe. Applying the effect to the Compound Clip will clamp the whole image. This procedure works very well to rein in these extreme looks without ruining their effect.

Presets ▼

Save Preset...

Alien Lab
Artificial Light
Ash
Brighten
Cold CCD
Contrast
Cool
Dew
Dim
Dry
Dust
Fall Sun
Frost
Moonlight
Night
Sewer
Spring Sun
Summer Sun
Warm
Winter Sun

FIGURE 9.20
Color looks presets.

Notice that in addition to the available presets, you can create your own by pushing the pucks around and then using the **Save Preset** selection in the menu. You get to name your preset, and it appears at the bottom of the preset menu. The presets are stored in your home/Library/Application Support/ProApps/ Color Presets folder.

You can also get additional looks from third parties. Be sure to check out Denver Riddle's great Luster Grade presets at www.colorgradingcentral.com.

TIP

Toggle Off: When you're in the Color Board, there is no button to toggle the board off and on, except for Reset, with the arrow button in the upper right, and then Undo to turn it back on. This, however, only toggles the one board, to toggle the whole correction off and on; you can use a hidden shortcut. In the Command Editor (**Option-Command-K**), search for *toggle*, and you'll find Toggle Correction on/off. Create a keyboard shortcut. I like **Option-Z**, but pick whatever you want. This toggles the entire grade off and on, to switch between before and after.

SECONDARY CORRECTION

So far we've done mostly primary color correction, fixing the Global Luma and Chroma of an image, even adding looks that affect the whole image. Sometimes, however, you want to correct only part of an image—make the sky more blue; make the yellow more yellow; or highlight an area of an image, like an actor's face, to make it pop. This is done on most every shot in primetime television and in the movies.

Shape Mask

There are two ways to make a selection in FCP to restrict the correction we're making. We do this by making masks. A mask is the area we select that we want to control. A mask can be either a **Shape Mask** or a **Color Mask**. A Shape Mask is just that—a shape we create that defines the area of our correction—whereas the Color Mask is a specific color range that we select that we want to affect. You can use multiple shapes and color masks on every image, but let's try just a few and look at how these masks work.

Shape Masks are usually areas that are greatly feathered to gently blend the effect into the rest of the image. We'll start with the *cs statue* clip in the *secondary* Keyword Collection:

1. Append the clip into the *Color* project and move the playhead over it. You don't have to select it. The gray ball on the clip tells you it's the focus and its controls appear in the Color Board. If you don't see the gray ball over the clip on the playhead, press **Shift-Command-A** to Deselect All.

2. Let's do a basic grade to adjust its levels in Correction 1.
 a. In the Exposure tab of the Color Board, reduce the Shadows by –3% and the Highlights by –8%.
 b. Increase the Global Saturation by +20%.
3. Return to the Video tab of the Inspector and add a second correction.
4. There are two buttons for creating masks. The one on the right makes a Shape Mask (see Figure 9.21), whereas the button with the eyedropper next to it creates a Color Mask. Click the Shape Mask button opposite Correction 2.

On-screen controls appear in the Viewer (see Figure 9.22). The inner circle is the area that will be affected by your controls. The outer circle is the fall-off from the control. You want to make the fall-off so smooth that the enhancement effect is not noticeable. The target in the center allows you to position the shape, while the handle allows you to change the angle. The dot to the left of the upper green dot lets you pull out the circle and change the shape to a rounded rectangle (see Figure 9.23). What we want to do is make a mask that allows us to brighten the statue while subduing the rest of the image so that the statue is the focus of the attention:

1. Draw out the top of the circle so it's a tall, narrow oval, with plenty of fall-off, and then position it around the statue.
2. Go to the Correction 2 Color Board, and in the Exposure tab, try these adjustments:
 a. Push up the Midtones about +15%.
 b. To increase the contrast, pull down the Shadows to –5%.
 c. Increase the Highlights by +6%.

This alters the area inside the Shape Mask. By increasing the contrast and brightness and, if there was color in the image, by increasing the saturation, you emphasize that part of the image.

To help the emphasis, you want to darken the outside, reducing the contrast and the saturation to de-emphasize that area. At the bottom of the Color Board, notice two buttons: one for Inside Mask and the other for Outside Mask.

1. Click on **Outside Mask**. These are entirely separate controls, a completely separate Color Board from the one for Inside Mask.

FIGURE 9.21
Shape mask button.

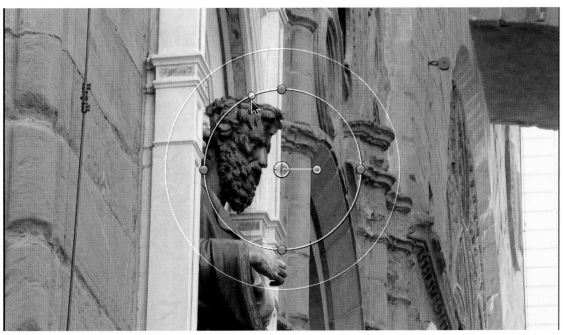

FIGURE 9.22
Shape mask controls in the viewer.

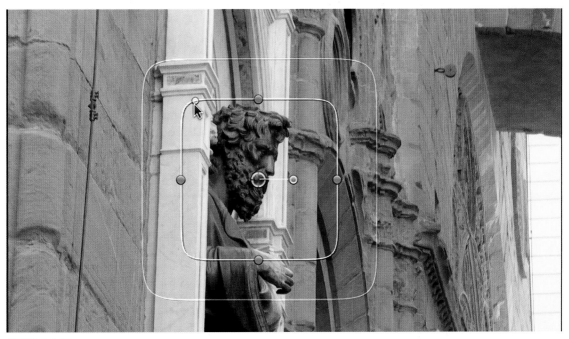

FIGURE 9.23
Rounded rectangle shape mask.

2. To reduce the contrast, we'll push up the blacks and pull down the whites in Exposure.

 a. Push Shadows up +5%.

 b. Pull the Highlights down −5%.

 c. Pull down the Midtones a lot, to about −19%.

If the fall-off is sufficient, the brightening of the statue will be imperceptible, or at most, the audience will think what a fortuitous shaft of light fell on that statue at the moment.

It's easier to see the effect without the On Screen Controls making it obvious. To hide the OSC, in the Video inspector, click the little blue Shape Mask icon opposite the correction (see Figure 9.24).

A commonly used technique with photographers is to use a graduated filter to reduce the brightness of the sky in the upper parts of an image, which can be overly harsh, drawing the viewer's eye to it rather than focusing on the subject. Let's do something similar to a portion of the *ws duomo* shot in the *secondary* keyword collection.

1. Select about the first four seconds of the *ws duomo* shot, before the camera pans left, and append that into the Timeline. The cathedral is too bright in relation to the rest of the image.

2. We'll dispense with the primary correction and go straight to the Shape Mask. Add the Shape Mask and drag out a highly feathered horizontal rectangle, as in Figure 9.25.

3. In the Exposure tab, pull down the Shadows just a little, down −4%. Pull the Highlights down just a little, about −2%. Pull down the Midtones to about −17%.

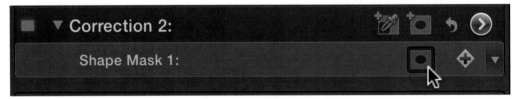

FIGURE 9.24
Shape mask icon.

NOTE

Animating Shapes: In these images, we're working with statues and cathedrals, which don't move much, but sometimes you want to make a mask around a person, such as we did to the statue. People aren't so static, and Shape Masks need to be animated. This can be done by adding keyframes using the keyframe button to the right of the Shape Mask in the Video inspector. You can then manually reposition and animate the motion as the mask needs to move around the screen.

FIGURE 9.25
Large, horizontal, rectangle-shaped mask.

A separate Shape Mask could be used to reduce the brightness of the sky and the building on the right side of the frame.

Color Mask

Sometimes you don't want to adjust an area on the image; you want to adjust a color or range of colors, make a color pop, or take out the color from everything else in the frame. Fixing the color itself is the easiest part of the process. The hard part is making the Color Mask and carefully selecting, adding to, subtracting from, and feathering the mask, like this:

1. For this exercise, we'll use the *duomo* clip from the *secondary* Keyword Collection. Append it into the storyline. What we want to do is to punch up the blue in the sky.
2. In the Video tab of the Inspector, click on the eyedropper button of Color Mask.
3. Go to the Viewer with the eyedropper and click and drag a small area of the sky (see Figure 9.26).
4. Hold the **Shift** key and drag another selection of the sky to add it to the selection. Repeat until you have most of the sky selected, but none of the building.
5. If you select too much, hold the **Option** key while dragging a selection to remove a color range from the selection.
6. In the Inspector, the slider between the eyedropper and the color swatch adjusts the mask feathering. Hold the **Option** key and drag the slider. While you're holding the key and dragging, you'll see a black-and-white representation of the Color Mask (see Figure 9.27). What's white is selected. What's black is not selected.

FIGURE 9.26
Using the eyedropper to make a color mask.

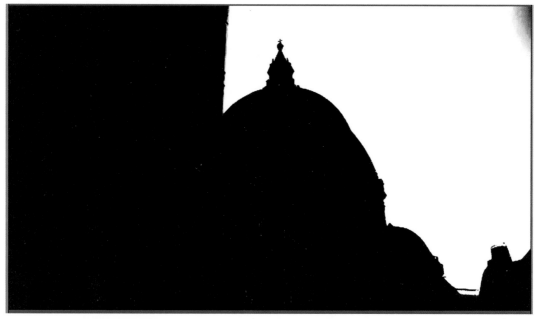

FIGURE 9.27
Mask display in the viewer.

7. With the Color Mask selected in the Color tab of the Color Board, push the Highlights to blue at 239° and raising them +26%.
8. In the Outside, set the Global color puck up in yellow a degree or two to warm it up and help the contrast with the blue of the sky.

That's it. The pale blue has become a vibrant blue that the chamber of commerce always wants.

Using these tools, you can see the great range of techniques that can be used and their power in shaping and controlling the way you use light and color in your productions.

COLOR CONTINUITY

So far we've looked at color correction for single images, but often, especially in narrative fiction, the shots used in a scene must be balanced not only within themselves but also in relation to the other shots in the scene. The light, the color, the skin tones, the clothing, the furniture, everything has to match from shot to shot so as not to distract the audience, while at the same time making the image as pleasing and powerful as called for in the story.

Setup

For this section, we'll go back to the *BB4* library, for the scene from Steve Oakley's short *A Great Life*. From the *color project* event, open the *Color Continuity* project. The scene is essentially the edit we did in Chapter 4. In it there are basically three shots that need to be corrected, the master shot and the two close-ups, one for Michael and one for Kathy. The cutaway of the photo album can be dealt with on its own. Let's begin by marking the shots we need.

1. Move the playhead or skimmer over the second shot, close-up of Kathy, *0028b*. Somewhere near the middle of the shot where you can see Kathy clearly, double-tap the **M** key.
2. Name the marker that's created *Kathy cu*.
3. Skim down to the middle of the master shot, *0025*, and press **Option-M**.
4. Name the marker *wide*.
5. Go to the next shot, where's Michael's looking toward Kathy, and add a marker naming it *Michael cu*.

If there were more representative shots, maybe a medium two shot or a very wide master showing the whole room, you could mark those. Where to begin? Normally you begin by color correcting a master shot. This may not be the widest shot in the scene, which may not be representative of the closer lighting and the all important skin tones of the characters. Generally a medium wide master shot is where we begin. In this case *0025* or *0026*. Let's set up the color correction environment.

1. Close the Browser with **Control-Command-1**, open the Waveform Monitor with **Control-Command-W**, make sure it's set to Luma, and open the Timeline Index, **Shift-Command-2** and set it show Tags (see Figure 9.28).

FIGURE 9.28
Timeline index.

If necessary you could set it to shows markers only, or To Do items. If there are a lot of markers in the Timeline, the index is the easiest way to navigate.

2. Move to the *wide* marker. You can move between markers using **Control-apostrophe** to go to the next marker, and **Control-semi-colon** to move to the previous marker.

3. Also switch off the skimmer. It's not helpful when color correcting except for one specific purpose where it's really useful.

4. Make sure nothing is selected in the Timeline and press **Command-6** to open the Color Board for the master shot underneath the playhead.

> **NOTE**
>
> *Playhead Losing Focus:* When you use the Timeline Index or the shortcut to move to a marker, the playhead loses focus from the clip. Normally the gray ball hangs on the playhead as you move it around the Timeline, but when moving to a marker, the marker unfortunately becomes the selected item, not the clip underneath it. When you move to marker, you need to press **Shift-Command-A** to drop the marker selection and return focus to the clip.

Master Shot

Now we're ready to begin. As always we should begin with the Exposure board, **Control-Command-E**.

1. Figure 9.29 shows the Viewer and the Waveform Monitor. Notice two things, the elevated bright light from the window and the pin point shadow areas that drop down to zero black. The fact is that these are not important to scene. We need to spread the contrast area through the central portion of the image, ignoring the extraneous and relying on the Broadcast Safe effect to clamp the tops and bottoms of the luminance range.
2. Pull down the Shadows puck till it's around −10% setting the bulk of the shadow just around zero.
3. Pull the Highlights down to about −9%. These two corrections will considerably darken the image.
4. Use the Midtones to set the brightness level for the scene. This is where your taste for the scene controls your setting. Somewhere around +11% should work well, but try something else. If you go too high, the scene will start to look washed out and you'll have to push more Chroma into it.
5. Switch to the Color tab or the Color Board (**Control-Command-C** when the board is active).
6. Switch the Waveform Monitor from Luma to RGB Parade. This is where you set the Shadow color. In the Exposure board, you do Shadows first, then Highlights, and then Midtones. You should do the same in Color, Shadows first, then Highlights, then Midtones. Figure 9.30 shows how elevated the reds are in the shadow areas in relation to the blues.
7. Move the Shadows puck to the right in the red/orange area to try to balance the RGB values at the bottom of the scale. The easiest way to fine tune the puck's position is to use the **Arrow** keys to move it around. Somewhere around 26° and down about −6% should work well.

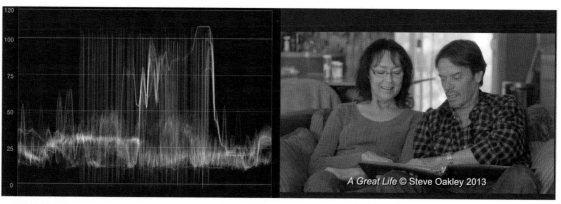

A Great Life © Steve Oakley 2013

FIGURE 9.29
Viewer and waveform monitor.

FIGURE 9.30
RGB parade.

There is very little highlight area in the image except for the window in the back, so we'll go to the Midtones. The principal color in this range we want to set is the skin tone. One trick to doing this is to limit the area that the scopes look at by using the Crop function. We'll look at cropping in more detail in the next chapter, but for now, let's use it to set the skin tone for Michael's face.

1. Activate the Crop function in the Viewer **Shift-C**, which unfortunately closes the scopes, but we can open them when we need them.
2. Pull in the corners and side of the image as needed so that only the skin on Michael's cheek is visible.
3. Open the Vectorscope with **Control-Command-V** and you'll see a faint line sitting slightly off the flesh line.
4. Right-click in the Vectorscope and increase the scale to 133% to make it easier to read.
5. Select the Midtones puck in Color and move it around to drive the trace onto the flesh line, something around 230° and up about +8% should do it (see Figure 9.31).

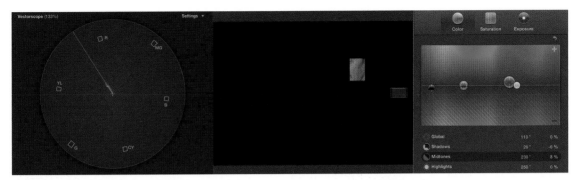

FIGURE 9.31
Cropped image with Vectorscope and color board.

6. Go back to the Video inspector and opposite Crop, use the reset button to remove the crop on the image, and see it in its full size.
7. It's still a little flat looking, so go back to the Color Board and the Saturation tab.
8. I usually pull down the Shadows puck to minimize any color cast in the blacks, something like –10%. Because the window is of little importance to the scene, we can pull down the Highlights a bit, perhaps –12%. We can afford to push a great deal of Chroma into the Midtones to make the scene richer, perhaps as high as +37%.

If you want to give an overall color cast to the image, rather than using the controls, you used to set the base low, add a secondary color correction, and use the Midtones Color and Saturation primarily to warm up or cool down the scene.

Matching Shots

Before we move on to setting up adjacent shots, let's take the color grade we did for *0025* master shot and apply it to the *0026* master shot at the end of the project. The simplest way in this instance is to just copy and paste.

1. Select the corrected master shot in the middle of the project and press **Command-C**. That copies the clip and every value associated with it.
2. Select the *0026* master at the end. You could use Paste Effects (**Option-Command-V**) to apply it, or you can use **Shift-Command-V** to Paste Attributes and check on Color to apply that.

Let's set up the close-up of Michael, *0030a*, that follows the master shot.

1. Move the playhead to the *Michael cu* marker and make sure the marker isn't selected.
2. Open the Exposure board and start by pulling down the Shadows a bit as we did before to about –5%. Do the same for the Highlights, down about –3%.

3. We'll use the Midtones to set the contrast for Michael's skin. To make this easier to see, in the Saturation board pull the Global puck down to zero. Do the same for the master shot.

4. This is where the skimmer becomes very handy. Activate it with the **S** key. Leaving the playhead at the *Michael cu* marker, move the skimmer over the master shot. Now toggle it off and on with the **S** key, allowing you to quickly compare the luminance values of the image in the Viewer and the Waveform Monitor. We want to try to set the skin tone to be about the same level. We probably should push up the mids about +3% or so.

Once you've set what looks like the correct luminance levels, we'll have to work on adjusting the color. But first be sure to reset the Global Saturation pucks for the shots. Just select each in its Saturation board and press the **Delete** key to reset it. The color is where the most radical difference is between the images, with the close-up having a distinct reddish cast.

1. In the Color tab for *0030a* start with the Shadows puck. Move it to about 1° and pull it about −6%.

2. Go to the Saturation board and pull down the Shadows puck around −10%.

3. Push the Midtones puck a little toward cyan to about 211° and push it up a little, about +2%.

4. Use the skimmer toggle to compare the two shots.

I'll probably leave it there for the time being, though I'd be tempted to use secondary color correction with a Color Mask on the left side of his face to pull down the extremes of the reddishness. It's not apparent when Kathy's face shadows his, but when it's in full light around the middle of the clip, it's quite distinctive (see Figure 9.32). In the Color board, just pull down the mids in the red area and maybe add a touch of blue in the Shadows. The nice thing about using the Color Mask is that as Kathy's face covers Michael's, the secondary correction will have almost no effect, because the selected red color is missing.

I'll leave you to color match Kathy's close-up at the first marker, and when you're done, we're ready to apply your two close-up grades to the other shots. They're two ways to do this, one using the Timeline Index and the other use some hidden keyboard menu items to which we can add keyboard shortcuts. Let's do Michael first with the Timeline Index.

1. Select the first Michael close-up we did, the *0030a* shot right after the master and copy it.

2. In the Timeline Index for Clips, use the search box to find *0030a* (see Figure 9.33).

3. Select all the clips and then use **Shift-Command-V** for **Paste Attributes**, checking on Color. It doesn't matter that one of the clips is audio only.

Before we apply the Kathy's color corrections, let's set up those hidden menu items with shortcuts.

FIGURE 9.32
Color mask selection.

FIGURE 9.33
Timeline index with selected clips.

1. Open the Command Editor from the **Final Cut Pro** menu (**Option-Command-K**) and in the upper right search for *copy*. Six items will appear. We're interested in the first three that copy a color correction from one clip and paste it to the selected clip.

2. For the third **Apply Color Correction from Two Edits Prior**, assign the keyboard shortcut **Shift-Control-Two** (see Figure 9.34).

3. For the first and second, **Apply Color Correction from Previous Edit** and **Apply Color Correction from Three Edits Prior**, set the shortcuts **Shift-Control-3** and **Shift-Control-1**, respectively.

4. First copy the graded Kathy close-up under the first marker, select the *0028b* shot that's between the two *0030a* Michael close-ups after the master and use **Paste Attributes** to apply the color correction.

5. Select the last *0028b* shot of Kathy and use the shortcut **Shift-Control-2** to copy and apply from two shots previously.

FIGURE 9.34
Hidden menu items in the command editor.

The shortcuts are especially useful for these types of dialog scenes or for scenes such as interviews where the shots are cutting back and forth. You set your master shot and then use the Timeline Index to paste to every use of the master shot. Color correct the first two close-up shots and then use the shortcuts to step through the program applying the corrections to the appropriate shot as the camera switches back and forth.

Finally, don't forget, once you're done all your color corrections, apply them to the clips to combine them all into a Compound Clip, or use an Adjustment Layer, and add the Broadcast Safe effect to it to clamp those stray deep shadow and excess highlight areas.

TIP

Comparing to the Master Shot: Once you have the master shot set, you can use it to compare other shots. Select the master shot and convert it to a Compound Clip with **Option-G**. Use **Shift-F** to find the compound in the event and select it. From the **Window** menu, select **Show Event Viewer**. If you have your scopes open, you can go to their **Settings** popup menu and choose **Vertical Layout**. You can do that for each Viewer and have separate Viewers and separate scopes, side by side, to compare the master shot with the shot you're working on.

> **TIP**
>
> *Limiting Color Mask:* Sometimes when you make a Color Mask selection, extraneous areas of the image get selected as well. You want to highlight someone's blue sweater and the blue curtains in the background get affected as well. You can prevent that by applying a Shape Mask after the Color Mask to limit the area the color selection gets applied to (see Figure 9.35).

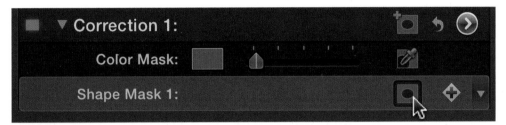

FIGURE 9.35
Shape mask after color mask.

SUMMARY

In this chapter, we looked at the tools for color correction in FCP, starting with the automatic Color Balance function. For manual correction, we learned how to use the video scopes and the manual controls in the Color Board. We saw how to white balance clips and to fix a number of common color correction problems. We applied the Broadcast Safe effect to keep video from exceeding legal luminance levels. We also used the Match Color function to make two clips have the same color and tonal quality, and the preset looks to create special visual effects. Finally, we saw the power of FCP's multiple secondary correction tools, including the extraordinary control of Shape and Color Masks. We also worked with a dialogue scene to match the colors accurately and to apply it to the various shots. Next, we'll look at the transform functions in FCP and use their animation capabilities.

CHAPTER 10
Animating Images

Final Cut Pro has considerable capabilities for animating images, allowing you to move them around the screen, resize, crop, rotate, and distort them at will. All of these properties can be animated, which allows you to enhance your productions and create exciting, interesting, and artistic sequences.

SETTING UP THE PROJECT

One more time, let's begin by preparing the material that you'll need. In this chapter, we'll use *BB9* library. You can download it from the www.fcpxbook.com website. This is the smallest library as it contains only still images.

1. Once the file is downloaded, the ZIP file, copy or move it to the top level of your dedicated media drive.
2. Double-click it to open the ZIP and then double-click the library to launch the application.

The library has an event called *Motion* with a project called *Motion*. We could use video clips, but for the purpose of this exercise and for space, it's easier if the media is stills.

Before we begin, let's duplicate the *Motion* project:

3. Start by duplicating the project in the event, either a full duplicate or a snapshot.
4. Open the original project, leaving the duplicate as a backup.

> **NOTE**
>
> **Stills Frame Rate:** The project is 1280×720 pixels and is at 23.98 frames per second (more correctly 23.976 fps, but we round it up when writing it). This frame rate is used by video when emulating film's 24 fps rate. In the Browser, select the first image in Keyword Collection 720. If you go to the Info tab of the Inspector, you'll see that the frame rate for the still image is listed as 60 fps, the highest frame rate FCP utilizes. The still, however, will take its frame rate from the project in which it's placed. If you select the same image in the **Motion** project and check the Inspector, you'll see its frame rate has become 23.98.

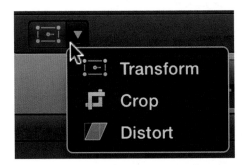

TRANSFORM

FCP has three different functions for positioning and animating video or stills around the screen. The three functions are **Transform**, **Crop**, and **Distort**. These functions can be accessed from the button in the lower left of the Viewer (see Figure 10.1), or with the keyboard shortcuts **Shift-T** for Transform, **Shift-C** for Crop, or **Option-D** for Distort, or by right-clicking on the image in the Viewer. The functions can also be accessed directly in the Video inspector for any clip in the Timeline.

The easiest way to control these functions is directly in the Viewer with some handy on-screen tools. For precision, you also have access to numeric controls in the Inspector (see Figure 10.2). Using the on-screen controls together with the Inspector controls, you can manipulate your images with precision and ease. Furthermore, all these properties can be animated.

Scale

The first Transform function we'll look at is **Scale**. Here's how to use it:

1. Select the first image in the *Motion* project and activate the Transform function by pressing **Shift-T**. The image is outlined in white with round, blue dots on the edges (see Figure 10.3).
2. To scale the image, grab a corner and drag. The image scales proportionately around the center.
3. If you drag one of the sides, the image's aspect ratio will change, squeezing the image and distorting it. This scales the image separately in the X-axis and the Y-axis.
4. If you hold the **Shift** key and drag a corner, you can scale and change the aspect ratio of the image at the same time, and these numbers will be reflected in the Scale values in the upper left in the viewer as well as in the Inspector (see Figure 10.4).
5. If you hold the **Option** key and drag a corner, you can scale around any opposite corner, which remains pinned in its original position. This is changing the clip's Anchor Point from the center of the image to opposite corner.
6. If you hold the **Option** key and drag a side handle, the image will stretch or squeeze from the opposite edge, which remains pinned.

You can scale an image larger than it is, but it's usually not a good idea to scale upward, not much above 110%–120%. Higher than that, and the image will start to soften and eventually show pixelization.

Rotation

Rotation is controlled in the Viewer or with a dial and value box in the Inspector. There does not appear to be a limit to how many times you can rotate an image, which means if you animate the rotation value, the image can keep on turning.

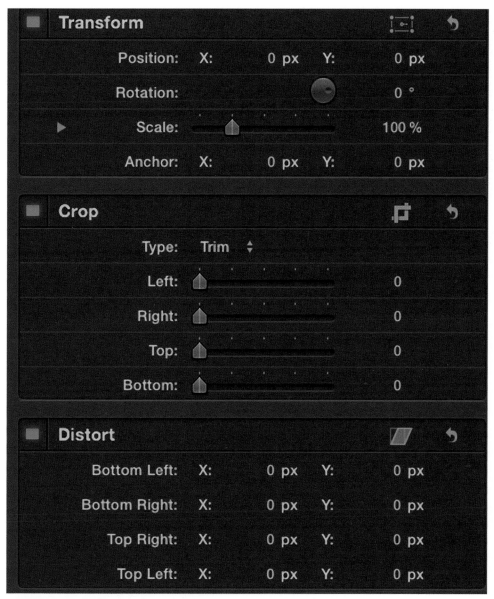

FIGURE 10.2
Transform, crop, distort inspector.

1. To rotate the image in the Viewer, grab the handle and drag.
2. Hold the **Shift** key to force the rotation to snap to 45° increments.

The farther out you pull the handle, the easier it is to rotate with precision. With the handle close to the anchor point, which is in the center of the image, you can rotate very quickly.

FIGURE 10.3
Scale outline.

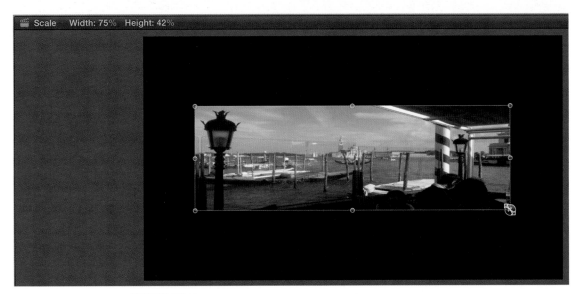

FIGURE 10.4
Scale values in the viewer.

Notice the dot on the right edge of the rotation circle. This indicates the last position of the image in its rotation. The first time you rotate a picture, it indicates what's horizontal, but the next time you rotate the image, it shows its last angle in the rotation circle.

Position

You can change the **Position** in the Viewer or with specific values for the X-Y coordinates in the Inspector. FCP counts the default center position (0, 0) as the center of the screen and counts outward from there, minus X to the left, plus X to the right, minus Y downward, and plus Y upward.

You can grab the image anywhere and drag it around the screen to position it, but if you drag it with the center target point, the image will snap to yellow center guides as you drag it (see Figure 10.5).

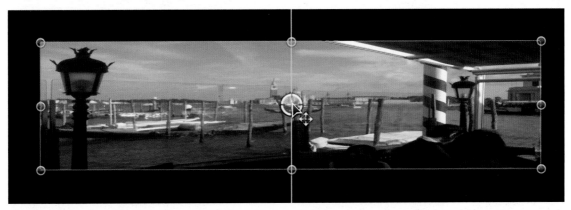

FIGURE 10.5
Positioning the image.

> **TIP**
>
> **Command-Drag:** If you're dragging an image with the center button and want to override snapping to the guides, simply hold the **Command** key.

Anchor Point

The **Anchor Point** is the place on the image that everything moves around. The image scales to the Anchor Point; it rotates around the Anchor Point; and when you position the image, you are repositioning its Anchor Point on the screen. The default location of the Anchor Point is the center of the image, regardless of where the image is on the screen, but let's see what happens when it's moved. First, we'll reset the Transform function:

1. To reset the image back to its default state, click the hooked arrow opposite Transform in the Inspector.
2. Double-click the X value of the Anchor Point, and using the scroll on your mouse, change it to –640 (or –90% if your Inspector Units preference is set to percentages). Alternatively, you can type in that value or mouse-drag within the X value boxes.

3. Change the Anchor Point Y value to 360 pixels. The Anchor Point is now in the upper left corner of the image, which should be off the lower right edge of the screen.

4. Grab the Anchor Button in the upper left corner and drag the image to the upper left corner of the Viewer using the alignment guides to help position the image (see Figure 10.6). Notice the Position value in the upper left of the Viewer.

5. Pull the Rotation handle out and drag it downward. The image pivots around in the upper left corner of the screen, as in Figure 10.7.

The Anchor Point becomes a powerful tool for animating images. After you finish working with the Transform function or any of the other two image manipulation functions, make a point of clicking the **Done** button in the upper right of the Viewer to close the function.

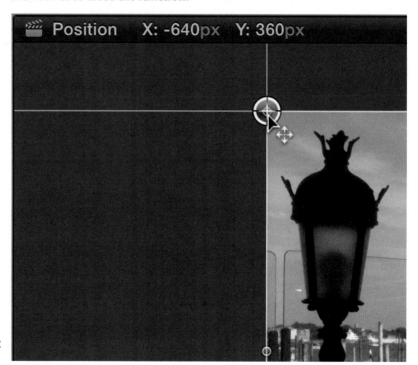

FIGURE 10.6
Positioning anchor point with alignment guides.

CROP

The **Crop** function allows you to trim the edges of a clip, cutting off the sides. You can use it to have multiple images on the screen or simply to remove an area that you don't want your audience to see. Be careful with this last function because it scales up the image, and that can make it look blurry or even pixelated, especially if it has to be recompressed for delivery on the web. There is a third crop function that creates a simple animated zoom on your image, a function that Apple calls the *Ken Burns effect*.

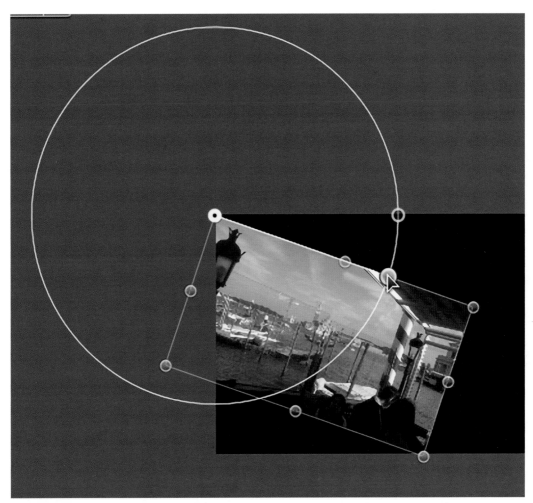

FIGURE 10.7
Rotating around the anchor point.

Trim

Let's leave the first image and work with the Crop tools on the second image, *0748*:

1. With nothing selected in the project, move the playhead over the image and press **Shift-C** to activate the Crop function. Three separate Crop functions can be selected using the buttons that appear at the bottom of the Viewer (see Figure 10.8).

2. With the default **Trim** function active, notice the square corner tabs and the dotted line around the image.

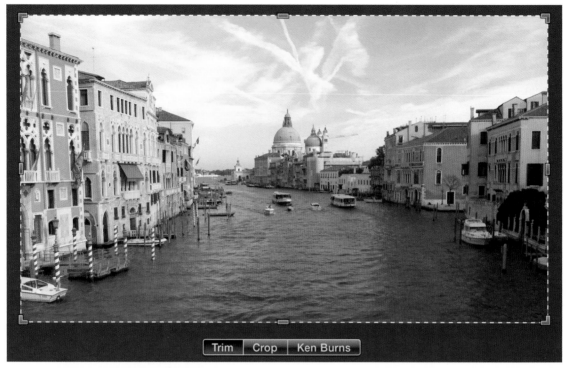

Trim | Crop | Ken Burns

FIGURE 10.8
Crop function buttons.

3. To crop the image, drag a corner tab or one of the side tabs to pull in those edges and crop off part of the image.

4. Once you've cropped an area, you can drag the cropped area around the screen to change the selection.

5. Drag with the **Shift** key to maintain the proportions. If you start holding the **Shift** key, the crop selection will remain 16:9. If you make the selection square and then hold the **Shift** key, the crop selection will remain square.

6. If you hold **Shift-Option** while dragging the corners of the image, it will be cropped proportionately on all sides around the center of the image. It does this center crop regardless of the location of the Anchor Point.

You can also control the Crop function with precision use of the value boxes in the Crop section of the Video inspector. Plus, you can switch the crop type from Trim to Crop to Ken Burns using the pop-up in the Inspector.

The area outside the cropped selection normally appears as black, but it's not. It's the emptiness of space. If you want the image to appear with a colored background, you should use one of the generators like this:

1. Select the image in the Timeline and use **Option-Command-Up arrow** to lift it out of the primary storyline so that it's a connected clip.

2. Find the generator you want to put underneath it, perhaps Organic, and drag it onto the Gap Clip in the storyline. Then hold and select **Replace from start** from the shortcut menu.
3. Select the cropped image on top and click the **Done** button in the Viewer, or by right-clicking on the image in the Viewer and selecting **None** from the shortcut menu.

> **NOTE**
>
> **Lifting Multiple Clips from the Primary:** If you lift a single clip from the primary storyline, it becomes a Connected Clip, connected to a Gap Clip. If you select a group of contiguous clips in the primary storyline and lift them using **Option-Command-Up arrow**, they will be connected as a secondary storyline with a single connection point at its head.

Crop

The **Crop** tool in the Crop function works a little differently. For one thing, no matter how you drag it, the image is always cropped proportionately. Why? Because when you finish cropping the image and click **Done**, the image will fill the screen.

Let's work on the third image in the project, *0755*:

1. Activate the Crop function with **Shift-C** and click the **Crop** button, the middle of the three at the bottom of the Viewer. Notice the image is outlined, but not with a dotted line; and now you only have drag tabs in the corners of the image.
2. Drag in the upper right corner to tighten the image, cropping a little from the right and the top of the taxi driver's cap.
3. Grab the selected area and drag it up so there is a little more headroom.
4. If you drag a corner holding the **Option** key, you will Crop the image proportionately around the center from all four corners.
5. Click **Done** or press the **Return** key and the image will fill the screen.

Remember, this example scales the image up, so that there will be some softening. Therefore, you should use this technique cautiously. It's a handy tool, though, if there's something on the edge of the frame that you need to cut out, like a microphone tangling into the shot.

If you wish, you can also drag beyond the edges of the image, which will create empty space around the image. This is an excellent way to give the image some breathing room around the image. And, of course, dragging it in this Crop function with the **Option** key will create a proportionately equal amount of space around the whole image.

Ken Burns

While the **Ken Burns** function does crop your image, it is primarily an automatic animation tool. It's used in many Apple applications, iPhoto, and iMovie, and also used in the operating system to create small animations on screen-saver images. The effect produces a zoom into or out of the image. The duration and speed of

the zoom are controlled by the length of the clip. The animation takes the whole length of the clip, so a short clip will have a fast zoom, whereas a long clip will have a slow zoom. Let's apply the Ken Burns effect to the fourth image in the sequence:

1. With nothing selected, put the playhead over the last image, *0778*, and press **Shift-C** to activate the Crop function.
2. Click the **Ken Burns** button. The image will appear in the Viewer with two boxes marked (see Figure 10.9), the green start box on the outer edge of the image and the red end box about 15% into the image.
3. At the top of the Viewer, click the button with the two chasing arrows, which swaps start for end. The effect will now zoom out.
4. Press the Play button next to the swap button to see the effect. It plays just the clip in Looped Playback mode. Click the button or press the spacebar to stop playback.
5. To adjust the start position, you will need to move the end position because it completely covers the inner box. Push the red end box off the left.
6. Make the green start box smaller by dragging the lower-right corner inward and position the box so that it's focused on the statue in the upper left.
7. Make the end box a little smaller and slide it back so that the end position is completely over the image (see Figure 10.10). Notice the arrow that indicates the direction of the zoom motion.
8. If the motion is too slow, drag either end of the clip to make it shorter and speed up the effect.
9. Play the animation and click **Done** when you're finished.

Although you can zoom in further, especially if you're working with large-format still images, for video that matches your frame size, 15% is probably

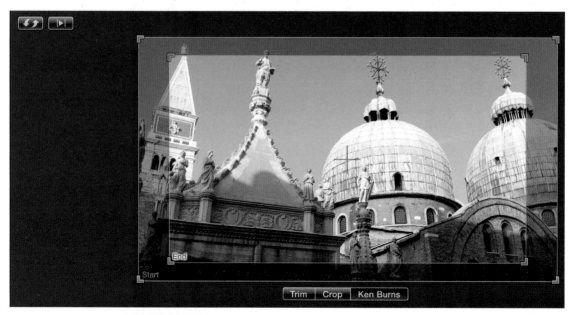

FIGURE 10.9
Default ken burns effect.

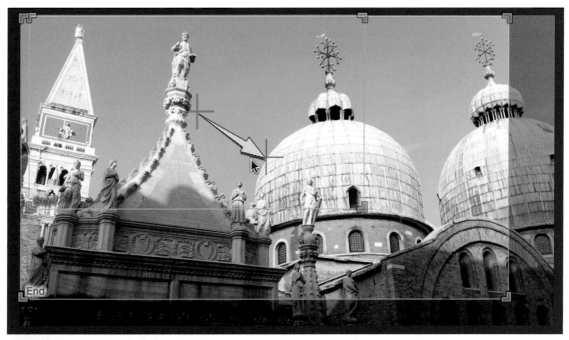

FIGURE 10.10
Custom ken burns effect.

as far as you should go. The Ken Burns effect has the option to use the default Ease In and Out and also just Ease In or just Ease Out or Linear interpolation. Just right-click in the Viewer and select what you want from the shortcut menu.

TIP

Multiple Ken Burn Effects: If you want to apply the Ken Burns effect to multiple clips, you cannot do it using the Viewer. If you select multiple clips, activate Crop and Ken Burns, it only gets applied to the clip under the playhead. To apply it to multiple clips, select them and change the Crop popup in the Video inspector. The default Ken Burns will be applied, so it trombones in and out on successive shots. You can change that in the viewer of course.

NOTE

Ken Burns Linear: If you want a linear Ken Burns effect without easing, you can do that by right-clicking in the Viewer while the Ken Burns controls are open and selecting **Linear**. There is a slight problem with this if you apply a transition, the linear movement does not begin at the start of the transition but in the middle of the transition. It really should begin at the first frame of the clip. You can correct this by selecting the clip with the Ken Burns crop, pressing **Option-G**, and making a Compound Clip. Now the Ken Burns movement begins at the very first frame of the video and appears to already be in motion as you transition into the clip and out of it as well.

Distort

The **Distort** function will let you skew an image almost as if you're twisting it in 3D space.

1. Put the playhead over a clip and click the **Crop** reset button in the Video inspector to reset it.
2. Use the pop at the bottom left of the Viewer to activate **Distort** or the shortcut **Option-D**. The image looks similar to the Transform function, except the drag tabs are square instead of round.
3. Grab a tab and start dragging a corner of the image to distort it (see Figure 10.11).
4. Drag the tabs on the edges to skew the image. The displacement will be reflected by corner point values in the Inspector.
5. You can drag the image to position it; you do not need to switch to Transform to do it.
6. Again, when you're done, click the **Done** button.

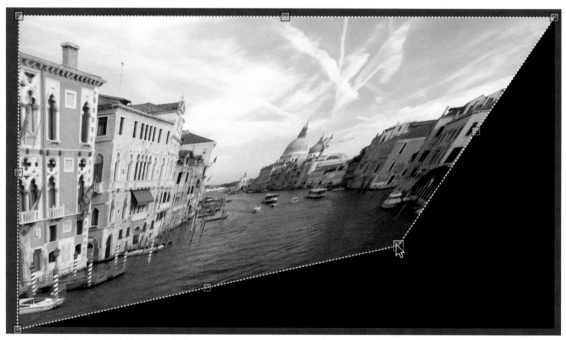

FIGURE 10.11
Distorting the image.

ANIMATION

Straight Motion

Final Cut Pro allows you to create many different types of animation for both motion and effects. Many of the parameters in the Video inspector can

be animated. The easiest way to set a motion keyframe is using the diamond keyframe button in the upper left of the Viewer. Let's do a simple motion animation using the last image, *0078*:

1. Start by resetting it by clicking the **Distort** reset button and the **Transform** reset button in the Video inspector.
2. Next, let's set the duration of the image. Select it, press **Control-D**, and type 5. (that's five period) and press **Enter** to make it five seconds long.
3. In the Viewer, go to the **Zoom** pop-up menu and set it to display the screen at 50% or a value that will give you some grayboard around the edge of the screen.
4. Activate the Transform function (**Shift-T**) and scale the image down to 50%, using the Transform Scale value in the Viewer as a guide.
5. Drag the image so that it's in the top-left corner of the screen, as in Figure 10.12.
6. Move the playhead so it's one second after the beginning of the clip in the Timeline and click the keyframe button in the upper left of the Viewer. This sets a global keyframe at the point for all the Transform values, Position, Rotation, Scale, and Anchor Point.
7. Go to the one second point before the end of the clip in the Timeline.
8. Drag the image across the screen so that it's in the lower-right corner of the screen.

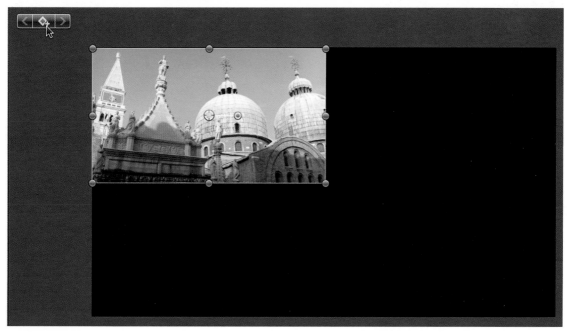

FIGURE 10.12
Start of the animation.

If you play the animation, you will notice that the motion is Smooth; it accelerates and decelerates. You can change this by right-clicking on the keyframe points at the start and end of the animation and selecting Smooth or Linear. There also a Lock Point function, which prevents a keyframe from accidentally being moved.

> **NOTE**
>
> *Scaling:* Notice that scaling has logarithmic values. An image at 50% is only a quarter size of the screen. This is why when scaling an image up, it will appear to scale quickly at first and then appear to slow down. Vice versa if you scale an image down, it will appear to zoom faster and faster. There is no way to defeat this in FCP. You need to use a function called exponential scaling. Fortunately this can be done with Motion, where you can animate with proper motion control.

Curved Motion

You can create a curved motion path in FCP by using Bezier handles. To add the handles, right-click on one or both of the keyframe points and make sure **Smooth** is selected. Bezier handles that control the motion path appear; you can pull them out to change the shape of the path (see Figure 10.13).

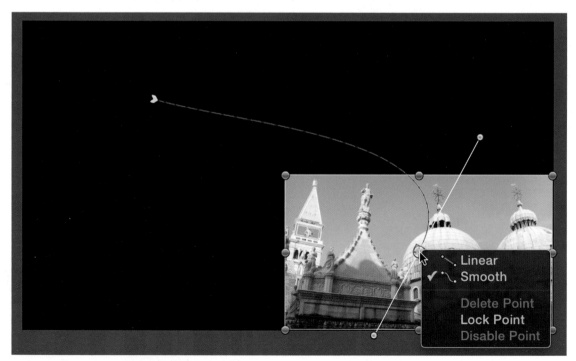

FIGURE 10.13
Using Bezier handles.

Keyframes

You can copy and paste keyframes between clips. Simply select the clip, use **Command-C**, and then use **Shift-Command-V** to **Paste Attributes**. In the dialog that appears, you can select which of the transform parameters you want to paste, and notice at the bottom the option to **Maintain Timing**, which keeps the keyframe spacing the same, or **Stretch to Fit**, which will expand or contract the keyframe spacing based on the clip length (see Figure 10.14).

> **TIP**
>
> **Disable/Enable:** There are also functions that allow you to Disable and Enable a keyframe. If you select Disable in shortcut menu, the keyframe has no affect on the animation, though you can move the keyframe around on the screen wherever you like. When you select Enable again, the keyframe position will be added into the motion path.

SPLIT SCREEN

A split screen is desirable for many reasons: for showing parallel action, such as two sides of a phone conversation, or showing a wide shot and a close-up in the same screen. It's easy to do if the video was specifically shot for a split screen. A phone conversation, for instance, should be shot so that one person in the conversation is on the left side of the screen and the other person is on the right side.

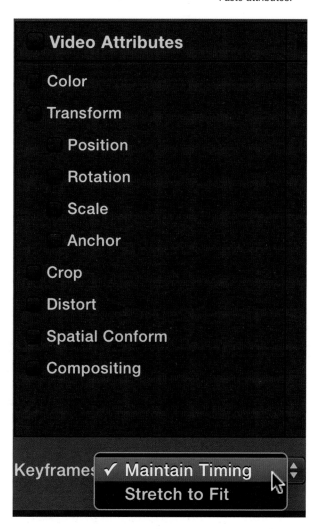

FIGURE 10.14
Paste attributes.

Let's do a simple split screen using the images we have in the project, but first let's reset them all:

1. Select all the images, and in the Inspector, click the reset buttons for **Transform**, **Crop**, and **Distort**.
2. Let's stack two images on top of each other. Take the third image, *0755*, and drag it on top of the second, *0748*, so that they are connected. With snapping turned on, the image should snap right into place. The magnetic timeline will close-up the gap.

TIP

Paste Parameters: An interesting feature of copying and pasting keyframes is the ability to copy compatible keyframes from parameter one to another. For instance, if I have keyframed a clip using position keyframes, I can copy those keyframes and paste them to the position values for an effect like a Radial Blur or Fisheye.

3. With nothing selected and the playhead over the stack, and with the upper clip as the focus, activate **Crop** and select **Trim**.
4. Grab the right side tab and drag it to the middle. It should snap to the centerline.
5. Select the image on the primary storyline and press **Shift-T** to switch to **Transform**.
6. Dragging with the Anchor Point, slide the image to the right and frame it as you like on the center alignment guide.
7. A separator bar is really useful for split screens. Go to the **Generators** and select one of the **Solids**. The Custom Solid gives you the most freedom.
8. Drag it on top of the other two images so that it snaps to them as a third Connected Clip.
9. Trim off the end by dragging it so that all three images are the same length.
10. Select the **Solid** and use **Shift-C** to go back to **Crop**.
11. Crop the left and right sides and change the Solid color to whatever you like in the Generator tab of the Inspector. Your project and Viewer should look like Figure 10.15.

Picture in Picture

By now, you've probably figured out how to make a Picture in Picture (PIP). You just scale down the image to the desired size and position it wherever you want on the screen. One note of caution about PIPs: Many video formats, such as material converted from analog media, leave a few lines of black on the edges of the frame. These are normally hidden in the overscan area of your television set and are never seen. However, as soon as you start scaling down images and moving them about the screen, the black line becomes apparent. The easiest solution is to use the Crop function and slightly crop the image before you do your PIP so that you don't get the black lines, which give the video an amateur look.

You might also want to add a border to the PIP to set it off, either with the Simple Border effect, or if you want something fancy, you might try the Frame effect. Be careful, however, if you need to crop the image. The cropping will cut off the border. One way around this is to put a generator background between the PIP and the underlying video and crop the generator to fit around the PIP as a border. To keep them together, you can select the two items and make them a Compound Clip.

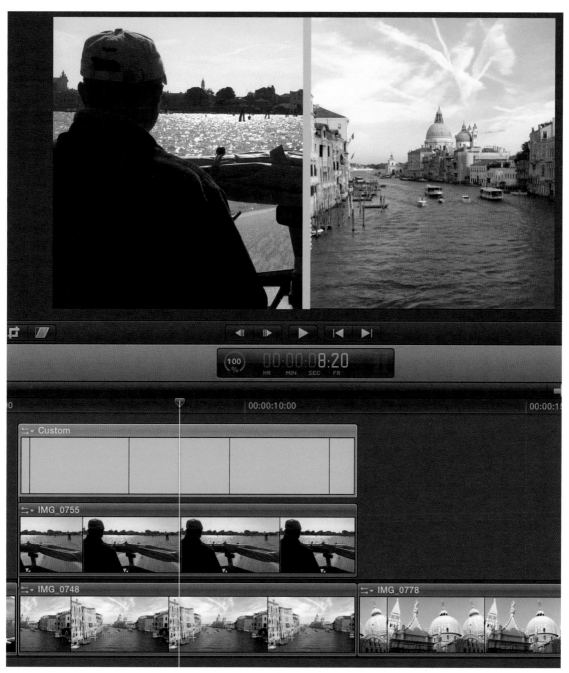

FIGURE 10.15
Split screen in the viewer and timeline.

MOTION CONTROL

Motion control is another term for the Ken Burns effect, also called *pan and scan*. It's a technique that's very useful on large-size still images. It has always raised some issues working in Final Cut Pro, but is much improved in the current version.

Although the Ken Burns effect using the Crop function works well, it is designed to do animation that you want to last the duration of the clip. There is a work-around that allows you to cut the clip and apply Ken Burns to sections, which we'll look at in a moment. This technique works well in some circumstances, but not so much in others.

Often you'll want to hold on an image and then push in or pull out and then hold again at the end. Often you'll want to make animations on still images or large graphics such as maps that are quite a bit larger than your frame size. Let's see what happens in FCP when we do a large-scale animation.

In the *Motion* event, find the *0773* image and append the entire clip, not just a selection, into the project. By default, the image will be made to fit the project. If you look in the Info inspector, you'll see that the image is 2592×1936 pixels in size, much larger than the size of the project we're working in, which is 1280×720 pixels. This is no more than a medium-resolution image. These days, it is not uncommon for images to be 4288×2848 pixels or greater. Whenever you bring a still image into an FCPX sequence, the application will always try to fit the image to the sequence size as best it can. If the image is tall and narrow—a vertical shot— the application will scale it so that it fits vertically in the frame. In this case, the image is a different aspect, so it shows pillarboxing—black bars on the left and right side of the image. To see the image at normal size:

1. Select the image in the Timeline, and in the Video inspector, go to **Spatial Conform** and set the pop-up to **None**. The image will now fill the frame.
2. Activate the **Transform** function to see the size of the image in relation to the screen (see Figure 10.16). To create the motion control effect, we'll need to animate the Transform function.
3. Move the playhead about two seconds from the start of the clip and click the keyframe button in the Viewer.
4. Move the image in the Viewer as far down in the frame as it will go so that the top edge is resting on the edge of the screen. This is our start position.
5. Move forward in the Timeline about five seconds.
6. Drag the corner of the image to scale it down till the sides align with the sides of the Viewer. Then slide the image up so that the top of the image remains aligned with the screen.

> **TIP**
>
> ***Spatial Conform in the Browser:*** You can set the **Spatial Conform** for a clip or multiple clips in the Browser before you put them in the Timeline. The change will have no effect in the Browser of course, but this allows you set how the clip will behave when put into a project that uses a different size or aspect ratio. This is especially useful when working with these types of large format still images as we are here.

FIGURE 10.16
Position for start of animation.

Another way to do this animation is to use the Crop function. Let me show you how to construct this:

1. Start by appending another complete copy of *0773* into the Timeline. Leave its **Spatial Conform** as **Fit**. If you change it, you'll get unexpected results.
2. Move the playhead to about three quarters of the duration of the image. This will be your end position.
3. Activate **Crop** and select the **Crop** button.
4. Move the selection area to the top of the screen so that the top edge lines up with the top of the Viewer, as in Figure 10.17.
5. Click the keyframe button in the Viewer to set the end point for the animation.
6. Move the playhead to about one second after the start of the image.
7. Drag the corner of the image to reduce the size of the selection. How far you can drag it is pretty much guesswork. Make it small enough so the winged lion is centered in the frame and clearly visible as the focus of interest.
8. When you have it cropped and the selection positioned as you like, click **Done**.

FIGURE 10.17
Crop selection for end of animation.

The animation will start zoomed in on the winged lion and pull back to as far as it can go within the image without showing any black around the edges.

> **TIP**
>
> **Checking the Scale Size:** If you are going to animate the Crop function, it's a good idea to set the Spatial Conform of the image to None to see what kind of magnification limits you have when you're at 100%. This will give you an indication of how far you can scale the image. After you've assessed the image, set Spatial Conform back to Fit before you begin your Crop animation.

Let's look at doing this with the Ken Burns effect to create a more complex animation.

1. Start by appending another complete copy of *0773* into the Timeline and leave its **Spatial Conform** as **Fit**. When we apply the Ken Burns effect, it will disregard the pillarboxing.

2. With the playhead over the clip, activate **Crop** and select the **Ken Burns** button. The animation is very slow as it stretches the 10-second length of the clip.

3. Set the End of the Ken Burns movement so it's zoomed into and focused on the winged lion above the arch something like Figure 10.18.

4. With the playhead still on the first frame of the clip, use **Edit>Add Freeze Frame** or **Option-F**, which makes a four-second freeze frame.

5. Trim the freeze frame so that it's about one-second long.

6. Move the playhead four seconds after the beginning of the Ken Burns animation and split the clip with **Command-B**. You now have the same animation twice, but at different speeds because the second clip is longer than the first.

7. With the playhead over the second animation, click the reverse button in the upper left of the Viewer, which makes the End position of the first animation match the Start position of the second. This is fine if you want a trombone effect, which we don't.

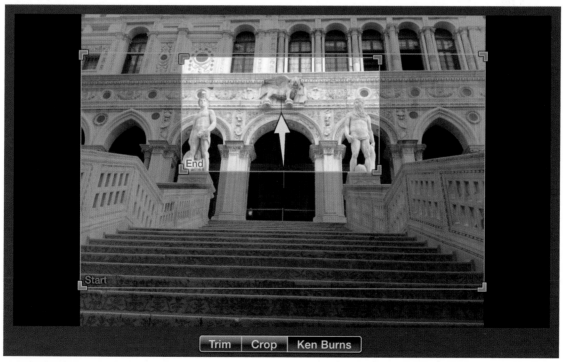

FIGURE 10.18
First Ken Burns animation.

8. Step back one frame so you're on the last frame of the first animation and use **Option-F** to make a freeze frame, again trimming it down to about two seconds.
9. With the playhead over the second animation, set it's End position, which is wide, down to about the same size as the Start position and reframe it so the focus is shifted to the statue on the left something like Figure 10.19.
10. Move the playhead forward about two seconds from the start of the second animation and again split the clip with **Command-B**.
11. Step back onto the last frame of the second animation and add the freeze frame with **Option-F**.
12. Trim the freeze to whatever length you want and delete the last part of the clip with the superfluous animation.
13. When you have it finished, click **Done**.

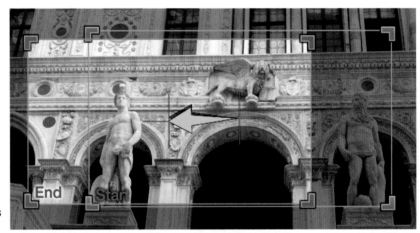

FIGURE 10.19
Second Ken Burns animation.

You have a simple animation that holds, pushes into the symbol of Venice, holds, moves over to the statue, and holds again. You need to be a bit careful with this animation as any movement of any of the elements will make the animation jump.

Which of these options you use to create your animations probably depends on the situation. Sometimes one might work better than another.

BRADY BUNCH OPEN

This is one of the classic show opens on American television. It's relatively easy to reproduce in FCP. In the *brady* Keyword Collection is a clip called *BB.mov*. Play through it. This is the sequence we're going to build, which is based on the timing of the original show's open. (If you know the *Brady Bunch* song, feel free

to sing along.) In building this sequence, we'll use still images rather than movie clips to conserve storage space.

1. Start by making a new project, name it *Brady* and save it in the *Motion* event.
2. If you want to edit the *BB.mov* clip into the Timeline to use as a reference, use the **Q** key to connect it into Timeline.
3. Drag it underneath the primary storyline where you can leave it as your guide track.

Sliding White Bar

Now we're ready to begin building the open. The first step is to create the white bar that slides across the screen. That's easy enough.

1. From the Generators browser in the Solids category, select the **Whites** generator and overwrite it into the beginning of the timeline with the **D** key.
2. In the Generator inspector, change the Color popup to Bright White.
3. Press **Shift-C** to activate the **Crop** function and set it to **Trim**.
4. Crop the top of the generator to 227 and the bottom to 238.
5. Switch to the Transform function (**Shift-T**) and slide the bar off the left side of screen so you start in black.
6. With the playhead at the beginning, set a Position keyframe in the Video inspector.
7. Move forward 22 frames into the project.
8. Drag the generator with the Anchor Point so that you can align with guides. Drag it across the frame to the right so that the Position X point is about 278.
9. Go forward four frames and split the generator using **Command-B**.
10. Delete the unused portion of the generator and delete the rest of the Gap Clip that's in the storyline.
11. Select the generator and open the Video Animation for the clip with **Control-V** and double-click Opacity to open that.
12. Use the fade handle to make a quick four-frame fade out at the end.

Fixing the Headshot

Next we're going to add the first headshot, which comes in underneath the white bar.

1. Begin by lifting the generator from the storyline with **Option-Command-Up Arrow** so that it's connected to a Gap Clip.
2. Move the playhead back to frame 22 where the fade begins.
3. From the *brady* keyword collection, find the *HeadshotPink* clip and connect it to the storyline with **Q**.
4. Use **Option-Command-Down arrow** to collapse it into the primary storyline underneath the bar.
5. In the Video inspector, set the Scale value for the headshot down to 62%.
6. Slide the image to the right so that it lines up with the right edge of the frame.

7. In the Video inspector's Crop section, set Left to 24 and Right 19 pixels.
8. Make sure the playhead is at the beginning of the pink headshot and use **Shift-C** for **Crop** selecting the **Trim** option.
9. Hold the **Option** key, and in the Viewer, drag the top so that it crops proportionately top and bottom so that it's a narrow slit underneath the white bar.
10. In the Video inspector, set Crop keyframes for Top and Bottom and go forward 14 frames.
11. Set the Top and Bottom values back to 0.

You've made the first part of the animation: The bar slides across the screen, stops, and fades out, and the headshot wipes open to reveal the picture. Don't worry about the lengths of the clips yet. We'll fix that later.

Middle Headshots

Now we're ready to bring in the next set of headshots.

1. Go down to 4:18 in the Timeline.
2. From the *brady* Keyword Collection, connect the *HeadshotGreen* clip on top of the pink head shot.
3. Scale the green headshot down to 32% and move it to the lower left corner of the Viewer so that its Position X is −222 and Y is −162.
4. Stretch out the pink headshot underneath it.
5. Select the green headshot, and open Video Animation with **Control-A** and double-click Opacity to open the graph.
6. Drag the start Opacity fade handle to make a 14 frame fade up.

We need two more copies of this image to make up the three headshots on the left of the screen. We'll do this by duplicating the one in the Timeline.

1. In the Timeline, hold the **Option** key and drag two copies of the green headshot so that they're stacked on top of each other in the timeline (see Figure 10.20). Make sure the start frames of the green headshots are lined up in the Timeline. At this stage, all three copies of *HeadshotGreen* are on top of each other.
2. Move the middle green headshot up in the Viewer so that its Position X is −222 and Y is 6.
3. Move the top green headshot to the upper left corner setting its Position X to −222 and Y to 172.

Where the fade ups on the green headshots end, the screen should look like Figure 10.21.

Extending

So far, so good. Next you should extend the image files in the Timeline to where they disappear.

1. Move the Timeline playhead to 15:00.
2. Select the edit at the end of the pink headshot and press **Shift-X** to do an Extend edit.

FIGURE 10.20
Headshots in the timeline.

3. Select the edit at the end of each of the green headshots and repeat by pressing **Shift-X**. Unfortunately there is no way at this time to select edit points on multiple layers.

At 15:00, all four shots end, and we cut to black—but not for long. Next we have to bring in a new white bar from the right side.

1. Copy the generator from the beginning of the project, move the playhead to 15:08 and paste the generator into the timeline. The line will appear with all of its motion and opacity just like the first time you made it. The only problem is that it's moving in the wrong direction.

2. With the **Transform** function switched on, using the Anchor Point button, drag the generator to the other side of the screen so that it's off at the right edge of the frame.

3. Move the playhead down to 15:28 and move the bar to the left side so that it's Position X is –240.

4. In the Video inspector, there is an extra keyframe copied from the first generator that will move the bar back to the right. Go to the next Position keyframe in the inspector and delete it so that the bar has only two Position keyframe.

5. Step forward four frames to 16:02 and trim the end of generator. Because you are not using keyframes to create the Opacity ramp, the four frame fade

FIGURE 10.21
Headshots in the viewer.

out will remain part of the trimmed clip. If we'd used keyframes, the fade would be trimmed off.

6. Go back to 15:28 where the bar stops moving, and from the *brady* Keyword Collection, connect the *HeadshotBlue* clip, which placed on top of the bar.

7. Select the blue headshot and use **Option-Command-Down arrow** to collapse it into the primary storyline.

8. Select the pink headshot and copy it.

9. Select the blue headshot and use **Shift-Command-V** to **Paste Attributes** selecting Scale and Crop options, not Position. This will make it the same size as the first headshot.

10. Move the blue headshot to the right so that it's positioned with its left edge on the left edge of the frame (see Figure 10.22).

FIGURE 10.22
Second headshot.

Adding More Headshots

Now we have to add the boys on the right side of the screen.

1. In the Timeline, go to 19:28 and connect the *HeadshotRed* clip to the story-line.
2. Copy the bottom green headshot, the one closest to the storyline.
3. Select the red headshot and use **Shift-Command-V** for **Paste Attributes**, checking on Scale, Crop, and Compositing, which will apply the fade in.
4. Reposition the red headshot to the bottom right corner so that its Position X is 226 and Y is –163.
5. As we did before, **Option**-drag the red headshot in the Timeline upward to duplicate it. Do this twice so that there are three red headshots stacked in the Timeline, all at the same start frame.

6. Move the middle red headshot up in the viewer so it's about the middle edge of the screen, making its Position X at 226 and Y at 6.
7. Move the top green headshot to the upper right corner with its Position X at 226 and Y at 172.
8. Move the playhead to 30:00, select the edit point at the end of the blue headshot and use **Shift-X** to extend it.
9. Do the same for the three red headshots, making sure they are extended to the same frame so that they all cut out simultaneously.

As before, the screen goes to black briefly.

New Headshots

1. Move the playhead down to 30:08 in the Timeline.
2. In the *brady* Keyword Collection, find the *HeadPinkSmall* clip and overwrite it with the **D** key into the storyline.
3. Select the clip in the Timeline, which has been scaled up to fit the screen, and in the Video inspector, set the **Spatial Conform** to **None**.
4. Using the **Transform** function (**Shift-T**) in the Viewer, drag the clip's Anchor Point straight up so that it's Position Y value is 126 and it's on the center alignment guide.
5. It's often easier to work backward in animation: to start with the end position on the screen and then animate the wipe on. Go to 30:18 in the Timeline, and in the Video inspector, set a keyframe for the Bottom Crop value. This is the end position to wipe the image onto the screen.
6. Go back to the head of the clip at 30:08, and using the **Crop Trim** function in the Viewer, drag the bottom edge of the pink headshot upward so that it's just off the top edge of the frame. This will wipe it onto the screen over 10 frames.
7. This image will remain on the screen for the rest of the video, so go to 57:10 in the Timeline, which is the end of title, and selecting the edit point at the end of the *HeadPinkSmall* clip, use **Shift-X** to extend it to the end.
8. Go back to 32:17 in the Timeline.
9. In the *brady* collection, find the *HeadBlueSmall* clip and connect it with **Q**.
10. Drag out the end of the clip so that it snaps to end of the pink headshot.
11. As before, select the small blue headshot, and in the Video inspector, set its **Spatial Conform** to **None**.
12. Switch on the **Transform** function in the Viewer and drag the clip's Anchor Point straight down so that it stays aligned with the center and its Position Y value is −122.
13. To animate the wipe onto the screen go to 32:26, and in the Video inspector, set a Top Crop keyframe. Again this is the end position.
14. Go to the start of the small blue headshot and switch to the **Crop Trim** function (**Shift-C**) to pull the top crop line down to the bottom of the frame, which will create the wipe onto the screen.

This has brought the two principles onto the screen. Both pictures should now be on the screen as in Figure 10.23. We're ready now to bring in the rest of the headshots. Let's add the kids back in, but before adding the kid shots back in both images, we need to scale down the headshots slightly so that the images fit into their final position.

1. Move the playhead to 36:08 and select both shots, and in the Video inspector, set **Scale** and **Position** keyframes for both shots.
2. Go down to 36:18, select the small blue head shot and scale it down to 69% and set it's Position Y to −167 leaving it on the vertical center line.
3. Change the small pink headshot Scale value to 68% and it's Position Y value to 172.

Now we're ready to bring in the rest of the headshots.

FIGURE 10.23
Two headshots.

Final Headshots

1. Start by copying the three green headshots from the beginning of the project.
2. Go to 36:28 and paste in the three green headshots.
3. Because we're going to be stacking a lot of clips with titles, it's probably best to set the Timeline to lozenge view, the last of the Timeline views, using **Control-Option-6**.
4. Select the three red headshots from earlier in the project and paste them into the Timeline at the same location at 36:28. They should all have their quick fade up to bring them onto the screen.
5. Drag out the ends of all headshots so that they line up with the end of the project.

Your Timeline should be like Figure 10.24 and the Viewer like Figure 10.25.

Titles

We're finished with almost all of the headshots. Next we have to get the titles on the screen. I've prebuilt them for you and saved them as Compound Clips in the *brady* Keyword Collection. They are made using the Marker Felt font, which is the closest in the current Apple font collection to the original title style.

1. Position the playhead at 44:16 where the first title cuts in.
2. Select *Brady Title* Compound Clip in the Browser and connect it. You'll see that it's at its full size and the right duration for the open, but we'll do a small scaling animation.
3. Move down to 45:16, activate **Transform** and set a keyframe in the Viewer. This is the end position.
4. Go back to the head of the title, and with it selected, use the Viewer controls to drag the corner of the compound and scale it down to about 53% (see Figure 10.26).
5. Go to 48:10, and with the compound selected, cut it with **Command-B**, discarding the end.

The next title that appears is the *Starring* title.

FIGURE 10.24
Headshots in the timeline.

FIGURE 10.25
Headshots in the viewer.

1. Move the playhead down to 48:18, and from the Browser, connect the *Starring* Compound Clip into the project.
2. It has no animation, but cuts out 51:08. Use **Command-B** on the selected title.
3. The next title appears at 51:15. Select the *Florence* Compound Clip and connect it into the project.
4. Cut it out at 54:06, again discarding end of the compound.

Final Polishing

We're in the home stretch now; just a few more steps! One more headshot has to appear and the final title before the fade to black.

1. Move the playhead to 54:10 and connect in another copy of the *Headshot-Green* clip.
2. Select it and with that activate the **Transform** function to scale down to 33% and set its Position Y to 5.
3. Trim off the end of the green headshot so that it's the same length as the other clips.

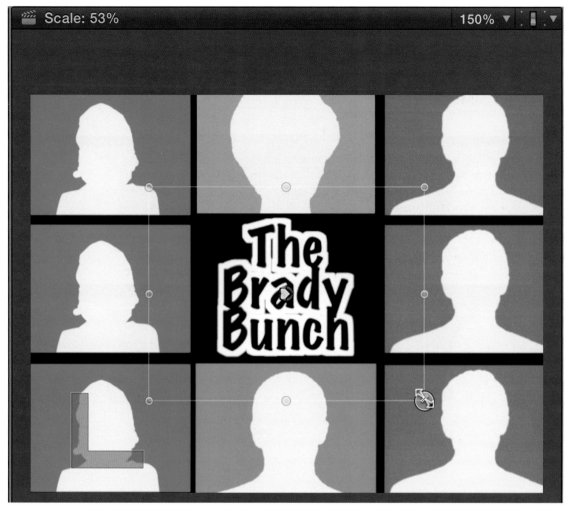

FIGURE 10.26
Scaling the title.

4. Move down to 54:17 and connect the *Ann* Compound Clip into the project.
5. Again there is no animation, a straight cut in and out, so just trim the end to line up with the ends of the other clips.

Fade to Black

The last step we want to do is to fade to black. We could ramp down the opacity on each of 10 layers now on the screen, but there's an easier way:

1. Move the Timeline playhead to 56:08 and go to the Generators browser to find and select the **Custom** generator.
2. Press the **Q** key to connect it into the Timeline.

3. With the generator selected, press **Control-D** and type in a duration of two seconds.
4. Because the fade is a full second, it's easiest to select the edit point at the head of the generator and press **Command-T** for the default one second cross dissolve.

Congratulations! You've made the Brady Bunch open.

SUMMARY

In this chapter, we looked at Final Cut Pro's animation capabilities. We used the Transform function to scale, rotate, and position the image. We also looked at Anchor Point behavior and how it affects an image's motion. We cropped the image using the Trim function to resize the image, the Crop function to reframe the clip, and the Ken Burns feature to create simple animations. We created both straight and curved motion paths. We also looked at different ways of making basic motion effects including using the Ken Burns crop effect to create complex motion paths. Finally, we created a complex multilayer project to reproduce the classic *Brady Bunch* TV show open. In the next chapter, we'll look at some more compositing techniques.

CHAPTER 11
Compositing

Compositing is the ability to combine multiple layers of video on a single screen and have them interact with one another. This capability adds great depth to Final Cut Pro (FCP). In the previous chapter on animation, we built stacks of images in layers. Compositing allows you to create a montage of images and graphics that can explain some esoteric point or enhance a mundane portion of a production.

Good compositing work can raise the perceived quality of a production. Compositing is used for a great deal of video production work on television—commercials, of course—but also on news programs and for interstitials, the short videos that appear between sections of a program. Be warned, though, that compositing and graphics animation are not quick and easy to do. Most compositing is animated, and animation requires patience, skill, and hard work.

SETTING UP THE PROJECT

For this chapter we'll use *BB10* library. If you haven't downloaded the material, do so from the www.fcpxbook.com website.

1. Once the ZIP file is downloaded, copy or move it to your dedicated media drive.
2. Double-click the ZIP file to open it and double-click the library to open that in the application.

In this chapter we'll be working with the event called *Composite*, which uses some standard definition DV footage shot in a mountain village in Japan.

BLEND MODES

One of the best ways to combine elements such as text or generator items with images is to use *blend modes*. If you're familiar with Photoshop, you probably already know that a blend mode is a way that the values of one image can be combined with the values of another image. Final Cut has 26 blend modes, including stencils and silhouettes. Any video element in the Timeline can have a blend mode applied to it. Compositing is the last item in the Video inspector together with the Opacity slider, which is a type of compositing mode. From the Blend Mode pop-up, you get to select the compositing type you want (see Figure 11.1). The default, of course, is **Normal**, which is the way the clip appears

FIGURE 11.1
Compositing blend modes.

without any blend mode applied. The blend modes are listed in groups. The best way to see the blend modes is to try them out. Before you start to do heavy text and compositing work, I think it's a good idea to switch off background rendering, if you haven't done it already. You really don't need the application constantly rendering as you make changes. Most computers can play this material in real time without difficulty. If there are occasional dropped frames, they're not a great inconvenience and playback does not stop. Remember to switch off playback rendering, go to **Final Cut Pro>Preferences (Command-comma)**, and in the **Playback** tab, uncheck the box for **Background render**.

To help you see what the blend modes do, I've created a project with the same clip on it and the same underlying generator repeated again and again. Each copy of the clip has a different blend mode applied to it. The lower third on each clip identifies the blend mode applied to the video clip in the stack. I left out a few that have specific uses and wouldn't show anything if composited on video.

Compositing Preview

Let's begin by looking at the blend modes available in FCP. From the *Projects* event, open the project titled *CompositeModes*.

The first group of blend modes darkens the image, and the second group acts to brighten the image. Some, such as Screen and Multiply, are used to create transparency in an image. The next group affects primarily the contrast of the image, and these modes are not unlike lighting effects. Difference and Exclusion have some of the most pronounced effects on the image. The transparency group of stencil and silhouette are used to affect the transparency of underlying images. The Behind mode simply moves the image below the underlying layers. As you look through the project, you'll see that some of the differences, especially within each group, can be pretty subtle. These are wonderful tools for controlling and combining images, especially text over video. To look at some of the blend modes, especially their specific uses, we'll start by making a new project and naming it *Composite*.

Screen and Multiply

One of the most useful blend modes is **Screen**, which will remove black from an image. It screens out portions of the image based on luminance values. Pure black will be transparent, and pure white will be fully opaque. Any other shade will be partially transparent. This is great for creating semitransparent shapes that move around the screen, and it is useful for making animated backgrounds. Many 3D and other animation elements are created against black backgrounds that can be screened out. Let's try the blend mode, and you'll see how it works, compositing the Lens Flare generator on top of another scene:

1. Let's put in the background layer first. From the *Composite* event, find the *Kabuki3* shot.
2. Press **Shift-2** to do a video-only edit. We don't need the sound for these compositing exercises.

3. Append the shot into the *Composite* project.
4. Move the playhead about halfway through the shot, and in the Browser find the *LensFlare* shot.
5. Connect the shot into the project and play it. All you see in the middle of the shot is the lens flare moving across the black screen. The underlying shot is hidden.
6. Select the *LensFlare* shot in the Timeline, and from the bottom of the Video inspector, find the Compositing section change the Blend Mode to **Screen**. Voila! We see the flare moving across the image.
7. Next, move the playhead back to the beginning of the project and connect the *Multiply* graphic to the project.
8. Select *Multiply* in the Timeline and change its Compositing Blend Mode to **Multiply**.

Instantly, the white background will disappear, and the black text will appear over the video and the lens flare. While Screen is in the Lighten category and removes the dark areas on an image, Multiply is in the Darken group and removes the light areas of the image, making whatever is pure white transparent, and whatever is pure black opaque, and luminance values in between will have different degrees of transparency. Screen is the more commonly used of the two because of its ability to knock out a black background.

These two effects can be seen in the assembled project called *BlendingFun* in the *Projects* event. A number of the other effects we do are also available in this project.

> **NOTE**
>
> **Lens Flare Size:** The *LensFlare* movie is a little undersized, and you can see the edges at the brightest part. Not a problem! Just use the Transform function to scale up the image a little.

Animated Text Composites

One of the best uses of blend modes is with text, especially animated text that's moving on the screen. The blend mode will allow the text to interact with the layer underneath, giving a texture to the text. We're still working with the *Composite* project primary storyline.

1. To start, let's trim off the excess of the *Multiply* graphic so it's the same length as the *Kabuki3* shot.
2. Next, append *Village3* into the project to be our background for the text.
3. Because FCP has so many prebuilt text animations, we'll not use our own animation, just one of the title templates. Put the playhead a short way into the *Village3* shot and connect the **Drifting** title on top of it. Drifting has to be one of the most widely used FCP title animations. I'm seeing it more and more.

4. For this type of thing, we want to use a large, chunky font and make it a bright color. I like Arial Black for this. In the Title inspector, you have to set both lines to this font, but if you switch to the Text inspector there is only a Line 1 font selection, and if no text is selected, both lines will change to the same font.

5. In the Text inspector, you can set both lines to **250**, big and bold, and pick a fairly bright red for them.

6. For the text, type the word *DAMINE* in the first line. It's the name of the village, and for the second line, type *JAPAN*. To keep the bold effect, type in all caps. Do not type in lower case and check on **All Caps** in the Text inspector. This produces a smaller and wider spaced lettering.

7. Finally, in the title's Video inspector, right down at the bottom, change the compositing blend mode. I used **Color Dodge** in Figure 11.2.

These kinds of compositing techniques are used constantly in motion graphics. Even if you don't use a blend mode, simply adjusting the opacity of your text so that the face has a little transparency will create interesting effects.

This effect is also in the *BlendingFun* project.

FIGURE 11.2
Text with color dodge.

> **NOTE**
>
> ***Unrendered Playback:*** If you have background rendering switched off while you do compositing work, you might notice a little wobbling or shimmer as you play the titles back. The reason is that the computer is playing back the unrendered title and trying to produce it in real time. To make the text look better during playback, in the upper right of the Viewer change the **Quality** setting from **Better Performance** to **Better Quality**. This may make it more difficult for your computer to play back the composites. You can also, of course, render by selecting it and pressing **Control-R** for **Render Selection**. Playback will be a lot smoother now.

> **TIP**
>
> ***Television Warning:*** If you are going to output your project to be seen on a television set, be careful in using blend modes, particularly **Add**. It will brighten the image, often beyond the luminance and chrominance values allowable for broadcast transmission. If the image is too bright or oversaturated, especially in red, it may bloom objectionably and smear easily when converted to formats such as MPEG-2 for DVD.

Adding a Bug

A *bug* is an insect, a mistake in software coding, and also that little icon usually in the lower-right corner of your television screen that tells you what station you're watching or who the program producer is. There are lots of different ways to make bugs, but I'll show you one using Photoshop and blend modes. In the *Composite* event there is a small Photoshop file called *Logo*. To start, do the following:

1. Put the playhead at the beginning of the *Composite* project and connect the *Logo* file into the Timeline.
2. Note the duration of the project at the bottom of the Timeline, select the *Logo* clip in the project, and open the **Duration** box in the Dashboard by double-clicking it or with **Control-D**.
3. Make the duration the same as the duration of the project.
4. With the *Logo* selected, go to the Video inspector, and in **Spatial Conform**, set the pop-up to **None**. It's still much too big for a bug, but let's work on compositing it first.
5. Right-click on either the *Logo* in the Browser and select **Reveal in Finder** (**Shift-Command-R**).
6. Open the file in Photoshop, and with the layer selected in the Layers panel, click the little *fx* at the bottom left and choose **Drop Shadow** (see Figure 11.3).
7. Leave the **Drop Shadow Angle** at **145** but set the **Distance** to **15**. Leave the other controls the same.
8. Select **Inner Shadow** and leave the **Distance** at **5**, but set the **Choke** and **Size** to **10**.

9. Also add a **Stroke** effect. Set the **Size** to 6. I made the color blue.
10. Click **OK** and save the file. You've built the effect.

When you switch back to FCP with **Command-tab**, the Photoshop files will be updated, both in the Event Browser and in the Timeline.

The next step is to change the logo's composite type. Several blend modes will work for this, but I like to use Multiply because this will make the white of the logo almost transparent. For a slightly brighter look, try Soft Light, and for an even less transparent look, use Overlay.

At the current size, the logo is probably a bit intrusive. Use Transform to scale it down a bit and reposition it in the corner of your choice. The bottom right is the traditional location on American television, but I like the bottom left for this. It will now be your unobtrusive watermark on the screen (see Figure 11.4). Some people also like to use effects such as displacements or bump maps in Photoshop, which add texture, but for something this small, I don't really think these effects are necessary. The simple transparency effect of a blend mode is enough.

I left this effect off the *BlendingFun* project so that you have the opportunity to build the logo for yourself in Photoshop. If you don't have Photoshop or Photoshop Elements, you can use the prebuilt *Logo2* file in the Browser to substitute for the bug.

FIGURE 11.3
Adding effects in Photoshop.

TIP

Distinctive Logo: There are any number of different ways to give your logo a distinctive edge by using the power of layer styles in Photoshop. Rather than using the Inner Shadow and Stroke method, you could also use Bevel and Emboss. Change the Technique pop-up to Chisel Hard and push the Size slider until the two sides of the bevel meet. This will give you maximum effect. Remember that the logo is going to be very reduced in size. Also, in the bottom part of the Bevel and Emboss panel, try different types of Glass Contour from the little arrow pop-up menu.

NOTE

Snapshots: A word of warning: You should be aware that snapshots are NOT immune to changes made to an external file, so if you alter a logo file in Photoshop such as we did, do not expect your original to be preserved in the snapshot project.

FIGURE 11.4
Bug on the screen.

STENCILS AND SILHOUETTES

Travel mattes, or traveling mattes, are a unique type of composite that uses the layer's transparency or luminance to define the underlying layer's transparency. The old film term *travel matte* is no longer used in FCP, where we now have **Stencil** and **Silhouette** blend modes. These modes allow the application to create a great many wonderful motion graphics animations. We'll look at a few that I hope will spur your imagination and get you started on creating interesting and exciting projects. Technically, these are blend modes as well, even though they function in a special way. There are two Stencil modes—one for **Luminance**

and one for **Alpha**—just as there are two Silhouette modes—one of each type. In these modes, the layer to which the blend mode is applied will give its shape and transparency from either the Luminance value or the Alpha (the transparency) value of the layer to the layers beneath it. A Stencil mode on a layer will reveal only what's inside the selected area, whereas a Silhouette mode on a layer will show what's outside the selected area, basically punching a hole through the layer or layers underneath it. In the project, any animation or change in the layer with the blend mode will be reflected in the layers below it. This makes Stencils and Silhouettes extraordinarily powerful tools.

These concepts are harder to explain in words than they are to demonstrate, so let's make a new project that we'll use to see how these compositing tools work:

1. In the *Projects* event, find the project called *TransparencyModes* and make a snapshot of it with **Shift-Command-D** to saving as a backup.
2. Open the original project, select the *Stencil* text clip on top, and in the Video inspector, set the Compositing Blend Mode to **Stencil Alpha**.

All you see is the bamboo and the grass (see Figure 11.5). The text itself is gone. Its only purpose is to provide the transparency shape information for the layers below it.

3. Select the *Stencil* layer and the *Natural* layer beneath it, and convert them to a Compound Clip with **Option-G**. Now you see only half of the word because the layer with the grass is cropped.

FIGURE 11.5
Stencil Alpha layer.

4. Undo that and select *Stencil*, *Natural*, and *Wood* and convert them to a Compound Clip, naming it *Stencil* and saving it in the *Composite* event.

Now you see the word divided into wood and grass, but the Stencil Alpha mode affects only those two layers, and for the first time, you can see the *Metal* layer beneath (see Figure 11.6).

FIGURE 11.6
Stencil Alpha in Compound Clip.

Let's look at what happens with the Silhouette Alpha mode:

1. **Option**-click to select the *Silhouette* clip and move the playhead, and in the Video inspector, change its Compositing Blend Mode to **Silhouette Alpha**. You will see the bamboo and the grass with the word *SILHOUETTE* punching a hole through the layers (see Figure 11.7).
2. Select the top three layers—the text, the wood, and the grass—and convert them to a Compound Clip called *Silhouette* in the *Composite* event. You'll see the text has cut a hole, but only through the first two layers, revealing the metal plate underneath (see Figure 11.8).

Here, we are using just text, but you can use the transparency channel of any image to create interesting effects. I think you can see the potential of this powerful compositing tool here.

The Stencil and Silhouette Luma modes work similarly. They use the luminance information of an image to either cut out the area surrounding the stencil or cut through the area of the silhouette. Let's try the Stencil Luma on the first stack:

1. Double-click the Compound Clip in the first stack to open it into the Timeline.
2. Select the text layer, and in the Inspector change the blend mode to **Stencil Luma**.

The luminance value of the text is being used, and because it is not fully white, it will show some transparency. Only what is pure white will be opaque, and pure black (or transparent) will be transparent in the underlying layers.

FIGURE 11.7
Silhouette Alpha layer.

FIGURE 11.8
Silhouette Alpha in Compound Clip.

Switch back to the *TransparencyModes* project, and you will see the stencil effect with the word ghosted on top of the metal background. If the red of *STENCIL* were pink or paler, the text would be more distinct on the metal. Make the Color adjustment in the **Inspector>Text>Face** section and see what happens. Try also the Silhouette Luma mode on the Silhouette Compound Clip.

> **TIP**
>
> ***Behind Blend Mode:*** The Behind mode is useful when using Stencil and Silhouette modes. It allows you to put a clip on a layer on top and using Behind make it appear underneath the composited Stencil or Silhouette without it being cut by them.

Organic Melding

A common technique that always works well is to use luminance maps to create effects that allow images to meld into each other organically. Usually, this is done by creating a grayscale image with motion in it that is used as the luma map. Let's do this in the *Composite* project that we were working on earlier:

1. To build this effect, start by making sure you're set to do a video-only edit (**Shift-2**).
2. Next, append the *Kabuki1* clip to the end of the project. It's only five seconds long, so, if necessary, zoom into the Timeline. Hold the **Z** key and drag a box around the clip.
3. Move the playhead back to the beginning of *Kabuki1* and press the **X** key to select the clip with edit points.
4. Connect *Archer1* to the storyline.
5. To add the Luma map, we'll use the Underwater generator from the **Back-grounds** category. Move the playhead to the beginning of the stack, find **Underwater**, and connect it to the stack.

Before we composite, there's a small problem we have to take care of first. The Underwater generator is quite long and the speed of the watery motion is determined by the length of the clip, so we don't want to shorten it. That would make motion very quick and not at all what we want. There is a way around this. Basically, we "nest" the generator in a Compound Clip all its own, so its motion happens there, and then we shorten the Compound Clip like this:

1. Select the *Underwater* clip and press **Option-G** to make it a Compound Clip. Name it *Underwater* and save it in the *Composite* event
2. Shorten the Compound Clip to make it the same length as the other two clips in the stack.
3. Next, we need to create a Luma map out of this. To do this, we'll adjust the Compound Clip luminance values, remove the color, and increase the contrast so that the motion has more effect on the images and gives a better definition to the effect:
4. Select the Compound Clip and press **Command-6** to go to the Color Board.
5. In the Saturation tab, pull the master puck all the way down to **0** (zero).
6. In the Exposure tab, set the **Shadows** down to −33%, the **Midtones** down to −60%, and to increase the contrast, push the **Highlights** up to +66%.
7. Go to the Compound Clip's Video tab and set the Compositing Blend Mode to **Silhouette Luma**.
8. Finally, to complete the effect, to blend the Compound Clip with the base layer, select the *Underwater* Compound Clip and *Archer1*. Then use **Option-G** to combine them into a new Compound Clip called *UnderwaterArcher*, making a Compound Clip within a Compound Clip.

What immediately happens is that you see the underlying *Kabuki1* clip and the two blend together based on the luminance and the motion of the Underwater generator (see Figure 11.9).

This is in the *BlendingFun* project in the library.

FIGURE 11.9
Silhouette Luma effect.

Highlight Matte

Next, we're going to create a **Highlight Matte**. This allows us to create a highlight area, like a shimmer that moves across an image or, as here, across a layer of text. Let's set up a simple animation:

1. Edit only five seconds of the video of one of the clips into the Timeline to use as a background layer. I used five seconds of *Ceremony1*.
2. Next, we'll add text on top of it. Go back to the beginning of your background clip, press the **X** key, and use **Control-T** to connect **Basic Text** tool to the beginning of the *Ceremony1* clip.
3. Double-click the middle of the text block in the Timeline to move the playhead and select the text and change it to *JAPAN* in any font you like, in a fairly large size, and in a nice, bright color. I used Optima for this, ExtraBlack, with a size of 220 in a fairly bright red, R 200, G 18, B 18.
4. Next, duplicate the text block and make a connected copy in the space above by **Option**-dragging the text upward.

5. Open the top text block, and make it a very pale version of the text color beneath it. I made it a pale pink.

6. Move the playhead back to the beginning of the stack, select **Shapes** from the **Elements** category of the Generators browser, and connect it on top of the other clips. Make it the same length as the other clips.

Now let's work on the highlight:

7. In the Generator inspector, set the **Shape** pop-up to rectangle.

8. Uncheck the **Outline** and set the **Drop Shadow Opacity** to 0 (zero).

9. In the Video inspector, open the **Transform** section and set the **Rotation** value to **90°**.

10. In the Effects Browser in the **Blur** group, find the **Gaussian** blur and apply it to the Shape.

11. Set the **Gaussian Amount** to **100**.

Your Viewer should look something like Figure 11.10.

FIGURE 11.10
Viewer with highlight bar.

Animating the Highlight

The next step will be to animate the highlight. We'll do this in the Viewer with the Transform function:

1. Put the playhead at the start of the *Shapes* clip and activate **Transform** with **Shift-T**.
2. Drag the shape so it's off to the left, past the edge of the text, and click the keyframe button in the Viewer to set a Transform keyframe.
3. Move to the last frame of the *Shapes* clip (**Down arrow**, **left arrow**) and drag it across the screen so it's clear of the right side of the text. Click **Done** to complete the animation.
4. Over the five seconds of the clip, the Highlight bar will sweep slowly across the screen. Of course, we still don't see the background layer.
5. Next, set the Compositing Blend Mode of the *Shapes* clip to **Stencil Alpha** or **Luma**. In this case, they will produce the same result.
6. Finally, select the *Shapes* clip and the upper text file and make them into a Compound Clip called *Highlight* and save it in the *Composite* event.

If you're at the start or end of the clip, you'll see the red text that's directly above the *Ceremony1* clip as well as the background, of course. As you skim over the stack, you'll see that the text highlight area will softly wipe onto the screen and then wipe off again as the Highlight layer slides underneath it. The pale text file's transparency is directly controlled by the transparency value of the layer above it. The matte layer, the *Shapes* clip in this case, is invisible. This highlight animation and the others below are in the *BlendingFun* project for you to check out.

Glints

We've seen how we can put a highlight across an image. Next, we're going to do something a little more complex—create a traveling highlight—but one that goes only along the edges of a piece of text, a highlight that glints the edges.

1. We'll begin again with a base layer and text. Select both the *Ceremony1* clip and the *Basic Text: Japan* above it and copy and paste them at the end of the Timeline.
2. From the Generators browser, find the **Shapes** generator again and connect it at the beginning of the second ceremony clip and on top of the text, making it the same length as the others.
3. In the Generator inspector, switch off the **Outline** and set the **Drop Shadow Opacity** to **0** (zero) again.
4. We need the Circle to be much smaller, so set the **Roundness** value to about 130.
5. We also need it blurred, so use the **Gaussian** blur effect at the default setting, which is fine for this.
6. We also need to move it higher in the frame using the Transform function. Set it up so the soft-edged circle affects only the top part of the text, as in Figure 11.11.

FIGURE 11.11
Circular highlight above the text.

Animating the Circle

To animate the circle, we want it to move from left to right across the screen and then back again, keeping it at its current height. At the start, we want the circle off to one side of the text.

1. Move the playhead to the beginning of the clip, and using the Transform function, move the circle straight to the left so it's clear of the text.
2. Set a Transform keyframe in the Viewer at the start of the clip.
3. Switch back to the Timeline and press **Control-P** to type in *+215* and press **Enter**.
4. Move the circle straight across to the right side so it's clear of the text on the right.
5. Go to the last frame of the five-second clip and move the circle back across the screen to where it came from. Click **Done**.

Over the five seconds of the clip, the circle will sweep across the text and then back again. So far, so good. If you skim the Timeline or play through it, you should see the circle swing from left to right and back again.

6. To make the glow appear only on the text, start by **Option**-dragging the text clip up, allowing the Magnetic Timeline to push the circle out of the way onto a higher level. Your stack should look like Figure 11.12.

7. Select the top text layer, and in the Text inspector, use its Face controls to change the color to white, pale yellow, or whatever glow color you want to use.

8. To the circle *Shapes* clip, in the Video inspector apply the **Stencil Alpha** Compositing Blend Mode.

9. Finally, select the *Shapes* clip and the *JAPAN* text directly beneath it. Then combine into a Compound Clip with **Option-G**, naming it *Glow* in the *Composite* event.

Immediately, the circle will disappear, and the glow will be composited on top of the lower text layer. The highlight areas move across the top edge of text. The result is similar to what we did before, but let's expand on that.

FIGURE 11.12
Graphics stack.

Polishing the Glow

What we really want is for the glow not to race across the whole text, but to run just along the top edge of the text. It's not hard to do. We just need to add a few more layers:

1. **Option**-drag two more copies of the text layer situated under the Compound Clip to the very top of the stack, completely hiding the glow.

2. Select the topmost text layer, and in the Video inspector, set the **Transform Position X** value to **0.5** and **Y** value to **−0.5**, half a pixel to the left and half a pixel down.

3. To the topmost text layer, apply the **Stencil Alpha** Compositing Blend Mode and combine the two top text layers into a Compound Clip called *Glint* saved in *Composite*.

The glow is now a little glint that runs on the edge of the text. You could do this just by putting an offset layer on top. It works, but it makes the font a little chunky looking. Using the approach here, you're left with just a glint that travels along the edges of the text (see Figure 11.13).

FIGURE 11.13
Text with Glint.

One More Touch

At the moment, the glint brushes across the upper-left edge of the letters as it moves back and forth across the screen. If you want to be really crafty and add a little something special, you can shift the glint side as it swings back and forth. For the first pass of the blurred circle that creates the text glint, leave the settings as they are. Then do this:

1. When the glint reaches the far-right side of the screen at 2:15, we'll shift the position of top layer of the text that's inside the upper Compound Clip. Double-click top Compound Clip, *Glint*, to open it into the Timeline.
2. With the playhead halfway through the stack, 2:15 from the beginning, select the top text layer, the one that's offset, and go to the text's Video inspector.
3. Click the Transform **Position** keyframe button to keyframe that one parameter.
4. Go forward one frame in the Timeline and add another **Position** keyframe.
5. Set the **X** value to –0.5, moving it one pixel left, while leaving the **Y** value unchanged.
6. Return to the project with **Command-left bracket**.

Now when the glint passes the first time from left to right, it will appear on the upper-left edge of the text, and when it goes back from right to left, it will be on the upper-right edge of the letters (see Figure 11.14).

FIGURE 11.14
Text glint on the right edge.

VIDEO IN TEXT

I hope you're getting the hang of this by now and are beginning to understand the huge range of capabilities that these tools make possible. Next, we're going to make an even more complex animation with traveling mattes, the ever-popular video-inside-text effect, the kind of technique that might look familiar from the opening of the old television program, *Dallas*. An important new feature in FCP is ability to now make resolution independent and aspect ratio independent projects.

To look at what we're going to do, open the *MasterTitle* project in the *Projects* event. That's what we're going to build. It might look like only two layers, but in fact it's much deeper and more complex than that.

Getting Started

We should be able to begin by making a new Compound Clip in a custom resolution and setting whatever frame rate we like. Unfortunately, at the time of this writing, custom Compound Clips with custom resolutions do not allow frame rates aside from 23.98p, which isn't appropriate for us. So there's a bit of a work around. We'll begin by making a new project using a custom size.

1. Press **Command-N** to make a new project and name it *Stage*.

2. Click **Use Custom Settings**, change the **Format** pop-up to **Custom**, make the **Resolution** values **1500** and **480**, the vertical height of the DV clips. Set the frame rate to **29.97p** (see Figure 11.15).

3. With the playhead at the beginning of the project, press **Control-T** to add **Basic Text** to the Timeline.

4. Basic Text defaults to 10 seconds, so let's shorten it to five seconds.

5. Select the text and press **Option-G** to make a new Compound Clip and save it in *Composite* event as *Stage*. If you select the Info inspector for the Compound Clip, you'll see it has the right frame rate.

Project Name:	Stage
In Event:	Composite
Starting Timecode:	00:00:00;00 ☑ Drop Frame
Video Properties:	◯ Set based on first video clip
	● Custom
	Custom ⬍ 1500 x 480 29.97p ⬍
	Format Resolution Rate
Audio and Render Properties:	● Use default settings
	Stereo, 48kHz, ProRes 422
	◯ Custom

Use Automatic Settings Cancel OK

FIGURE 11.15
Custom settings.

Making Text

Next, we need to make the text. We need to make it big and bold so that we can fill each letter with a piece of video. We don't need to worry about the title safe area because the text will be animated across the screen.

1. Double-click the text block in the Timeline to select it and type in the word *JAPAN* in caps.

2. In the Text controls in the Inspector, set the font to **HeadlineA**, set the **Size** to **1280**, and set the **Baseline** to **–180**.

3. To help create separation between the letters, set the tracking to about 7%. Your text should look something like Figure 11.16.

FIGURE 11.16
Text in custom Compound Clip.

TIP

Distorting the Text: If you use a different font or one that's a bit more squat like Arial Black, you can use the aspect ratio distortion feature of the Transform Scale function. This allows you to scale an object in X and Y axes independently. Activate **Transform** in the Viewer and hold the **Shift** key pull down from the bottom or side as needed. You can also scale X and Y separately in the Video inspector.

Separating the Letters

You now have the base layer for the text. It's very important that you do not move the text, change its position or size on the screen. We're going to make multiple copies of the text that all have to line up exactly:

1. First, let's lift the text out of the storyline with **Option-Command-Up arrow** to make a Gap Clip that can be replaced with video.
2. Holding the **Option** key, drag a copy of the text directly above it to make a new Connected Clip.
3. Repeat the process until you have a total of six text layers, one for each letter of the word and one extra (see Figure 11.17).
4. To separate the text, we're going to crop each word except for one letter. Start by drag-selecting all the text layers except the bottom one and pressing the **V** key to make them invisible.
5. Adjust the Viewer so you have a little grayboard around the screen, select the bottom, visible, text file, and activate the **Crop** function (**Shift-C**), making sure it's set to the **Trim** function.

FIGURE 11.17
Text stacked in the Timeline.

6. Drag the right-edge crop handle to crop all the letters except the *J*.
7. With the first layer selected, press **V** to hide it and then select the second text layer and press **V** to reveal it.
8. Crop from the left and right so that only the first letter *A* is visible.
9. Hide the second text layer and reveal the third.
10. Crop from both sides so that only the *P* is visible.
11. Repeat for the next layer, hiding the other layers, revealing the fourth layer and cropping to show the second *A*.
12. Finally, with only the fifth layer visible, crop from the left side only so that the final *N* is visible. Click **Done** when you're finished with the Crop function.
13. Leave the top layer hidden for now. We'll come back to that at the end.

Adding Video

We're now ready to put in the video. We're still working with video only here—no audio. To simplify this process and make it easier to see what's happening, we'll start by working with one text layer and then add in each one sequentially till each of the letters is filled with a different piece of video.

1. Use the **V** key to switch off all the text layers except the bottom.
2. Select the Gap Clip in the storyline, then find the *Kabuki1* clip in the Browser and press **Option-R** to **Replace from Start**.
3. In the Viewer with *Kabuki1* selected, switch on the Transform function (**Shift-T**), scale the image, distort the aspect ratio, and position it as you like so that it covers the area of the letter *J* (see Figure 11.18).
4. Select the text layer *J*, and in the Video tab inspector, set the Compositing Blend Mode to **Stencil Alpha**.
5. Select the two layers, the *Kabuki1* video clip, and the text layer with the letter *J* and combine them into a Compound Clip with **Option-G** and name it *J*.

That's the basic process. We just have to edit in more clips and repeat the transforming and compositing process four more times:

FIGURE 11.18
Video ready to be composited with first letter.

6. Put the pointer over the *J* compound and press the **X** key to make an edit selection.

7. Find the *Kabuki3* clip in the Browser and press **Q**.

8. Drag the clip down so it's below the second text layer, above the Compound Clip.

9. Turn on the *A* layer and change its Blend Mode to **Stencil Alpha**.

10. Then scale and distort and position the video layer to fit inside the letter. Try to keep the girl's head in the top part of the *A*. By applying the Blend Mode first, it's easier to see how the video will fit into the letter.

11. Combine the *A* layer and the video layer into a Compound Clip naming it *A*.

12. Make an edit selection of one of the layers, and for the letter *P*, connect the *Archer1* clip into the Timeline.

13. Apply **Stencil Alpha** to the text layer and transform the video clip to be scaled and positioned directly beneath *P*.

14. Make a Compound Clip of the two layers and name it *P*.

15. Now we're on a roll. Make the next text layer visible, make it an edit selection with **X**, and connect the *Kabuki2* clip, moving it beneath the second *A* layer.

16. Set the second *A* layer to **Stencil Alpha**, position the video clip underneath it, and combine the two into a Compound Clip called *A2*.

17. Turn on the letter *N* text layer, make it an edit selection, and connect the last part of *Archer2* using **Shift-Q** and move it underneath the text.

18. Apply **Stencil Alpha** to the *N* layer, position the video, and combine it with the text layer, naming the Compound Clip *N*.

Congratulations! You've got through the hardest, most tedious part of building this composition. Your Timeline should look like Figure 11.19. You've composited multiple tracks of video with multiple tracks of text, blending the two to create a composition that shows an array of images simultaneously in the screen within the constraints of the text.

We're almost there—just one more refinement before we animate the image.

FIGURE 11.19
Project Timeline after compositing video.

Edging

The last thing that works well on this type of composition is to add an outline edge. It helps to separate the text from the underlying image. We'll add an edging that borders the letters and separates the text and the video from what will be the background layer. That's what that last layer, which has been hidden for so long, is for.

1. Make the top text layer visible. It should completely cover all the underlying layers.
2. Select the layer, and in the Text tab of the Inspector, open the **Face** controls and set the **Opacity** to **0** (zero).
3. Turn on the **Outline** function and set the **Width** to about **10**. The default red works well for this. The Viewer should look like Figure 11.20.

FIGURE 11.20
Composition with edging.

Animating the Text

To animate the composition, we need to make a project with background video. We'll use *Village1* for the background.

1. Make a new project with the default settings, letting the first clip define the project properties. Call the project *MasterTitle* and save it in the *Composite* event.
2. Find *Village1* in the Browser, select the first five seconds, and append it into the Timeline.
3. Find the Compound Clip called *Stage* and drag it into the Timeline to connect it to the video on the storyline.
4. Select the compound and in the Video inspector set the **Spatial Conform** to **None**.
5. Set the Viewer to a comfortable size that allows you to have some grayboard around it and then move the playhead to the beginning of the project. Your Viewer should look something like Figure 11.21.
6. Select the *Stage* compound, switch on the Transform function, and drag the Compound Clip with the Anchor Point straight off the right side of the frame. In the Inspector, check that the Position Y value is still at 0 (zero).
7. Click the Transform keyframe button in the Viewer to set a keyframe for the Transform functions.
8. Move to the last frame with the **End** key and then use the **Left** arrow to step back one frame.
9. Drag the Compound Clip straight across the screen till it disappears off the left side, again making sure that the Inspector still has the Position Y value set to 0 (zero).

Over the course of the five seconds, the text and the video inside it will travel from right to left over the top of your background video. There is a huge amount you can do with these tools. Play with them and have fun!

FIGURE 11.21
Compound Clip in the Viewer.

SUMMARY

We're now at the end of this chapter on compositing. We looked at FCP's compositing tools, including a prebuilt preview to show off the various effects. We worked with the Screen and Multiply blend modes because of their unique properties. We also built a text composite using these tools and added a bug to our project. We then worked with some of the most powerful compositing blend modes, the Stencil Alpha and Luma and the Silhouette Alpha and Luma functions, which allowed us to use one image to cut through multiple layers of video. It also has the ability to let clips meld organically with each other. We created highlight mattes, animated them, and made them into glints, which we also animated. Finally, we built a complex multilayer project of video within multiple letters of a title, all animated against a video background. With that, we're almost ready to export our material from FCP out into the world, which is the subject of our final chapter.

CHAPTER 12
Outputting from Final Cut Pro

The hard, technical part of nonlinear editing is at the beginning, setting up and setting your preferences, importing, organizing, adding metadata; the fun part in the middle, hopefully, is the editing; and the easy part is the outputting at the end. Well, we're finally up to the easy part: sharing. Basically, when outputting, you're delivering your media in some digital form, whether it's heavily compressed for low-bandwidth web delivery or a high-resolution, uncompressed HD or higher format to save as your digital master.

In this chapter, I am using a library called *BB11*. You can download it from the www.fcpxbook.com website if you wish. The library has a single event with a project. You don't really need to download it if you don't want to. You can use any project of your own to follow along.

SHARING

I know the term **Share** rankles many users because it has a California hippy-dippy, touchy-feely quality to it, but that's where the product came from, after all, and it is an attempt to smooth the transition for iMovie users to a professional application by keeping a common nomenclature. Whatever you call it, this is the place where you export your finished project. A project can be shared either from an open Timeline or directly from the event in the library that's holding it. Also, any selected clip or Compound Clip can be exported directly from the event. You can also share a section of a clip exported from the Browser or a section of a project exported from the Timeline, simply by marking a selection on the clip or on the project's primary storyline. However, note that currently you cannot mark a selection in a project and export just that selection from the Browser; you have to mark the selection in the Timeline and export from the Timeline panel.

There is no batch export function; only individual items can be exported. That said, you do not have to wait for each export function to be completed before initiating another export. The export function is handed off to the Share Monitor, which used to be a separate application, but is now built into Final Cut Pro (FCP).

With the exception of the XML export function and the **Send to Compressor** function, which are only in the **File** menu, all of FCP's other outputting options are in the **Share** submenu or more commonly accessed from the **Share** button at the far right end of the Toolbar.

Send to Compressor opens that application, which we'll look at later, and gives you access to all its options including the ability to do distributed processing over Ethernet to other machines that have the application. Generally, for single files, using custom Compressor settings, the **Send to Compressor** function is quite a bit slower than simply exporting a master file and taking that to Compressor. If you use standard FCP settings, the speed is about the same; on the other hand, there is no real benefit unless you have distributed processing set up for multiple machines.

XML export is straightforward and allows exporting primary color grades, effect parameters, and audio keyframes. You can export an XML file of a project, or an event, or even an entire library. You can also export specific metadata settings as in Figure 12.1. This is extraordinary when collaborating between multiple users in different locations. The small XML files contain an enormous amount of information. An exported XML project file can be imported into Logic Pro X for audio sweetening and mixing. This includes keyframed volume and pan information.

Source: BB11

Metadata View: Extended

New Folder Cancel Save

FIGURE 12.1
XML library with metadata export.

> **NOTE**
>
> *Copyright:* Due to copyright restrictions, you cannot use the media files that are supplied for use with this book for any purpose other than performing the exercises in the book.

Destinations

The **Share** button offers a number of basic exporting options that can be added to as a user preference (see Figure 12.2). The default export is **Master File** and has the keyboard shortcut **Command-E**. What appears in the **Share** button is controled by the **Destinations** preferences, which we skipped in the chapter on preferences. You can access these preferences from the FCP preferences in the **Final Cut Pro** menu or from the selection at the bottom of the **Share** button, the **Add Destinations** option.

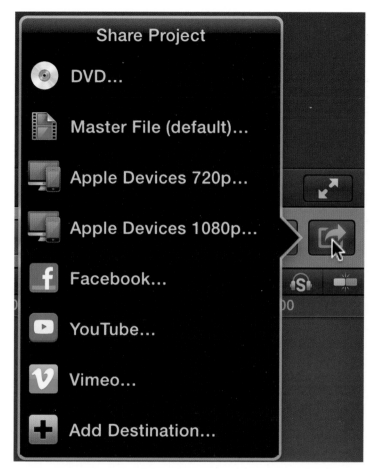

FIGURE 12.2
Share button.

The **Destinations** preference lets you add or subtract items from the list in the sidebar (see Figure 12.3). So if you never uploaded to YouTube or Facebook, you can right-click on them and delete, or select and press the **Delete** key. To add a function, drag it from the right into the sidebar or click the + button at the bottom.

Here, you can also change the default destination from Master File to whatever you want from the shortcut menu, and the keyboard shortcut **Command-E** will go with it, which is very handy if you have one format you're always going to.

When you select a destination like Vimeo, you can click on **Details** and enter your username and password (see Figure 12.4). This is handy if you have multiple Vimeo or YouTube accounts. You can have a separate destination for each.

In the Destinations preferences, you can add items such as still image export, called **Save Current Frame**, and Blu-ray burning and others. Blu-ray and DVD

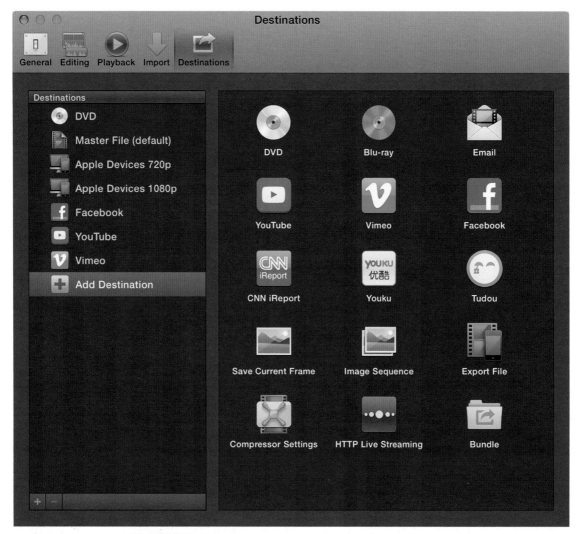

FIGURE 12.3
Destination preferences.

output accept chapter markers created in the project. These markers also export to QuickTime. You can also add **Compressor Settings** or create a **Bundle**, which is a folder that holds multiple presets that you can select to batch process on a project; simply drag the share selections you want into the folder, or **Option**-drag a duplicate. You can have a Vimeo setting in the sidebar and a duplicate setting in the bundle, which you can name anything you want. When you select the bundle, you'll see all the settings added as well as having the option to change them (see Figure 12.5).

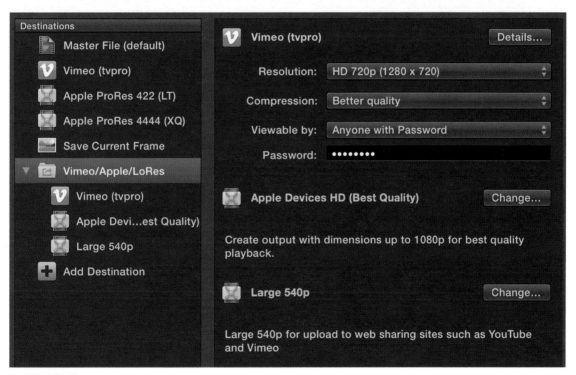

FIGURE 12.4
Custom Vimeo setting.

FIGURE 12.5
Destination bundle.

Export

Once the destination is selected in FCP's **Share** popup, the Info panel appears. The name assigned is the name of the project, but you can change it to anything you want. This will be the name that appears at the top of the QuickTime player, or in iTunes, or Vimeo or YouTube. This is not the name of the file on your hard

drive, which you assign when you assign the save location. This name can be something like *CDL140307*; nobody but you will see that unless you send them the digital file.

Here, you can also enter a description, creator name, as well as **Tags**. In **Description**, you can add in information such as copyright information or whatever you want. The tags that appear here are assigned in the Share inspector (see Figure 12.6). By default, the name of the event is entered and all the keywords

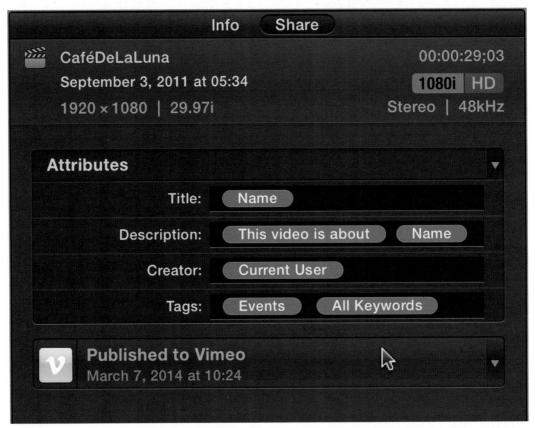

FIGURE 12.6
Share inspector.

that appear in the Timeline. You can add additional tags in the Share inspector or in the Info panel when you export (see Figure 12.7). This makes it easier for search engines to locate your video when it's online.

If you're exporting a bundle, at the bottom left, you can toggle between the settings to see what the approximate file sizes are. On some export options, a small button will appear that shows the export file's compatibility with different devices and systems (see Figure 12.8).

In the **Settings** tab of the share dialog that you see in Figure 12.9, you can change the options. Notice the information at the bottom about the file format

FIGURE 12.7
Description and tags.

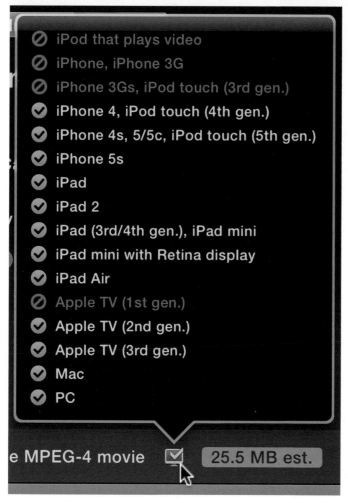

FIGURE 12.8
Compatibility popup.

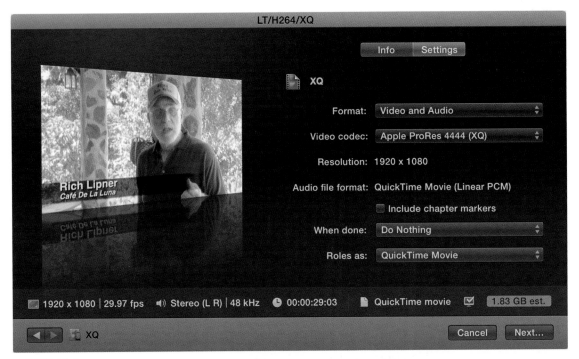

FIGURE 12.9
Settings tab.

and expected size and the tiny, checkmark button that will show you device compatibility.

The final window lets you name the computer file. If you're sharing a bundle, they'll all have the same name tagged with the name of the export option that's in the bundle. When each encode is finished, a notification will appear on your screen to let you know it's complete, which you can close or click the **Show** button to take you to the file (see Figure 12.10). If you've done a web export, you'll be taken to your default web browser and the web page with your movie.

FIGURE 12.10
Notification.

One of the nice features in FCP is that exporting or sharing does not seize control of the application. The export process is a background process, and you can monitor the progress in the Dashboard or the Background Task window (**Command-9**). You can continue to edit while this is going on. This allows you to queue up multiple files to export, different projects or portions of projects,

or different clips, just add them to the Background Process window and they will be done sequentially. There is no true batch processing, no ability to select multiple clips, and send them off to export with one setting. For this, you need Compressor.

IMPORTANT NOTE

Proxy Project: If you're working with proxy files in your project, do not export the project unless you want a proxy quality file. Exporting a project full of proxy files and setting ProRes 422 (HQ) as the output will give you a very large, very poor quality export file. If you want to export a real master file, make sure you switch the Viewer setting back from **Proxy** media to **Optimized/Original**. There is no warning in the export operation when you are exporting a project of proxy clips. You just have to do it.

NOTE

Missing Items: If you try to export a project with missing elements, generators, title, or effects, you will get an error message, while still have the option to export the project as it is or to cancel the export operation (see Figure 12.11).

FIGURE 12.11
Export error.

Master File

This function allows you to export a high-resolution version of your project. I would suggest that it should be standard procedure; when you have completed a project, you use the **Share** button and select **Master File**. This gives you the opportunity to produce a high-resolution, high-quality master that you can use to reproduce your project or recompress to other formats with minimal degradation of your image. The export dialog allows you to output Video and Audio, Video only, Audio only, or Roles, which we'll look at in a moment. If you export a video file, in the **Video codec** popup, you get to choose from a number of available codecs (see Figure 12.12). The first item is the source file, which is whatever render preference you have selected in Project Properties, usually ProRes 422, which is the default. In the section below that, the ProRes options from ProRes

FIGURE 12.12
Available HD codecs.

4444 XQ to ProRes Proxy appear in every export. Below that are formats like XDCAM, which will vary based on whether export is HD or standard definition. For SD export in addition to the ProRes codecs, you have **DV** and **DVCPRO50** codecs, as well as IMX options. For creating an SD master of your project, I would recommend using DVCPRO50 although the file sizes are twice that of standard DV. It is a robust 422 codec that stands up very well to duplication and creates good quality output when compressed.

Which codec to use? Although H.264 is an option here, it really should never ever be used as a master file, which should always be a high-resolution format. Use **Apple ProRes 422 (Proxy)** if you want to export a low-resolution proxy file—good for training videos that require heavily compressed media to fit onto a disc, otherwise it's probably not something you're going to use.

In my view, **Apple ProRes 422 LT** (LT meaning Light) is an outstanding codec. I wish FCP would allow transcoding to this codec for Optimized Media as it is an excellent compromise of high quality with moderately high data

rate. For AVCHD originals, this would be an excellent codec for importing. Unfortunately it's not available for that. If you're going to continue editing on another platform, this may be a good export choice for you. For most purposes, the **Apple ProRes 422** codec, the standard current settings for render output, should be your choice for creating a high-resolution master file of your project. Anything edited in HD that's 1080p or smaller should be exported to this codec. If you are working in larger formats that are 2K in size, then you would be best served exporting to the **Apple ProRes 422 (HQ)** codec (HQ stands for high quality). Be warned though these are very large, very high data rate files and require very fast drives to support them for proper playback. If you need to export a file with transparency, then you should use **Apple ProRes 4444**. If you need a pristine file, of the highest quality as a digital intermediate, with transparency, you can now export to **ProRes 4444 (XQ) e**xtreme quality.

When you're exporting a video and audio file, you have no real control over the audio format. However, if you are exporting audio only, either as a single file or as Roles, you get different audio export codec options (see Figure 12.13). These

FIGURE 12.13
Audio codecs.

allow for compressed versions of your audio output, **AAC** and **MPG3**, which are suitable for iPods, **AC3**, which is used for DVD production, **CAF** for 5.1 Surround audio, and **AIFF** and **WAV** for uncompressed audio, which should always be your first choice if you're making an audio master or exporting your audio for use in another production application.

Notice the **When done** popup that lets you select an application to open the file, including the default QuickTime player or Compressor, which will load the file directly in that application.

TIP

No Transparency: If you should need ProRes 4444 or ProRes 4444 (XQ) without transparency, you'll need to use Compressor where you have these separate options.

> **NOTE**
>
> *Interlacing:* If you shoot interlaced video, when you export to the Share options that compress the video, such as Apple devices and H.264, the material is deinterlaced, but when you export, and want to make a full-size file without interlacing, you have to set that up manually. Go to the project's properties using **Command-J** and click the **Modify Settings** button. In the drop-down sheet, change the format to a **p** for progressive format or change the frame rate to a **p** frame rate. This deinterlaces the project and allows you to output a deinterlaced version.

Roles

Exporting Roles allows you to create what are called *stems*, separate tracks of audio based on the content, for instance separate stems for dialogue, effects, and music for professional audio mixing. Once you've created and assigned Roles, these assigned Roles carry over to the exporting media function. You can export **Roles As Multitrack QuickTime Movie** (see Figure 12.14), which will create a QuickTime file using any of the available ProRes and proprietary codecs, with each Role laid on a separate track. When you export to **Multitrack QuickTime Movie**, you will have the option in the Video popup to switch off the titles if

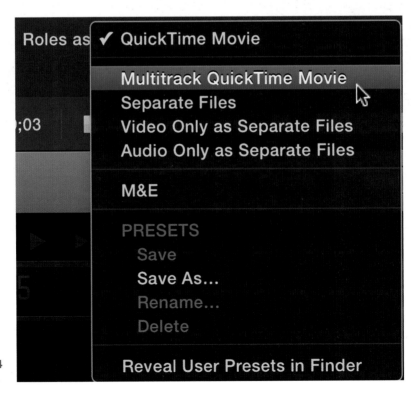

FIGURE 12.14
Exporting roles.

you wish, which can be handy if supers or subtitles are being added elsewhere. Notice in the popup menu that you can save presets for different combinations of role outputs.

In addition to a multitrack QuickTime movies, you can of course also export **Roles As Separate Files**, which will give you QuickTime files, one for video and one for titles, as well as separate AIFF or WAV files for the audio stems (see Figure 12.15). However, you should be aware that if you're exporting separate tracks for video and titles, you must export using the ProRes 4444 or the ProRes 4444 (XQ) codecs, otherwise you will lose title transparency. This is also true for course of the **Video Roles Only As Separate Files** option. Notice that you can switch on and off individual roles with the **minus** button. You can add a role back in with the buttons at the bottom. Being able to remove roles is really useful if you need to output an M&E version (Music and Effects) for language replacement.

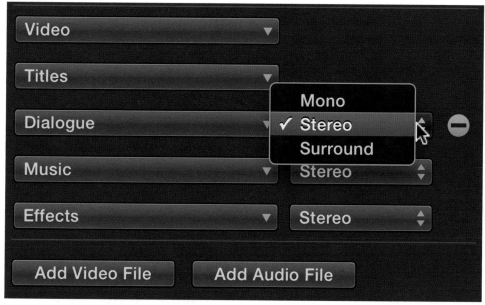

FIGURE 12.15
Roles options.

NOTE

Export AAF/OMF: Although FCP cannot export directly to AAF or OMF for use in ProTools, you can get X2Pro (www.x2pro.net), which is available from the Mac App Store. This is a really well-done tool that brings compatibility with ProTools to FCP.

> **NOTE**
>
> **Change List X and Producer's Best Friend:** These are two more tools from the inventive minds at Intelligent Assistance. Change List X (http://assistedediting.intelligentassistance .com/ChangeListX/) uses XML to bring together two versions of a project. It analysis the timelines and produces a report that delineates what's needed to match the two versions. For those working with versioning and in collaborative workflows, change lists are hugely important. The Producer's Best Friend (http://assistedediting.intelligentassistance.com/ ProducersBestFriend/) uses spreadsheets to generate lists of clip usage for reporting. This is an incredible time saver for those needing to generate music usage reports, stock footage lists, and it includes reports on all used material, clips, roles, keywords, markers, effects, and transitions.

WORKING WITH COMPRESSOR

If FCP is a simplification of earlier versions of that application, then similarly Compressor 4 is a simplification of earlier versions of Compressor. Although earlier versions of Compressor had folders upon folders with multiple presets, version 4 will often only have one preset. Many people think of this as a reduction in the application's capabilities, but it's actually not. It simply weeds out many presets that were mediocre at best because of their generic, one-size-fits-all nature. This version of Compressor on the other hand goes in the opposite direction; instead of giving multiple, weak presets, it gives a single preset as a starting point. It sets up a formula that gives the user the basic options for the encoding process he or she wants, and then leaves it to the user to fill in the blanks. The application's formula is basic: Here's the template, adjust it how you need to for your media and your desired output.

The whole black art of compression is based on finding the best balance of file size versus quality. The file size is determined solely by the bit rate: the higher the bit rate, the larger the file. To maintain quality, you can either give the file a large enough bit rate or reduce the image size: smaller bit rate for a smaller image will maintain the quality. The other factor that will affect the bit rate applied to an image is the content. This is a factor of the complexity of the image; the amount of movement in the clip, including pans, transitions, and effects; and how frequently the image changes in the clip. If you're making a production destined only for the web, the complexity of the image is an extremely important factor to keep in mind when shooting and editing the project. And remember, compression is a one-way street. It's done by throwing away content information, and once it's gone, it cannot be brought back, which is why you should always start from a high-quality master file.

Let's look at how you should use this application. While FCP still has the **Send to Compressor** function, a very useful feature is **Export Using Compressor Settings**, which is the best of Compressor inside FCP.

Sending versus Export Using

Send to Compressor will allow you to have Compressor encode while you edit in FCP, but you end up doing neither of them well. Editing in FCP becomes bog slow and encoding in Compressor drops practically to a standstill. If you use the **Send to Compressor** function, I would suggest not to edit in FCP, in fact you should shut it down. This route used to be a lot slower, but in Compressor 4, the encode is not slower than you exporting a master file and taking that to Compressor to encode, if you use one of the Compressor presets.

Once you've finished your project, you probably do want to make and keep a high-quality master version for showing and for creating new copies in compressed formats. You don't want to have to go back to, and don't need to go back to FCP, if you have that high-resolution master, you simply encode in Compressor from the master.

A common procedure for access to QuickTime export functions in legacy versions of FCP was to use the QuickTime Conversion option, which no longer exists in FCP. In FCP, you now have the new option of using **Export Using Compressor Settings**, which is the best of both Compressor's capabilities without having to export a master from FCP. This is especially useful if you need to export a version, say with a timecode burn for screening. You do not need to overlay a timecode generator in FCP, and you can add the timecode overlay using a Compressor setting. The trick to using this function is to make sure you have the preset you want in Compressor, either an Apple preset or a custom preset.

Compressor Interface

Like FCP, Compressor 4.1 is a single window application, with three tabs at the top and five buttons, one in the center to **Add File**, and one in each corner. In appearance, the application has changed completely, from its original pale gray, multiwindow configuration, to the new, dark gray, single window model that most professional applications are moving to. The new look is singular minimalist (see Figure 12.16). At the top are two buttons that open, respectively, the **Settings & Locations** on the left (**Command-5**), and the **Inspector** on the right, which, like FCP, uses the **Command-4** keyboard shortcut. Although Compressor looks all new, it is still very much the same.

When you click the **Add File** button and select a file, a sheet drops down that gives you access to all your settings, Apple presets as well as custom settings (see Figure 12.17). Pick your settings and click the **Start Batch** button in the lower right and off it goes. The interface on its surface could not be simpler and easier to user. Use the Actions (gear) popup at the bottom left to duplicate a preset. The controls to change the settings are in the Inspector.

Apple Built-In Presets

The Settings tab is the same as the drop-down sheet, with seven preset actions such as **Add to iTunes Library**, **Create Blu-ray**, **Create DVD**, and **Publish to**

FIGURE 12.16
Compressor interface.

Vimeo, and eight groups of presets such as **Apple devices** and **ProRes**. The disc burning options are the similar to FCP's and include job actions that will burn the disc or create a disk image on your hard drive. In Compressor in addition to creating disk images for discs on your hard drive, it also saves the files, MPEG and AC3 audio files, separately. The actions (see Figure 12.18) often have only one preset, some such as the disc burning actions have two, and **HTTP Live Streaming** has seven for different mobile device capabilities. HTTP Live Streaming can be done from any server; it does not have to be a dedicated streaming server. The concept of HTTP Live Streaming is that the server automatically switches to the best supported file to send to the viewer based on the viewer's bandwidth. To do that you'll need to send a variety of different files of different sizes and bit rates to be able to accommodate the server's demands. That's what these presets do.

APPLE DEVICES

It has three formats; the first two are basically the FCP Share to Apple Devices, one 10 Mbps (Megabits per second) for newer devices, and one 5 Mbps for compatibility with older devices. The third is for standard definition output. You probably don't need to tinker with these or duplicate them, as there is no adjustment you can do and still keep them compatible with Apple devices, which have very stringent requirements for compatibility.

Select one or more settings:

▼ BUILT-IN

　▶ ↗ Add to iTunes Library

　▶ ↗ Create Blu-ray

　▶ ↗ Create DVD

　▶ ↗ Prepare for HTTP Live Streaming

　▶ ↗ Publish to Facebook

　▶ ↗ Publish to Vimeo

　▶ ↗ Publish to YouTube

　▶ ▤ Apple Devices

　▶ ▤ Audio Formats

　▶ ▤ Motion Graphics

　▶ ▤ MPEG Files

　▶ ▤ Podcasting

　▶ ▤ ProRes

　▶ ▤ Uncompressed

　▶ ▤ Video Sharing Services

▶ CUSTOM

🔍▾

Location:　Default (Source)　▴▾

Cancel　　OK

FIGURE 12.17
Settings sheet.

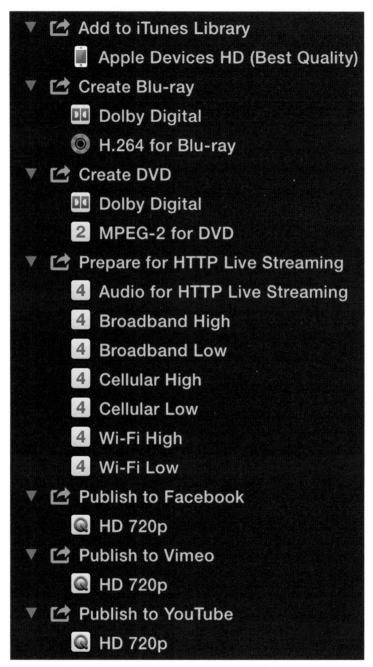

FIGURE 12.18
Action presets.

AUDIO FORMATS

These presets are the same as the five options available directly in FCP using **Master File** and selecting **Audio Only**. The one exception is **EC3**, Dolby Digital Plus or Enhanced AC-3.

MOTION GRAPHICS

The Motion Graphics folder has four presets, two for image sequences, Open EXR and TIFF, and two for video formats, either using the Animation codec or the ProRes 4444 with alpha codec. If you want to export video with an alpha channel, you'll need to use one of these two codecs. None of these presets can be altered unless they are duplicated. The 4444 and the 4444 (XQ) codecs can be accessed from within FCP of course. All of these video presets use the same frame resolution and frame rate and field order as the original files.

MPEG FILES

This is the MPEG group of compressed video formats including audio that's multiplexed into the video stream, two program streams, one that's higher resolution 4:2:2 and one transport stream. This is different from the DVD elementary stream that is video only, and the audio remains separate until it is muxed (multiplexed) by the DVD authoring application. We'll look at DVD burning in a moment, but these should not be used for that.

PODCASTING

This group has three presets, two for audio, AAC and MP3, and one for video using H.264, which is now the most ubiquitous codec for QuickTime web delivery.

PRORES

Here is where you can access the Apple ProRes codecs. In addition to the six ProRes codecs that are available in FCP, there are two additional options. You can use the **ProRes 4444** and the **ProRes 4444 (XQ)** exports without any alpha channel, but with black. If you need the transparency channel in these codecs, you need to select the specific **ProRes 4444 with Alpha** or the **ProRes 4444 (XQ) with Alpha** setting that appears at the bottom of the list. The only time you might need to duplicate one of the ProRes settings is if you need to do cropping or other frame resolution alteration. The variable bit rates used by these codecs cannot be changed by the user.

UNCOMPRESSED

There are two Uncompressed 4:2:2 presets, one 8-bit and the other 10-bit. These also use the frame resolution and frame rate of the original and will produce absolutely enormous files for even the shortest video. Our 29 second Café de la Luna video is a whopping 4.84 GB. Frankly looking at the files very carefully, I simply cannot see any difference between an uncompressed 10-bit file and an XQ file that is only 1.83 GB for the same video, using the word *only* pretty loosely.

VIDEO SHARING SERVICES

Video sharing basically provides another way to access the presets used for uploading to YouTube or Vimeo, which has high-quality presets ranging from 4K through HD in 1080 or in 720; a large preset that's 960 × 540 that really should be avoided; and a standard definition at 640 × 360, and a small preset at 428 × 240. The standard definition presets will adapt to 4:3 media.

Using Compressor

You've exported your master file from FCP; you have Compressor, now what? The first thing you have to do is to bring the exported file into Compressor, either by dragging it into the area underneath the preview, called the Job panel, or by clicking the **plus** button underneath it (see Figure 12.19) or by pressing **Command-I** for import.

FIGURE 12.19
Add files.

In the Preview window, you can play or scrub through the scrub the video. You can also use the **JKL** keys, and you can mark In and Out points with **I** and **O**, which will trim the output. If you have a setting applied, you can move the vertical bar across the image to see a before and after comparison of the image (see Figure 12.20). Notice the boxes around the outer edge of the Preview window, which allow you to crop the image for output right in the window. Perhaps it's not very precise, but certainly visual. Under the Preview window is also a Marker popup that gives you a number of useful options, including importing a chapter list, add markers, and setting the file's poster frame (see Figure 12.21), though as of this writing setting the poster frame is not working as advertised.

To create chapter markers from a text file, you need to make a simple text file using TextEdit. The file cannot be in Rich Text Format. The file needs to have the exact timecode for the marker location and the name you want to use for the chapter. The timecode must have hours:minutes:seconds:frames separated by colons or semicolons. After the timecode, add a tab and then the chapter name. The time and the name must be separate by the tab to create the tab-delineated file that Compressor will read.

To add the text chapters, click on the marker popup in the lower right of the Preview and select **Import Chapter List**.

To apply a preset to the job, find the one you want in the Settings panel. If you know the name of the format or are looking for a specific codec, use the

FIGURE 12.20
Preview window.

FIGURE 12.21
Marker popup.

search box at the bottom. Drag the preset you want to use onto the item in the Job panel.

In the Inspector if you select the job, you'll see information about the job (see Figure 12.22). Here you can add information and tags and set a Job Action, such as send an e-mail message. If you have the preset selected in Job panel (see Figure 12.23), the Inspector will have up to three tabs, **General** that gives, you basic information about the encode, **Video**, where you can customize the video

FIGURE 12.22
Job inspector.

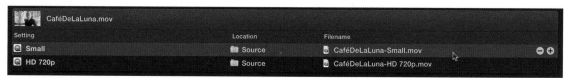

FIGURE 12.23
Setting selection.

settings, including adding effects and cropping the image, and **Audio**, where you can alter the audio settings.

The job displays three items, the Setting applied, **Small** or **HD 720p**, the Location, which is where the file is going, the default being **Source**, back to the same location it came from, and **Filename**, which you can of course change to whatever you want. Compressor automatically assigns a file name based on the name of the original and the applied setting. You can also change the Location by right-clicking on it and selecting **Other**. You can apply multiple settings to batch encode any job. To remove applied setting, simply select it and press **Delete**.

Use the + button at the bottom of the Settings panel and select **Add Destination** (see Figure 12.24). This will create a custom destination allowing you to select a job action; it is NOT a custom location where your files will be saved. Here, you can also create a custom setting or group.

FIGURE 12.24
Plus popup.

To start the job, click the **Start Batch** button in the lower right of the Jobs window. Once you click the button, the job goes into the **Active** window, which immediately opens (see Figure 12.25). Here, you can see the progress of your job. When the job is completed, and all the encodes created, they move onto the **Completed** window (see Figure 12.26). The elapsed time information is useful and the little magnifying glass that will take you to file on your hard drive.

Name	Status	Elapsed Time	Progress	
▼ CaféDeLaLuna.mov	Processing	0:00:29		
▼ CaféDeLaLuna.mov				
▼ CaféDeLaLuna-Small.mov	Processing	0:00:20		
CaféDeLaLuna-Small.mov	Processing: Transcoding	0:00:18		
CaféDeLaLuna-HD 720p.mov	Waiting	0:00:02		
CaféDeLaLuna-Dolby Digital.ac3	Waiting	0:00:02		
CaféDeLaLuna-H.264 for Blu-ray.264	Waiting	0:00:02		
CaféDeLaLuna-Hi Res MPEG-4.mp4	Waiting	0:00:02		

FIGURE 12.25
Active window.

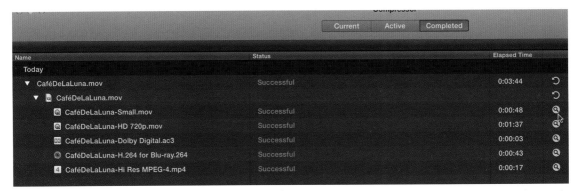

FIGURE 12.26
Completed window.

> **TIP**
>
> **Elapsed and Remaining:** In the Active panel, you can click the header for the **Elapsed Time** column and change it to **Remaining**.

Creating Custom Presets

You can use the + button to create a custom setting, but the simplest way is to start with one of the existing Apple presets as a base and duplicate it. Another neat way is to take the settings from an existing clip. If you have a clip that you really like the way it's been encoded, even something you've downloaded from the web, simply drag the file into the Custom group in the Settings tab, and Compressor will take all its audio and video parameters and create a preset from it. Very cool, but do be a little careful, as sometimes the video codec may be misinterpreted or the original may have been adjusted using filters.

We can't look at all the different formats and capabilities of Compressor, but I just want to show you three typical formats, a custom MPEG-2 file, an MPEG-4 file, and a QuickTime movie.

MPEG-2

In earlier versions of Compressor, there used to be a multitude of different variations for different lengths of DVD project. Now it's simplified to two basic presets, one for compressing audio, which should be done for all disc formats and one for standard definition DVD. The MPEG-2 preset uses a single pass variable bit rate, an average bit rate of 5 Mbps and a maximum bit rate of 7.5 Mbps. This works well for most discs, but it will have trouble doing a long project and keeping it on a single layer. You might want to reduce the data rate; or you might only need to put a short project on the disc, under 20 minutes, and there is no need to force the data rate to be that low. You might want to use two-pass VBR for better processing with a higher data rate, or single-pass

constant bit rate set up to 7.7 Mbps. To make the custom setting, duplicate the existing setting by right-clicking on it and selecting **Duplicate**. The setting will appear with all the controls available in the Custom group. Once you've set your custom setting the way you want it, the setting will be available to use directly in FCP.

The MPEG-2 setting will show two tabs in the inspector, **General** and **Video**. The General tab gives basic information, but notice the popup that allows you to switch from elementary stream used on DVDs to program or transport stream used in broadcasting. If you select one of the other two, an **Audio** tab will appear.

Most of the real work is done in the **Video** tab, which has all the controls. Notice at the top, it says 2.25 GB per hour. You could just squeeze a two-hour movie onto the disc.

In the Video inspector, you should leave the frame size, frame rate, and anamorphic on automatic. You can select in the Encoding Mode pop-up whether to encode in Single Pass CBR (constant bit rate), Single Pass VBR (variable bit rate), or Two Pass VBR. There are also selections for one and two pass Best. Don't use Best. It's really slow and doesn't do much for you, and in some instances, actually it isn't as good as Better. Set Motion Estimation to Better. It works perfectly well. If you don't care how big the file is but want to encode quickly, use One Pass CBR. Generally it's safest to set the bit rate not more than 8 Mbps, although some would say as low as 7.5 Mbps is safest. For large files, use Two Pass VBR. With two pass, you have separate sliders for average and maximum bit rate. Refer back to the summary at the top of the inspector to see what differences your selection is making to the file size.

To change the bit rate, switch off **Automatically select bit rate**, then you will have two sliders for **Average bit rate** and **Maximum bit rate**, unless you set Single Pass CBR, in which case only the Average bit rate slider is available.

DVDs are often played on computers not on television sets for which the format were designed. For all interlaced video that is to be seen on a computer, you should make sure to deinterlace the material. While your custom settings may show **Field order: Same as Source**, once you have added a file into the Jobs panel, you'll have the option to leave it as it is or to change it to **Progressive**.

You can add **Video Effects** in the Video inspector with the button at the bottom. There are three useful ones at the bottom of the list, **Text Overlay**, **Timecode Generator**, and **Watermark**. The Watermark allows you to add a graphic. Make one with transparency at the right size and place it in one of the corner positions. It is simplest to create the graphic at the size of your image and position the watermark in the appropriate position in your graphics application. Text Overlay lets you add text over your video like NOT FOR DISTRIBUTION or something like that. Timecode lets you add timecode in any of the standard locations and will either start the TC burn at zero or will read the timecode from the file that's being encoded. These are the handiest ways to add these elements rather than overlaying them in FCP itself.

MPEG-4

MPEG-4 is a widely used format because of its cross-platform use. Although most computers can play QuickTime and other Mac formats quite easily, some still prefer to stick with MPEG. To make an MPEG-4 file, you could start with an HTTP Live Streaming Broadband High setting or just start with a blank setting from the + button. When you select **New Setting**, a sheet drops down letting you choose the format you want (see Figure 12.27). Select **MPEG-4**, give it a name, and add a description, though you can do this later and save it at any time.

Format ✓ Common Audio Formats
Name Dolby Digital
 H.264 for Apple Devices
Description H.264 for Blu-ray
 Image Sequence OK
 MP3 File
 2 MPEG-2
 4 MPEG-4
 QuickTime Export Components
 QuickTime Movie

FIGURE 12.27
Custom setting options.

In the General inspector, you can change the name, amend the description, set the default location, and notice the Retiming section where you can adjust the frame rate for typical adjustments such as 23.98 to 24 (see Figure 12.28).

In the Video inspector, you can set the output frame size or you can set **Automatic**, which will leave the frame resolution the same as the original. For computer output, you should always use a frame resolution that allows you to use a square pixel aspect ratio. You can also specify the output frame rate or leave it as **Automatic**. Reducing the frame rate is something to consider as it will help reduce the file size. For projects with very little motion, like talking heads, this can be very useful. If you're going to change the frame rate of your output, in the **Retiming quality** popup under set it to **Better (Motion adaptive)**. Field order should be progressive, which you'll need to set on each job. The **H.264 profile** should be **Main** unless you have a specific requirement to set **High** or **Baseline**.

The most important setting in the Video inspector is the **Data rate** slider and value box. If you've set your frame resolution to Automatic, then the data rate

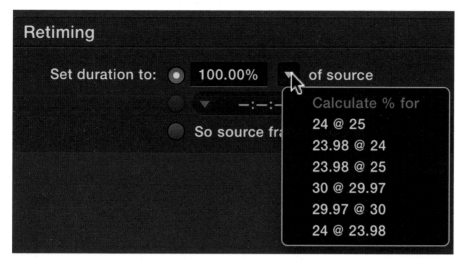

FIGURE 12.28
Retiming.

setting needs to be fairly high to support large frame sizes. Another option is to set the frame resolution using an **Up to** value, for instance **Up to 1280x720**, which mean that anything smaller that will be in its native frame resolution, while anything greater will be reduced in size to that resolution. For HD sizes to create low-resolution, smaller files, set the data rate to around 1500–2000 kbps, never go below 1200. For high-quality, but larger files, you should set the data rate to 8000–10,000 kbps or even higher.

An important feature of the Video inspector is that it allows you to create custom sizes for your media, nonstandard shapes either by cropping or by padding the image. You can also set specific standard frame sizes by cropping or padding or a combination of the two (see Figure 12.29).

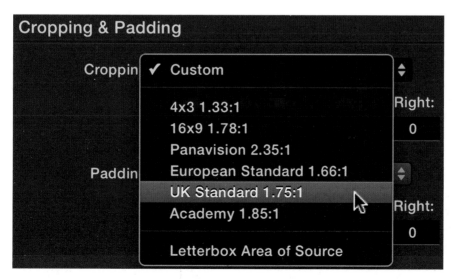

FIGURE 12.29
Cropping.

When making web video that may be seen on both Macs and PCs, using either MPEG-4 or QuickTime, it's beneficial to add a couple of filters. You should use the Gamma Correction filter to make a small adjustment to the video that will be a good compromise for the different systems. Make the gamma (the mid-tones gray point) a bit darker by setting it to 1.05. To improve the saturation of the video for web display, set the Color Correct Midtones filter to increase all three: red, green, and blue, by +3.

These filter settings can be added either to the preset or to the settings after it's been applied to the clip.

In the Audio inspector you can set the channel layout and the sample rate. You can't change the compression type as you can with QuickTime.

QUICKTIME

The simplest way to start making a QuickTime custom setting is to use one of the Video Sharing Services presets, basing it on the size you want up to 720 or up to 1080. We'll start by duplicating the **HD 1080p** preset.

The real difference in QuickTime compared to MPEG formats is astonishing flexibility in the types of codecs, video and audio, which can be applied to your media. Currently, there are a whopping 65 video options, including six ProRes, six DVCPRO HD, ten HDV, six MPEG IMX, ten XDCAM EX, and fifteen XDCAM HD. The two ProRes 4444 codecs do carry transparency, but you have to make sure that under Compressor in the **Depth** popup that appears, select **Million of Colors+**, the + being the transparent alpha channel. To access them, click the **Change** button opposite **QuickTime settings**, which brings up QuickTime's Standard Video Settings panel (see Figure 12.30). The default for this list is H.264, now the most commonly codec for both acquisition and delivery, widely used in cameras and on the web. But these are just the standard codecs that come with Apple's professional applications. There are many more than can be added, including x264 (a better H.264), REDCODE, Media 100, and more. A 264 codec is the best for web use. Use H.264 or x264 for the web.

Never use Automatic for the data rate in the Standard Video Settings panel, nor the Quality slider. It's always best to dial in a number in the Data Rate box. The higher the number the larger the file size will be, but the quality will be better. The larger the frame resolution, the higher the data rate needed to maintain the quality.

Keyframes should be set to either 200 or 300. Automatic will add too many keyframes and increase the file size. Frame Reordering should be checked on. Encoding should be set to Best Quality (multipass). If there is very little movement in the video, and very simple images, you can use Faster Encoder.

In the Audio inspector, in addition to setting the channel layout and the sample rate, you can use the **Change** button opposite **QuickTime** settings to access the available audio codecs (see Figure 12.31). The default is AAC, which is excellent for compressed audio. If you're creating a preset for production using a video codec like ProRes, you should set the audio to Linear PCM for uncompressed audio.

Standard Video Compression Settings

Compression Type: | H.264

Motion

Frame Rate: | Current | fps

Key Frames: ● Automatic
○ Every [] frames
○ All

☑ Frame Reordering

Data Rate

Data Rate: ○ Automatic
● Restrict to [20000] kbits/sec

Optimized for: | Download

Compressor

Quality

Least Low Medium High Best

Encoding: ● Best quality (Multi-pass)
○ Faster encode (Single-pass)

Preview

(?) Cancel | OK

FIGURE 12.30
Standard video settings.

For many jobs, especially for video with speech only, setting the audio to Mono will work as well as Stereo and will save file size. For files with music, set the Rate to 48K or 44.1, CD quality. For files with speech and natural sound only, set it down to 22K. This will also reduce the file size. When creating a heavily compressed settings, designed for minimum file size, using AAC Mono at 22K, set the Target Bit Rate to 40. Otherwise, leave it at 128 for Stereo 48 or 44.1K.

It's good before you output your file to always test a short section, about 2–10 seconds, to see how your encoding will work. Use the In and Out points in the Preview window to select a section that has the most movement or has the most complex images, or has transitions, such as cross dissolves, which are very difficult to encode well. Once you're satisfied with the test results, you can encode the entire file.

Give your QuickTime custom setting a useful name and enter a description of the video and audio settings, compressor and data rate, as well as the geometry used in the preset. Now you're ready to use your custom settings not only in Compressor but directly from inside FCP.

FIGURE 12.31
Audio inspector.

Groups

Groups allow you combine multiple presets, save them, and apply them to a job. So for instance if you repeatedly need to encode files in H.264 for the web as well as .m4v for Apple devices, and a ProRes master, you just need to drag the group onto the job to apply all the settings. If you've already made a job that has these three settings applied, including the output locations you want, simply make a **New Group** from the + button and drag the settings into the group (see Figure 12.32). To use your group, simply drag the group from Custom settings onto the job.

FIGURE 12.32
Custom group.

Droplets

A **Droplet** is a tiny application that lets you apply a compression setting to a media file. You can put the Droplet anywhere you want. Usually you just leave it sitting on your desktop. You can make any preset, Apple or custom, into a Droplet. Simply select it, right-click on the settings, and choose **Save as Droplet**. A sheet drops down letting you name the Droplet, add Finder Tags, and select where you want to save the Droplet. Also you can select the Location for the output files.

Compressor does not have to be, nor does it even launch when using the Droplet. To use the Droplet, simply drag the files you want to compress onto the droplet. The Droplet window will open, which allows you to confirm the setting, the output file name, and the output location (see Figure 12.33).

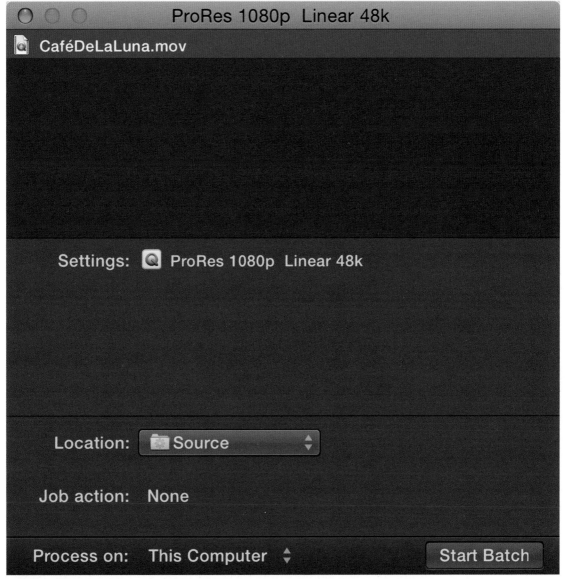

FIGURE 12.33
Droplet window.

With the Droplet window open, you can add more files to the job by dragging them into the panel. Simply click **Start Batch** to begin the process.

Preferences

Most of the Compressor preferences are taken up with setting up distributed rendering, what's called a render farm. You can set up as many machines as you want that have Compressor installed and are on a shared network that's linked with gigabit Ethernet or better. Do not try to do distributed rendering via WiFi. It really does not have sufficient speed to carry frames back and forth to make it worthwhile.

To activate distributed rendering for a specific setting or job, in the General inspector, make sure **Allow job segmenting** is checked on. This allows the application to pass portions of the job to other machines for processing.

The first tab of Compressor preferences lets you set default behavior, a default Setting, and a default Location. The second tab, **My Computer**, is where you switch on your computer and make it available to the network for distributed rendering. You can also add a password needed by other machines to access yours. The **Shared Computers** tab is where you can set up a group of computers for use on your render farm. This allows you to single out specific machines on the network excluding others. To create a new group, click the + button in the lower left, and to add another machine, click the + button underneath the computers (see Figure 12.34). The **Advanced** tab lets you add additional copies of Compressor as well as specifying the interfaces and network ports.

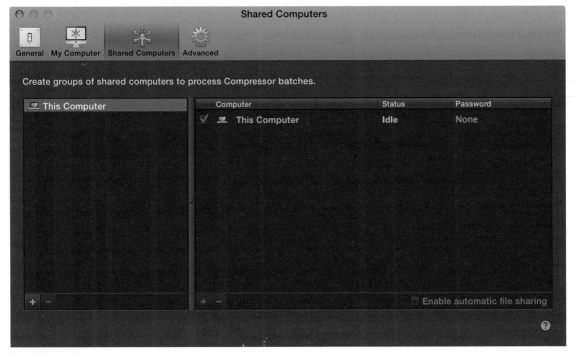

FIGURE 12.34
Shared computer preferences.

That's our quick look at Compressor. It's a very useful and powerful application not only in itself but also in its ability to provide features for FCP.

ARCHIVING

Now that you've finished your project, you need to think about archiving your material. Archiving is an essentially part of the postproduction workflow. Digital media redundancy is the future of production. Whether it's on disc, LTO, hard drives, SSDs, or servers in the cloud, redundancy in your digital life is essential.

Before archiving, consider exporting a full-resolution, native QuickTime file of your edited program. These are your master files and should be included in your archive.

The original memory cards, disks, or tapes on which you shot the project should have been correctly backed up already and should be your primary archive for your camera media.

To archive the project, you need the project file and the associated media. Basically there are two archive options, one is to combine everything ever used in the production in a single library in a single location and the second option, preferred by some, is to only archive the used media with the project content. Personally I think it's preferable, if practical, to archive everything.

Whichever method you use, before you archive, you should import your exported master files to bring them back into the library, perhaps in a separate *Masters* event. To archive, the simplest way is to begin with a new library created on a drive that you want to use to store your archive. If you only want to backup your projects and used media, simply drag the projects to back up into the event in the new library, which brings up the drop-down sheet in Figure 12.35. Leave **Optimized Media** and **Proxy Media** unchecked. There is never

Copy media to the library "B11archive"

Final Cut Pro will copy all selected items and original media files to the library "B11archive".

Media stored in external folders will be linked to, but not copied. You can include any available optimized or proxy media.

Include: ☐ Optimized Media
 ☐ Proxy Media

Cancel OK

FIGURE 12.35
Copying library.

any point in archiving these as these can be recreated by the application at any time. This will copy the projects and all the used content into the new library. If you're using managed media, you're done. If you're using external media, you should consolidate the new library to bring the media into the library for archiving.

If you want to preserve all the media from the project, you use essentially the same process, except rather than copying just the projects to the new library you copy all the events, which includes all the projects and events. Again, if you're using external media, make sure you consolidate everything into the new archive library in the new location.

SUMMARY

We've now gone through the whole cycle of work in Final Cut Pro X, including setting up your computer; working with the interface; importing raw material; editing; and adding transitions, titling, special effects, motion effects, color correction, and compositing. Now, finally, we have output our finished work and shared and exported it for everyone to see and enjoy. It's been a long road, but I hope you found it an exciting, interesting, and rewarding one. Good luck with all your future video projects and with your work in Final Cut Pro!

Index

Note: Boldface page numbers refer to figures and tables

A

absolute level, in dashboard 126, **126**
Adaptive Limiter 237
Add Density preset 237
Add Noise effect 232
adjustment layer 214–18, **217**
Advanced tab 378
AIFF settings **50**
Anchor Point 291–2, **292**, **293**
angle editor 162–4, **163–5**
angle viewer 166–70, **167–9**, **174**
animation: circle 336–7; custom 199–200, **201**; effects 213–14, **215**; highlight 335; Ken Burns 307, **307**, **308**; position for start of **305**; shapes 274; straight motion 298–300, **299**; text composite 324–5
appending close-ups 102–4
Apple Color Picker 185, **186**; RGB colors in 187
Apple FCP 2
Apple Magic Mouse 4
Apple ProRes 422 356, 357
Apple ProRes 4444 357, 359, 365, 374
Apple ProRes 422 LT 356
Apply Clip button 190
Archive dialog sheet 42
archiving 379–80
audio: codecs **357**; edit, rolling 117, **117**; effects 234–9; enhancements 120–3, **121**, **122**; fade out **115**; level, reducing 118, **118**; monitoring angles 164; recording 153–5, **154**; and video, separation **170**
Audio inspector 120, 374, **376**
audio meters 119–20; overmodulated **119**
auditions: clips and 85–7, **86**; compound clips for 145; effect 211–12

B

Backup dialog **36**
Behind blend mode 331
Bezier handles 300, **300**
Black Magic Disk Speed Test 26
Bleach Bypass 232
blend modes, compositing 321–3, **322**; adding bug 326–7, **328**; animated text composite 324–5; preview 323; screen and multiply 323–4
blurring effect 211
Bokeh Random effects 230, **231**
Brady Bunch open 308–9; extending 310–2; fade to black 318–19; fixing headshot 309–10; headshot, middle 310; headshot, new 314–15; headshots, adding 313–14; polishing 317–18; sliding white bar 309; titles 316–17, **318**
Broadcast Safe effect **267**, 267–8
Browser: library and **59**; media, adding 142, **142**; motion project 216, **216**; music 47; sound 47; title 185
bug, adding 326–7, **328**

C

cache files, migrate 31
camera archives: converting 44–5; creating 42–3
Cantemo Portal software 43
Car Radio favorites 235
Censor 234
Change List X 360
channel configurations 123–4, **124**, 152, 175–6, **176**, **177**
Channel EQ HUD **123**, 236
chapter markers 145, **145**
Choose option, storage settings 31
Automatic Speed 241
Automatic stabilization options **244**, 244–5
A/V Output 26

circular highlight **336**
client media structure **65**
Clip Distortion effect 236
clips: and auditions 85–7, **86**, 145; changing levels on part of 126–9; deleting 128; editing see editing clips; index **149**; organizing 70–5; selection **242**; skimmer 95, 164; spatial conform 304; synchronizing 151–3; trimming expanded 115–19
close-ups, appending 102–4
closing shots **108**
Cold Steel, sliders 232
collaboration 67–70
color balance 248, **248**; analysis 28
Color Board 255–60, **256**, **257**; using 261–2, **262**
color continuity: master shot 279–81, 284; matching shot 281–5; setup 277–8
color correction 247; Broadcast Safe effect **267**, 267–8; color balance 248, **248**; Color Board 255–62, **256**, **257**; Color Mask 271, 275–7, **276**, **283**, **285**; looks 269–71, **270**; Match Color function 268–9, **269**; night 265; Shape Mask 271–5, **273–5**, **285**; silhouette 264; video scopes 249–54; white balance 263
color-effected angles, in Timeline 175, **175**
Color Mask 271, 275–7, **276**, **283**, **285**
color panels, shortcuts 259
color position, adjusting end 182, **183**
color scopes, shortcuts 259
Color Selection keying tools 224, **225**
ColorSync technology 5
Color tab 260, 262
command editor **38**, 284, **284**
Compatibility popup 353

composting: blend modes 321–3, **322**; project setting 321
compound clips, for auditions 145
compound titles 202–4
Compressed Memory 1
compressed video formats 249
Compressor Built-In presets 361–6; action presets **364**; Apple Devices 362; audio formats 365; motion graphics 365; MPEG files 365; podcasting 365; ProRes 365; settings sheet **363**; uncompressed 365; video sharing services 366
Compressor: custom presets, creating 370–5; Droplet 376–7, **377**; groups 376, **376**; interface 361, **362**; preferences 378; sending *vs.* export using 361; using 366–9; working with 360
Consolidate Event Files 33–4
Consolidate Library Files 33–4, **34**
constant speed changes 239–40
continuity editing 98–100
controlling levels 119; with effects 134–8
Control-Option-L 126
crop controls **203**
Crop & Feather controls **219**, 220
Crop function 292, 305, 306; buttons **294**
Crop tool 295
cross fades, overlapping **118**
Cross Hatch effect 233
curved motion 300
custom animation 199–200, **201**
custom metadata 75–7, **76**, **78**; compound clips and auditions 85–7, **86**
custom speed settings **240**, 240–1
cut audio, in Timeline **133**
cutting, video 89–92, **96**

D
Dashboard, absolute level in 126, **126**
date/time stamp, in FCP 162, **163**
Delay Designer effect 236
delete generated event files **69**
Destination preferences 348–51, **350**, **351**
Detach Audio 176
deutsch 263
Directional blur 219, **219**
disk image, create **52**

Distort function 298, **298**
distortion effects 219–20, 235
Dock, libraries in **66**
documentary structure **64**
Drop Shadow effect 233
drop zone, selection 189, **189**
duotone effect 212
duplicate library dialog **69**
dutch 263
dynamic editing 92–8

E
Echo group 236
edging, composition with 344, **344**
editing: continuity 98–100; dynamic 92–8; multicam clip 166–70; music 142; shortcuts 22, **104–5**
editing clips: loading media 15–16; project editing 16–22
Editing preferences panel 24, **25**
effects: Add Noise 232; animating 213–14; applying 210–11; audio 234–9; audition HUD 212, **213**; auditions 211–12; blurring 211; Bokeh Random 230, **231**; Broadcast Safe **267**, 267–8; Clip Distortion 236; copying and pasting 211; Cross Hatch 233; Delay Designer 236; distortion 219–20, 235; Drop Shadow 233; duotone 212; Echo group 236; Film Grain 233; Filmic Black & White 210; Flash 230; Frame stylized border 233; Gaussian blur 335; kaleidoscopic 234; kaleidotile 234; Ken Burns 292, 296, **296**, 297, **297**, 304, 306; Letterbox 233; limiter **135**, 136; Luma Keyer 229, **230**; Mask 228–9, **229**; Photo Recall border 233; Ringshifter 236; Silhouette Luma **333**; Stereo Delay 236; Super 8mm 232; Tile 234; Tremolo 237; video *see* video effects
Energy Saver 4
episode libraries 63
EQ HUD **131**
export, AAF/OMF 359
Export Using Compressor Settings 360, 361
Exposure tab 256, **258**
external media 30–3

F
faded audio, overlapping **115**
fade HUD **125**
fading levels, in Timeline **125**, 125–6
files, reimporting and relinking 52–5, **54**
Film Grain effect 233
Filmic Black & White effect 210
find and replace 199
Flash effects 230
Flipped distortion 220, **221**
fold controls **188**
frame, changing end 243, **244**
Frame stylized border effect 233

G
garbage matte tool 229
Gaussian blur 219; effect 335
Gaussian effect 211
General preferences 23, **24**
glints 335, 338, **338**, **339**
global exposure **259**
glow, polishing 337–8
gradient color, adding 182, **183**
gradient controls 181, **182**
graphics stack 337

H
HD codecs **356**
headshots **313**, **315**; adding more 313–14; fixing 309–10; middle 310; in Timeline **311**, **316**; in viewer **312**, **317**
Highlight Matte 333
HTTP Live Streaming 362
HUD: Channel EQ **123**, 236; chapter marker 145, **145**; effects audition 212, **213**; EQ **131**; fade **125**; keywords collection 78–9, **79**; markers **144**; search filter 82

I
iMovie 7–10, **9**, 29
importing 40–1; music 46–9; preferences **27**, 27–8; sheet **32**; from XML 51
InertiaCam stabilization options **244**, 244–5
Info inspector: changing active angle in **173**; general view 159

inspector: Audio 120, 374, **376**; info *see* info inspector; Job 367, **368**; roles in 147, **147**; Share 352, **352**
Inspector Units 24
Instant Replay tool 242–3
interlace video shoot 358

J

J-cut, split edit 112, **113**
Job inspector 367, **368**

K

kaleidoscopic effects 234
Kaleidotile effects 234
Ken Burns: animation 307, **307**, **308**; effect 292, 296, **296**, 297, **297**, 304, 306; function 295–7; linear 297
keyboard: customizing 37–40; shortcuts, naviagation and playback **17–18**
keyframes 301; adding 213, **214**
keynote controls 190
keywords collection 78–80, **79**, **81**, 162

L

LatinLoud clip 134
layer structure 216, **217**
L-cut, split edit 112, **113**
legacy FCP 7
Lens Flare size 324
Letterbox effect 233
library: backups **35**, 35–6, **36**; and browser **59**; in Dock **66**; preferences, consolidate in 33–5; properties 29, **29**; updating 10–5, **15**
light, video effects 229–31
Light Wrap 225
limiter effects **135**, 136
loading media: editing 89; editing clips 15–16; organization 57
logic compressor controls **137**, **137**
logic limiter controls 136, **136**
Logic Test Oscillator presets 238, **238**
looks: color correction 269–71, **270**; video effects 232
Luma Keyer effect 229, **230**
Lumberjack 75

M

managed media 29–30
manual core color control 224, **226**
Marker popup 366, **367**
markers: adding 142–5, **144**, **145**; shortcuts **144**
Mask effect 228–9, **229**
match audio 129–30, **130**
Match Color function 268–9, **269**
Matte Tools 224, **227**
Mavericks 1
media *see also* loading media; organizing media: browser, adding 142, **142**; management 29–30; setting 209–10
memory clean 2, **2**
metadata: custom *see* custom metadata; export, XML library with 348, **348**
metatagging 82
Midtones **260**
mixing levels, in Timeline 125
Modulation group 237
monitors 5–6
montage editing 92
motion control 304–8
motion graphics 365
motion project browser 216, **216**
motion template folder **198**
motion text layers 193, **194**
movie library 61
MPEG-2 preset 370–1
MPEG-4 preset 372–4
MPEG Streamclip: batch list **48**, **51**; components 44, **45**; conversion in 48–9; movie exporter 46; task popup 49
multicam clip: channel configurations 175–6, **176**, **177**; editing 166–73, **171**; effects 174–5; making 158–62; options **160**; in Timeline 172
multicam editing, project setting for 157–8
music: browser **47**; importing 46–9

N

naming presets **74**
natural scrolling 4, **5**
navigation keyboard shortcuts **17–18**
Network File System (NFS) 72

Night Vision look 232
nudging values 221

O

opacity fade button **203**
open library dialog **14**
optimizing, computer for FCP 2–5
Option-Command 2 28, 33, 37
Option-Command-B 248
Option-Command-Drag 33, **33**
Option-Command-K 37
Option-Command-M 268
Option-Command-N 84
Option-Command-S 95
organic melding 332
organizing clips 70–5
organizing media 57–8; worflow structures 56–66
overmodulated audio meters **119**
overwriting, master shot 100–2

P

pan animation graph 141
Pan levels **138**, 138–42, **139**
paste attributes 301, **301**; dialog 211, **212**
phase error 138
Photo Recall border effect 233
Photoshop, adding effects in **327**
Photoshop scroll 193
Picture in Picture (PIP) 302
pitch shifting 239
playback keyboard shortcuts **17–18**
playback levels 155
Playback preferences 24–6, **25**
Playback tab 323
Player Background 26
playhead losing focus 278
Plus popup 369
polishing glow 337–8
positioning clip 128
precise levels 128
Precision Editor **107**; roll edit in **107**
preferences: files 36–7; general and editing 23–4, **24**; importing **27**, 27–8; Playback 24–6, **25**
presets: action **364**; Add Density 237; Apple Built-In *see* Compressor Built-In presets; Logic Test Oscillator 238, **238**; MPEG-2 370–1; MPEG-4 372–4; naming **74**; Space Designer 237, **237**; Test Oscillator 238, **238**

Prevent App Nap 2, **3**
Producer's Best Friend tool 360
project setting: animating images 287; compositing 321; multicam editing 157–8; still images adding 179; title adding 179; working with audio 111–12
projects/events, updating 11–5
ProRes codec 28
pucks: nudging 262; selection 254

Q

QuickTime components **45**
QuickTime custom setting 374–5, **375**
Quit function 36

R

ramping audio with keyframes **127**
Range Selection tool 126, **127**
recording audio 153–5, **154**
RED RAW 51–2, **53**
red stats **198**
reference waveform 129, **129**
reimporting files 52–5
relink dialog **12**
Relink Event Files function 11
relinking files 52–5, **54**
replace, find and 199
resolution 207
Retime to Fit function 241–2
retiming 239–44, **240**; constant speed changes 239–40; custom speed settings **240**, 240–1; speed transitions 241, **241**
Reveal in Finder 14; button 70, 75
Rewind tool 242–3
RGB: colors in Apple Color Picker 187; controls **187**; Overlay 250, **253**; Parade 250, **254**, 280
RGB1 color gradient 181, **182**
ribbon title edit 191, **191**
Ringshifter effect 236
ripple tool 241, **242**
roles: exporting 358, **358**; options 359, **359**
roles, FCP 146–8, **147**, **148**; shortcuts 148
roll edit, in precision editor **107**
rolling audio edit 117, **117**

S

SAN *see* Shared Area Network
Saturation tab 256, 258

Save Current Frame 349
save dialog **12**
scene, closing shots in **108**
screens: shooting green 228; text and 196–9
scroll bar preference 3
scrolling title 192
Scrub Boxes 224, **226**
search filter 81, **82**
secondary correction, shape mask 271–5, **273–5**
Send to Compressor function 347–8, 360, 361
series episodes transfer, to new libraries 62
series master library **62**, **63**
7toX XML tool 7, **8**
shadows **259**
Shape Mask 271–5, **273–5**, 285
Shared Area Network (SAN) 67
Shared Computers preferences 378, **378**
Share inspector 352, **352**
Share option 347–8, 349; Destination preferences 348–51, **350**, **351**; export 351–5, **355**; master file 355–7; roles **358**, 358–9, **359**
Shift-Command-R 14
shifted audio layers 117, **117**
shooting green screens 228
Show Package Contents 14
Silhouette blend modes 328, **331**
Silhouette clip 264
Silhouette Luma effect **333**
single-track audio 124
skimmer, clip **95**
sliding white bar 309
slipped audio, in Timeline 134
Smart Collections 82–5, **83**; analysis sheet **83**; audio only 84, **85**
smart folder criteria 71, **71**
SmoothCam stabilization options 244, 244–5
Smoothing slider 245
snapshots 328
sound browser 47
Space Designer presets 237, **237**
Speed Blade function 241
speed ramp 243, **243**
speed tools 242–4
speed transitions 241, **241**, **242**

Spill Levels slider 224
split edit 112–4, **113**; making **114**, 114–15; in Timeline **108**
split screen 301–2, **303**; Picture in Picture (PIP) 302
spot image 231, **231**
stabilization 244, 244–5
StatsGlass colorize **197**
stats layers **196**
statue dutch clip 263
Stencil blend modes 328, **329**, **330**
Stereo Delay effect 236
still images 204–6, **207**; adding, project setting 179; preference 24
stills frame rate 287
storage settings **30**
straight motion 298–300, **299**
stylize video effects 232–3
subframe audio edit **133**
subframe precision 131–3, **132**, **133**
Super 8mm effect 232
surround panner 139; and controls **140**; dialogue keyframe **141**
switched off roles 151, **151**
switching color selection modes 224
Sync Angle to Monitoring Angle 165, **166**
synchronizing clips 151–3
Sync-N-Link X 153

T

Tags tab 149, **150**
Telephone controls 235, **235**
Test Oscillator presets 238, **238**
text: layers, motion 193, **194**; and screen 196–9; styles 179–85, **181**, **184**
texture 202–3
third-party hardware technologies 6–7
Tile effect 234
Timeline: after compositing video 344; changing active angle in 172; channels in 176, **177**; color-effected angles in 175, **175**; connected audio in 129; cut audio in **133**; display shortcuts 115; fading levels in **125**, 125–6; headshots in